MODIGLIANI

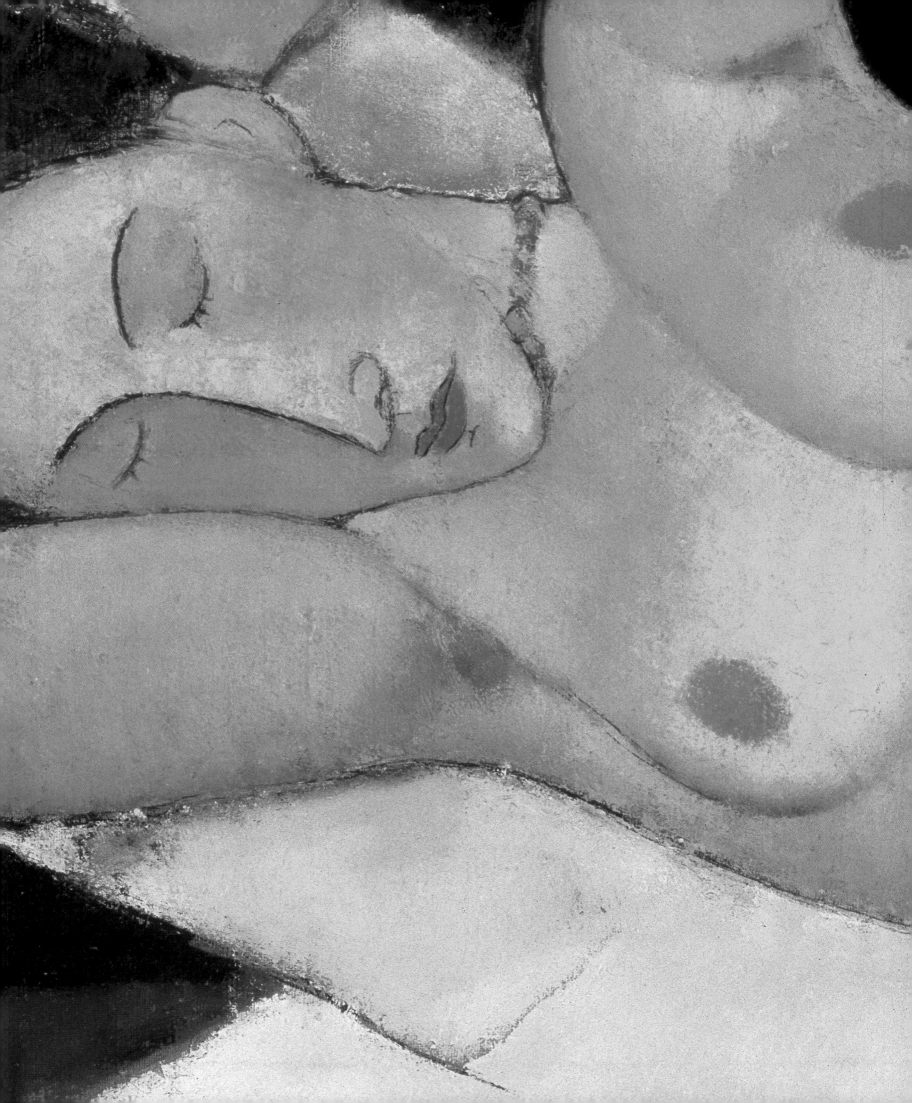

Kenneth Wayne

MODIGLIANI
& THE ARTISTS OF MONTPARNASSE

HARRY N. ABRAMS, INC., PUBLISHERS in association with the ALBRIGHT-KNOX ART GALLERY Buffalo, New York

FOR THE ALBRIGHT-KNOX ART GALLERY
EDITOR FOR SPECIAL PROJECTS: Karen Lee Spaulding
EDITOR OF PUBLICATIONS: Sarah Hezel

FOR HARRY N. ABRAMS, INC.
PROJECT DIRECTOR: Margaret L. Kaplan
EDITOR: Deborah Aaronson
DESIGNER: Brankica Kovrlija
PRODUCTION DIRECTOR: Hope Koturo

LIBRARY OF CONGRESS CATALOGING-IN-PUBLICATION DATA
Wayne, Kenneth.
 Modigliani and the artists of Montparnasse / Kenneth Wayne.
 p. cm.
 Catalog of an exhibition held at the Albright-Knox Gallery, Buffalo, N.Y., Oct. 19,
2002–Jan. 12, 2003, the Kimbell Art Museum, Forth Worth, Tex., Feb. 9–May 25, 2003,
and the Los Angeles County Museum of Art, Los Angeles, Calif., June 29–Sept. 28, 2003.
 Includes bibliographical references and index.
 I. Modigliani, Amedeo, 1884–1920. —Exhibitions. 2. Modernism
(Art)—Europe—Exhibitions. 3. Expatriate artists—France—Montparnasse
(Paris)—Exhibitions. I. Modigliani, Amedeo, 1884–1920. II. Albright-Knox Art Gallery.
III. Kimbell Art Museum. IV. Los Angeles County Museum of Art. V. Title.
N6923.M55 A4 2002
790'.2–dc21

 20020180118

ALBRIGHT**KNOX**
ART GALLERY

Harry N. Abrams, Inc.
100 Fifth Avenue
New York, N.Y. 10011
www.abramsbooks.com

Abrams is a subsidiary of

LA MARTINIÈRE
GROUPE

Page 1: Amedeo Modigliani, c. 1918

Pages 2-3: Amedeo Modigliani. *Nude* (detail), 1917.
Oil on canvas, 28 ¾ x 45 ⅞" (73 x 116.7 cm.)
Collection Solomon R. Guggenheim Museum, New York. Gift, Solomon R. Guggenheim, 1941 (41. 535)

Page 6: Amedeo Modigliani. *Rose Caryatid with Blue Border* (detail), c. 1913.
Watercolor on paper, 21 ⅞ x 17 ¼" (55.6 x 45.1 cm.)
Private Collection

MODIGLIANI
& THE ARTISTS OF MONTPARNASSE

ALBRIGHT-KNOX ART GALLERY
Buffalo, New York
October 19, 2002–January 12, 2003

KIMBELL ART MUSEUM
Fort Worth, Texas
February 9–May 25, 2003

LOS ANGELES COUNTY MUSEUM OF ART
Los Angeles, California
June 29–September 28, 2003

This exhibition is supported by an indemnity from the
Federal Council on the Arts and the Humanities and, in part,
by a grant from the National Endowment for the Arts.

Made possible, in Buffalo, through the generous support of

▲▲ M&T Bank

The Albright-Knox Art Gallery is supported, in part, by public
funds from the New York State Council on the Arts, and by
grants-in-aid from the County of Erie and the City of Buffalo.

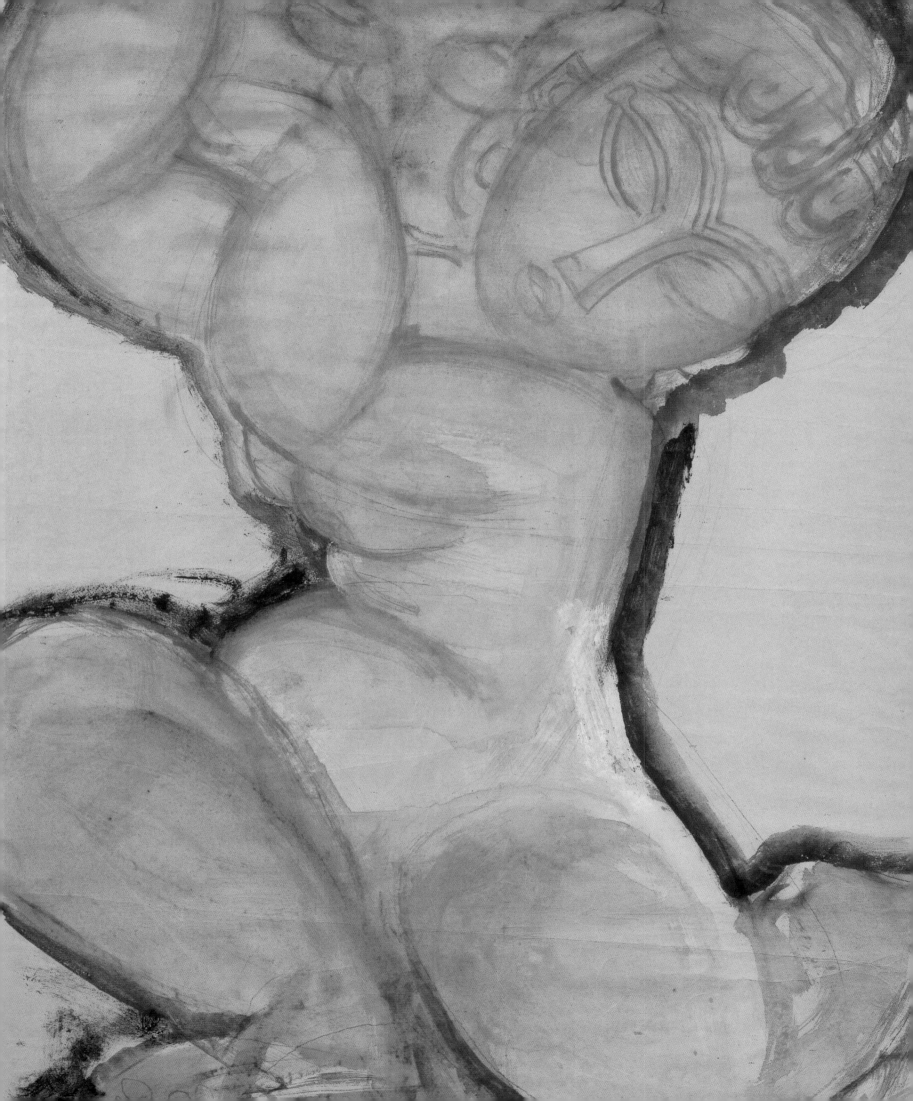

CONTENTS

LENDERS TO THE EXHIBITION

LATNER FAMILY ART COLLECTION, Toronto, Canada

ESTATE OF ELIE NADELMAN

THE HENRY AND ROSE PEARLMAN FOUNDATION, INC.

PRIVATE COLLECTIONS

PRIVATE COLLECTION, Boston, Massachusetts

PRIVATE COLLECTION, courtesy Steve Banks Fine Arts, San Francisco, California

GWENDOLYN WEINER

THE WHITEHEAD COLLECTION, courtesy Achim Moeller Fine Art, New York

AICHI PREFECTURAL MUSEUM OF ART, Nagoya, Japan

ALBRIGHT-KNOX ART GALLERY, Buffalo, New York

ALLEN MEMORIAL ART MUSEUM, OBERLIN COLLEGE, Ohio

ART GALLERY OF ONTARIO, Toronto, Canada

THE ART INSTITUTE OF CHICAGO, Illinois

THE BROOKLYN MUSEUM OF ART, New York

CINCINNATI ART MUSEUM, Ohio

THE CLEVELAND MUSEUM OF ART, Ohio

DALLAS MUSEUM OF ART, Texas

DENVER ART MUSEUM, Colorado

THE EVERGREEN HOUSE FOUNDATION, and THE JOHNS HOPKINS UNIVERSITY, Baltimore, Maryland

FOGG ART MUSEUM, HARVARD UNIVERSITY ART MUSEUMS, Cambridge, Massachusetts

HIRSHHORN MUSEUM AND SCULPTURE GARDEN, SMITHSONIAN INSTITUTION, Washington, D.C.

HONOLULU ACADEMY OF ARTS, Hawaii

INDIANAPOLIS MUSEUM OF ART, Indiana

KUNSTSAMMLUNG NORDRHEIN-WESTFALEN, Dusseldorf, Germany

LOS ANGELES COUNTY MUSEUM OF ART, California

THE MARION KOOGLER McNAY ART MUSEUM, San Antonio, Texas

MEADOWS MUSEUM, SOUTHERN METHODIST UNIVERSITY, Dallas, Texas

THE METROPOLITAN MUSEUM OF ART, New York

MUSÉE D'ART MODERNE DE LA VILLE DE PARIS, France

MUSÉE D'ART MODERNE LILLE MÉTROPOLE, Villeneuve d'Ascq, France

MUSÉE DES BEAUX-ARTS, Nancy, France

MUSÉE DES BEAUX-ARTS, Rouen, France

MUSÉE NATIONAL D'ART MODERNE, CENTRE GEORGES POMPIDOU, Paris, France

MUSÉE PICASSO, Paris, France

THE MUSEUM OF MODERN ART, New York

NAGOYA CITY ART MUSEUM, Japan

NEUBERGER MUSEUM OF ART, PURCHASE COLLEGE, STATE UNIVERSITY OF NEW YORK

NORTON MUSEUM OF ART, West Palm Beach, Florida

ÖFFENTLICHE KUNSTSAMMLUNG BASEL, KUNSTMUSEUM, Switzerland

PHILADELPHIA MUSEUM OF ART, Pennsylvania

THE PHILLIPS COLLECTION, Washington, D.C.

THE SAINT LOUIS ART MUSEUM, Missouri

SOLOMON R. GUGGENHEIM MUSEUM, New York

STAATSGALERIE STUTTGART, Germany

STATENS MUSEUM FOR KUNST, Copenhagen, Denmark

TATE, London, England

TOLEDO MUSEUM OF ART, Ohio

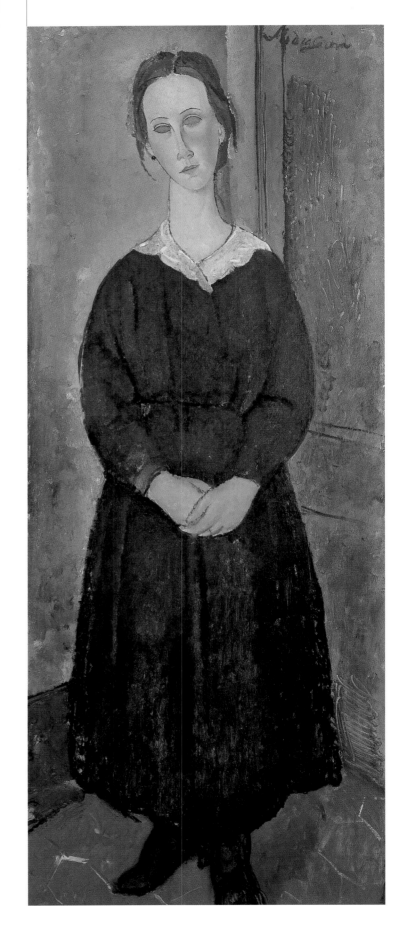

MODIGLIANI. THE SERVANT GIRL. c. 1918
Collection Albright-Knox Art Gallery
Room of Contemporary Art Fund, 1939

Taking place nearly a century after Amedeo Modigliani first arrived in Paris in 1906, this exhibition celebrates this artist and the extraordinary circle of fellow artists, critics, dealers, collectors, writers, and musicians who gathered in Paris during the first decades of the twentieth century. These figures—from Pablo Picasso and Alexander Archipenko to Diego Rivera and Henri Rousseau—are responsible for launching several of the varied and diverse manifestations of twentieth-century European modernism. Modigliani's unique artistic vision is intricately tied to his relationship and friendship with this particular group of individuals.

Long considered to be one of the Albright-Knox Art Gallery's masterworks, Modigliani's portrait, *The Servant Girl*, c.1918, has been a favorite among Gallery visitors since it was acquired in 1939. It is, therefore, with great pleasure that the Albright-Knox Art Gallery has organized this first major Modigliani exhibition—culled from important collections in North America and abroad—in the United States in more than forty years. *Modigliani & the Artists of Montparnasse* provides a splendid opportunity to recontextualize the masterworks of Modigliani and to consider the rich cultural climate from which they emerged.

My colleagues Timothy Potts at the Kimbell Art Museum and Andrea L. Rich at the Los Angeles County Museum of Art have been actively involved since the project's inception and were critical partners in the formation of the exhibition's tour. The Gallery extends sincere appreciation to the numerous private and public lenders to the exhibition; their support and enthusiasm for this project have been tremendous. An exhibition of this magnitude is simply not possible without the critical support of public and private funding sources. We are deeply grateful to the Federal Council on the Arts and Humanities and to the National Endowment for the Arts. In Buffalo, the M&T Bank has once again shown its confidence in our efforts by providing major corporate sponsorship for this exhibition.

Finally, the exhibition and the catalogue that accompanies it are the fruits of Curator Kenneth Wayne's longtime interest in Modigliani. His dedicated work provides a detailed record of Modigliani's life in Montparnasse and the artist's place among the early twentieth-century avant-garde.

DOUGLAS G. SCHULTZ, DIRECTOR
Albright-Knox Art Gallery

This book, which accompanies the exhibition *Modigliani & the Artists of Montparnasse*, has ambitious aims. It seeks to move beyond the romantic story and the myths that surround Amedeo Modigliani in order to concentrate on facts and analysis, all of which provide a new and fuller understanding of his art. Until now, Modigliani has largely been seen as a "peintre maudit," or cursed painter, a handsome womanizer consumed by alcohol and drugs who, like Vincent van Gogh, died young, poor, and relatively unknown. Compounding this view is the perception that Modigliani was not a serious avant-garde artist, but instead a figurative artist who spent most of his time in the Montparnasse cafés. Since the artist's death, writers have perpetuated this characterization and have downplayed, or simply disregarded, any information that might challenge this view of him as a sad, unrecognized artist. As this book will demonstrate, however, Modigliani was a serious and ambitious artist who exhibited extensively both in France and abroad, and garnered significant interest from collectors, dealers, and critics during his lifetime.

An early death for Modigliani—at age thirty-five, younger than van Gogh by a year—is not the only reason that a romantic myth has developed around him. Adding to the aura of tragedy is the fact that many of those closest to Modigliani died tragically or young. These individuals include his three principal lovers, two of whom committed suicide. Jeanne Hébuterne, who was nine months pregnant with their second child, killed herself by jumping out of her fifth-floor bedroom window on January 26, 1920, just two days after the artist died.[1] Simone Thirioux, who had a son by Modigliani around 1917, died of tuberculosis in the early 1920s.[2] A third, Beatrice Hastings, whose body was found on October 31, 1943, committed suicide in Worthing, England.[3] In addition, Modigliani's dealer Paul Guillaume died at the age of forty-two on October 1, 1934, while his other dealer, Léopold Zborowski, died at the age of forty-three on March 24, 1932.

Most writings on Modigliani have taken a biographical rather than an art historical approach, as interest in his life story has outweighed interest in his art. A notable example is Pierre Sichel's outstanding biography of 1967, which still stands as a key resource for those interested in the artist's life.[4] Not all books have been so scrupulous, however, and even such a simple fact as Modigliani's death date has varied from account to account.[5]

Biographical issues and questions of authenticity dominate even the most recent discussions about Modigliani, rather than the more substantive issues of meaning, style, influence, and the interpretation of his art. There are several reasons for this, namely the paucity of documentary materials left by Modigliani and his two principal dealers, the number of forgeries in existence, and a lack of scholarship on him. Even Modigliani's friend Chaïm Soutine, who was surrounded by a less romantic myth, has benefited from more scholarly attention.[6]

To break the biographical mold, this book is arranged thematically instead of chronologically. The first essay explores Modigliani's relation with Montparnasse to underscore the cosmopolitan character of that area and Modigliani's place within it. The second essay addresses his relationship with the avant-garde movements and figures of the early twentieth century. The third essay takes a close look at his lifetime exhibitions and the criticism surrounding them to arrive at a better understanding of the artist's reception during his life.

Modigliani's exhibitions are key to understanding the artist, as most of the published references to Modigliani during his lifetime are connected to exhibitions in which he participated. Eighteen exhibitions are discussed herein—about twice the number cited in any previous exhibition history of the artist. It is probable that still more lifetime exhibitions will be uncovered, along with more reviews or articles about him. The extensive new material in this book not only illuminates Modigliani but also provides the researcher with a resource of materials on other Montparnasse artists such as Pablo Picasso and Henri Matisse who participated in many of the same exhibitions.

This book also helps us to better understand Modigliani's figurative style. For today's eyes, which have seen Surrealism, Abstract Expressionism, Pop Art, and the many manifestations of Postmodernism, Modigliani's art may seem tame. Modigliani's contemporaries, however, did not see his art as naturalistic or realistic. Indeed, his portraits rarely resembled the sitters. His portraits of Hébuterne are an excellent case in point. Photos reveal her to be a dark-skinned woman with a broad nose, while Modigliani's portraits of her portray her as light-skinned and with a narrow nose. The same is true of the artist's many paintings of Hastings. Seeing Modigliani's art through the eyes of his contemporaries helps us to appreciate their subtlety and novelty—an art seen as "literary,"

which generally meant imaginative. As contemporary observers have commented, he turned his sitters into "Modiglianis."[7] This book attempts to recapture the sense of daring and wonder that his art conveyed at the time it was made.

Modigliani was indeed a major figure during his own time. His contemporaries took notice of the fact that he was gifted in three media: painting, sculpture, and drawing. Modigliani captured the attention of the leading writers and critics of his day such as Guillaume Apollinaire, Clive Bell, Blaise Cendrars, Roger Fry, Max Jacob, André Salmon, and Louis Vauxcelles. His lifetime exhibitions, which took place both in France and abroad in Zurich, London, and New York, help confirm that he was an internationally known artist. The large number of lifetime exhibitions is an indication of the artist's ambition.

It is an exaggeration to claim, as some writers have, that Modigliani's work was not collected during his lifetime. A glance at early salon catalogues reveals that the Modigliani works on view were not always lent by the artist, but sometimes by others. The most active collector during Modigliani's life, Dr. Paul Alexandre, tried to buy everything he could from the artist, during their years of contact from 1907 to 1914.[8] Modigliani's first dealer, Guillaume, noted that the artist had many collectors after he seriously turned to painting in 1914—including André Level, Georges Menier, an M. Parent, Paul Poiret, and various Scandinavians—and was at the time considered to be a "grand peintre" or major painter.[9] With the help of Guillaume, Modigliani became established internationally during the First World War. Modigliani was even being sold on the secondary market during his lifetime, with his work appearing at the Hôtel Drouôt in 1919.

Modigliani's status as an artist can be attested to by the leading avant-garde and scholarly publications of his day. His name was mentioned or his works were illustrated in: 291 (New York), 391 (New York and Barcelona), American Art News (New York), Art and Letters (London), Cabaret Voltaire (Zurich), Coterie (London), Littérature (Paris), Blast (London, Paris, and Toronto), The Burlington Magazine (London), L'Élan (Paris), L'Éventail (Geneva), Les Arts à Paris (Paris), and SIC (Paris). During his lifetime, Modigliani was also mentioned or featured in the leading newspapers and magazines in Paris and abroad such as The Athenaeum (London), Le Bonnet Rouge (Paris), The Christian Science Monitor (Boston), Commoedia Illustré (Paris), Le Cri de Paris (Paris), Dagbladet (Oslo), L'Europe Nouvelle (Paris), L'Excelsior (Paris), La Gazette de l'Hôtel Drouôt (Paris), L'Intransigeant (Paris), The Nation (London), The New York Times (New York), Svenska Dagbladet (Stockholm), and La Vie Parisienne (Paris).

Modigliani was the quintessential artist of Montparnasse, that tiny area in Paris—about a mile square—which seemed to magically transform artists who moved there.[10] Artists such as Constantin Brancusi, Jacques Lipchitz, and Piet Mondrian saw their style mature quickly and inevitably towards modernism upon their arrival. One could state, only partly in jest, that the address of a given artist indicates the level of modernity contained in his or her art: the closer to Carrefour Vavin, or the Vavin intersection, in the heart of Montparnasse, the more modern the work.

It is not possible to understand Modigliani without discussing Montparnasse, which was his base from late 1908 or early 1909 until his death in 1920, the very years when his art matured and when he was the most prolific. The converse is also true. When Modigliani died—and a long procession transported his body past his Montparnasse haunts en route to Père Lachaise cemetery, a resting spot reserved for famous and important figures—Montparnasse was no longer the same place.[11] His death marked a definite turning point. As Lipchitz wrote, "I will never forget Modigliani's funeral. So many friends, so many flowers, the sidewalks crowded with people bowing their heads in grief and respect. Everyone felt deeply that Montparnasse had lost something precious, something very essential."[12] And, as Jean Cocteau commented, "[The death of] Modigliani represented the end of great stylishness in Montparnasse, although we did not realize it at the time. We imagined that his long painting sessions with Moïse Kisling, the drawings he made on the café terraces, his five-franc masterpieces, his pastels, his embraces, would last forever."[13]

The editors of a special issue of Montparnasse magazine, published on the tenth anniversary of the artist's death, discussed Modigliani's special place in Montparnasse history: "While he will always be the handsome, tempestuous painter, a passionate and unconventional man, Modigliani has become, with the posthumous admiration of thousands, the center of a religion, so to speak. He shined, suffered and died, but not without leaving us a legacy. His legend is essentially the cornerstone of Montparnasse."[14] Hence the approach of this book and exhibition, Modigliani & the Artists of Montparnasse. In the end, we will see how Modigliani's art and life epitomized the diverse and international artistic approach that developed in Montparnasse during those extraordinary early decades of the twentieth century.

KENNETH WAYNE, CURATOR

Albright-Knox Art Gallery
Buffalo, New York

My interest in Amedeo Modigliani and the artists of Montparnasse has been a consuming passion for more than fifteen years. During this time, there have been many individuals around the world who have assisted me. For research help, I extend deepest appreciation to Nicole and José Altounian-Cruz, Alain Beausire, Sir Alan Bowness, Ella Brummer, William Camfield, Miriam Cendrars, Lucille Chveder, Marie Cécile Comerre, Wanda Corn, Jon Cowans, Claude Duthuit, Roger Conover, Albert Elsen, Kelly Frank, Malcolm Gee, Jacqueline Gojard, Frances Archipenko Gray, Christopher Green, Michelle Harvey, Elsebeth Heyerdahl-Larsen, William Homer, Madame Justman-Orloff, Ivanonia Keet, Pick Keobandith, Sophie Krebs, Quentin Laurens, Shirley Levy, William Lieberman, Rubin Lipchitz, Yulla Lipchitz, Charles Little, William Loos, Darius Michaud, Cynthia Nadelman, Jill Ortner, JoAnne Paradise, Hélène Pinet, Carol Radovich, John Richardson, Deborah Ronnen, Alex Ross, Pierre Sichel, Kenneth Silver, Ornella Volta, Eva White, Jake Wien, Véronique Wiesinger, and Judith Zilczer.

Eight colleagues have been particularly instrumental during the course of my research. Billy Klüver and Julie Martin, the historians of Montparnasse, have generously shared their materials and insights with me. In addition, their work has been a great inspiration to me throughout every phase of this project. Claude Bernès in Paris, another Montparnassian at heart, also helped me to obtain key information. Sophie Bowness kindly carried out valuable research in London for this exhibition catalogue. New York Dada scholar Francis Naumann generously answered my questions about Marius de Zayas and the Modern Gallery. Rodrigo de Zayas kindly allowed me to consult the archives of his father Marius de Zayas, located in his home in Seville, Spain. Patrick Elliott of the Scottish National Gallery of Modern Art in Edinburgh and I have had many valuable discussions and written exchanges over the years about artists in Paris at the turn of the century. Colette Giraudon, formerly the documentaliste at the Musée de l'Orangerie in Paris, which houses the Paul Guillaume collection, has been an enormous help with my Modigliani and Montparnasse research since it began.

In 1992, I had the great privilege of interviewing one of Modigliani's last models, Paulette Jourdain, in her Paris apartment. Throughout our taped interview, she sat in exactly the same pose, interestingly enough, as she did in Modigliani's famous portrait of her, maintaining the delicate and measured mannerisms of a professional artist's model. I shall always remember that very special encounter.

I would also like to thank Guido and Giorgio Guastalla for allowing me to visit Modigliani's "casa natale," or birth home, in Livorno, Italy, which they now own and hope to turn into a museum or research center devoted to the artist. Local arts officials Dario Matteoni and Daniela Nenci were also very hospitable during my visit to Livorno. Christian Parisot, in Paris, allowed me to see and make an inventory of the one hundred Modigliani items—postcards, letters, photos, and ephemera—formerly in the possession of Jeanne Modigliani, the artist's daughter, which he now has. While most of this material has been published, it was a treat to see the primary material.

Organizing this exhibition required the collaboration of many individuals. The list of people at museums, galleries, and auction houses whom I would like to thank warmly for their assistance in tracking down or securing Modigliani works for this exhibition is extensive: William Acquavella, Ida Balboul, Steve Banks, Neal Benezra, Brent Benjamin, Roger Berkowitz, Ernst Beyeler, Diederik Bakhuÿs, Doreen Bolger, Peter Boris, Blandine Chavanne, William Chiego, Catherine Clement, Harry Cooper, Christina Corsiglia, James Cuno, Lisa Dennison, Elizabeth Easton, Carol Eliel, George Ellis, Savine Faupin, Eliza Frecon, Katsunori Fukaya, Matthew Gale, Jay Gates, Lucinda Gedeon, Elizabeth Gorayeb, Diane De Grazia, Charlotte Gutzwiller, Saburoh Hasegawa, Anne d'Harnoncourt, Cornelia Homburg, Cindy Kelly, Tatsuo Kobayashi, Dorothy Kosinski, Lori Kutsher, Heather Lammers, Dominique Labbé, Ellen Lee, Brigitte Léal, Christophe Léribault, William Lieberman, John Lunsford, Edouard and Daniel Malingue, Maureen McCormick, Patrick Michel, Blake Milteer, Achim Moeller, Hanne Møeller, Pia Müller-Tamm, Hiroya Murakami, David Nash, Leonard Nelson, Jessica Nicoll, Patrick Noon, David Norman, Christina Orr-Cahall, Alfred Pacquement, Suzanne Pagé, Michael Parke-Taylor, Sharon Patton, Avril Peck, Klaus Perls, Ann Percy, Joëlle Pijaudier-Cabot, Denise Pillon, Ted Pillsbury, Timothy Potts, Birgid Pudney-Schmidt, Katherine Lee Reid, William Robinson, Cora Rosevear, Katy Rothkopf, Timothy Rub, Laurent Salomé, Jennifer Saville, Manuel Schmidt, Daniel Schulman, Hélène Seckel-Klein, Lewis I. Sharp, Richard Smooke, Michael Taylor, Matthew Teitelbaum, Ann Temkin,

Elizabeth Turner, Kirk Varnedoe, Bret Waller, Patricia Whiteside, Allison Whiting, Karl E. Willers, and James Wood.

I have greatly enjoyed working with my curatorial colleagues at the two participating venues on the Modigliani tour: Malcolm Warner, Chief Curator at the Kimbell Art Museum, and his predecessor Charles Stuckey; and Carol Eliel, Curator of Modern and Contemporary Art at the Los Angeles County Museum of Art.

I also wish to thank Jill Ortner at the University of Buffalo and William Loos at the Buffalo and Erie County Public Library for their research assistance. Isabelle Martinez provided assistance with this project by translating Beatrice Hastings's work "Minnie Pinnikin."

At the Albright-Knox Art Gallery, Director Douglas G. Schultz, Board President Charles E. Balbach, and the Board of Directors committed the significant staff and financial resources necessary for this important project to reach fruition. Curatorial Assistant Holly E. Hughes handled the many administrative functions involved in organizing a major exhibition—preparing loan request forms, gathering photos and information, and proofreading, among countless other tasks—with great efficiency and dedication. She was an invaluable asset to this project. Head Librarian Janice Lurie, System Services Librarian Conan Cerretani, and Library Assistant Amy Hezel aggressively tracked down many of the reviews, references, and bits of information that are so crucial to a book such as this. They were ably aided by Curatorial Interns Min Hee Suh and Yoon Jeong Lim. In the Gallery's Image Resource Center, Yvonne Widenor, who handles the complicated copyright issues facing the Albright-Knox and today's museums, treated the various issues that presented themselves with great promptness and dedication. She did this with the able assistance of Michael Benner, Rights and Reproductions Coordinator. The Albright-Knox's photographer Tom Loonan expertly took dozens of photographs, which are important contributions to this book. Richard Cherry, Bryan Gawronski, and Jill Bencini of the Gallery's Information Technology department also provided invaluable support.

The Publications department brought great professionalism to this project to make this book so memorable. Editor for Special Projects Karen Lee Spaulding arranged for its important copublication with Harry N. Abrams. Editor of Publications Sarah Hezel, who served as project editor for this book, worked tirelessly over many months: she convened countless meetings, heroically coordinated the efforts of the library staff, and oversaw literally every editorial detail of this book with extraordinary patience and good humor. Without Karen's and Sarah's extensive knowledge, experience, and expertise, this book would not have been possible. Working in their department, Publications Intern Robin Boyko diligently tracked down the many supplementary photos for this book from individuals and institutions all over the world. It was a pleasure working with all three of them.

I would also like to thank Margaret L. Kaplan, Senior Vice President and Executive Editor of Harry N. Abrams, for her enthusiasm and commitment to this publication. At Abrams, Deborah Aaronson oversaw the project with great professionalism and Brankica Kovrlija produced the catalogue's elegant design.

With great skill and proficiency, Senior Registrar Laura Fleischmann arranged the complicated international shipping and insurance for this ambitious traveling exhibition. Associate Registrar Daisy Stroud helped her in this endeavor. Aided by Joseph Porto and his team, the Albright-Knox's art handler/preparator Bruce Rainier helped create the exhibition's beautiful installation in Buffalo. Tom Getska and the Gallery shop staff oversaw the exhibition's satellite shop. Anne Hayes, Development/Membership Officer, worked hard to secure the major funding necessary for this exhibition. Director of Marketing Susan A. Scholterer, Public Information Officer Cheryl Orlick and Marketing Assistant Maureen Fayle, promoted this exhibition extensively and made sure that as many people as possible benefitted from it. Curator of Education Mariann Smith and the entire staff of the Education department ensured that visitors learned as much as possible through audioguides, visual guides, and a wide range of creative programming.

Most of all, I would like to thank my wife, Olivia, and my son, Gabriel, whose warmth, love, and good humor sustained me throughout this project. This book is dedicated to them.

K.W.

MODIGLIANI AND MONTPARNASSE

In late 1908 or early 1909, Amedeo Modigliani moved from Montmartre to Montparnasse and continued to be based there with some interruptions until his death at an early age in January 1920.[1] It was in Montparnasse that his art matured and where he created most of his work. The artistic community that developed in Montparnasse in the first few decades of the twentieth century had a distinctive character due in large part to the numbers of foreigners who had settled there. By 1913, it had evolved to a point where one writer referred to the area as a "little international republic."[2] Another writer that same year remarked that Montparnasse had been "invaded by numerous colonies of foreign painters."[3] The writer André Warnod called it an "artistic Babel,"[4] referring to the ancient biblical city dominated by a confusion of languages.

As a result, Montparnasse became home to many foreign artists' associations such as the American Art Association, the American Students and Artists Center, the Association des Artistes Scandinaves, the Union des Artistes Polonais en France, and the Union des Artistes Russes. Underscoring Montparnasse's uniqueness and its special place in history, Marcel Duchamp called it "the first really international group of artists we ever had. Because of its internationalism it was superior to Montmartre, Greenwich Village, or Chelsea."[5] The internationalism of the Montparnasse artists'

community is its single most defining characteristic and a key point to consider when evaluating the art that developed there in the early twentieth century by artists such as Modigliani. Internationalism and modernism are inextricably linked. The international group of artists in Montparnasse to which Duchamp refers included the Spaniards Juan Gris and Pablo Picasso; the Italians Giorgio de Chirico and Modigliani; the Poles Alice Halicka, Henri Hayden, Moïse Kisling, Louis Marcoussis, and Elie Nadelman; the Bulgarian Jules Pascin; the Mexican Diego Rivera; the Hungarian Joseph Csáky; the Dutchman Piet Mondrian; the Americans Jacob Epstein (who became an Englishman), Stanton MacDonald-Wright, and Morgan Russell; the Russians (from present-day Ukraine) Alexander Archipenko, Sonia Delaunay, and Chana Orloff; Russians (from present-day Belarussia) Marc Chagall, Maria Vorobieff Marevna, Chaïm Soutine, and Ossip Zadkine; Russians (from present-day Lithuania) Jacques Lipchitz and Marie Vassilieff; and the Romanian Constantin Brancusi. This multinational group of artists brought with them a wide range of artistic histories, traditions, and backgrounds, and created a remarkably lively, cosmopolitan, and sophisticated environment. Thus, a new artistic approach developed in Montparnasse. It was no longer essential, as much previous art had required, to know French history or literature, let alone religion (Christianity, of course) or mythology, to be able to appreciate the art that they produced. The new art was trans-national, trans-cultural, and drew from many historical periods.

The art created in Montparnasse was not necessarily linked stylistically—consider the differences between the abstract art of Mondrian and the figurative art of Modigliani—but instead shared commonalities on conceptual and theoretical levels. In his or her own way, each artist was going back to fundamentals (circle, square, triangle, or primary colors), back to the long Western art tradition (to ancient art or that of the Renaissance), or to non-Western sources (African, Oceanic, or Cambodian art), as a way to create a universal and international artistic language that could be understood by a wide range of individuals.

Of the many distinguished artists who worked in Montparnasse, Modigliani had perhaps the widest range of discernible sources: Florentine and Venetian Renaissance painting, the nude tradition, portraiture, African art, Cambodian art, Egyptian art, Roman art, Greek art, medieval sculpture, the sculpture of Michelangelo, direct carving, contemporary life, popular art/café culture, the kabala and Jewish mysticism, Symbolism, Fauvism, Cubism, and fantasy art, not to mention French, German, Italian,

British, and American literature. These wide interests made him the ultimate Montparnassian sophisticate and quintessential figure of this extraordinary time and place.

The Montparnasse context is essential for understanding Modigliani's art, for it was not until he moved there that his art really began to mature and develop into his signature style. Modigliani made a transition from overtly Symbolist-inspired "blue period" paintings or drawings reminiscent of Henri Toulouse-Lautrec,[6] and began in Montparnasse to create works whose inspiration and influence were both more diverse and more assimilated. For example, he devoted himself largely to making sculptures of figures whose visages have direct stares and, in many cases, beatific smiles that directly recall the Cambodian sculpture he had seen in the Musée Ethnographique du Trocadéro on his visits with Dr. Paul Alexandre, an early patron and key supporter.[7] Alexandre remarked that Modigliani admired Cambodian art and African masks for their simplification and sought to reduce his own figures to their bare essentials and unleash their power of suggestion.[8] Alexandre also remarked—without detailed explanation—on the importance to Modigliani of his Jewish background and Mediterranean roots, and by consequence, to his art.[9] At the time, African masks, Cambodian art, and Judaism were largely new sources of inspiration for Western art.

Modigliani also created many drawings at this time, mostly of caryatids and figures. In these graphic works, he takes the caryatid, a classical architectural feature, and gives it a vaguely Egyptian feel: the figure is shown in profile or frontally in a flat graphic style that makes it seem like a hieroglyphic (cat. no. 1). He also imbues his caryatids with a quality that one does not normally associate with this static, solid architectural feature, namely that of emotional intensity. Instead of presenting them in their standard erect stance, he depicts them buckling under the weight of an unseen burden (cat. no. 53). He gives them further appeal, and modernizes them, by depicting them often in red or blue crayon or watercolor. Modigliani's art had quickly advanced from valiant beginner work to some of the most beautiful and engaging images ever put to paper.

Interestingly, a similar transformation into a mature style occurred with other artists who moved to Montparnasse, such as Modigliani's good friend Brancusi. Initially, while living in the first arrondissement, Brancusi produced works with impressionistic surfaces in the style of Auguste Rodin. When he moved to Montparnasse in 1908, his signature style quickly began to emerge.[10] The exposure to a wide range of influences and sources no doubt helped

him to find his own way, as it did for Modigliani. The same is true for Mondrian, who moved to Montparnasse in 1912 and stayed until 1938 (with an absence during the First World War).[11] This is the exact period during which his art evolved from Cubist experimentation to complete abstraction.

Modigliani's cosmopolitan background may have made him especially open to the rich inspiration of Montparnasse. He was born in Livorno, Italy, into a Sephardic Jewish family that was made up of intellectuals, businessmen, teachers, and a public official.[12] Of substantial size, Livorno is a cosmopolitan Mediterranean port that was made important during the Renaissance by the Medici family. Modigliani's Livorno, more a small city than a large town, was a thoroughfare for the many different traders around the Mediterranean. After Rome, it had the second largest Jewish population in Italy, and after Amsterdam, it had the second largest synagogue in Western Europe. Jews could and did thrive there.

The international group of artists who arrived in Paris in the early years of the twentieth century did so for a variety of reasons. Impressionist art, which was exhibited internationally, inspired young artists to head to Paris to see what led to this new art form. A wide range of venues to exhibit their art (notably the Salon des Indépendants, the Salon d'Automne, the many private galleries) provided further appeal. The Exposition Universelle of 1900, which put Paris in the international spotlight and underscored its role as the leading modern city, was another factor. Negative impetuses were the pogroms and virulent anti-Semitism in Eastern Europe that forced many Jewish artists to move to Paris where they could work under less threatening circumstances.

The arrival of these foreign artists coincided with a surge of immigration into France by artists and non-artists alike. A front-page editorial in a 1910 issue of the popular Paris newspaper Gil Blas alerted readers that residence declarations by foreigners had been steadily increasing: 122,008 in 1907, 149,907 in 1908, and 159,336 in 1909.[13] That same article indicated that foreigners were being closely watched. Thus, the significant immigration brought with it fears and tensions for many of the locals. The Cubist sculptor Csáky described the situation: "Foreigners live[d] in great isolation in France. At least they did before 1914. A foreigner would only meet foreigners. The doors of French homes remained closed before them. A small invitation would sometimes occur, but nothing followed it."[14] Thus, two artistic worlds existed in Paris at this time: one composed largely of Frenchmen, the other mostly of foreigners.

Many of the critics, dealers, and collectors of the artists in Montparnasse were foreigners as well. There were the Poles Adolphe Basler (art critic and dealer), Waldemar George (critic), and Léopold Zborowski (poet, man of letters, and dealer concentrating especially on Modigliani). The German Daniel-Henry Kahnweiler, who lived in London early in the first decade, was Picasso's and Georges Braque's dealer before the First World War. The American writer Gertrude Stein was an active collector of the new art, as were her brothers Leo and Michael, and sister-in-law Sarah.

Gertrude Stein lived with her companion Alice B. Toklas at the now-legendary 27, rue de Fleurus, a few minutes by foot from Carrefour Vavin, the center of Montparnasse. For decades, they hosted important dinners and gatherings, attended regularly by such artists as Picasso and Henri Matisse.[15] Americans, particularly American artists, visited to see their art collection or to attend Stein's Saturday night soirées.[16] This group included Michael Brenner, Patrick Henry Bruce, Arthur B. Carles, Alvin Langdon Coburn, Andrew Dasburg, Jo Davidson, Arthur B. Davies, Charles Demuth, William Glackens, Marsden Hartley, Walt Kuhn, Alfred Maurer, Walter Pach (also a writer), Charles Sheeler, Joseph Stella, Maurice Sterne, Max Weber, and Mahonri Young. These artists added to the cosmopolitan atmosphere of tiny Montparnasse.[17]

The Frenchmen living in Montparnasse were unusual in that they enjoyed the company of foreigners and, equally significant, were not trained at the official school, the École des Beaux-Arts, but instead were self-taught. Therefore, like the foreign artists, they were outside of the French artistic mainstream. The Frenchmen associated with Montparnasse included Robert Delaunay, Raymond Duchamp-Villon,[18] Henri Gaudier-Brzeska, Henri Laurens, Fernand Léger, Matisse, Rodin (who in 1900 briefly had an academy on boulevard Montparnasse),[19] and Henri "Le Douanier" Rousseau. These artists had extensive contact with foreigners in France and abroad. Rodin had lived in Belgium and visited England on several occasions. Most of his patrons were foreign, especially English women. Laurens—whose friends included Gris, Julio González, and Modigliani—was one of the few Frenchmen to live in the international artists' colony known as La Ruche. Léger lived there as well. Gaudier-Brzeska traveled abroad extensively, especially to England, and took as his companion a Polish woman named Sophie Brzeska, with whom he had combined his name in 1911. Gaudier-Brzeska met her at the Bibliothèque Ste. Geneviève where he would go each night. According to Gaudier-Brzeska, this library was filled with foreigners, and the table where he sat was surrounded mostly by Germans and Slavs.[20]

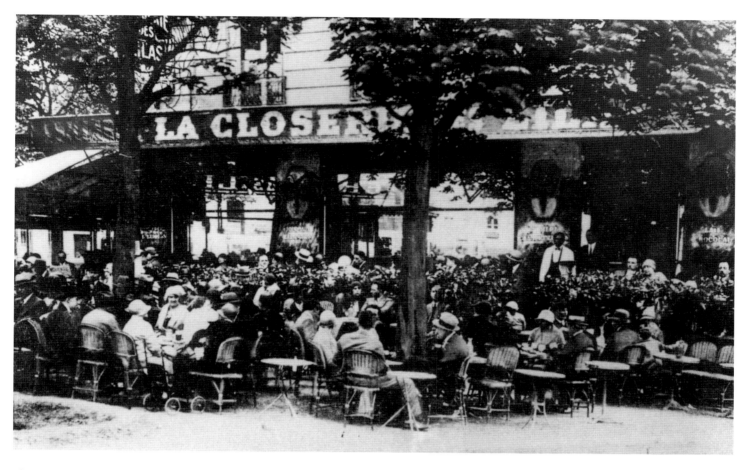

(fig. 1) La Closerie
des Lilas in the late
1920s

The three principal cafés in Montparnasse—the Closerie des Lilas at 171, boulevard du Montparnasse, the Café du Dôme at 108, boulevard du Montparnasse, and the Café de la Rotonde at 103, and then 105, boulevard du Montparnasse were frequented by all of the foreign artists mentioned above. Literature on Modigliani makes it clear that he frequented all three. The Closerie (fig. 1) is about a five-minute walk from the center of Montparnasse. The French poet Paul Fort began organizing Tuesday evening poetry readings there starting in 1903.[21] In the fall of 1903, Fort heard the young André Salmon and Guillaume Apollinaire read their poetry elsewhere and invited them to come to his Tuesday night readings.[22] In 1905, they brought Picasso and the artists who gathered around him.[23] In her journal entry for February/March 1906, Picasso's then lover Fernande Olivier described the crowd at the Closerie and gives an idea of the raucous intellectual atmosphere that reigned there:

. . . they're almost all intellectuals or artists, the picture of bohemianism, with their capes, broad-brimmed felt hats, untidy long hair and loosely tied cravats.

Often we go on foot, which is fun, even if it means walking right across Paris. These Tuesday evenings are organized for *Vers et Prose* by the journal's founder, Paul Fort, and are attended by poets, writers, painters, sculptors and musicians, young and old, who crowd into the café and onto the terrace. Drink is unlimited and by midnight everyone has become quite exhilarated. Paul Fort, who's always full of energy and manages to create chaos everywhere, tries to make his strange, shrill little voice heard through the pandemonium, but the discussions often go on so long that the owner ends up throwing us all out.[24]

Picasso and Olivier were still living in Montmartre at the time, in a group of artists' studios known as the Bâteau Lavoir, and walked across Paris to attend these evenings. These Montparnasse discussions helped lead to the development of Cubism. As Gino Severini notes, it was mostly a literary café:

The Closerie des Lilas was above all the café of the Symbolist poets and the literary review *Vers et Prose*, founded and directed by the poet Paul Fort.

The review had existed since 1905, as stated in the inaugural issue, where the aims of the publication are described in these

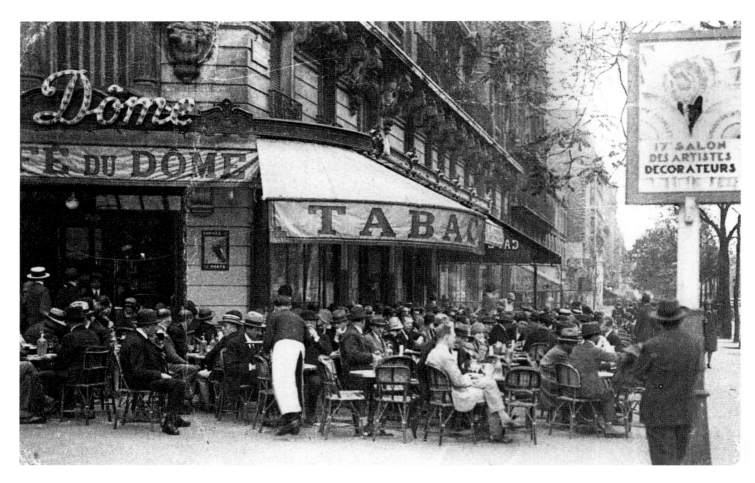

few words: "'Vers et Prose' proposes to reunite the heroic group of poets and writers of prose who renewed the essence and the form of French literature, re-awakening the taste for superior literature and for the lyricism that has been abandoned for so long. . . . Hence, the glorious movement which claims its origins in the first days of Symbolism will continue to exist."[25]

Fort referred to Modigliani, a fellow poet and lover of literature, as a regular there.[26] Indeed, many Montparnasse accounts do.

The Café du Dôme and Café de la Rotonde are located in the heart of Montparnasse at the Carrefour Vavin, just yards from the studios of Modigliani and his fellow artists. These cafés played an important role in the development of artists, since they went there to congregate, to socialize, and to meet models for hire. The cafés also acted as their offices and received messages for them.[27] In 1912, Epstein even used the Dôme as his mailing address in Paris.[28] Many of Modigliani's portrait drawings were created at the Dôme and especially at the Rotonde. By contrast, the academic French artists associated with the École des Beaux-Arts did not frequent the Montparnasse cafés—maintaining instead a more formal set of social customs—and were not, therefore, exposed to or influenced by the cosmopolitan café life.

The Café du Dôme (fig. 2), located on the southern part of boulevard du Montparnasse and boulevard Raspail, was dominated by a large group of American and German artists during the pre-World War I period.[29] A recent study on the Dôme shows in fascinating detail the importance of this café to German artists, most of whom had studied in Munich and who were so numerous and conspicuous that they acquired the name "Dômiers."[30] The dealer Alfred Flechtheim held an exhibition of twenty-three of these artists at his Dusseldorf gallery in June 1914.[31] One of the most famous of the Dômiers was the sculptor Wilhelm Lehmbruck. With the arrival of World War I, the Germans and Americans left, and the Café de la Rotonde across the street became more important.

Indeed, the Rotonde, on the northern corner of boulevard du Montparnasse and boulevard Raspail, was the principal café during the war period. Montparnasse historians Billy Klüver and Julie Martin have asserted that, "During World War I, the Rotonde was the

(fig. 2) The Café du Dôme was a favorite gathering place for artists, shown here in the mid-1920s.

single most important meeting place for the artists still in Paris—Picasso, Modigliani, Diego Rivera, Ilya Ehrenburg, Marevna, [Mánuel] Ortiz de Zarate, Max Jacob—and for those home on leave or invalided out of the war, such as Léger, Kisling and Apollinaire."[32] An article on the Rotonde from the June 3, 1917, issue of the Paris periodical *Le Cri de Paris* described the atmosphere there: "It is a very welcoming establishment and a good place to sit down. It has been chosen as the headquarters by those men the cubist painters. That is where they gather. That is where we can see their pope, Mr. Picasso, surrounded by his cardinals, Misters Kisling, Modigliani, Ortiz de Zarate, etc. . . . That is where their prophets Misters Guillaume Apollinaire and André Salmon establish their attack plans against the bourgeois spirit and debate between them the most abstruse questions of pyramidal, spherical, cylindrical and conical aesthetics."[33] The café was also cherished for its sunny terrace, which was given the name "Ras-

(fig. 3) Rosalie Tobia and her son, Luigi, stand in front of her restaurant, Chez Rosalie, at 3, rue Campagne-Première, c. 1925.

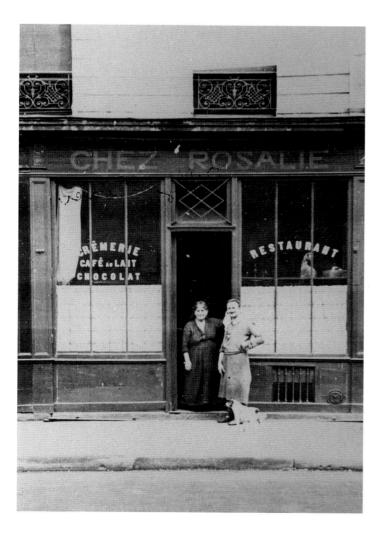

pail beach."[34] The reason for the Rotonde's importance for artists was that the owner, Victor Libion, who bought the café in 1911, was exceedingly sympathetic to artists and encouraged them to come there.[35] He subscribed to foreign newspapers, which assured a foreign clientele, and allowed the poorest artists to pay with paintings. He allowed artists to sit for long periods and nurse only a café-crème without chasing them away. In a sense, this café owner had a profound effect on the development of Montparnasse and modern art. The Rotonde was also popular with Russians, artists, and others, including Vladimir Il'ich Lenin, Leon Trotsky, and Anatoly Vasilievich Lunacharsky who are known to have frequented it before the Russian revolution.[36]

Equally important in terms of social interaction, especially for Modigliani, was the eatery Chez Rosalie at 3, rue Campagne-Première, just off boulevard du Montparnasse (fig. 3). It was open from 1908 to 1925.[37] Among the artistic figures known to have frequented the restaurant were Apollinaire, Fort, Picasso, Alice Prin (known as Kiki de Montparnasse), Salmon, Soutine, Maurice Utrillo, Edgard Varèse, and Vassilieff. It is virtually certain that de Chirico ate there as well since his Montparnasse studio was located nearby at 9, rue Campagne-Première from October 1913 to May 1915.[38] Modigliani and Rosalie Tobia spoke their native Italian to each other, which undoubtedly helped make him a regular.[39]

Another important gathering place for the Montparnasse artists during the First World War, when food was scarce, was the Vassilieff canteen (fig. 4). Vassilieff, a Cubist painter who is best known for her doll portraits (poupées-portraits), opened up a cooperative canteen in her studio at 21, avenue du Maine, to nourish her fellow artists.[40] It opened in February 1915 and served full meals for a low price to an international clientele of artistic figures.[41] It was sparsely furnished with flea-market furniture, but the walls featured paintings by Modigliani and Chagall.[42] Today, that space has been converted into the small Musée de Montparnasse.

An important artist residence in Montparnasse was the Cité Falguière, which partially stands today on the rue Falguière in the fifteenth arrondissement (fig. 5). Named after Jean-Alexandre-Joseph Falguière, a renowned academic sculptor who had the ensemble of studios built for his assistants, the Cité Falguière, with its numerous ground-floor studios, appealed especially to sculptors.[43] Modigliani lived at 14, Cité Falguière by April 1909 and stayed there until 1913 or 1914.[44] The Cité Falguière also housed at certain points such foreign artists as Tsugouharu Foujita, Leon Indenbaum, Lipchitz, Oscar Miestchaninoff, and Soutine.[45]

It was exactly in connection with rent that it turned out what a philanthropist Boucher was. We paid the first quarter of a year's rent in an orderly manner when we moved in, but after that no one thought about paying it. And no one ever demanded it. The caretaker never asked for a penny either. I never saw a single receipt. And in addition to this, every evening we found a model paid by Boucher in the studio behind the caretaker's house. So we went there to draw every evening—for free. Since the round building, the Ruche, was usually full, gradually the whole area around it was built up, unsystematically and without any unified plan—shaky and strange little huts were built, which were also meant for use as studios. When I moved in there were ninety-six studios in all. Mine was on the third floor, right above the door.[49]

On the outskirts of Montparnasse, at 2, passage Dantzig, was an impor-tant artists' residence called La Ruche or "beehive," so named because of its shape (fig. 6).[46] Although it is not certain whether Modigliani lived there, it is most probable that he at least frequented it.[47] According to the Cubist sculptor Csáky, who lived there briefly, "Very poor artists lived in the Ruche, most of them Russians."[48] He remarked that new residents "sought refuge there for a short time," suggesting that an impoverished artist might start there before finding more comfortable lodgings. Here is how Csáky described La Ruche:

(fig. 4) Arvid Fougstedt's charming drawing of Vassilieff's canteen was done on March 25, 1915.

The Ruche was a three-story-high, round building. That's where it got its name from. The staircase was in the center, and the stu-dios were situated radiating out. As at the time the surrounding areas weren't built over, every studio had very good lighting. The studios weren't big. The Ruche wasn't built for residential pur-poses. It was built as a pavilion for the 1900 Fair. After the Fair was over, the sculptor Alfred Boucher (1850–1934) realized how well it could be utilized. He was a good person.

He saw that every room could make an excellent little studio, because they all had such big windows. He got hold of the build-ing with the intent of providing lodging for destitute artists. He had a small brick house built separately from the building for the caretaker, and a considerably large brick studio building behind it. This latter wasn't for renters. The rent was really minimal, even for those times. I can't remember exactly how much it was, but I know even I could pay it.

Among the other artists to live at or frequent La Ruche were: Archipenko, Chagall, Indenbaum, Kisling, Laurens, Léger, Lipchitz, Marevna, Rivera, Soutine, and Zadkine.[50] La Ruche still exists today.

Modigliani lived at several places in Montparnasse in addition to the Cité Falguière and possibly La Ruche. Beginning in June 1917, he lived at 8, rue de la Grande-Chaumière (fig. 7), the same build-ing in which Paul Gauguin lived during his brief stay in Montpar-nasse in 1893.[51] The studio building was constructed by an artist named Emile Delaune with materials salvaged from the 1889 Expo-sition Universelle in Paris. Modigliani and Jeanne Hébuterne lived in a top-floor studio that Zborowski had arranged for them; it was composed of two narrow rooms, eight by fif-teen feet each, which offered a view of the Parisian rooftops.[52] After Modigliani died in January 1920, the English painter Nina Ham-

(fig. 5) A view of the artists' studios at the Cité Falguière, Paris, 1992

nett and the Polish artist, Jean Waclaw Zwadowski (known as Zawado), moved in.[53]

The independent academies of Montparnasse—Ranson, Julian, Colarossi, Matisse, and Russe—were all distinctly international in character and played an important role. Many of the Montparnasse artists studied at more than one academy for many years. This fact is especially significant because most of them had already received extensive training in their home countries. Modigliani had eight years of academic training in Livorno, Florence, and Venice before arriving in Paris. From his arrival in Paris in 1906 until his death fourteen years later, he frequented numerous Montparnasse academies.

Most foreign artists preferred studying at the independent academies of Montparnasse, which not only offered training similar to that of the École des Beaux-Arts but also instruction by EBA professors.[54] Records from the period reveal that around eighty-(fig. 6) The artists' five percent of the enrollees at the École des studios at La Ruche Beaux-Arts were French.[55] In the private were small, cramped, academies, this ratio was reversed.[56] While and basic. the independent academies of Montpar-

(fig. 7) 8, rue de la nasse catered to foreigners, the École des
Grande-Chaumière, Beaux-Arts was located in the center of Paris
Paris near the Assemblée Nationale, favored French nationals, and was permeated with a strong xenophobic sentiment. This sentiment was reflected in a pamphlet from around 1887 entitled "Concerning the invasion of foreigners at the École des Beaux-Arts. Protests by French students."[57] The two main complaints among the French were that foreigners were taking award money and valuable places from them. In the article, French students at the École des Beaux-Arts accuse foreign artists of not becoming French citizens in order to avoid military service.

Xenophobia at the École des Beaux-Arts intensified in 1902, the year that Epstein arrived at the school, when official policy declared that "foreigners . . . are not entitled to receive sums of money coming from endowments made to the École or linked to medals obtained in certain competitions of emulation."[58] At that time, a certain number of places were reserved for Frenchmen and could not be taken away by foreigners.[59] As Epstein recalled, "The 'foreigners' were few and unpopular, and it was not unusual for a French student to turn on a foreigner and ask him why he didn't stay in his own country."[60] On one occasion, "the great Bougereau" [sic] referred to Epstein as "this savage American."[61]

Modigliani attended the Académie Ranson, located at 7, rue Joseph-Bara, according to Noël Alexandre[62] and Paulette Jourdain, whose portrait was painted by Modigliani at the end of his life.[63] In fact, Jourdain said that it was thanks to Modigliani's attendance there that she met him, for she lived on the same street at 3, rue Joseph-Bara and modeled for art classes at the Academy. The Académie Ranson was started by the painter Paul Ranson, a friend of Gauguin, and a founding member of the Nabis.[64] According to

Warnod, this Academy was large and important at the time, one of the *grandes académies*, a point echoed by others as well.[65] Members of the Nabis group—Pierre Bonnard, Maurice Denis, Paul Sérusier, Edouard Vuillard—were among those who taught there. Many of Modigliani's paintings share the same linearity and lush colors of the Nabis painters.

The Académie Russe, founded in 1910 by Vassilieff, was located at 54, avenue du Maine. The instruction offered there was probably modeled on the Académie Matisse, since that is where Vassilieff had been studying before founding her own school.[66] Indeed, the artistic aim was similar: "While working from nature the student is guided above all by the greatest examples of ancient and modern art as well as by the general principles derived from all the theoretical premises of both painting and sculpture."[67] Modigliani studied at the Académie Russe, as we know from the following account by Marevna:

> In those early days, Soutine and his friends would spend many evenings at the Russian Academy, which consisted of two rooms, one for sculptors and the other for painters, in the Impasse Avenue du Maine, behind the Gare Montparnasse. It was a meeting place for young emigrants from Kiev, Vitebsk, Minsk, Riga and Odessa, and there were also a few students from Finland and Estonia, and some from St. Petersburg and Moscow passed through fleetingly. There were two woman painters besides myself from Tiflis—Olga Sakharova, a doctor's daughter, who was very talented, and Dagmar Mouat, half Georgian, half English, who drew very well. There was also an extremely gifted sculptress from Palestine, Chana Orloff.
>
> At the Academy, morning sessions were devoted to oil painting and sculpture, and in the evenings everybody gathered in one room to sketch. Modigliani and other non-Russian artists used to attend these sketching sessions, which were always crowded. A nude model posed by the stove at one end of the room, and we drew in free style—what we wanted and how we wanted. Soutine always sat by the wall at the back, concealing the paper he was working on. I never succeeded in seeing a single one of his sketches, and sometimes wondered whether he ever drew anything. . . .there was always the resonant voice of Zadkine, known to us all as "thundering Jupiter," to shatter the calm.[68]

At the Académie Russe there were eighty-three members: thirty-seven "foreigners" and forty-six Russians.[69] These "foreigners" were mostly German and Scandinavian in nationality,[70] and included Archipenko, Indenbaum, Lipchitz, Miestchaninoff, Nadelman, Orloff, and Zadkine, in addition to Modigliani.

Modigliani also frequented the Académie Colarossi, located on his street at 10, rue de la Grande-Chaumière, to sketch.[71] Marevna described it and the mix of nationalities there:

> Another place where young artists gathered to sketch was the Colarossi Academy in the rue de la grande Chaumière. The crowd there, made up of all nationalities, was even thicker than at the Russian Academy, and all the rooms were generally packed. The clothed models—men, women and children—were usually Italian, and looked out of their element in the chilly fog of Paris, almost as though they had just disembarked from a voyage from Naples. In the room where we drew from the nude the air was stifling because of an overheated stove, and the model perspired heavily under the electric light, looking at times like a swimmer coming out of the sea. It was like an inferno, rank with the smells of perspiring bodies, scent and fresh paint, damp waterproofs and dirty feet, tobacco from cigarettes and pipes, but the industry with which we all worked had to be seen to be believed.[72]

Filippo Colarossi had been a model himself and supervisor of models at the École des Beaux-Arts; in fact, he even asked EBA professors to teach at his academy as well.[73] The sculpture professor from the École des Beaux-Arts who taught at his Academy was Jean-Antoine Injalbert.[74] Aristide Maillol taught sculpture there as well.[75] The Académie Colarossi was likewise made up mostly of foreigners.[76]

It is also likely that Modigliani attended the very popular Académie de la Grande Chaumière, which was founded in 1904 and continues to be located at 14, rue de la Grande-Chaumière.[77] There were six drawing studios that were open "morning, noon and night."[78] Injalbert taught the sculpture class there from the Academy's opening day.[79] At the Académie de la Grande Chaumière, the students were Italian, American, Greek, Japanese, Czechoslovakian, Scandinavian, and German.[80]

It is also likely that Modigliani attended the Académie Julian, located at 6, rue du Dragon on the outskirts of Montparnasse, which was very popular at the time and was dominated by foreigners as well. The subheading of the advertisement for the Académie Julian, for example, was even published in English: "School of painting, modelling and drawing. For Gentlemen and Ladies–Separate."[81] The Académie Julian's courses clearly catered to a transient crowd, for subscriptions to half-day and day-long instruction could be pur-

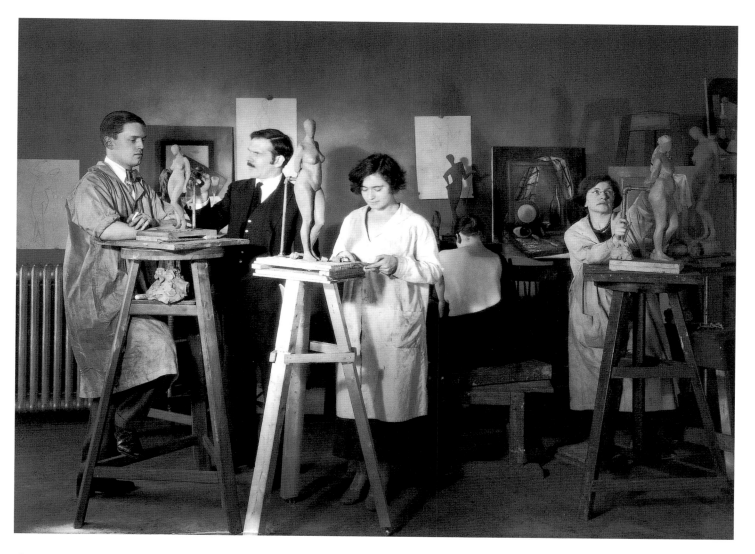

(fig. 8) Alexander Archipenko's academy

chased for as little as a one-month period or for as long as one year, with other possibilities being three, four, six, and nine months. At other academies, such as the Grande Chaumière, Colarossi, and the Ranson, it was even possible to pay a fee at the door and come for the day or for just a few hours.[82] The nationalities of the artists at the Julian were as diverse as Armenian, Norwegian, Scottish, and Canadian with an especially significant presence of Hungarians, Russians, and Japanese. However, Americans—and especially New Yorkers—seemed to have had the largest representation in the student body.[83]

Other academies, ones that Modigliani did not attend, were also very international. The Académie Matisse, for example, which opened on January 1, 1908, was almost entirely composed of foreigners (including the Americans Michael and Sarah Stein), in spite of being led by a Frenchman.[84] Indeed, of the eighty-three students there, only three were French. Archipenko opened an academy on April 10, 1913 (fig. 8), located most likely at 169 bis, boulevard du

Montparnasse, next door to the Closerie des Lilas.[85] His students appear to have been exclusively non-French artists including a Hungarian[86] and "two beautiful German girls."[87] Rodin briefly had a Montparnasse academy, l'Institut Rodin, located at 132, boulevard du Montparnasse.[88] Commenting on the Institute, one of Rodin's contemporaries observed: "Most of these first students are foreigners. It is a noteworthy fact."[89] The Institute only lasted a couple of months, however, from around mid-February to mid-April 1900.

The most important point to consider in the schism between the École des Beaux-Arts and the independent academies is the fact that foreigners were not eligible to compete for the crowning prize of the academic system, the prestigious Prix de Rome, which was essential for obtaining official teaching positions and state commissions.[90] To obtain this prize, French students at the École des Beaux-Arts were encouraged to look at antiquity as seen by past French masters. Conformity to an idea of the "French tradition" was stressed above all. Foreign artists may have been taught to value

antiquity and the classical tradition in the independent academies, but because they were outside of the French system, they did not need to interpret it as had past French masters and could be more diverse in their interpretation. Thus, the restriction that kept them outside of the French system also acted as a liberating force.

Foreign artists scarcely received mention in the mainstream French press such as the *Gazette des Beaux-Arts* and *Art et Décoration*.[91] Writing to his dealer Kahnweiler, Gris noted the great success of the Cubists in the Salon des Indépendants of 1920, particularly Braque and Léger, but added "No one says much about me because I'm a foreigner."[92] Foreigners were only discussed in the "foreign" reviews in Montparnasse such as *Hélios*, which was the journal of the Académie Russe, and *Les Soirées de Paris*, based at 278, boulevard Raspail, which was run by Apollinaire and his Russian backers, Serge Ferat and the Baroness d'Oettingen. Despite its historical importance, *Les Soirées de Paris* had barely fifty subscribers, most of whom seemed to have been the foreign artists discussed in its pages.[93] While the periodical *Montjoie!* was not produced in Montparnasse—but instead in the ninth arrondissement at 38, Chaussée d'Antin—it was published by a foreigner, an Italian named Ricciotto Canudo. It featured works by Archipenko, Nadelman, and Russell, among other foreigners, and discussed extensively the activities of the Montparnasse crowd.

It is no coincidence that the main critic to pay significant attention to non-French artists before the First World War was himself a foreigner: Apollinaire. Born in Rome, of a Polish mother named Angelica de Kostrowitzky and an unknown father,[94] Apollinaire came into the world with the name Guglielmo-Alberto Dulcigni. He wrote hundreds of reviews chronicling artistic activity in Paris from 1902 until his death in 1918 mentioning, among others, Modigliani.[95] He was the most active and important supporter and defender of modern art both before and even during the First World War, in which he fought as a member of the French Foreign Legion and died as a result of a war injury.

Another central contributor to the unique character of Montparnasse was the Hungarian art dealer Joseph Brummer who sold African art—along with pieces from many other distant places and cultures—out of his Montparnasse gallery (fig. 9). At the time considered to be the leading dealer of tribal art, this antiquarian can be linked to virtually every Montparnasse artist.[96] All of them, including Modigliani, would have had direct access to his stock. Thus, in his own small neighborhood, Modigliani could see African and Egyptian objects first-hand.

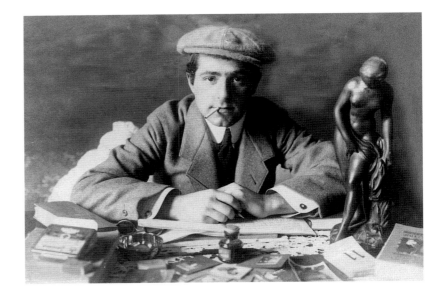

By August 1908, Brummer was living at 4, Cité Falguière and within months Modigliani had moved into no. 14.[97] A friend of Brummer's named Sterne described Brummer's lodgings around 1908–1909, probably at the Cité Falguière: "You [Brummer] lived in a deplorable room. The furniture was a bed and an excuse for a chair, a chest in the corner with your materials, drawings attached to the wall and a bust that you made, which you invited me to examine. I was completely depressed to see you in this household, in a room that resembled a grotto more than a place to live. It is amazing that despite it all you were able to continue to work."[98] Brancusi, who lived nearby, was in regular contact with Modigliani and would have met Brummer around then too. We know that Modigliani was a close friend of Brummer's gallery assistant, Martin Wolff (fig. 10), as Basler recounts: "One day he [Modigliani] dragged me along to the rue de Buci, where he had an appointment with Martin Wolf [sic], the employee of the antiquarian Brummer, and an English poetess. This Wolf [sic], a figure straight out of a story by E.T.A. Hoffmann, spent his day dusting Egyptian, Greek and African sculptures and in the evenings posed as an artist. He was frail and ill and could hardly stand up. He drank nothing but kept Modigliani company after [the artist's] jealous arguments with his poetess (Beatrice Hastings)."[99] Modigliani's closeness to Wolff suggests that he was a regular at Brummer's gallery. The years of contact with Brummer correspond to the maturation of Modigliani's style. The influence of African art is seen throughout the teens in the angular, mask-like quality of the faces of Modigliani's figures with their narrow-cut eyes.

(fig. 9) Joseph Brummer, here at his desk in Paris c. 1910, was a central figure in the life of the artists in Montparnasse, introducing many of them to "primitive" art.

Brummer's early ledger books reveal that while he started out selling Persian miniatures, Japanese prints, and some ancient pieces, by 1911, Greek, Roman, Egyptian, and Gothic art formed the bulk of his stock.[100] Brummer started buying African art in June 1912 from a very precocious twenty-year-old dealer named Paul Guillaume, who became the main supplier of African art in Paris and who would also become Modigliani's dealer, and soon thereafter, African objects formed about twenty percent of his stock.[101] Brummer also dealt in modern art, buying for example, a painting by André Derain from Basler on September 27, 1911.[102] Brummer's was a successful operation located in the heart of Montparnasse, as documented in the ledger books and from the lease that describes the large size of the gallery.

Given Brummer's pivotal role in Montparnasse, it is worth presenting an in-depth profile of this little-studied figure. Brummer's closeness to the artists of his day, especially sculptors, is directly related to the fact that he had been a sculptor himself prior to becoming an art dealer. He had been passionate about the medium since he was a child in Szeged,

(fig. 10) Martin Wolff, Brummer's shop assistant and Modigliani's friend, stands in front of the Eiffel Tower, with the Palais du Trocadéro behind him, c. 1912.

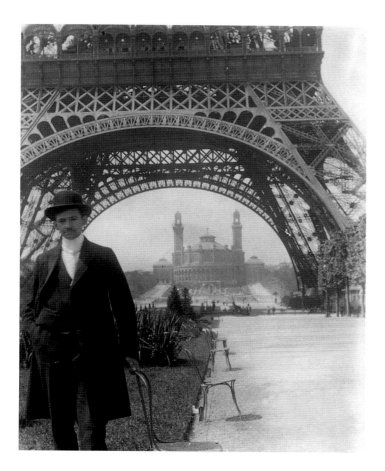

Hungary.[103] In 1897, when he was fourteen years old, his parents enrolled him in an industrial school for wood and metal study, where he completed courses in materials.[104] At the suggestion of his professors, he enrolled in 1899 in the School of Applied Art in Budapest.[105] After finishing these studies, he sought further training at the Munich Academy.[106] Brummer returned to Hungary and set up a studio in Budapest and then in Szeged.[107]

In 1905, Brummer traveled to Paris to study sculpture, and he established himself there for the next decade or so.[108] He left Montparnasse for New York at some point between 1917 and 1921 to open a gallery there, and his brother Ernest, who fought in the war for France, continued his brother's Paris operations thereafter.[109] First, he studied at the École des Beaux-Arts in the sculpture studio of J. Coutan, as indicated by a letter from the latter dated October 17, 1905, to the director of the school.[110] Brummer also studied with Matisse and is counted as one of the first students at the Académie Matisse in 1908: "Another of the early students was Joseph Brummer . . . The students seem to have paid tuition according to their means, but Brummer, later to become the greatest of American art dealers, was almost penniless and earned his fee by tending the stove and occasionally serving as a model."[111] Brummer remembered how Weber would sometimes play the harmonium to his fellow students in the Académie Matisse.[112] The archive also reveals that Brummer was a student at the Académie de la Grande Chaumière, where several modernist artists were enrolled around the same time. A certificate written by a school official and dated June 1, 1909, records his attendance and notes his positive performance.[113] Brummer's friend Sterne recalled that this had been a tough period in Brummer's life, which forced him into the position of modeling to survive: "Arriving at this academy [presumably the Grande Chaumière] from a small town, you wanted to model to earn some money. I was very sad to see you in this situation, but realizing that there was nothing else to do I asked my friends to vote for you and you were accepted to do the morning poses, for which you got twenty francs."[114]

According to later accounts, Brummer also studied with Rodin. This point is questionable, however, as Rodin did not formally have students. Except for a brief period in 1900, he had only *praticiens* or assistants. The extensive correspondence between Brummer and Rodin does not confirm a teacher-student relationship.[115] Alain Beausire, archivist at the Musée Rodin, indicates that some sculptors would show their works to Rodin and get his opinion. The Hungarian article from 1910 confirms this suggestion: "Even

Auguste Rodin congratulated [Brummer] about some of his sculptures and about the artistic direction that he has taken."[116] A photograph in the Brummer archives of one of his sculptures reflects Rodin's influence in its mottled surface, suggesting that Brummer learned from Rodin's sculpture at least, if not from the master himself. Soon thereafter, Brummer became a major seller of antiquities to Rodin.[117]

Brummer's involvement with the pre-war avant-garde has been assumed more than it has been proven, and there are lingering mysteries. Scholar Jean-Louis Paudrat wondered, for example, whether Brummer was a regular member of the Stein circle: the homes of Leo and Gertrude Stein at 27, rue de Fleurus and of Michael and Sarah Stein at 58, rue Madame.[118] That question can now be resolved thanks to Brummer's friend Sterne who recalled that the two of them "used to spend most of their Saturday nights at the Steins on rue Fleurus and rue Madame."[119] Sterne added, "There we spoke of [Paul] Cézanne, van Gogh, Gauguin, Matisse, Picasso, and other moderns from this group." In 1908, Brummer became good friends with Rousseau, who painted his portrait the following year (fig. 11).

It appears that Brummer formally became a dealer and opened a gallery in October 1909, the date of his earliest known ledger book.[120] This date makes sense, for Brummer appears to have continued his studies until the spring of that year. It is virtually certain, however, that Brummer worked as a part-time dealer before committing himself to opening a gallery. His first was located at 67, boulevard Raspail before he moved down the street to 3, boulevard Raspail.[121] He appears to have done well from the start of his business. As his close friend Csáky remarked concerning this early period: "[Brummer] knew a lot of people, and he utilized this to make money."[122] According to the ledger books, two of the individuals to whom Brummer regularly sold were the important collectors Sergei Stchoukin and Frank Burty Haviland, the latter being a close friend of both Picasso and Modigliani. Indeed, Modigliani painted his portrait (cat. no. 4).

By August 8, 1910, Brummer was living at 55, rue du Montparnasse, a small street where Brancusi and Lipchitz also lived.[123] Each of these sculptors later received one-person exhibitions in Brummer's New York gallery. Csáky describes Brummer's rue du Montparnasse home as "a gigantic studio,"[124] which reflects the dealer's new economic success. Rousseau's 1909 portrait of the dealer confirms this new status in its depiction of a relaxed Brummer wearing a chic turtleneck sweater. About Brummer's studio, Csáky added, "It became very famous later, because of the visitors."[125]

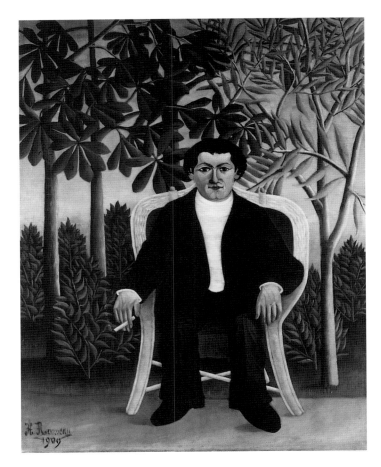

(fig. 11) HENRI ROUSSEAU. Portrait of Joseph Brummer. 1909. Oil on canvas, 45 5/8 x 34 7/8" (115.8 x 88.6 cm.) Private Collection

Picasso's relations with Brummer have been assumed by scholars, but not closely studied. Brummer knew Picasso most certainly by 1910 at the latest, and probably by 1908 or 1909.[126] Brummer's ledger books reveal that he sold some Picasso paintings in 1912 and 1913, a time when Picasso lived on the same street, the boulevard Raspail.[127] Brummer undoubtedly acquired these paintings directly from Picasso. Indeed, Csáky states in his memoirs that upon his arrival in August of 1908, Brummer talked to him about Picasso: "Next day Brummer showed me the sculpture that he had been working on at the time: an exact copy of a Negro sculpture from the Congo. That was the height of fashion those days. Brummer told me that there was a painter in Paris who could paint wonderfully in the spirit of Negro sculptures. His name was Picasso. I never forgot that name."[128] At the famous Kahnweiler auction sales in 1922—when the German dealer's confiscated stock was being liquidated by the French authorities—Brummer was one of the primary purchasers of Picasso's work.[129]

Epstein also knew of Brummer's antiquities gallery. He visited it in 1913, just after installing his *Tomb of Oscar Wilde* at the Père

Lachaise cemetery; this work shows a direct influence of Assyrian art in its stylized block form. At the gallery, Epstein was captivated by an Egyptian work of art. Epstein later recalled that visit:

> I have in my possession the great work called "Brummer Head" which I had seen in Joseph Brummer's shop in Paris many years before in 1913. On that occasion when I asked the price of it, this astute dealer told me there was no price to it and removed the work from view. The piece was later sold and disappeared. In 1935, when all Paris was seeking it, the owner having just died, I came on it by chance in a dealer's basement. . . .This remarkable Phaouin head has qualities which transcend the most mysterious Egyptian work. It is an evocation of a spirit that penetrates into another world, a world of ghosts and occult forces, and could only be produced where spiritism stills holds sway. On the plastic side also, the head is very remarkable, with its surrounding prongs of hair off-setting the large roundness of the forehead, a perfect example of free wood-carving.[130]

Brummer was also very important to Lipchitz. As noted above, they were neighbors on the rue du Montparnasse. Referring to his early period, Lipchitz later recalled, "I was always visiting museums and art galleries and, needless to say, dealers in antiquities."[131] Irene Patai, in her book *Encounters: The Life of Jacques Lipchitz*, written with the close involvement of the artist, confirms that one of these antiquities dealers was Brummer: "Lipchitz and Joseph [Brummer] were old friends since the days when the young Hungarian had come to Paris to try his hand at sculpture."[132] In 1935, when Brummer was running a successful gallery in New York, he gave Lipchitz his first show in the United States. In 1940, when Lipchitz fled Europe for New York, he immediately looked up Brummer to obtain his help.[133]

The Brummer archives confirm that the two men were in close contact between 1909 and 1911. Indeed, Lipchitz was actively collecting during that period. In Brummer's ledger books one finds over a dozen references to Lipchitz from 1909 to 1912. They indicate that Lipchitz started collecting works immediately after his arrival in Paris in October of 1909. On November 15, he bought "3 bibelots" or trinkets from Brummer. He made another purchase from Brummer on the twenty-ninth of that month. The purchases continued on almost a monthly basis thereafter until 1911. While the purchases are not usually described, one of the two 1911 purchases included a Persian vase, a Chinese vase, a statue, and a

miniature. It appears that Lipchitz stopped buying from Brummer in 1911. This information corresponds to what we know about Lipchitz's financial situation: he was financially secure until 1911 when his father lost his money through bad investments, and he stopped receiving support.[134] At that point, Lipchitz had to fend for himself. After the war, however, Lipchitz started to buy from Brummer once again,[135] thanks undoubtedly to the income he obtained from the dealer Léonce Rosenberg and the Philadelphia collector Dr. Albert Barnes.[136] Lipchitz and Brummer had been so close, in fact, that in the middle of 1910, the artist loaned the dealer some money. During the second half of 1910, the ledger books show that Brummer made two payments to Lipchitz, for forty francs and ten francs respectively. In the first instance, Brummer writes that he had "paid a debt to Lipchitz"; the second sum is not described.

Brummer and his brother Ernest were both in contact with another Montparnasse artist, the sculptor Nadelman, before the First World War. From 1910 to 1913, Nadelman was a regular part of the art scene, according to Ernest Brummer who declared that: "He was part of the decor in that period."[137] Ernest recalled that Nadelman was nicknamed "Praxitelman" or "Phidiasohn" because of his attachment to the Greeks.[138] Brummer remembered that Matisse posted a sign on the wall of his Academy: "Do not speak of Nadelman here."[139] The exact meaning is unclear, but it may refer to the significant envy that Nadelman stirred up in pre-war Paris through his interesting work and successful exhibitions. Brummer's Greek and Roman antiquities were no doubt a major source of inspiration for Nadelman as he developed his classicized modern sculpture.

Montparnasse was a special place for foreign artists in the first decades of the twentieth century. Hundreds of artists from dozens of countries lived there. They socialized and theorized at a handful of cafés and eateries: the Closerie des Lilas, the Café du Dôme, Café de la Rotonde, Chez Rosalie, and at Vassilieff's canteen. They lived in studios within a hundred yards of the Carrefour Vavin, and in the Cité Falguière or at La Ruche. They avoided the all-powerful École des Beaux-Arts in favor of the independent academies of Montparnasse that catered to foreigners: Académie Ranson; Académie de la Grande Chaumière; Académie Colarossi; Académie Russe; Académie Matisse; l'Institut Rodin, and Académie Julian. And they frequented the famous soirées of Gertrude Stein and the antiquities shop of Joseph Brummer. It was in this highly charged cosmopolitan atmosphere, with the broadest range of international and cultural stimuli, that Modigliani lived and where his art matured.

MODIGLIANI AND THE AVANT-GARDE

Amedeo Modigliani was keenly aware of his avant-garde predecessors and contemporaries. By looking at the individuals in his artistic world—artists (an Impressionist, several Post-Impressionsts, Henri Matisse, Pablo Picasso, other Cubists, etc.), poets, writers, composers, and collectors and dealers of avant-garde art—one learns a great deal about Modigliani's influences and his stature in the art world of his day. These interests help underscore how Modigliani's art and life epitomized the international artistic approach that developed in Montparnasse in the early twentieth century.

Of the Impressionists, Modigliani is known to have met Pierre-Auguste Renoir. While on the Riviera during the First World War, Modigliani visited Renoir at his villa in Cagnes (fig. 1).[1] The Impressionist artist gave the Italian advice on painting nudes.[2] According to accounts, though, the visit was not entirely successful, and Modigliani left irate.[3] Nonetheless, Modigliani's nudes often do recall those of Renoir in their fleshy sensuality and choice of contemporary rather than historical figures. The poet Jean Cocteau discusses another quality shared by Modigliani and Renoir: "If, in the end, all [of Modigliani's] models look alike, it is in the same way as Renoir's girls. He reduced us all to his type, to the vision within him, and he usually preferred to paint faces conforming to the physiognomy he required. . .for Modigliani's portraits, even his self-

struck by Rousseau's painting *The Wedding*, 1904–1905 (fig. 4), a large canvas in which the artist depicts the marriage of simple contemporary folk in a naïve manner.[10] Like many artists of his generation, Modigliani was undoubtedly attracted to Rousseau's simple, direct, fresh, and untutored approach. Modigliani himself would later depict everyday people on a grand scale in a somewhat similar naïve style (cat. nos. 32 & 37).

Of his own generation, Modigliani can be linked to the most important figures including Matisse, Picasso, and Jacques Lipchitz, underscoring his firm place within the avant-garde. In fact, Modigliani rendered Matisse's portrait in 1916 (fig. 5). This previously unknown drawing confirms that there was direct contact between the two artists. The drawing was featured in the Norwegian newspaper *Dagbladet* on November 5, 1916, along with an equally unknown portrait of Picasso by Modigliani (fig. 6). These were published alongside an article about an upcoming exhibition of French art to be held at the Kunstnerforbundet in Oslo: "Through the exhibition's excellent organizer, Mr.

(fig. 1) Renoir's Villa "Les Collettes" in Cagnes, on the French Riviera

portraits, are not the reflection of his external observation, but of his internal vision. . . ."[4]

Of the previous generations, Modigliani looked more to the Post-Impressionists than to the Impressionists, whose concerns with directly observed light and nature did not interest him as much as the taking of artistic liberties. Modigliani's favorites included James Ensor, Edvard Munch, Henri Toulouse-Lautrec, James A. McNeill Whistler, and especially Paul Cézanne and Paul Gauguin.[5] Some of Modigliani's early drawings display theatrical settings and figures much like one finds in the work of Toulouse-Lautrec. Modigliani's interest in tone may owe something to both Whistler and Ensor. With Munch, Modigliani shared an interest in the psychological state of figures. Modigliani visited the Gauguin retrospective at the Salon d'Automne of 1906, and it impacted him profoundly.[6] Gauguin had found inspiration in so-called "primitive" sources—peasants in rustic Brittany and exotic Tahiti—just as Modigliani would later do with African and Khmer art. Cézanne died in 1906, and the following year the Salon d'Automne, in which Modigliani exhibited, featured a Cézanne retrospective, which Modigliani surely saw. Modigliani also visited the Cézanne retrospective at the Galerie Bernheim-Jeune in Paris in 1910 where he was particularly struck by *Boy in a Red Waistcoat*, 1888–90 (fig. 2).[7] Modigliani continued to think about this work and made a drawing of it from memory.[8] It is notable that Modigliani was attracted to one of the artist's figure paintings rather than a landscape, as Modigliani's own mature style concentrated almost exclusively on the figure. As a result of this interest, Modigliani's early Parisian works show extensive faceting characteristic of Cézanne.

Another older artist whom Modigliani admired was Henri "Le Douanier" Rousseau (fig. 3), whom he visited regularly in Montparnasse with Dr. Paul Alexandre.[9] Modigliani was particularly

(fig. 2) PAUL CÉZANNE. Boy in a Red Waistcoat. 1888–90. Oil on canvas, 35 ¼ x 28 ½" (89.5 x 72.4 cm.). Collection National Gallery of Art, Washington, D.C. Collection of Mr. and Mrs. Paul Mellon in Honor of the 50th Anniversary of the National Gallery of Art

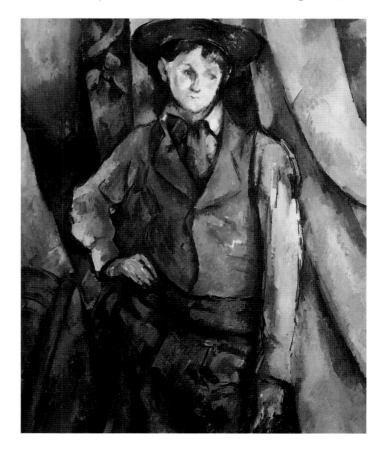

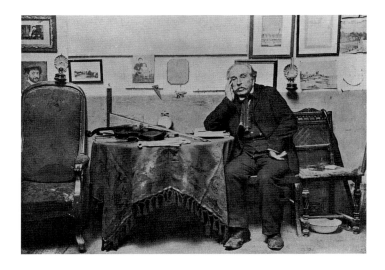

Halvorsen, *Dagbladet* has been able to pur-
chase the portraits of Matisse and Picasso,
which we print today. They are drawn by
the excellent Paris artist Modigliani."[11]
Modigliani's connection to Matisse has
not been previously discussed by scholars.
However, Modigliani exhibited with Matisse on numerous occa-
sions.[12] Additionally, Modigliani undoubtedly had regular contact
with Matisse during the fourteen months that the Italian was in
Nice from April 1918 through May 1919, when Matisse was already
in permanent residence there.[13] The rich colors of most of
Modigliani's paintings demonstrate a definite awareness of
Matisse's liberation of color as an expressive force. In addition,
both artists reduced their figures to essential elements.

Modigliani's closest artistic and social affinities were not
reserved for Matisse and the Fauves, however, but rather for the
Cubist artists and especially Picasso. Reviews cited in the following
essay indicate that Modigliani was seen as a Cubist who shared the
same anti-naturalistic interests. Indeed, his portraits rarely resem-
ble the sitter. Furthermore, Modigliani associated with numerous
artists affiliated with the Cubist movement and rendered portraits
of at least eight: Juan Gris (fig. 7); Henri Laurens (fig. 8); Lipchitz
(and wife Berthe) (cat. no. 9); Picasso (fig. 9); Diego Rivera (Ceroni
41, 42); Morgan Russell (fig. 10); Léopold Survage (fig. 11); and
Marie Vassilieff.[14] Other artists in the Cubist group that can be
linked to Modigliani include Alexander Archipenko, Joseph Csáky,
Fernand Léger, Maria Vorobieff Marevna, Amadeo de Souza Car-
doso, and Ossip Zadkine. Souza Cardoso's drawings could easily be
mistaken for the graphics of Modigliani.[15] Archipenko and
Modigliani were particularly close while both were on the French

(fig. 3) Henri Rousseau
in his studio, c. 1890.
To support himself
in his later years, the
artist gave violin and
painting lessons.

Riviera during the war.[16] Archipenko's sensual depictions of
women with curvy lines and almond-shaped eyes at the time
recall Modigliani's portraits (fig. 12). Marevna, who wrote about
Modigliani at length in her autobiography,[17] leaves us a triple por-
trait of Modigliani, Rivera, and Ilya Ehrenburg (fig. 13).

It appears that Georges Braque and Modigliani knew each other
but were not necessarily close. Braque later contributed the follow-
ing comment to a tribute of Modigliani: "I join Modigliani's friends
with all my heart to pay homage to my friend the great painter."[18]
Modigliani appeared uninvited at a dinner organized by Vassilieff
and Max Jacob in honor of Braque on January 14, 1917, upon the lat-
ter's discharge from the army (fig. 14).[19] Picasso and Gris were both
in attendance, and the latter wrote about the Braque banquet in a
letter to Maurice Raynal: "The Braque
banquet was charming, spirited and
full of good humour. Max [Jacob] was
at his most brilliant and witty in two
parodies—of a colonel and of Braque's
mother. There were, naturally, a few

(fig. 4) HENRI ROUSSEAU.
The Wedding. 1904–1905.
Oil on canvas, 64 ¼ x 44 ⅞"
(163 x 114 cm.) Collection
Musée de l'Orangerie,
Paris.

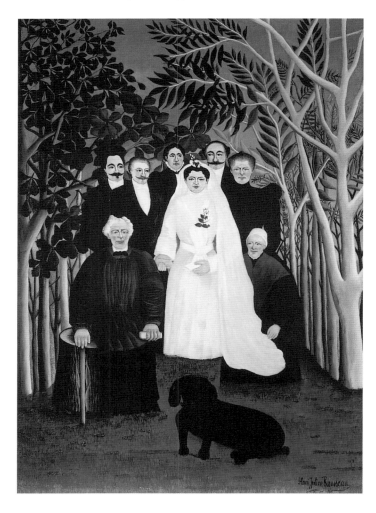

Matisse, tegnet av Modigliani.

Picasso, tegnet av Modigliani.

(figs. 5 & 6) Modigliani's drawings of Henri Matisse and Pablo Picasso were published in the Oslo newspaper *Dagbladet* on November 5, 1916.

awkward moments with people who had drunk too much. But that one expects. Tonight there's a reading of works by [Pierre] Reverdy with a short talk by Max."[20] The mention of people "who had drunk too much" is an oblique reference to Modigliani, who had created a scene there.[21]

Modigliani's portrait of Gris is dated 1915. In her well-researched biography of her father, Jeanne Modigliani speculated that Modigliani met Gris in 1909–1910 at one of Gertrude Stein's soirées.[22] Modigliani probably knew Gris even earlier, however, when both lived in the Bâteau Lavoir.[23]

Modigliani and Cubist painter Survage were particularly close during World War I, when both were living in Nice, and Survage was making charming, colorful, light-filled Cubist depictions of towns on the Riviera. Survage leaves a sensitive account of Modigliani's art and working method:

A born psychologist, perceptive and subtle, he had by this time [just before the war] found his true path. He read the character of someone near him very accurately and quickly. This psychological gift was such that you could say that his sitters resembled their portraits rather than vice versa. He underlined and exaggerated the characteristics of his sitters and brought out what was hidden by secondary and subsidiary features.

These portraits go far beyond the acuteness of caricature, for in their truthfulness they attain a high level of style. Sometimes he

would say, "I've found the means that will allow me to express myself." And again, "What I see before my eyes is an explosion which forces me to take control and organize." It was by geometry, proportion and rhythm that he achieved his aims.

His work was executed rapidly because it was preceded by deep reflection. His psychological instinct led him to investigate the characters of his sitters first of all by talking with them for a shorter or longer time. But once he had come to a decision and had a conception of the portrait, he worked straight off.[24]

It was fellow artists like Survage who seemed to understand Modigliani's art best.

Lipchitz (fig. 15), who met Modigliani in 1912, also leaves a wonderful account of Modigliani's views and approaches to sculpture:

Modigliani, like some others at the time, was very taken with the notion that sculpture was sick, that it had become very sick with [Auguste] Rodin and his influence. There was too much modeling in clay, "too much mud." The only way to save sculpture was to start carving again, direct carving in stone. We had many very heated discussions about this, for I did not for one moment believe that sculpture was sick, nor did I believe that direct carving was by itself a solution to anything. But Modigliani could not be budged; he held firmly to his deep conviction. He had been seeing a good deal of [Constantin] Brancusi, who lived nearby, and he had come under his influence. When we talked of different kinds of stone–hard stones and soft stones–Modigliani said that the stone itself made very little difference; the important thing was to give the carved stone the feeling of hardness, and that came from within the sculptor himself: regardless of what stone they use, some sculptors make their work look soft, but others can use even the softest of stones and give their sculpture hardness. Indeed, his own sculpture shows how he used this idea. It was characteristic of Modigliani to talk like this. His own art was an art of personal feeling. He worked furiously, dashing off drawing after drawing without stopping to correct or ponder. He worked, it seemed, entirely by instinct—which however was extremely fine and sensitive, perhaps owing much to his Italian inheritance and his love of the painting of the early Renaissance masters.[25]

Modigliani's sculpture was directly carved in stone while Lipchitz both carved and modeled his sculptures. Modigliani's

34

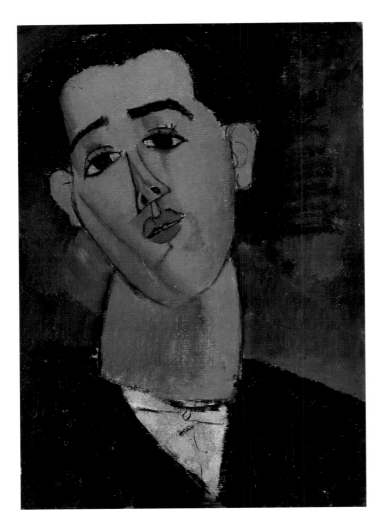

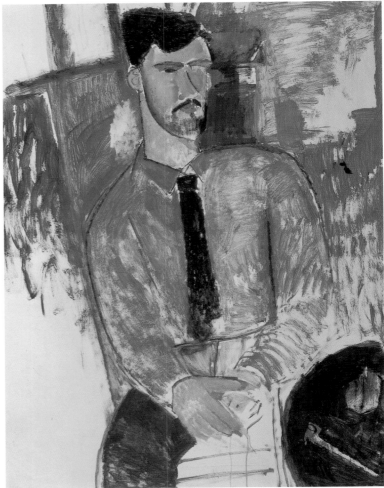

(fig. 7) MODIGLIANI. *Juan Gris*. 1915.
Oil on canvas, 21 ⅝ x 15" (54.8 x 38.1 cm.)
Collection The Metropolitan Museum of Art, New York.
Bequest of Miss Adelaide Milton de Groot (1876–1967), 1967.
(67.187.85). Photograph © 2002 The Metropolitan Museum of Art

(fig. 8) MODIGLIANI. *Portrait of Henri Laurens*. 1915.
Oil on canvas, 45 ⅝ x 34 ¾" (115.8 x 88.3 cm.)
Rosengart Collection, Lucerne

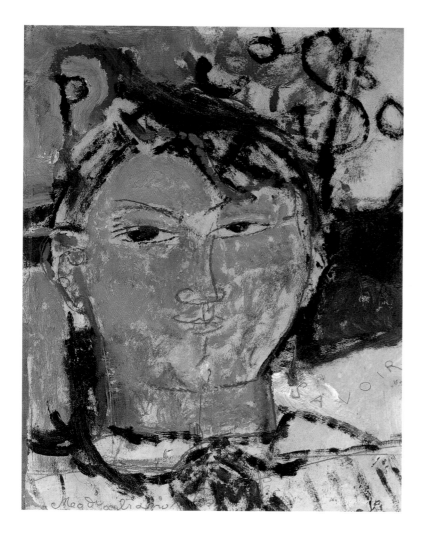

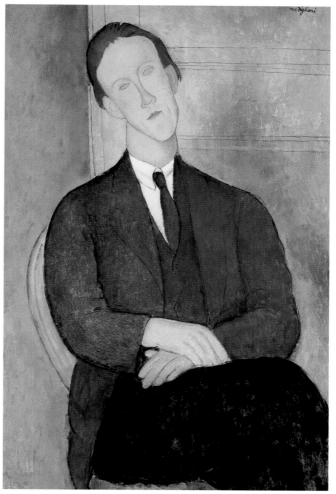

(fig. 9) MODIGLIANI. *Portrait of Pablo Picasso.* 1915.
Oil on canvas, 13 ½ x 10 ⅜" (34.2 x 26.3 cm.)
Courtesy Galerie Schmit, Paris

(fig. 10) MODIGLIANI. *Portrait of Morgan Russell.* 1918.
Oil on canvas, 39 ⅜ x 25 ½" (100 x 64.7 cm.)
Private Collection

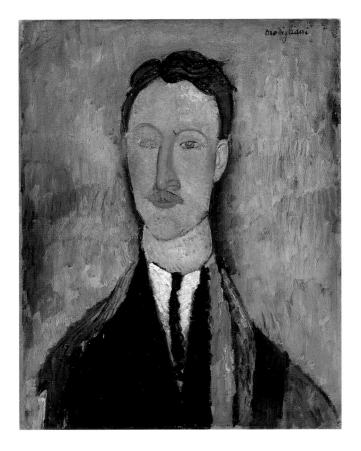

he would place candles on the top of each one and the effect was that of a primitive temple. A legend of the quartier said that Modigliani, when under the influence of hashish, embraced these sculptures."[28]

Picasso knew Modigliani from the latter's first year in Paris until his death. Indeed, Modigliani's artistic life was intertwined more closely with that of Picasso than with any other artist. Modigliani saw Picasso, who was already starting to become famous, soon after arriving in Paris in 1906, appropriately enough at the Café de la Rotonde in Montparnasse.[29] He would soon actually meet the Cubist and reportedly loaned Picasso five francs shortly thereafter.[30] Both Modigliani and Picasso lived at the Bâteau Lavoir around 1906–1907,[31] during the time that Picasso was creating his seminal work *Les Demoiselles d'Avignon*. In addition, Picasso is reported to have said that "There's only one man in Paris who knows how to dress and that is Modigliani."[32]

(fig. 12) ALEXANDER ARCHIPENKO. *Woman at her Toilet*. 1916. Oil on cardboard, painted wood, and painted sheet metal support, 33 7/8 x 25 3/8 x 2" (86 x 64.5 x 5 cm.). Collection Tel Aviv Museum of Art. Gift of the Goeritz Family, London

sculptures reflect his profound interest in African art—through their mask-like quality—and in Khmer or Cambodian sculptures with their enigmatic smiles (fig. 16). Lipchitz also shared a profound interest in African art, but its influence on his sculpture is more assimilated.

(fig. 11) MODIGLIANI. *Portrait of Léopold Survage*. 1918. Oil on canvas, 24 1/4 x 18 1/8" (61.5 x 46 cm.) Collection Ateneum Art Museum, Helsinki

Jacob Epstein, who was most closely identified with the English Vorticist movement (an offshoot of Cubism), was particularly close to Modigliani. In the fall of 1912, when he came to Paris to work on his *Tomb of Oscar Wilde* (fig. 17), he saw the Italian artist almost daily for nearly six months.[26] Epstein owned a caryatid drawing by Modigliani, which he presumably acquired directly from the artist (fig. 18), possibly indicating the closeness of the two artists. Epstein provides us with a good indication of Modigliani's popularity and character: "All bohemian Paris knew him. His geniality and *esprit* were proverbial....With friends he was charming and witty in conversation and without any affectations."[27] Epstein also describes the symbolic and mystical power that Modigliani saw in his own sculptures: "[His studio] was then filled with nine or ten of those long heads which were suggested by African masks, and one figure. They were carved in stone; at night

(fig. 13) Marie Vorobieff Marevna drawing of Modigliani in Diego Rivera's studio, 1916. Left to right: Rivera, Modigliani, and Ilya Ehrenburg. Pencil drawing, 8 x 10" (20.3 x 25.4 cm.) Collection James K. Moody

(fig. 14) MARIE VASSILIEFF. *Le Banquet Braque.* c. 1925. Collection Claude Bernès, Paris. In this work Modigliani is depicted as just having entered the room.

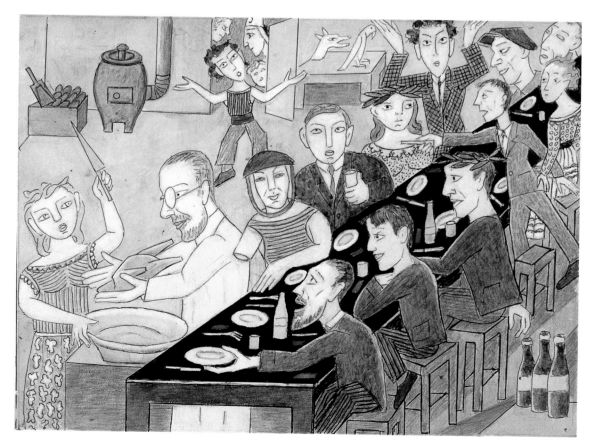

Modigliani saw Picasso's work early on and was captivated by it, as Alexandre recounts: "At Vollard's, in his shop in the rue Laffitte, I remember our silently examining a series of 'blue' Picassos. We would also go to [Daniel-Henry] Kahnweiler's [gallery] in rue Vignon: I can see Modi there, completely absorbed in front of a small, strange watercolour of Picasso's representing a young fir tree turning green in the middle of transparent blocks of ice."[33] According to one source, the two artists whom Modigliani most admired were Picasso and Rousseau.[34]

Modigliani rendered Picasso's portrait on at least three occasions, all during the war: once in paint (fig. 9) and twice in pencil on paper. One of the drawings (fig. 6), executed in April 1916, was featured in the aforementioned Norwegian newspaper *Dagbladet* on November 5, 1916, along with the drawing of Matisse. Both drawings appeared in conjunction with an exhibition of modern French art at the Kunstnerforbundet. Montparnasse historians Billy Klüver and Julie Martin explain the circumstances: "In April 1916, Walther Halvorsen decided to organize an exhibition of French art in Oslo.

(fig. 15) Jacques Lipchitz in his Paris studio, 1916–1925

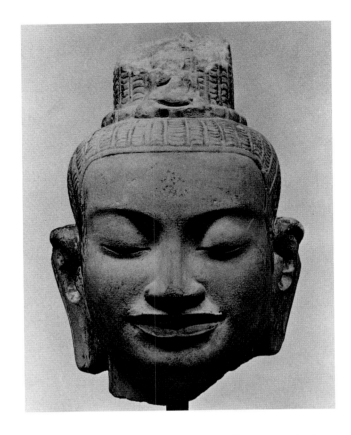

(fig. 16) Cambodian, style of Bayon. *Head of Lokesvara.* Late twelfth-early thirteenth century. Pink sandstone, 13 7/8" (35.3 cm.) high Collection The Cleveland Museum of Art. Purchase from the J.H. Wade Fund.

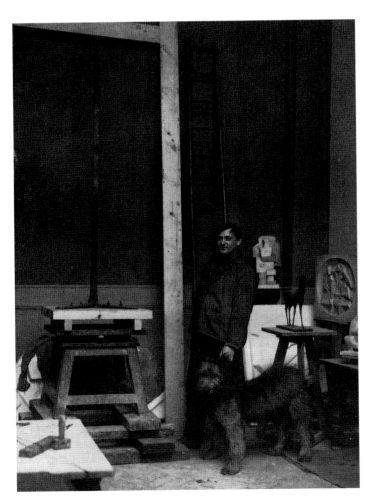

When he broached the idea at the Rotonde, André Salmon was skeptical, but Picasso loudly approved. Modigliani and Beatrice Hastings joined them, and Halvorsen asked Modigliani to make a drawing of Picasso. While posing, Picasso evoked the image of Halvorsen at the helm of a boat filled with paintings, a boat so small it wouldn't be spotted by the German U-boats. Halvorsen, with the advice of Matisse and [Albert] Marquet, selected ninety-four paintings, which he shipped from Rouen; and the exhibition opened November 22."[35] A second Modigliani drawing of Picasso, made around the same time as the first, is located at the Musée Picasso, Antibes, France. The painting is in a private collection.

Modigliani and Picasso exhibited together no fewer than six times between 1916 and 1919.[36] Picasso was a great admirer of Modigliani's art and acquired his painting *Black Hair (Young Seated Girl with Brown Hair)* (cat. no. 24) in the 1930s.[37] Picasso also helped Modigliani to sell some of his works. The famous collector André Level wrote about his first encounter with Modigliani in August or October 1914, at which time he bought the artist's works with Picasso's assistance. As Level recalled: "One after-

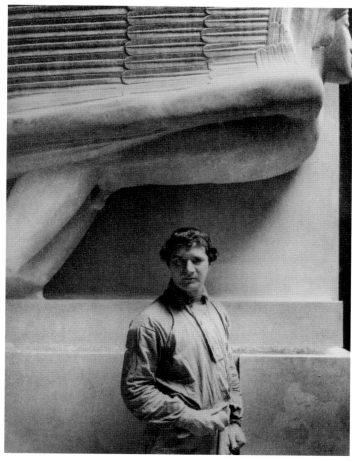

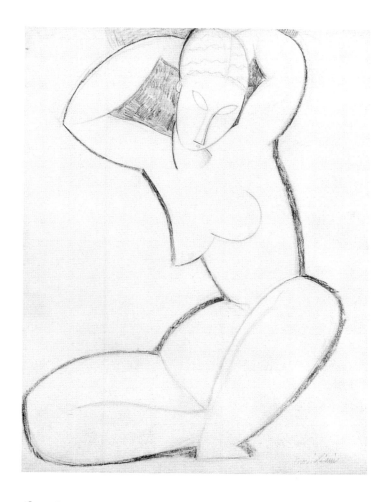

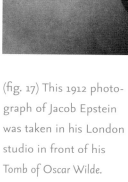

(fig. 17) This 1912 photograph of Jacob Epstein was taken in his London studio in front of his *Tomb of Oscar Wilde.*

noon at the beginning of the war, probably on a Sunday when I was free, I met up with [the art dealer] Léonce Rosenberg and Picasso at the Dôme, which at this time was still a small café, like the Rotonde. At my table, I was introduced to a young man with fine features whom I did not know: Modigliani—and when we left the café, Picasso took Rosenberg and me to the studio of the Italian artist who was sculpting heads in stone and painting faces of women and friends. A large watercolor of a red caryatid with beautiful lines seduced me and Modigliani, when asked by Picasso, fixed the price at 25 francs, so I took it away rolled under my arm."[38] Picasso was one of the many artists who attended Modigliani's funeral.[39] (Other individuals in attendance included Brancusi, André Derain, Jacob, Moïse Kisling, Mánuel Ortiz de Zarate, Salmon, Chaïm Soutine, and Maurice de Vlaminck.)[40] Seeing all the police agents who saluted Modigliani as his coffin went by, Picasso remarked that the artist had been avenged since he did not have good relations with many of these individuals previously.[41] On his own deathbed, Picasso is reported by the attending

(fig. 18) MODIGLIANI. *Caryatid.* c. 1912. Pencil and crayon on paper, 21 5/8 x 16 3/8" (55 x 41.5 cm.) The Garman Ryan Collection, The New Art Gallery, Walsall, England

physician to have mumbled the names Modigliani and Guillaume Apollinaire repeatedly.[42]

Non-Cubist artists whose portraits were painted by Modigliani include Brancusi (Ceroni 22b); Soutine (cat. no. 5 and fig. 19); Kisling (fig. 20; Ceroni 98, 107); Leon Indenbaum (Ceroni 91);[43] and Oscar Miestchaninoff (fig. 21). Brancusi is usually credited with introducing Modigliani to sculpture; their carved work shares an affinity with primitivism. Modigliani would certainly have known the sculptor Elie Nadelman, since both actively frequented the same cafés. Alexandre said that "He also liked Nadelmann's [sic] bronze sculptures."[44] Adolphe Basler mentioned one of Nadelman's famous exhibitions at the Galerie Druet (probably the one in 1909 rather than 1913) and exclaimed that "Modigliani was astounded by Nadelmann's [sic] first sculptures; they inspired him."[45] Other artists who can be linked to Modigliani are Jean Arp (fig. 22), Marc Chagall, Giorgio de Chirico, Tsugouharu Foujita, Nina Hamnett, Augustus John, Jules Pascin, and Ortiz de Zarate. Gino Severini said that Modigliani

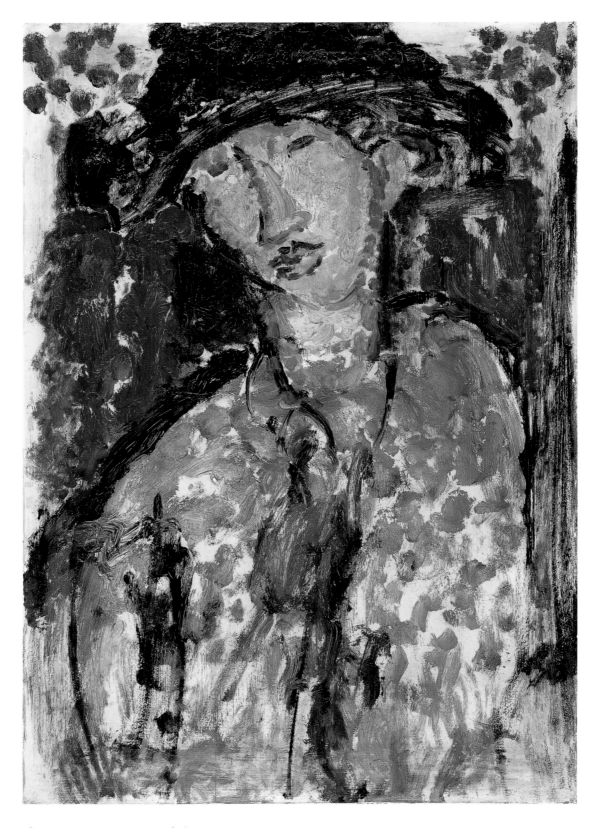

40

(fig. 19) MODIGLIANI. *Portrait of Chaïm Soutine.* 1917.
Oil on door panel, 31 x 21 3/8" (78.7 x 54.3 cm.)
Private Collection

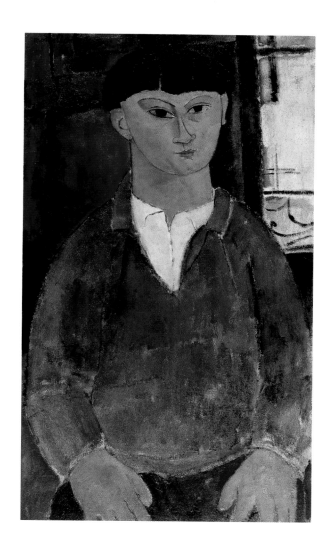

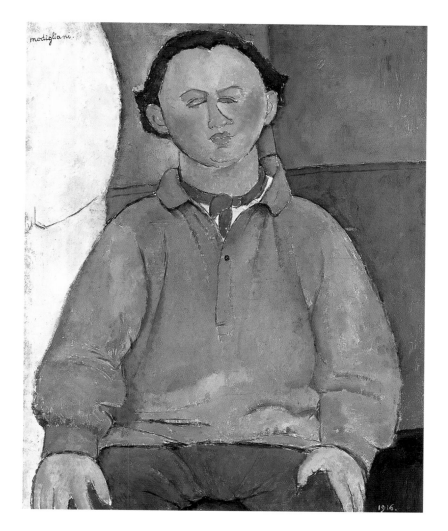

(fig. 20) MODIGLIANI. *Portrait of Möise Kisling*. 1916.
Oil on canvas, 32 ¼ x 18 ½" (82 x 47 cm.)
Collection Musée national d'art moderne, on loan to
Musée d'art moderne Lille Métropole, Villeneuve d'Ascq

(fig. 21) MODIGLIANI. *Portrait of Oscar Miestchaninoff*
(Portrait du sculpteur Oscar Miestchaninoff). 1916.
Oil on canvas, 31 ⅞ x 23 ⅝" (81 x 60 cm.)
Private Collection

(fig. 22) Pencil portrait of Hans Arp by Modigliani, 1916,

in Cabaret Voltaire: a collection of artistic and literary contributions, Zurich, 1916, p. 13

is the only artist he would have liked to see join the Futurist group, but that Modigliani was not interested.[46]

Interestingly, many of the artists with whom Modigliani associated were Jewish, like himself: Chagall, Epstein, Indenbaum, Kisling, Lipchitz, Ludwig Meidner, Nadelman, Pascin, Soutine, and Zadkine. Many individuals have commented on the importance of his Jewish heritage to Modigliani, including both his main patron, Alexandre, and one of his principal dealers, Paul Guillaume (fig. 23).[47] According to both, Modigliani saw himself as a Jewish artist and felt that his art was Jewish. Jews had always respected the Old Testament teaching of not making graven images, and perhaps Modigliani was expressing his awareness that he was part of the first major group of Jewish artists to become established in the art world.

(fig. 23) Paul Guillaume posed for this photograph c. 1915–16 in Modigliani's rented studio on the rue Ravignan, Paris.

Aside from artists, particularly Cubists, Modigliani also closely associated with a large group of writers, of whom he created many portraits: Anna Akhmotova;[48] Apollinaire; Blaise Cen-

drars (fig. 24);[49] Cocteau (cat. no. 14); Ehrenburg;[50] Hastings (cat. no. 6); Franz Hellens (Ceroni 285); Jacob (cat. nos. 10 & 11); Raymond Radiguet (Ceroni 56); Reverdy (fig. 25);[51] and André Rouveyre (Ceroni 90). It is possible that Ceroni 206 is a portrait of the Baroness d'Oettingen, patron of the arts, who later penned an article on Modigliani under the name Roch Grey.[52] Other writer friends included Francis Carco, Paul Fort, Salmon, and André Warnod. Given the number of portraits he painted of fellow artists and writers, Modigliani could be considered the Man Ray of his generation. Ray, who arrived in Paris the year after Modigliani died, chronicled the inter-war avant-garde just as Modigliani had chronicled the artists and writers of war-time Paris.

The poet Akhmotova was especially close to Modigliani in 1911 and gives us an indication of the importance of the Louvre and especially of Egyptian art in his development: "He used to rave about

(fig. 24) Modigliani's drawing of Blaise Cendrars, 1917

Egypt. At the Louvre he showed me the Egyptian collection and told me there was no point in seeing anything else, 'tout le reste.' He

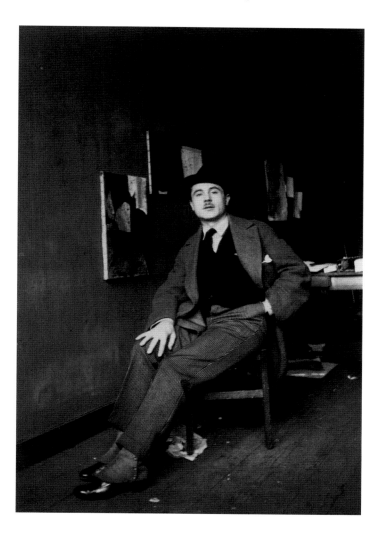

44

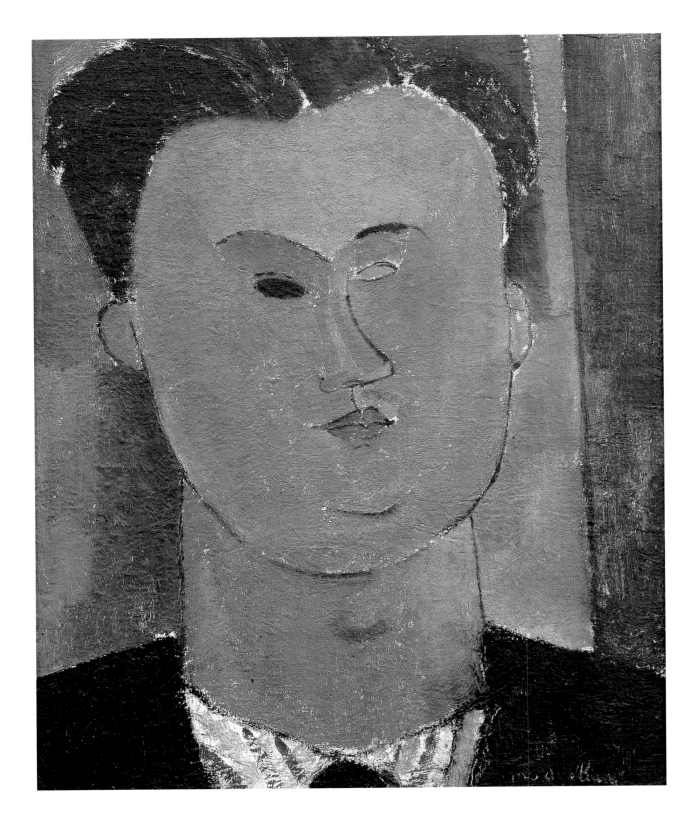

(fig. 25) MODIGLIANI. Portrait of Pierre Reverdy. n.d.
Oil on canvas, 16 x 13 ¼" (40.7 x 33.7 cm.)
The Baltimore Museum of Art: Collection of
Louis B. Thalheimer, Elizabeth Thalheimer Wachs,
and Marjorie Thalheimer Coleman BMA L.1967.10.1

drew my head bedecked with the jewelry of Egyptian queens and dancers, and seemed totally overawed by the majesty of Egyptian art. Egypt was probably his last fad. Shortly afterwards he became so independent that his pictures betray no external influence. Today this period is referred to as Modigliani's *Période Nègre* (Negro Period)."[53] In his poetic way, Cocteau described seeing Modigliani in the heart of Montparnasse: "All the rest is no more; and [Auguste] Rodin's statue of Balzac now stands, motionless, where Modigliani, in the same stance, and himself like a bronze statue, resisted our efforts to take him home. . ."[54] It was Cocteau who took the now-famous photographs of Jacob, Modigliani, Picasso, Ortiz de Zarate, and others on August 12, 1916 (figs. 26–28).[55]

Modigliani was close to Cendrars throughout his time in France.[56] Cendrars wrote "Sur un portrait de Modigliani," a poem that appeared in the catalogue of Modigliani's only lifetime one-person exhibition, at the Galerie Berthe Weill, which took place in December 1917. In 1919, Cendrars used one of Modigliani's many depictions of him in his book *Dix-Neuf Poèmes Élastiques*, giving the artist further exposure in the literary world (figs. 24 & 29). Later, it was Salmon who wrote the most about Modigliani. After Modigliani's death, Salmon essentially became Modigliani's personal biographer.

Modigliani's closeness to the poets of his day was not merely due to his residence in Montparnasse, but also to the fact that he was a poet himself,[57] and that he loved the work of authors such as Danté Alighieri, Charles Baudelaire, Henri Bergson, Gabriele D'Annunzio, le Comte de Lautréamont (pseudonym for Isidore Ducasse), Stéphane Mallarmé, Friedrich Wilhelm Nietzsche, Arthur Rimbaud, Paul Verlaine, and Oscar Wilde. Lautréamont's *Les Chants de Maldoror* is filled with wild, dream-like sequences; this book later became a favorite of the Surrealists. It is tempting to think of Modigliani as a proto-Surrealist, especially in view of a statement he wrote in a sketchbook about the subconscious: "What I am searching for is neither the real nor the unreal, but the Subconscious, the mystery of what is Instinctive in the human Race."[58] Of Nietzsche, he is known to have read both *Beyond Good and Evil* and *Thus Spoke Zarathoustra*.[59]

The Russian writer and journalist Ehrenburg commented on how well read Modigliani was: "I was always astonished by the width of his reading. I don't think I have ever met another painter who loved poetry so deeply. He could recite by heart verses from Dante, Villon, Leopardi, Baudelaire, Rimbaud."[60] He also gives us a poetic understanding of Modigliani's art: "His canvases do not

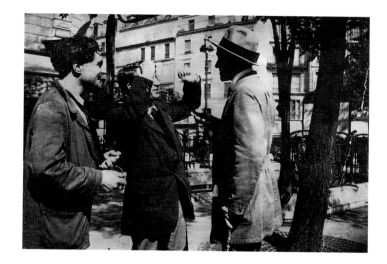

(figs. 26, 27, & 28) These three photographs were taken on August 12, 1916, when Modigliani spent the day with his artist friends and compatriots. Top and bottom photographs, left to right: Modigliani, Picasso, and Salmon. Middle photograph, left to right: Modigliani, Jacob, Salmon, and Ortiz de Zarate.

represent fortuitous visions: they are a world apprehended by an artist who has a rare combination of childlikeness and wisdom. When I say 'childlikeness' I do not, of course, mean infantilism, a native lack of ability or a deliberate primitivism; by childlikeness I mean freshness of perception, immediacy, inner purity."[61] Interestingly, it is writers and poets who, along with artists, seem to have understood his art particularly well. Basler also commented on Modigliani's vast knowledge of literature: "One never saw him without a book in his pocket. He read a lot and enjoyed taking part in discussions on literature, art and philosophy. He did not have to wait for the Surrealists to make the acquaintance of the Comte de Lautréamont.... In his studio in the Cité Falguière I saw books in every corner—Italian and French, the sonnets of Petrarch, the Vita Nuova, Ronsard, Baudelaire, Mallarmé, and even philosophical works: Spinoza's *Ethics* and an anthology of Bergson. Talking to him was a real pleasure."[62]

Modigliani had some contact with the composers of his day, though music seemed less of an interest than literature. He was involved in the first Lyre et Palette (fig. 29) Cover and title page exhibition with Erik Satie, and Satie of Blaise Cendrars's Dix-Neuf performed at the opening which Poèmes Élastiques

Modigliani attended.[63] Edgard (fig. 30) MODIGLIANI. Roger Varèse introduced Georges Auric to Dutilleul. 1918. Oil on canvas, Modigliani, and the artist immedi- 39 ½ x 25 ½" (100.8 x 64.8 cm.) ately made Auric's portrait in pen- Private Collection cil.[64] (Auric noted that he was later part of Modigliani's funeral procession.)[65] Modigliani also rendered two oil portraits of the pianist Germaine Meyer (later Madame Léopold Survage) (cat. no. 26).[66]

Modigliani was also linked to the leading collectors and dealers of avant-garde art. Alexandre was a major collector and supporter of Modigliani from 1907 to 1914.[67] The collector Level continued to purchase Modigliani's works after being introduced to the artist by Picasso:

I won't stop here with regard to this handsome artist and Paul Guillaume, whom I probably met through Apollinaire, and from whom I had already bought some beautiful negro masks before the war, and who at the beginning of war would not only let me

acquire some negro objects, but also a certain number of paintings by Modigliani, who he came to represent for a while. This way I acquired several paintings of women's heads from prices starting at fifteen, twenty-five, thirty-five and even sixty francs for a big portrait of Madame Hastings. A little later, I made another acquisition, for fifty francs—a little head of a woman that was featured in an exhibition chez Wassilieff on avenue du Maine, where evenings of music and Russian songs took place in 1915 or 1916.[68]

Another collector to whom Modigliani was linked was Roger Dutilleul (fig. 30), who purchased works from the artist as well as other modernists such as Léger.[69]

Modigliani's closeness to the collector Frank Burty Haviland is described by Basler in the following account, which discusses the Italian's profound appreciation of Haviland's African art collection:

He went to the painter and art collector Frank Burty Haviland who lived next to Picasso in the Rue Schoelcher. Frank lent him some paints, brushes and canvases. Modigliani wanted to translate the experience which he had gathered as a sculptor into painting. Another factor was that wartime restrictions forced him to try his hand at a less complicated form of art than sculpture, a form of art that was less expensive and easier to carry out. Haviland also possessed the most wonderful collection of African sculptures. They captivated Modigliani; he could not see enough of them. Soon he could think only in terms of these forms and proportions. He was transfixed by the pure and simple architectonic forms of the Cameroonian and Congolese fetishes, of those attenuations found in the elegantly stylized figurines and masks along the Ivory Coast. Slowly they led him to develop a form with elongated lines, with gently distorted proportions. The details were influenced by his admiration for African sculpture. Right from the start the oval head and the uniform, geometric nose developed from the African fetishes gave his portraits a special character.[70]

The closeness of Modigliani and Haviland is further attested to by the fact that Modigliani painted Haviland's portrait (cat. no. 4).

Modigliani's first major dealer, Guillaume (cat. no. 7), also sold works by other major modern artists including Braque, Cézanne, de Chirico, Edgar Degas, Derain, Édouard Manet, Matisse, Claude Monet, Berthe Morisot, Picasso, Camille Pissarro, as well as important pieces of African art. Guillaume, who started

(fig. 31) Léopold Zborowski was a private dealer until he opened a gallery in 1927 on the rue de Seine.

buying Modigliani's art as early as 1914,[71] had a gallery on the chic rue Miromesnil, and later on the elite Faubourg Saint-Honoré. Clearly, Modigliani had arrived. Soon afterwards, Modigliani was represented by a second, equally dynamic and ambitious dealer, Léopold Zborowski (fig. 31).

Modigliani's affiliation with the avant-garde underscores his ties to the Cubists and Cubism. He was friends with many of them and painted numerous portraits of Cubists. Like them, he was attracted to such Post-Impressionist artists as Gauguin and Cézanne rather than to the Impressionists and was intrigued by African art. Like them, he was tied to writers and literature, rather than to composers and music, or other art forms. He even attracted the same collectors as the Cubists, namely Level and Dutilleul. What kept Modigliani from being a full-fledged Cubist was most likely his interest in Old Master painting, specifically Italian Renaissance portraiture, and his interest in being a Jewish artist.

MODIGLIANI'S LIFETIME EXHIBITIONS

Amedeo Modigliani's lifetime exhibitions, spanning the period from 1907 to 1919, provide great insight into the artist and how he was viewed while his career was unfolding. The sheer number of confirmed exhibitions—eighteen within a short twelve years—already reveals just how popular he was.[1] Most of these exhibitions, and reviews of them, have not previously been recorded in Modigliani literature, and none of them has been examined closely for the information they might reveal. Most of the published references to the artist during his lifetime relate directly to an exhibition, so it is advantageous to find out where and when he exhibited to be able to document written accounts. In addition, material surrounding these exhibitions often allows us to identify specific works that were seen, thereby confirming their importance within his oeuvre, as well as their authenticity.

Of Modigliani's lifetime exhibitions, seventeen were group exhibitions, and only one was devoted to his work alone. This situation can be explained partly by the First World War during which time single-person exhibitions in Paris were relatively infrequent while group exhibitions were more common; in peaceful times this was reversed.[2] Modigliani's art had the misfortune of hitting its stride during the war, and so he did not have as many one-person exhibitions as he might have. During the war, a much more collab-

After Modigliani's arrival in Paris in 1906, he exhibited at both the Salon d'Automne (1907, 1912, 1919) and the Salon des Indépendants (1908, 1910, 1911), two relatively new organizations that helped attract many foreign artists to Paris. These organizations were formed as alternatives to the other Paris salons, especially the Salon de la Société Nationale des Beaux-Arts and the Salon de la Société des Artistes Français, which essentially excluded non-academic artists. Founded in 1884, the Salon des Indépendants was not juried and did not give prizes; any artist could enter whatever he or she liked.[4] Established as a direct result of the rejection of Impressionist art from the official salons, it was the most democratic and open exhibition venue for new artists in Paris or, for that matter, anywhere.

The Salon d'Automne, founded in 1903, did have a jury but one that was formed anew each year to prevent powerful cliques from forming.[5] Moreover, the jury was decided by drawing lots instead of by appointment. Four out of five places were filled from within the organization by founding members or by *sociétaires*—exhibitors themselves. As a result, foreign artists could be on the committee. A fifth place was reserved for honorary members. Complementing the presentation of painting, sculpture, graphics, and architecture were literary and musical events and, in the early 1920s, film projections. This broad approach encouraged interaction between writers, critics, architects, painters, and sculptors and resulted in such collaborative projects as the "Cubist home" in the Salon d'Automne of 1912 and the mural projects of Joseph Csáky and Fernand Léger in 1923.

Modigliani must have felt significant encouragement by being included in the Salon d'Automne of 1907, his first juried

(fig. 1) This photograph of Amadeo de Souza Cardoso's building on the rue du Colonel-Combes in Paris was taken in 1911.

orative feeling reigned, an *esprit de corps*, even in the civilian sector, thereby favoring group exhibitions.[3] The collaborative spirit turned exhibitions into multi-cultural events with concerts and literary readings held concurrently. Modigliani died just fourteen months after the armistice. Neither Pablo Picasso nor Henri Matisse had had a one-person exhibition in Paris during the war, making Modigliani's 1917 one-person exhibition there seem all the more impressive. All of his group exhibitions were, tellingly, international, for that is the world in which he lived.

Modigliani's solo and group exhibitions played an important role in his life, as they do for all artists: each one invariably led to another exhibition, more confidence for the artist, and to more dealer and collector interest in his work. Modigliani's exhibitions were not limited to Paris, but reached as far away as London (twice), New York, and Zurich (twice), underscoring the artist's international profile. He was, without a doubt, an internationally known artist during his lifetime. Modigliani's reputation as the "Vincent van Gogh" of his generation, someone who died unknown and unappreciated only to receive posthumous fame, can now be completely dismissed.

(fig. 2) Amadeo de Souza Cardoso and Francisco Carneiro in Souza Cardoso's studio in Paris in 1911

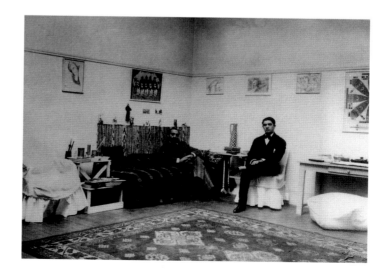

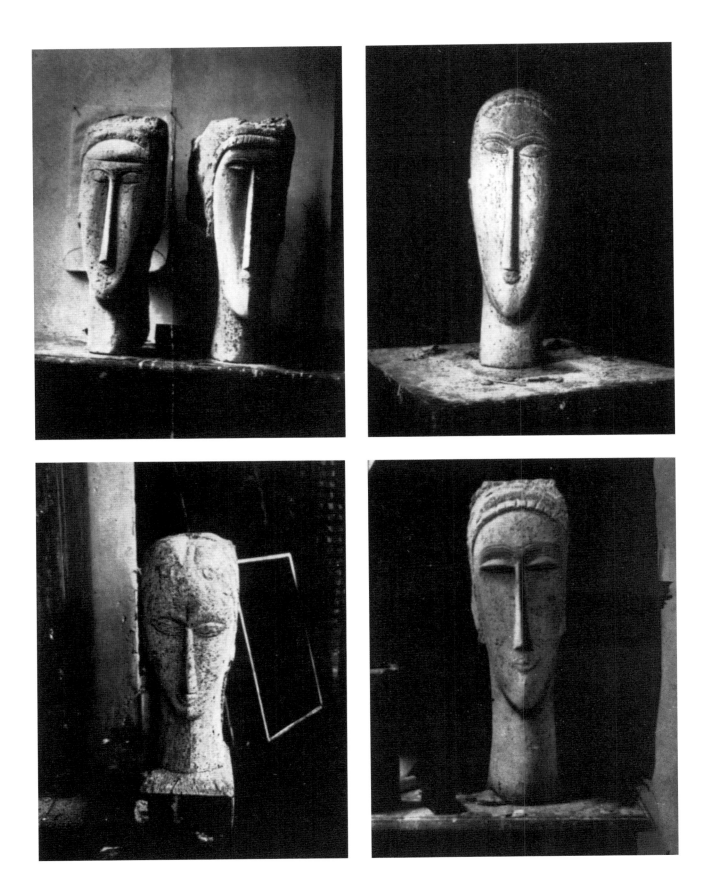

(fig. 3) Sculptures by Modigliani in Souza Cardoso's studio, Paris, 1911. Clockwise: *Head of a Woman*, 1911, Collection Minneapolis Institute of Art and Sculpture A (not included in Ceroni); *Head*, 1911, exhibited in 1984 from the collection of Stavros Niarchos, present whereabouts unknown; *Head of a Woman*, c. 1911, Private Collection; and *Head*, c. 1911, which was sold at auction at Sotheby's, New York, 1995.

LE SALON D'AUTOMNE

MODIGLIAN
Tête
décorative

Ma petite Loute chérie,

C'était jusqu'à maintenant une partie de plaisir que d'aller annuellement au Salon d'Automne pour t'écrire mes impressions. Désormais ça devient une grosse affaire, même une affaire dangereuse ; d'abord parce que des gens malintentionnés — des membres de l'Institut évidemment ! — accumulent des barricades de rails et de pavés de bois dans l'avenue d'Antin ; ensuite parce qu'*ils sont trop*. On entre, on croit voir cette exposition-là, comme les autres, au pas-de course, et retrouver les bons, les purs dans des milieux de cimaise qui sont toujours les mêmes depuis les siècles des siècles... Ah ! je t'en fiche ! Tout de suite là-bas on est perdu ; on ne sait plus où on est, où on va, si l'on se trouve réellement dans le Palais du regretté Thomas, si l'on marche encore les pieds en bas et la tête en l'air! Ces diables d'artistes automnaux ont juré de faire tourner la cervelle aux vieux Parisiens; leur Salon idéal, qu'ils semblent avoir réalisé cette année, est tout à fait digne de ce jardin céleste qu'expliquait en chaire un bon curé de mon pays : « Supposez, mes chers frères, que le clocher soit un pain de sucre et que l'église soit un plat de crème — et que le clocher tombe dans l'église... Ça serait délicieux n'est-ce pas ?... Eh bien, mes chers frères, à côté du Paradis, ça ne serait que de la pâtée de chien ! »

Tiens, un exemple, mon loulou ! Dès le seuil tu te trouves en plein établissement Poiret-Martine : le bas de l'escalier est à lui ; on dirait l'express de Munich entrant dans la foire de Nijni-Novgorod : roses vertes, choux roses, tomates tricolores, artichauts en feux d'artifice... Tu t'élances à gauche, tu crois reprendre ton calme dans la salle crépusculaire vouée de tout temps au repos des œuvres inférieures... Ah! mon enfant, quel repos!... Dans cette salle-là, cette humble salle, ils ont bâti une ville : d'un côté, la maison du riche entrepreneur moderne toute constellée de roses taillées en plein bois par Sué; de l'autre, un hôtel cubiste, oui, cubiste, dont l'architecte se nomme Duchamp-Villon, où est logé tout un phalanstère : Richard Desvallières en a forgé les fers, André Mare en a fait les meubles, Marie Laurencin les trumeaux, etc., etc... Et il n'y a pas à dire, ce n'est pas mal du tout !... Au moins c'est autre chose que ces affreuses machines que les tapissiers apportent toutes faites dans les maisons dites de rapport !

Mais ce n'est pas fini; dans la maison Duchamp-Villon une porte ouvre sur la maison Groult, autre phalanstère où les salons délicats succèdent aux salons charmants; trois marches te font descendre à la salle à manger Gauthier-Poinsignan qui a collaboré avec Lombard (ça doit être le marchand de chocolat!), et puis après c'est le cabinet de travail Majorelle, et puis la chambre à coucher Bigaux, et puis, et puis des appartements, et encore des appartements... C'est une ville, te dis-je, ma petite Loute.

Oui, voilà comment ces gens-là comprennent le Salon ! Les voilà qui s'amusent maintenant à accrocher les tableaux sur des vrais murs, entre des cheminées, des tables, des chaises ! Où allons-nous, Dieu duciel ?

Oh ! il y a bien encore, en haut, dans quelques salles un cent de toiles à la queue leu-leu, pour mémoire ; mais comme ça paraît prétentieux ces chefs-d'œuvre qui s'offrent avec l'ambition de faire bien n'importe où !

Tu les jugeras quand tu reviendras à Paris ; moi j'avoue que ces pauvres tableaux alignés m'ont paru ridicules — après ma promenade dans les installations du bas — autant qu'une revue de pompiers de village. L'un tente de transporter votre esprit dans un paysage de printemps; son voisin immédiat vous fait subitement passer dans une cuisine ; le suivant vous sort des casseroles pour vous faire tomber dans les bras d'une dame d'un décolletage sans limites... Comment faire un choix dans cet étalage où chaque artiste, par la petite fenêtre de son cadre, vous aguiche au détriment de son voisin : « Pstt!Pstt ! Viens donc voir ma poésie bucolique!... Pstt! Pstt! Tu ne veux pas de mon petit sentiment religieux?... Eh ! par ici, pour la grande peinture, la vraie, la seule qui vivra dix siècles et qui rapportera du cent mille pour cent ! »

Oui, je sais bien, j'aurais pu me livrer plus tôt à ces profondes considérations depuis qu'il y a des salons, et même depuis qu'il y a des musées. Mais si je ne m'y suis pas livrée, c'est que, jusqu'à aujourd'hui, le saugrenu de ces installations artistiques ne m'avait pas frappée; oui, c'est le Salon d'Automne qui m'a ouvert les yeux, voilà le fait.

Je m'avoue donc parfaitement incapable de te donner mon avis, comme tu me l'as demandé, sur les meilleures peintures. Je suis presque tentée

ARCHIPENKO
(*L'homme qui comprend les femmes*)
Vénus

MODIGLIANI
Autre tête
décorative

KUPKA. — Devinette en deux couleurs

Fermez les yeux, tenez le dessin à bout de bras et tournez-le en tout sens, jusqu'à ce que vous y ayez reconnu le portrait d'un célèbre danseur russe.

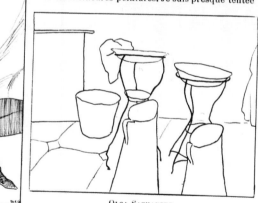

DIEGO M. RIVIERA
Le record de la hauteur

OLGA SACHAROFF
Après la bataille
ou
le confort moderne

(fig. 4) This review of the Salon d'Automne appeared in *La Vie Parisienne* on October 5, 1912, page 713.

exhibition. He contributed seven pieces, most of them watercolors. This particular Salon d'Automne was especially important because of its inclusion of a large retrospective exhibition on Paul Cézanne, who had died the previous year. The faceted qualities of Modigliani's paintings over the next few years, so reminiscent of Cézanne, undoubtedly owe a great deal to the many works he would have seen there.

Modigliani's 1908 and 1910 appearances at the Salon des Indépendants are notable for the fact that he was mentioned in reviews by the leading critics of his day, Louis Vauxcelles in 1908 and Guillaume Apollinaire in 1910 respectively.[6] With 6,000 works on display at the 1910 exhibition,[7] Modigliani was fortunate to be among the handful singled out for mention by Apollinaire. Apollinaire had some general comments about the Salon of 1910 that are quite illuminating: "If we had to sum up the general sense of this exhibit, we would say—and with what pleasure—that it means the definitive downfall of impressionism."[8] His discussion of Matisse tells us what he meant by that: "Matisse is one of the rare artists who have completely freed themselves from impressionism. He strives not to imitate nature but to express what he sees and what he feels through the very materials of painting."[9] In other words, the new art reacts against Impressionism by being anti-naturalistic. That characterization would certainly apply to Modigliani's contributions to the salon as well. One of his painting submissions, *Cello Player* (Ceroni 23), bathed in a blue glow, is concerned more with emotion and expression than with description. Speaking of the salon as a whole, Apollinaire added in a second review of the salon, "The influence of a [Pierre-Auguste] Renoir, of a Picasso, or of a Matisse is predominant among other, less clearly marked, influences."[10] Indeed, in the press Modigliani was most closely identified with Picasso as the former's art evolved.

Modigliani's next exhibition opened in Paris on Sunday, March 5, 1911, according to a note sent by Constantin Brancusi to Dr. Paul Alexandre, a supporter of his and Modigliani's at the time.[11] In all likelihood that is the exhibition in which Modigliani showed works in the atelier of the Portuguese painter Amadeo de Souza Cardoso, a studio that was much larger than his own; Brancusi helped to install the exhibition.[12] Souza Cardoso lived primarily in Montparnasse but at the time was living briefly at 3, rue Colonel-Combes in the seventh arrondissement close to the Quai d'Orsay and the Seine (figs. 1 & 2).[13] At that exhibition, Modigliani showed at least five sculptures that were recorded in photos taken in Souza Cardoso's studio (fig. 3), in addition to some sketches or gouaches.[14] Sculp-

ture A appeared in subsequent exhibitions; records on the work seem to stop in 1927, and its current whereabouts are unknown.[15] Jeanne Modigliani remarked that "other heads, a statuette and a caryatid, all in limestone" were exhibited there as well.[16] It is very possible that this exhibition in Souza Cardoso's studio was in fact a solo exhibition. Modigliani literature does not refer to it as being a joint exhibition, while Souza Cardoso literature does.[17] Unfortunately, there are no known reviews of this exhibition.

The Salon des Indépendants of 1911, which ran from April 21 to June 13, was notable because it featured, in salle 41, the first public manifestation of Cubism.[18] At the urging of Roger Allard, Apollinaire, and André Salmon, the Cubist painters—Robert Delaunay, Henri Le Fauconnier, Albert Gleizes, Léger, Jean Metzinger, but not Picasso and Braque—decided to present themselves as a group to have maximum impact. To do this, the Cubists had to change the rules governing installation of works, which precluded groupings in favor of a democratic—and chaotic—presentation. This was a shrewd decision, as it alerted the public for the first time to the fact that a new movement was under way. Modigliani's submissions were probably overshadowed by this major Cubist event, in addition to the fact that four of his six submissions were drawings and were probably small in comparison with the large salon-size paintings hanging nearby. This salon was also significant because it included a retrospective exhibition of the work of Modigliani's friend Henri "Le Douanier" Rousseau, who had died the previous year.

At the Salon d'Automne of 1912, Modigliani exhibited seven sculptures each titled "Tête, ensemble décoratif." The large body of similar works must have made quite a dramatic impact, and would have firmly signaled to visitors that Modigliani, was above all else, a sculptor. It is not known exactly what Modigliani meant by "ensemble décoratif," but the title does imply that the sculptures were meant to be seen as a group. (Interestingly, this is the same salon that featured another decorative project, the famous "maison cubiste" or "cubist home," designed by Raymond Duchamp-Villon).

While not necessarily discussed in the press, the sculptures did receive significant exposure by means of illustration or photographic reproduction. *La Vie Parisienne* of October 5, 1912 (fig. 4) features crisp line drawings of two of the sculptures, allowing us to identify Sculpture A on the left and *Head, 1911–12* (Ceroni XXII) on the right. *L'Illustration* of October 12, 1912 (fig. 5) featured an installation photo of the salon in which four of Modigliani's seven sculptures are seen; the one on the left can be identified as *Head, 1911–12*

Kupka : « fugue à deux couleurs ». Picabia : « Danse à la source ». (A droite et à gauche de Picabia, « le Moulin » et « Après le bain » de Souza-Cardoso.)

Metzer : « Une vue de soleil », « Navigation », « Prière du soir », « Vaulère de jouer ». Metzinger : « Danseuse » Le Fauconnier : « Montagnards attaqués par des ours ».
Sculptures de A. Modigliani : têtes formant un « ensemble décoratif ». et « Paysage ».

LA SALLE DES CUBISTES AU SALON D'AUTOMNE

(Ceroni XXII). *Commoedia illustré* of October 20, 1912 (fig. 6) features photographs of two sculptures that can be identified as Sculpture A on the left and *Head of a Woman*, c. 1911 (Ceroni XV) on the right.

Jacques Lipchitz's commentary provides additional information about the sculptures exhibited at the Salon d'Automne:

> The first time we met was when Max Jacob introduced me to him, and Modigliani invited me to his studio at the Cité Falguière. At the time he was making sculpture, and of course I was especially interested to see what he was doing.
>
> When I came to his studio—it was spring or summer—I found him working outdoors. A few heads in stone—maybe five—were standing on the cement floor of the court in front of the studio. He was adjusting them one to the other.
>
> I see him as if it were today, stooping over those heads, while he explained to me that he had conceived all of them as an ensemble. It seems to me that these heads were exhibited later the same year in the Salon d'Automne, arranged in stepwise fashion like tubes of an organ to produce the special music he wanted.[19]

From this description, we can infer that most of the sculptures in the Salon d'Automne had probably not been exhibited the previous year in Souza Cardoso's studio, that they were newly created for the Salon exhibition. Lipchitz also confirms the fact that the sculptures were conceived as a group.

(fig. 5) An installation view of the Cubist Room at the Salon d'Automne of 1912 shows four heads by Modigliani among works by František Kupka, Henri Le Fauconnier, and Jean Metzinger.

The installation photo in *L'Illustration* allows us to see that Modigliani's work was exhibited in Salle XI in the cubist room. That room included works by Alexander Archipenko, Le Fauconnier, Gleizes, František Kupka, Léger, Metzinger, Francis Picabia, and Souza Cardoso. While Modigliani's placement with the Cubists may seem like an anomaly, based more on friendship or a shared interest in African art than on Cubist principles, it deserves serious consideration here because later reviews also group him with the Cubists. This fact might say as much about the broad definition of Cubism at the time as it does about Modigliani and his art, but it still needs to be evaluated seriously. Apollinaire joked about the status of the Cubists the day before the Salon officially opened: "The cubists, grouped together in a dark room at the far end of the retrospective exhibit of portraits, are no longer ridiculed the way they were last year. Now the feeling they arouse is hatred."[20] In a subsequent report, he elaborated:

> In the painting section, there are no new group exhibits. Paintings representing the various trends have been dispersed

~ LA COMÉDIE ARTISTIQUE ~

❧ ❧ ❧

Au Salon d'Automne
Maîtres Cubes

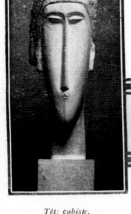

Tête cubiste.

Tête cubiste.

Eɴ voulant faire rire, souvent on se ridiculise. Sitôt qu'une œuvre d'art fait crier à la mort ou à l'horreur, c'est qu'elle contient un peu d'offensante vérité. Ainsi ce bon M. Lampué, conseiller - photographe, tour à tour dénonça Monet, Carrière et Rodin. On n'aimait point fort les cubistes : tant de lourdes attaques rendent leur art sinon sympathique, du moins respectable. Au Moyen Age on

les aurait brûlés, sans doute. Ces œuvres sont toutes de résistance : quoi d'étonnant qu'on leur résiste ? J'en sais plus d'un se gaussant des faiseurs de cubes qui vient de recevoir un pavé.

Le public, toujours très simpliste, appelle du nom de cubistes aussi bien les peintres-géomètres que les apôtres de la peinture cinématographique. Cubistes, futuristes ? Préférons ce dernier mot : il fut inventé par un littérateur. Or ces artistes sont farcis de littérature : c'est un bien gros danger. Loin d'être fous, ils pèchent par excès d'intelligence ; eux qu'on accuse d'incohérence et de facilisme, ils cherchent laborieusement la cohésion ; ils excitent le rire, on les dit « des farceurs » : ils sont l'austérité même.

Leurs amis, leurs instigateurs, hommes de lettres, plus indisciplinés, s'ébahissent et se grisent de manifestes forcenés. « Détruisez la syntaxe, s'écrie Marinetti cuirassé d'images, abolissez la ponctuation, orchestrez les images en les disposant suivant un maximum de désordre, traduisez l'obsession lyrique de la matière... Nous inventerons ensemble ce que j'appelle l'imagination sans fils (sic) ». Qu'on se rappelle l'exposition des futuristes italiens. Voici quelques extraits de leur préface :

« Le geste que nous voulons reproduire sur la toile ne sera plus un instant fixé... Tout

bouge, tout court, tout se transforme rapidement. Un profil n'[est] jamais immobile devant no[us] mais il apparaît et disparaît sans ces[se]. Etant donnée la persistance de l'ima[ge] dans la rétine, les objets en mou[ve]ment se multiplient, se déforment, poursuivent comme des vibrati[ons] précipitées dans l'espace qu'ils p[ar]courent... Nos corps entrent dans [les] canapés sur lesquels nous no[us] asseyons et les canapés entrent [...]

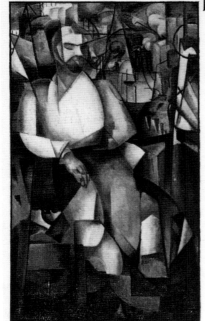

ARCHIPENKO. — *La vie familiale.*

GLEIZES. — *L'homme au balcon.*

LÉGER. — *La femme en bleu.*

(fig. 6) Two of Modigliani's sculptures were featured in Claude Roger's article "Au Salon d'Automne: Maîtres Cubes," in Commoedia illustré (Paris), October 20, 1912, p. 62.

throughout the rooms, and the cubists are virtually the only ones who have been grouped together. Again this year, they constitute the most distinctive group in the Salon d'Automne. The jury was not at all inclined in their favor, however, and if most of them had not been saved at the last minute, there would be no cubist exhibit at this year's Salon. That would have been a pity for the Salon d'Automne, which is above all a salon of modern art. As a matter of fact, the jury reversed its earlier decision regarding the cubists only because this group of young French painters has taken on considerable importance over the past year. The influence they are already exerting on foreign artists did not escape the attention of the organizers of the Salon d'Automne.

These new works by the cubists, which are no longer executed, as before, with the elements of visual reality but with the purer elements of conceptual reality, are certainly open to criticism as far as individual works are concerned; but the general tendency that they represent seems to me worthy of the interest of everyone who cares about the future of art.[21]

This description could certainly apply to Modigliani's sculptures as well. They do not represent specific individuals but instead "types" that have been primitivized under the influence of African and/or Egyptian art.

Modigliani's work next appeared in London at the Whitechapel

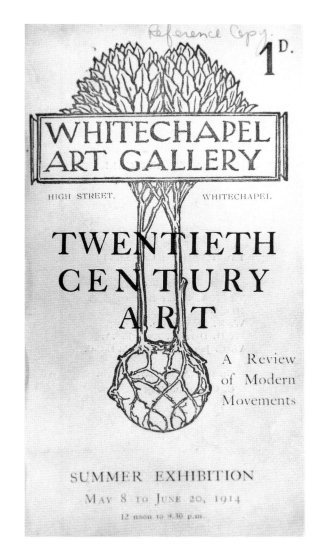

(fig. 7) A view of the Whitechapel Art Gallery on Whitechapel High Street, London, from the early part of the twentieth century

Art Gallery (fig. 7), in an exhibition that ran from May 8 to June 20, 1914. Entitled *Twentieth-Century Art: A Review of Modern Movements*, it was the Whitechapel's summer exhibition (fig. 8). A Modigliani sculpture now at the Tate, London (fig. 9)

(fig. 8) Cover of the Whitechapel Art Gallery's exhibition, catalogue

and a drawing were exhibited. According to the catalogue introduction, the point of the exhibition was to show the recent move away from naturalism and imitation to something more profound. The catalogue introduction specified further that "The 'Twentieth Century Art' exhibition is concerned with the progress of art, since the absorption of the impressionist teaching, as shown in the work of the younger British artists and of artists of foreign origin working in this country." While Modigliani had several close friends from England—Jacob Epstein, Nina Hamnett, Beatrice Hastings, C.R.W. Nevinson— and almost certainly visited London early on, he is not known to have lived or worked in England, and therefore did not exactly fit into the exhibition's premise. The same is true for three other participants in this exhibition, namely Moïse Kisling, Elie Nadelman, and Jules Pascin. All of these artists may have been included because they helped give a more complete idea of "modern move-

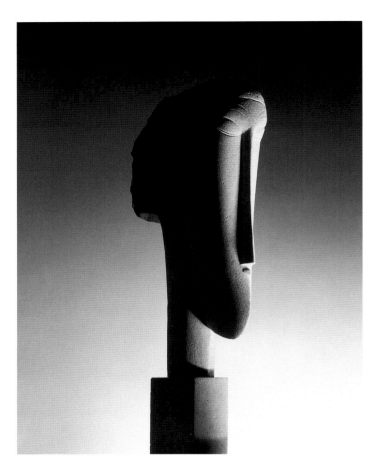

Montparnasse artists, but instead concentrate on the English artists, whose work was the focus of the show. Many of the reviews refer to the work in the exhibition as "Cubist," while others labeled it "Futurist." Other adjectives used to describe the works include "humorous" and "insane."[24]

The works by Kisling, Nadelman, Pascin, and Modigliani exhibited at Whitechapel did not come directly from the artists themselves. Instead, the Paris-based critic and dealer Adolphe Basler lent the works by the first three artists. The Modigliani sculpture was lent by a South African painter named Edward Roworth (1880–1964) who was living in London at the time.[25] Roworth was a student at the Slade School of Art, London, from 1911 to 1914.[26] In a letter to the author, Roworth's daughter Ivanonia Keet of South Africa explained how her father came to acquire the sculpture: "I think it was during 1911[–]1912 when he was on his honeymoon, that my father met Modigliani in Paris. Although himself a traditional painter, my father was very impressed with this beautiful sculpture of Modigliani's and purchased it for the princely sum of five pounds sterling! Modigliani was very modest and wondered whether he was asking too much for it! My father told me that he found Modigliani to be very pleasant and unassuming. I do not know who introduced my father to Modigliani—a fellow artist, I think."[27] According to a biographical dictionary entry, Roworth married in 1911, presumably the year that he acquired the sculpture.[28] The source for the Modigliani drawing exhibited at Whitechapel was not noted and may have come from Roworth as well.

Other artists featured in the exhibition include Vanessa Bell, Roger Fry, Henri Gaudier-Brzeska, Duncan Grant, Wyndham Lewis, Paul Nash, and Walter Sickert. The Omega Workshop was particularly well represented. These artists would have gotten to know Modigliani's name and art through this exhibition if they were not already familiar with it. Most of the works in the exhibition were for sale, and the address of the Omega Workshop was given to allow prospective buyers to contact them directly.

On the day that the exhibition closed, Gaudier-Brzeska published an article called "Vortex" in the first issue of Lewis's Vorticist journal Blast, mentioning Modigliani and citing him as one of the "moderns": "And WE the moderns: Epstein, Brancusi, Archipenko, [Franciszek] Dunikowski, Modigliani, and myself, through the incessant struggle in the complex city, have likewise to spend much energy."[29] The timing with the Whitechapel exhibition, where a Modigliani sculpture was on view, is surely not coincidental:

ments," and/or because of the impact of their work on English artists working either in England or in Paris.

(fig. 9) MODIGLIANI. Head. c. 1911–12. Limestone, 25 x 4 5/16 x 13 7/8" (63.5 x 12.5 x 35 cm.) Collection Tate, London

All four might also have been included because of their heritage. Indeed, their work was exhibited in the "Jewish section," along with such English artists of Jewish heritage as David Bomberg and Mark Gertler. (The work of Epstein was not seen in this section, but nearby.) Given the location of the Whitechapel in the East End of London, which had recently developed into a Jewish area through immigration from Eastern Europe,[22] this part of the exhibition undoubtedly held special importance. Indeed, the Jewish section was located in the "Small Gallery," which was a showcase of sorts. Before the exhibition opened, the Manchester Guardian reported that, "The little gallery at Whitechapel has always made a particular feature of these exhibitions. This year it will house the younger Jewish artists, with Mr. Bamberg [sic] and other Cubists as the nucleus."[23]

This exhibition elicited extensive reaction from the London press with many fascinating discussions about modernism and its meaning. The reviews do not mention Modigliani, or the other

himself in Paris.[31] She also noted that before leaving Italy (presumably in 1906), Modigliani had gone before the draft board and was judged unfit for military service.[32]

With the closure of the Paris salons during the war, artists had limited exhibition opportunities. One particularly interesting figure emerged as a savior, the fashion designer Germaine Bongard (fig. 10), who held at least three war-time exhibitions in addition to many musical and literary soirées in her fashionable shop at 5, rue de Penthièvre, in the chic eighth arrondissement (fig. 11).[33] Modigliani participated in the second exhibition held in March 1916, which was devoted to black-and-white drawings.[34] It is not known which or how many drawings Modigliani exhibited, as a handlist or catalogue to the exhibition do not seem to exist. We know of the exhibition's existence only through newspaper accounts and personal reminiscences. It was quite a distinguished avant-garde event that also featured artists such as André Derain, Roger de la Fresnaye, Jacob, Kisling, Marie Laurencin, Léger, Lipchitz, Maria Vorobieff Marevna, Matisse, Amédée Ozenfant, Picasso, and Gino Severini, among many others.[35] The exhibition itself was organized by Ozenfant for Madame Bongard.[36]

Severini recalled that sales were not great for the exhibition, but that the artists were able to establish an agreement with Bongard whereby they gave her paintings and she dressed their wives in fashionable clothes.[37] "The artists' wives at that time were thus more elegant than they ever had been," he wrote.[38] One of the paintings that Severini gave her was a large self-portrait.[39]

(fig. 10) Madame Germaine Bongard, c. 1923. Bongard was a dressmaker who held wartime exhibitions in Paris.

(fig. 11) Madame Bongard's elegant salon, 1912

Gaudier-Brzeska would have seen the exhibition and confirmed in his own mind Modigliani's importance, especially as a sculptor, citing the artist with himself and other sculptors. Published in London (and New York and Toronto), the *Blast* article would have helped secure Modigliani's place in the international avant-garde. Gaudier-Brzeska died the following month, and Ezra Pound wrote an important book about him in 1916 that reprinted this article, thus furthering its dissemination.[30]

When war broke out in August of 1914, Modigliani chose to remain in Paris. The Whitechapel exhibition and Modigliani's previous exhibitions were evidently good for Modigliani's reputation. His mother later remarked that the artist did not want to come home when the war erupted, as his family very much desired, because he felt that he was starting to make a name for

Bongard apparently became a dealer at the end of 1915: Matisse wrote a letter to fellow Fauve Charles Camoin on November 22, 1915,

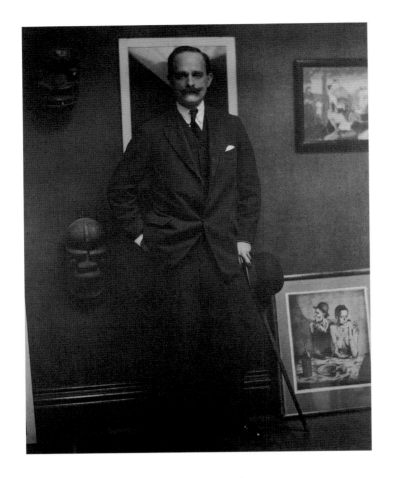

Adelheid Lange Roosevelt, Adolf Wolff, and Alice Morgan Wright. Fifteen sculptures were included, two of which were by Modigliani, each with the title, *Figurehead* (fig. 13). The discovery of this exhibition demonstrates that Modigliani was known in New York during his own lifetime and that he had more of an international career than had previously been acknowledged. Furthermore, the exhibition appears to have been the first Modigliani exhibition to involve the art dealer Paul Guillaume, who had begun representing the artist just a short time before.

The New York exhibition was organized by de Zayas, a Mexican caricaturist and central figure of the New York Dada movement.[44] De Zayas was born into a wealthy aristocratic family in Veracruz, Mexico (fig. 12). He later achieved fame after interviewing Picasso in their native Spanish, which provided the first published account of Picasso's views on art.[45] De Zayas played a crucial role in bringing modern art to the United States from Europe and helped to make New York an important center, first by assisting Alfred Stieglitz with groundbreaking exhibitions at his now-famous 291 Gallery and then by opening his own exhibition space, the

(fig. 13) This handlist of the Modern Gallery's 1916 Exhibition of Sculpture shows that two works by Modigliani were included.

mentioning that Bongard had filled her townhouse with paintings borrowed from all over, which she planned to sell.[40] She approached Matisse directly to see about acquiring a drawing. Matisse was impressed with her and called her "an intelligent woman."[41] Bongard came from a distinguished family in the fashion industry that included her siblings Jeanne Boivin, Nicole Groult, Paul Poiret, all of whom were fashion designers.[42] There were not many illustrations, and almost none of her creations still exist. Bongard's decision to open a gallery in her shop may owe something to the fact that her brother's building on Faubourg Saint-Honoré housed the Galerie Barbazanges (The gallery director rented from Poiret and allowed the latter to mount exhibitions there).[43]

Particularly surprising because of the war-time complications is Modigliani's inclusion in an *Exhibition of Sculpture* in New York from March 8 to 22, 1916, at Marius de Zayas's Modern Gallery, 500 Fifth Avenue, across the street from the New York Public Library (figs. 12–15). There were five participants: Brancusi, Modigliani,

(fig. 12) ALFRED STIEGLITZ. *Marius de Zayas.* 1915. Platinum print, 9 5/8 x 7 5/8" (24.5 x 19.4 cm.). Collection National Gallery of Art, Washington, D.C., Alfred Stieglitz Collection

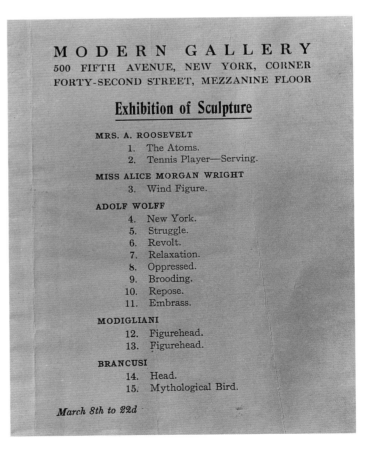

MODERN GALLERY
500 FIFTH AVENUE, NEW YORK, CORNER FORTY-SECOND STREET, MEZZANINE FLOOR

Exhibition of Sculpture

MRS. A. ROOSEVELT
1. The Atoms.
2. Tennis Player—Serving.

MISS ALICE MORGAN WRIGHT
3. Wind Figure.

ADOLF WOLFF
4. New York.
5. Struggle.
6. Revolt.
7. Relaxation.
8. Oppressed.
9. Brooding.
10. Repose.
11. Embrass.

MODIGLIANI
12. Figurehead.
13. Figurehead.

BRANCUSI
14. Head.
15. Mythological Bird.

March 8th to 22d

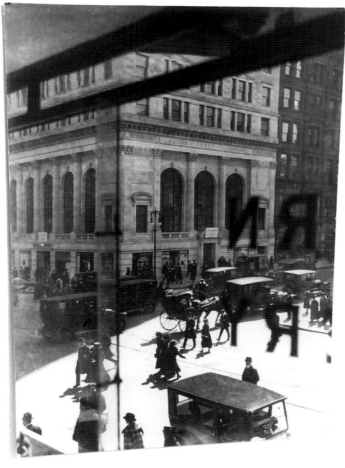

(figs. 14 & 15) Looking out of the front window of the Modern Gallery in 1915, one had a direct view of Fifth Avenue and 42ⁿᵈ Street, where the New York Public Library is situated.

Modern Gallery, in 1915. De Zayas was also a writer and theorist who wrote important books and articles on modern art, and a regular contributor to Stieglitz's journal *Camera Work*. De Zayas first came to Stieglitz's attention for his artistic work and was given exhibitions in 1909, 1910, and 1913. From late 1910 to 1915, he spent a significant amount of time in Paris acting "as emissary and talent scout for Stieglitz."[46] He may have met Modigliani and Brancusi on one of these scouting trips.

It was in 1905 that Stieglitz founded his Little Galleries of the Photo Secession, which became known as 291 because of its address on Fifth Avenue, to celebrate and promote photography and then, in 1907, other media as well.[47] The Modern Gallery opened on October 7, 1915, at 500 Fifth Avenue. De Zayas called it "an ideal place" that was on the mezzanine, measured twenty by twenty-eight feet, and had the advantage that art could be shown in the window (figs. 14 & 15).[48]

De Zayas wrote a detailed history of his artistic activities called *How, When and Why Modern Art Came to New York*, which reconstructs the sequence of events.[49] The Modern Gallery originally opened as a branch of 291, but with a specific purpose. While 291 was fiercely anti-commercial and strongly didactic (Stieglitz had private income and saw himself as a proselytizer), the Modern Gallery was unabashedly commercial and laissez-faire. Its commercialism, though, was based on altruism, as de Zayas explained: "Stieglitz's mission as an importer of French Modern Art was interfered with by the war. Most of the French artists had become soldiers. It was known that the art market in Paris was practically closed. An altruistic spirit invaded the Photo-Secession, inspiring the idea that the "moderns" should be helped in some way, most particularly those artists whose work had been shown at the Photo-Secession for "experimental purposes" only. It was therefore proposed to open another gallery, a branch of '291' in which works of art would be used both for propaganda and for sale, in order to help the needy. The result of this suggestion was the opening of the Modern Gallery."[50] The new gallery

was announced in the October 1916 issue of *Camera Work*: "'291' announces the opening of the Modern Gallery, 500 Fifth Avenue, New York, on October 7th, 1915, for the sale of paintings of the most advanced character of the Modern Art Movement, Negro Sculpture, pre-conquest Mexican Art, Photography. It is further announced that the work of '291' will be continued at '291' Fifth Avenue in the same spirit and manner as heretofore. The Modern Gallery is but an additional expression of '291'."[51] These descriptions reveal that de Zayas was trying to help Modigliani and Brancusi by offering their work for sale in the United States. This material also implies that Modigliani's art was considered to reflect "the most advanced character of the Modern Art Movement," for displaying such work was the mission of the gallery.

De Zayas explained his rationale for organizing the *Exhibition of Sculpture*: "In 1916 I arranged an exhibition of comparative sculpture: Brancusi, Modigliani, Mrs. A. Roosevelt, Alice Morgan Wright, Adolf Wolff, three Americans who had started modeling with modern tendencies. A few Negro sculptures were around to complete the comparativeness."[52] De Zayas explained that he liked to combine the work of several artists to suggest comparisons.[53] Evidently he saw a similar spirit in the work of these five artists. This is somewhat surprising given that the work of Brancusi and Modigliani was essentially figurative while Wolff's was architectural, and that of the two women artists was abstract. Perhaps it was the strong sense of originality that permeated all of the work, or the influence of African art that he felt they all shared. That same year, de Zayas published the book, *African Negro Art: Its Influence on Modern Art*, the theme of the exhibition. Referring to the two Europeans by last name only suggests that they were established entities, while the Americans, whose full names were used, were less known. The implication is that the Europeans Modigliani and Brancusi were the masters, while the Americans Roosevelt,[54] Wright,[55] and Wolff[56] were novices. While largely unknown today, these American artists produced work that was genuinely advanced and impressive. Roosevelt and Wright studied in Paris before World War I—Roosevelt with Duchamp-Villon and Wright at the Académie Colarossi—and may have known Modigliani.

Modigliani was not completely unknown in New York at the time of the exhibition. He had received mention in the final two issues of the magazine 291, published prior to the exhibition's opening. Affiliated with Stieglitz's 291 gallery, the monthly magazine was edited by de Zayas (and supported by Stieglitz, Paul Haviland, and Agnes Meyer) and "was dedicated to the most modern art

LUCIEN LEFEBVRE-FOINET, 19, Rue Vavin et 2, Rue Bréa. — PARIS

and satire."[57] The first mention indicated that "Mr. Modigliani is one of the rare painters of our generation whose synthetic studies have maintained a feeling for materials."[58] The second mention of Modigliani appeared in the next issue:[59] "We even noticed behind the scenes the suits of Modigliani—jacket with a pearl gray side over a pale green woman's vest; white satin tie; round hat; checkered shirt with blue and white squares; laced shoes in rough leather, this outfit will be the rage. Modigliani will be the mode(igliana)."[60] It suggested that Modigliani was a prominent person in the Parisian art scene at the time, a trendsetter even. The fact that these articles appeared in French underscores an international orientation of the magazine, as well as of Stieglitz's and de Zayas's gallery endeavors. The second issue of 291 was clearly intended by de Zayas to promote or complement the exhibition of sculpture at his Modern Gallery, for the issue reproduced a sculpture from the show, Roosevelt's *Tennis Player–Serving*. It also featured a reproduction of an African mask on the cover, which may have been in the exhibition, and an essay by de Zayas on the importance of African sculpture to modern art, an underlying theme of the exhibition. This issue of 291 must have served as a companion to the exhibition and was undoubtedly available there.

We know from de Zayas exactly how Modigliani's sculptures got from Paris to New York for the exhibition:

From the first exhibition at the Photo-Secession to the last one at the Modern Gallery, the packing and shipping of all the modern art works shown in these two galleries was made by the firm

(fig. 16) Lucien Lefebvre-Foinet owned this art supply store that occupied two addresses, at 19, rue Vavin and 2, rue Bréa, in the sixth arrondissement.

of Lucien Lefebvre Foinet, Paris. In time of peace, the packing and shipping presented no difficulties, but it was quite a different matter during the war, when all shipping space was needed for war materials and private transportation of freight was practically forbidden, yet Monsieur Lucien Lefebvre managed somehow or other to send boxes containing works of art from Paris to New York, and what was still more difficult from New York to Paris. The Modern Gallery could not have existed without the collaboration of Monsieur Lefebvre, whose business was not mainly packing and shipping but the manufacture of artists' materials.[61]

Located in the heart of Montparnasse at 2, rue Bréa, just off of Carrefour Vavin, Lefebvre-Foinet (fig. 16) was easily accessible to Modigliani. Indeed, he probably carried the sculptures over to the shop himself. Lefebvre-Foinet continued to be a Montparnasse institution and only recently closed its doors.[62]

The Modigliani works were shipped on November 1, 1915, as indicated by a "bor-

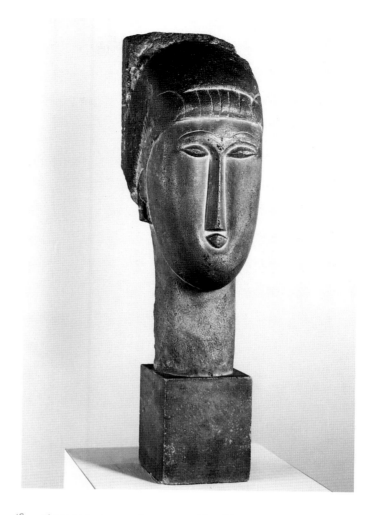

(fig. 17) Sculpture A, as seen in de Zayas's account

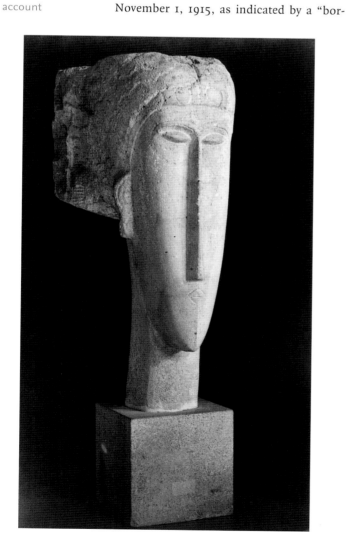

(fig. 18) MODIGLIANI. Head 1909–1914. Limestone, 25 ¼" (64 cm.) Collection Staatliche Kunsthalle, Karlsruhe, Germany

dereau rectificatif," or corrected invoice, on Guillaume's stationery. It notes in French the details of "a shipment made on this day to Mr. Marius de ZAYAS, Director of MODERN GALLERY, 500 Fifth Avenue, New York, under the care of Mr. LEFEBVRE-FOINET."[63] The invoice specified that twenty-four Modigliani works were sent on that day: twenty drawings priced at fifteen francs each, one pastel priced at twenty-five francs, one painting priced at fifty francs, and two original sculptures in stone priced at 200 francs each. Reviews of the exhibition do not refer to the two-dimensional works, and in all likelihood they were available in the gallery but not necessarily on view.

Identifying which specific Modigliani sculptures were exhibited has proven to be a complicated task. De Zayas's *How, When and Why Modern Art Came to New York* features the work referred to earlier as Sculpture A, and calls it simply *"head"* not *"figurehead"* (fig. 17). It may, however, simply have been a photo that de Zayas had in his archives and used as an illustration. Indeed, the sculp-

CABARET VOLTAIRE

EINE SAMMLUNG KÜNSTLERISCHER UND LITERARISCHER BEITRÄGE

VON

GUILLAUME APOLLINAIRE, HANS ARP, HUGO BALL, FRANCESCO CANGIULLO, BLAISE CENDRARS, EMMY HENNINGS, JACOB VAN HODDIS, RICHARD HUELSENBECK, MARCEL JANCO, WASSILIJ KANDINSKY, F. T. MARINETTI, L. MODEGLIANI, M. OPPENHEIMER, PABLO PICASSO, O. VAN REES, M. SLODKI, TRISTAN TZARA

HERAUSGEGEBEN VON HUGO BALL

CATALOGUE DE L'EXPOSITION CABARET VOLTAIRE
KATALOG DER AUSSTELLUNG CABARET VOLTAIRE

Hans Arp:	Zeichnung I (1914)	L. Modegliani:	Portrait Hans Arp II (Dessin)
	Zeichnung II (1914)	Eli Nadelmann:	Dessins I — IV
	Papierbild I (1916)	Max Oppenheimer:	Remboursement (Oel)
	Papierbild II (1916)	Pablo Picasso:	Eau-forte I
	Papierbild III (1916)		„ II
Paolo Buzzi:	L'Ellipse (Parole in libertà)		„ III
Francesco Canguillo:	Parole in libertà		„ IV
Corrado Govoni:	Parole in libertà	O. van Rees:	Landschaft I (Oel. 1913)
Marcel Janco:	Dessins I — V		Landschaft II (Oel. 1913)
	Décorative		Landschaft III (Tempera. 1913)
	Enterrement et voiture		Stilleben (Papierbild. 1916)
	Matrapazlāc	M. Slodki:	Affiche Cabaret Voltaire
	Mouvement (Peinture)		Dostojewski Holzschnitt
	Caracterul arhanghelilor		Tolstoi „
V. Kissling:	Paysage I		Interieur I „
	„ II.		Interieur II „
August Macke:	Landschaft (Aquarell)	Artur Segall:	Compositie.
F. T. Marinetti:	Dune (Parole in libertà)		Holzschnitte I — III
L. Modegliani:	Portrait Hans Arp I (Dessin)	Henry Wabel:	Landschaft (Oel)

ture by Wright featured in the de Zayas account, *Sculpture to be Touched*, does not correspond to the work in the 1916 exhibition, which was called *Wind Figure*. A similar anomaly exists with one of the Roosevelt sculptures as well.[64]

Fortunately, there are period photographs in the de Zayas archives featuring two Modigliani sculptures and Brancusi's *Prodigal Son* glued to the same page.[65] The Modigliani sculptures in these archival photographs are the ones now in the collections of the Kunsthalle in Karlsruhe, Germany (fig. 18) and the Philadelphia Museum of Art (cat. no. 44). These museums' files do not have material on the early provenance of those pieces. However, the provenance of Brancusi's *Prodigal Son*, now at the Philadelphia Museum of Art, indicates "With the Modern Gallery, New York, 1916."[66] In the photographs, the Karlsruhe sculpture is sitting atop a crate as if it were being prepared for shipment or being unpacked. These photos might have been taken by de Zayas as a record of their condition when they arrived or perhaps they were sent to him by Guillaume so that he could know what to expect. Either way, it is most likely that the Karlsruhe and Philadelphia sculptures are the ones that were exhibited at the Modern Gallery in New York in 1916.

The Modern Gallery's exhibition was reviewed, discussed, or mentioned in numerous periodicals. Generally, the critics—all anonymous—expressed bemused bewilderment. *The New York Times* reported on March 13, 1916, that Wright's *Wind Figure* was the most interesting in the group and that "Modigliani's two 'Figureheads' are very unequal, one having a monumental quality lacking in the other."[67] About the exhibition as a whole, the critic remarks, "Most of the work seems to the outsider transitional in character, but most of it seems also on the way to something, and that is more than can truly

be said of the larger part of the sculpture placed in exhibitions in whatever school it finds itself."[68] In other words, the reviewer found the work more interesting than most of the sculpture that he or she had come across.

(figs. 19 & 20) Cover and catalogue notes for the *Cabaret Voltaire* exhibition, published as a single-issue magazine, Zurich, 1916

The Christian Science Monitor in Boston noted on March 25 that the Modern Gallery was presenting an exhibition of "some of the latest evolutions in idealistic sculpture."[69] By idealistic, the critic may have meant non-naturalistic, a term that came up often in the press for describing modern art. The article noted further that, "Two 'Figureheads' by Modigliani would look well on the prow of some classic bark in architecture or on a monument," and that the exhibition would "repay study by the thoughtful seeker after artistic truth and beauty."[70]

The World reported on March 12 that the Modern Gallery's sculpture exhibition was "much in the style of previous ultra-modern productions in which this gallery specializes." The writer continued: "All the workers know the technique of their medium. Their cleverness in projecting sections of spheres and cubes from mass foundations and in rounding the curves of statuary so that unfinished figures seem ready to shape themselves and step out from block stone is a matter of wonder and excitement."[71] The last comment about stepping out from block stone undoubtedly applies to Modigliani's works, for he was the only one to contribute stone pieces (the others being made in wood, metal, and plaster). The reviewer considered the pieces to be unfinished, a comment often made about modern art in the press of the time.

The American Art News reported on March 11, 1916, that "Five exponents of 'modernism' in sculpture" were showing at the Modern

Gallery. However, the anonymous reviewer did not like what he or she saw: "The results of reductio ad elementium are sometimes interesting, but rarely convincing. Nature is left almost entirely out of the question, and art is certainly not held to have any relation with truth or beauty."[72] For this writer, naturalism represented "truth" and "beauty." He added that, "Modigliani shows a couple of odd figure heads."

The Brooklyn Daily Eagle reported on the exhibition on March 13, 1916: "At the Modern Gallery five sculptors of the newer school show pieces that exhibit their desire to make visitors use their imaginations in order to understand what meaning the creators of the works intend to convey."[73] After colorful comments on the other four artists, the article concludes by saying simply that, ". . . and by Modigliani are two 'Figureheads'."

It is not known whether the Modigliani sculptures were sold. In all likelihood, they were not and were sent back to Paris. De Zayas noted that sales at the Modern Gallery were negligible despite his best efforts.[74] The three principal buyers at the Modern Gallery were the American artist Arthur B. Davies, and collectors John Quinn and Walter Arensberg,[75] and none of them is known to have owned a Modigliani sculpture. On March 16, Guillaume sent a letter to de Zayas in which he inquires: "Are you thinking of doing something with the paintings, sculptures, drawings, etc . . . ? Here, [Giorgio de] CHIRICO and MODIGLIANI are now known and sell."[76] The letter implies that the sculptures had not yet been sold. Moreover, there were no Modigliani works listed in the 1921 inventory of the de Zayas gallery (successor to the Modern Gallery), suggesting that they were either sold or returned.[77] The provenance of the Karlsruhe and Philadelphia pieces are in keeping with this history and would suggest that the pieces were returned to Guillaume.[78]

Modigliani's next exhibition was also outside of France. It was a group exhibition in June 1916 at the Cabaret Voltaire in Zurich, home to that city's Dadaists.[79] The exhibition was simply called Cabaret Voltaire and its "catalogue" or handlist was published in the single-issue magazine called *Cabaret Voltaire: a collection of artistic and literary contributions* (fig. 19), dated May 15, 1916. According to the "catalogue" (fig. 20), in which his name is misspelled, Modigliani contributed two drawings to the exhibition: *Portrait of Hans Arp I* (see fig. 22 in "Modigliani and the Avant-Garde") and *Portrait of Hans Arp II. Portrait of Hans Arp I* was featured in the magazine itself with Modigliani listed as a contributor on the cover.

While sponsored by the Dadaists, the exhibition was not a Dada event. In addition to the Dadaists Jean (Hans) Arp and Marcel Janco, the exhibition included works by Modigliani, Kisling, Auguste

Macke, Nadelman, and Picasso, as well as F.T. Marinetti's visual poetry, *parole in libertà*. The magazine featured the drawing by Modigliani and contributions by Apollinaire, Blaise Cendrars, Wassily Kandinsky, and the Dadaists Hugo Ball, Emmy Hennings, Richard Huelsenbeck, and Tristan Tzara, among others. In his diary entry of June 4, 1916, Ball explained the magazine saying, "In [thirty] two pages it is the first synthesis of the modern schools of art and literature. The founders of expressionism, futurism, and cubism have contributions in it."[80] This description could apply to the exhibition as well, which sought to be as aesthetically broad as possible.

(fig. 21) Cover of the exhibition catalogue for L'Art Moderne en France held at the Salon d'Antin in Paris in 1916. The Museum of Modern Art Library, Special Collections, The Museum of Modern Art, New York. Photograph © 2002 The Museum of Modern Art, New York

Ball was careful to note in *Cabaret Voltaire* that the magazine was not nationalist in orientation but rather international: "To avoid a nationalist interpretation the editor of this magazine declares that he has no sympathy with the 'German mentality.'"[81] He further notes that the contributors came from all over Europe: France, Italy, Spain, Germany, Holland, Austria, Poland, and Russia. He points out

that there is even one person without a country, Hennings, meaning perhaps that she did not identify with her native Germany. Ball had referred to his cabaret in the introduction to the magazine as being an "international cabaret," underscoring that defining characteristic. The Dadaists were internationalists because they rightly believed that it was nationalism that led directly to the First World War. A preoccupation of artists working in pre-war Montparnasse, such as Modigliani, internationalism was indeed a central concern for this entire generation of artists.

In 1916, Modigliani's visibility increased when he was included in one of the most important exhibitions of the war years, *L'Art Moderne en France* (fig. 21). The exhibition took place in Paris from July 16 to 31 in the Salon d'Antin at 26, avenue d'Antin, in the mansion of the fashion designer Poiret (fig. 22).[82] It is possible that some of the Salon d'Antin exhibition was actually presented at the Galerie Barbazanges, which was also located on his premises.[83] This enormous exhibition, often referred to simply as the Salon d'Antin, featured 166 works by fifty-two artists of many different nationalities. In addition to Modigliani, who exhibited three portraits, the exhibition featured a "Who's Who" of the contemporary art scene: de Chirico, Derain, Kees van Dongen, Raoul Dufy, de la Fresnaye, Othon Friesz, Henri Hayden, Jacob, Kisling, Léger, André Lhôte, Marevna, Matisse, Chana Orloff, Mánuel Ortiz de Zarate, Picasso, Georges Rouault, Severini, and Marie Vassilieff, among others. As Severini later remarked, "Almost all of the avant-garde painters of a certain calibre took part in the exhibition."[84] The Salon d'Antin is also notable because it was in this exhibition that Picasso unveiled his groundbreaking work, *Les Demoiselles d'Avignon*, 1907. *L'Art Moderne en France* was organized by the writer and

(fig. 22) Paul Poiret's mansion at 26, avenue d'Antin housed the Salon d'Antin

Hos "Lyre et palette", hos madame Bangard och André Dérain.

Vernissage hos Lyre et palette.
(Den lille mannen i förgrunden är Picasso. Lutad mot hans axel står konsthandlaren Max Jacob och på hans andra sida, bakom honom, synes målaren Ortez.)

(Bref till Svenska Dagbladet.)
PARIS, januari.
En dag skyndade den moderne konstnären ned i metropolitainstationen vid Raspail, fick ett klipphål i biljetten af den kvinnliga konduktören, och pang!

tillbommade bric-à-brac-affärer komm[a] två cyklande poliser med revolvrar hängande på ryggen och kapuschongerna väl uppfällda, ty regnet börjar fall[a] tätt och genomträngande. Det är me[d] en känsla af varmt välbehag han slä[r] sig ned i kamratkretsen i det efterläng[...]

critic Salmon, and was sponsored by Poiret along with the important avant-garde journal *SIC* (Sons, Idées, Couleurs, Formes).[85] Like many avant-garde exhibitions during the war, it featured musical and literary events, allowing artists, composers, and writers to provide mutual support during this stressful time.[86] Hastings read from her unpublished novel "Minnie Pinnikin," based on her love affair with Modigliani.[87]

(fig. 23) Arvid Fougstedt's drawing of the opening of Lyre et Palette was published in 1917 in *Svenska Dagbladet* on page 4. Depicted on the wall are Picasso's *Guitar and Clarinet*, 1915 (center) and Matisse's *Still Life with Bowl*, 1914.

The exhibition received extensive press coverage. The *Cri de Paris*'s review titled "Cubistes" considered it to be a Cubist exhibition with some Fauves mixed in, and wrote that "The Cubists are not waiting for the war to end to recommence hostilities against good sense."[88] It refers to "Picasso, their leader." *Le Bonnet Rouge* called Modigliani's contributions "jokes."[89] Of all people, Michel Georges-Michel, future novelist and documentor of the Montparnasse circle, was critical of the exhibition in an article called "Mont-

parnasse Art," published in *L'Excelsior*.[90] The longest, most serious review was written by painter Roger Bissière who praised Salmon highly for organizing a coherent exhibition characterized by such uniformly high quality.[91]

Modigliani's next exhibition, the first exhibition of the Lyre et Palette society from November 19 to December 5, 1916, at the "Salle Huyghens," 6, rue Huyghens, near Carrefour Vavin, was a major event in his career. The society was devoted to presenting painting, poetry, and music side by side. Only five artists were featured—Kisling, Matisse, Modigliani, Ortiz de Zarate, and Picasso—and Modigliani had many more works on view than anyone else: fourteen paintings and an unspecified number of drawings. (By contrast, Matisse was represented by one drawing and Picasso by two paintings.)[92] The inclusion of works by Matisse and Picasso, the acknowledged leaders of the avant-garde, emphasizes Modigliani's stature at the time. This important wartime exhibition received extensive press coverage as far away as Stockholm and Frankfurt.[93] The opening itself was

(fig. 24) Cover of the first exhibition at Lyre et Palette, 6, rue Huyghens, in the fourteenth arrondissement in Paris, 1916

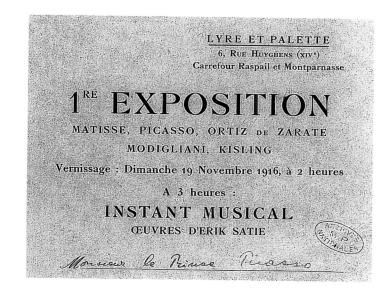

(fig. 25) Pablo Picasso's invitation to the first exhibition at Lyre et Palette, 6, rue Huyghens, in the fourteenth arrondissement in Paris, 1916

quite an event and was recorded in print and image by the Swedish artist Arvid Fougstedt (fig. 23).[94]

The presence of twenty-five African masks and sculptures in the exhibition, lent by Guillaume, helped make the exhibition a major event. According to the catalogue (fig. 24): "This will be the first time that negro sculptures and African and Oceanic fetishes are presented not for their ethnic or archeological value but instead for their artistic value." The catalogue also featured poems by Jean Cocteau and Cendrars dedicated to Erik Satie. The invitation indicates that the exhibition opened on November 19 with a "musical moment" by Satie (fig. 25), and the show was complemented by readings by such distinguished writers and poets as Apollinaire, Salmon, and Cocteau.

The exhibition was organized by the Swiss painter Emile Lejeune and took place in his studio, where he had already been organizing concerts. Lejeune later wrote a long series of articles about the Lyre et Palette, including this first exhibition, leaving us an invaluable record of what took place.[95] Lejeune commented that the years from 1914 to 1918 were a heroic period for Montparnasse's foreign artists who banded together, as Frenchmen either went home or off to war.[96] He said that Kisling was responsible for turning this group exhibition into essentially a one-person exhibition for Modigliani as a way to help his friend.[97] The titles of the works exhibited allow us to identify four of Modigliani's paintings: *La Jolie Ménagère* (fig. 26), *Madame Pompadour* (fig. 27), *Les Epoux Heureux* [also known as *Bride and Groom*] (fig. 28) and *Portrait of Kisling* (Ceroni 107).

Despite Picasso's meager representation at this exhibition, *Le Cri de Paris* referred to it as a "cubist opening" and made a remark about entering the "cubist salon."[98] With their muted palettes and faceting, however, the Modigliani paintings at the exhibition could easily be construed as cubist. A review in the December 1916 issue of *SIC* mentions the "completely interesting grouping that gives a good idea of modern painting and makes one feel very strongly how much the painters of today really are painters."[99] Critic Vauxcelles remarked that "I look with interest at the new style of Modigliani; he elongates the faces, stylizing them like Derain and Dahomian sculptures making interesting tonal relationships."[100]

Poet Paul Morand visited the Salle Huyghens on Sunday, November 26, for a poetry reading and recorded these observations in his journal:

> I dined on this rainy Sunday in Saint-Germain. Returned to Paris toward four in the afternoon. Went to a Montparnasse atelier, among the cubists, in Rue Huyghens. Three hundred people in a small hall; cubist paintings on the wall; Jean Cocteau, Madame [Eugenia] Errasuriz, Erik Satie, [Cipriano] Godebski, [José Maria] Sert, wearing large automobile capes, their velvet lapels drawn over their noses, as though muffling themselves in a place of ill repute. I see Apollinaire for the first time, in uniform, his head bandaged. The only really funny thing is the poetry of little Durand-Viel, who is five years old, recited by Jean Cocteau with a straight face and complete self-assurance. He is completely at ease in this milieu quite new to me. Verse by Cendrars, [Jean] Leroy, Max Jacob. At last I've seen Apollinaire.[101]

Morand's notes underscore the great popularity of the Salle Huyghens—300 people at this event alone—and that it was frequented by such significant figures as Errasuriz, Godebski, and Sert, all noted patrons of the arts. Cocteau read the poetry of his five year-old niece. The Lyre et Palette exhibition capped off the best year of Modigliani's entire career.

In May 1917, Modigliani participated in two exhibitions, demonstrating his continued popularity. One exhibition was at the Galerie Chéron, at 56, rue de la Boétie, in a chic section of Paris, from May 1 to 20, while the other was at the Galerie Dada at Bahnhofstrasse 19 in Zurich (fig. 29) from May 2 to 29.[102] Modigliani had painted two portraits of Georges Chéron, one of which is illustrated here (fig. 30);[103] it may have been in the exhibition. That same year Chéron signed a contract with Tsugouharu Foujita and became his

dealer, and may have been Modigliani's dealer briefly too.[104] Unfortunately, it is not known which works were exhibited at the Galerie Chéron and Galerie Dada.

Modigliani's new dealer, Léopold Zborowski, arranged his first one-person exhibition, *Exposition des Peintures et de dessins de Modigliani*, which took place in Paris from December 3 to 30, 1917.[105] Thirty-two paintings were presented and about thirty drawings (figs. 31 & 32).[106] Since Zborowski did not have his own gallery space yet, the exhibition took place at the Galerie Berthe Weill at

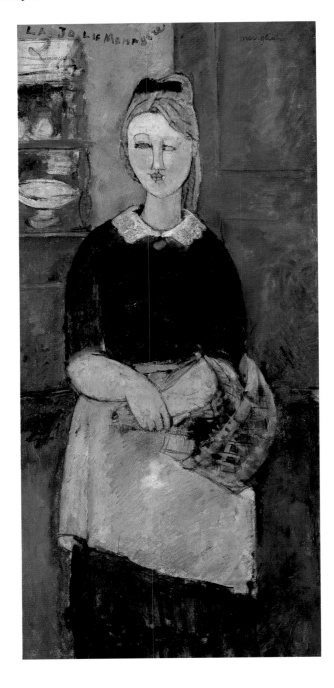

(fig. 26) MODIGLIANI. *La Jolie Ménagère*. 1915. Oil on canvas, 43 3/8 x 19 3/4" (110 x 50 cm.). Collection The Barnes Foundation

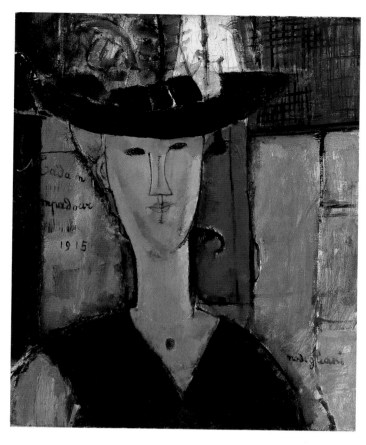

(fig. 27) MODIGLIANI. *Madame Pompadour*. 1915. Oil on canvas, 23⅞ x 19½" (60.6 x 49.5 cm.). Collection The Art Institute of Chicago. The Joseph Winterbotham Collection, 1938.217. Photograph © 2002 The Art Institute of Chicago, All Rights Reserved

50, rue Taitbout near the Hôtel Drouôt in the ninth arrondissement, a commercial district. The exhibition brochure featured a poem by Cendrars entitled "Sur un portrait de Modigliani" (fig. 32).

This exhibition is the source of a great deal of legend about Modigliani. Sixteen years later, Berthe Weill gave a confused account of the exhibition and its opening that has led even Modigliani's biographer Pierre Sichel to believe that it closed on the day it opened.[107] Weill noted that she was ordered to remove a nude from the window, because it depicted pubic hair, and that she removed the nudes inside as well. She said that "all the paintings" were taken down, which can either be read as "all the nudes" or literally "all the paintings." She also said that she closed the gallery that day. She never wrote, however, that she closed the exhibition. Writing soon after the exhibition took place, the critic Francis Carco asserted that the exhibition continued despite the disturbance.[108]

Carco's was the only article devoted solely to Modigliani during his lifetime. Published in *L'Éventail* a year and a half after the exhi-

bition took place, Carco's article is essentially a review of the ill-fated one-person exhibition and of Modigliani's art in general.[109] Written before Modigliani's untimely death and, hence before a romantic myth developed around him, this article is one of the purest, most sensitive, and insightful pieces of writing ever penned about the artist and his work by someone close to him. Carco calls most art "a meticulous copy" and writes that Modigliani has moved away from naturalism towards an art that is more poetic, graceful, and expressive. He gives special praise to Modigliani's drawings and his abilities as a draughtsman. The article reproduces three paintings by Modigliani: *Blonde Nude* (Ceroni 193), *Portrait of a Young Woman* (fig. 33), and *Seated Woman Resting on Arm* (Ceroni 111).

Modigliani's great run of exhibitions soon came to an abrupt halt as he left Paris in April 1918 for fourteen months to live on the Riviera. Three factors led to this decision: Germany's "Big Bertha" cannons were pounding Paris, his lover Jeanne Hébuterne was pregnant with their child, and his health was getting worse.[110] Modigliani was featured in a brief but significant exhibition during that time period, a nine-day display

(fig. 28) MODIGLIANI. *Bride and Groom*. 1915–16. Oil on canvas, 21¾ x 18¼" (55.3 x 46.4 cm.) Courtesy Landau Fine Art Inc., Montreal, Canada

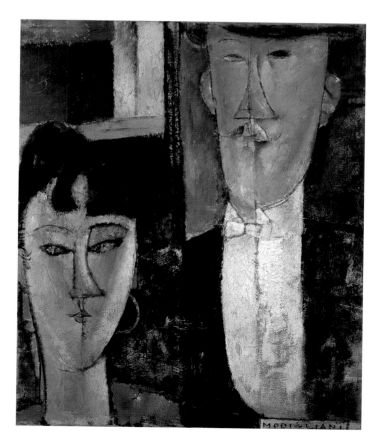

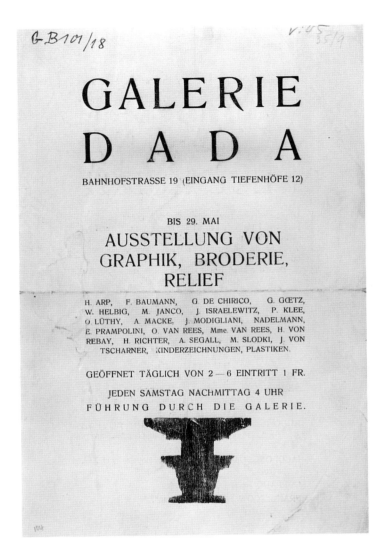

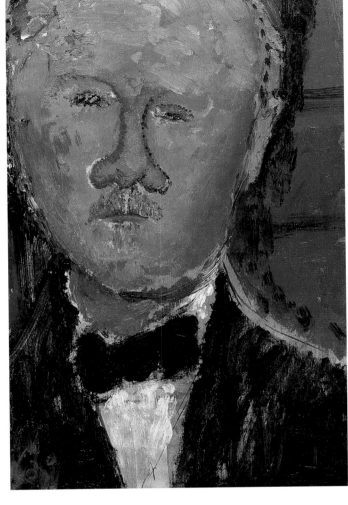

called *Peintres d'Aujourd'hui* at the Galerie Paul Guillaume, 108, Faubourg Saint-Honoré from December 15 to 23, 1918. Despite its short run, this exhibition was a major artistic event. Among those at the opening were the leading Parisian writers, collectors, dealers, and artists: Allard, Georges Bernheim, Jacques-Emile Blanche, Jacques Doucet, Louise Faure Favier, Gustave Fuss-Amoré, André Gide, Natalie Gontcharova, Joseph Hessel, Albert Marquet, Georges Menier, Picasso, Poiret, the Princess of Polignac, Salmon, Gertrude Stein, and Vauxcelles.[111]

The exhibition was reviewed or mentioned in more than fifteen newspapers, including *The New York Herald*.[112] J.-G. Lemoine wrote in *L'Intransigeant* that: "While the tendencies of Henri Matisse, Picasso, André Derain, Roger de la Fresnaye, Modigliani, [de] Chirico, [Maurice] Utrillo, [Maurice] de Vlaminck are fairly different, they are quite representative of the effort of one part of the current genera-

(fig. 29) Cover of the *Ausstellung von Graphik, Broderie, Relief* held at the Galerie Dada in Zurich in 1917. Collection Kunsthaus Zürich, Dada-Archiv

tion who search to free themselves from reality to reach, and keep only, the true characteristics contained within."[113] In *Aux Écoutes*, an anonymous writer reported: "But Mr. Paul Guillaume has above all in his pictorial stable—if one can speak that way—two favorite ponies. One is Mr. Modigliani, an Italian of the Batignolles; and the other, Georgio [sic] de Chirico, a Spanish [sic] Montparnassian. Modigliani is a repentant humorist (like Juan Gris and Jacques Villon) who cubified his paintings for a while, so as to not single himself out, and now deforms, stretches and elongates his faces, under the double influence of maori fetishes and André Derain."[114] Bissière wrote in *Paris-Midi* that: "Paul Guillaume recently brought together in his gallery about forty paintings by Misters Matisse, Picasso, Derain, Chirico, de Vlaminck, de la Fresnaye, Modigliani, Utrillo. It was a good choice and it would be nice to see on a regular basis in this place works of such importance. That would have the primary

(fig. 30) MODIGLIANI. *Portrait of Monsieur Chéron* (detail). 1915. Oil on canvas, 18⅛ x 13" (60.6 x 49.5 cm.). Private Collection

advantage of keeping people who had only experienced poor, secondary works from speaking incorrectly about modern painting."[115]

The handlist to accompany this exhibition was printed in the third issue of Guillaume's newsletter *Les Arts à Paris*, which appeared on the day the exhibition opened (fig. 34). At least two of the four Modigliani paintings appear to be works that he already had in stock, having already been represented in the Lyre et Palette exhibition (*La Jolie Ménagère* and *Madame Pompadour*). Indeed, he may have pulled the entire exhibition from his holdings.

Salmon leaves a precious record of how Modigliani was viewed at the time: "Mr. Paul Guillaume, not at all intimidated by the injunctions of Mme. Rachilde, and who does not believe that his *Les Arts à Paris* duplicates the eclectic and liberal *Mercure de France*, has just organized a fairly complete exhibition of his gallery regulars: Giorgio de Chirico, André Derain, Roger de la Fresnaye, Henri Matisse, Modigliani, Picasso, Utrillo, de

(fig. 31) Cover of the catalogue for Modigliani's exhibition of paintings and drawings at the Galerie B. Weill, Paris, December 3–30, 1917

Galerie B. Weill
50 rue Taitbout Paris (9me)

EXPOSITION
des
PEINTURES
et des
DESSINS
de
Modigliani.
du 3 décembre au 30 décembre 1917.
(Tous les jours sauf les dimaniches)

Vlaminck. Eight names that speak to his incredible importance."[116] Modigliani was seen ever more as being an equal of Picasso and Matisse, and indeed one of the most important artists of his generation, a view that gained prominence at the Lyre et Palette exhibition.

Modigliani's last exhibition outside Paris, during his lifetime, took place in London from August to early September 1919 at Heal & Son's Mansard Gallery on Tottenham Court Road. Called an *Exhibition of French Art, 1914–1919*, it was generally considered to be the most important exhibition of vanguard art in London since Fry's two exhibitions of Post-Impressionist art at the Grafton Gallery in 1910 and 1912–1913. It was an enormous exhibition featuring 318 works (158 paintings, 19 sculptures, and 141 drawings) by thirty-nine artists, making it quite an event. Among the artists featured with Modigliani were Archipenko, Derain, Marthe Tour Donas (a protégée of Archipenko), Dufy, Alice Halicka, Hayden, Kisling, Léger, Lhôte, Louis Marcoussis, Matisse, Picasso, Morgan Russell, Suzanne Valadon, Vassilieff, Ossip Zadkine, and many others.

With fifty-nine works (nine paintings and fifty drawings), Modigliani was the best-represented artist in the exhibition. Some or all of the Modigliani drawings were available in "an enormous wicker basket...from which the visitor could choose a specimen for a shilling."[117] He received especially high praise by Arnold Bennett who wrote in the catalogue (fig. 35), "But I am determined to say that the four [sic] figure subjects of Modigliani seem to me to have a suspicious resemblance to masterpieces."[118] According to Bennett, the exhibition was intended to give English artists and the public a taste of the "younger pioneers" from the continent to keep his countrymen from being too insular.

Heal and Son was and still is a department store devoted to home furnishings, operating out of the same location on Tottenham Court Road since 1818.[119] Heal's opened the art gallery in 1917 and called it the Mansard Gallery apparently because of its location on the top floor of the store, under a sloping mansard roof (fig. 36). Its location was intended no doubt to lure customers to the top floors of the store. Invitations to Mansard Gallery exhibitions were typically sent to all of Heal's customers, sometimes as many as 35,000.[120] A beautiful color poster advertised this exhibition throughout London (fig. 37), giving the dates as August 9 to September 6 (the catalogue noted simply August).[121] Further, the Mansard Gallery's archives reveal that 550 posters, 4,000 circulars, and 1,300 catalogues were printed for this exhibition.[122] The catalogues came close to selling out with a total of 1,131 sold. There

Sur un portrait
de
Modigliani

Le monde intérieur
Le cœur humain avec
ses 17 mouvements
dans l'esprit
Et le vaetvient de la
passion

Blaise Cendrars.

1 La dame au grands yeux
2 Portrait du poète L
3 La femme qui crie
4 La petite Lucienne
5 Portrait de Madame L
6 Le garçon rouge
7 Indiana
8 Portrait du comte W
9 L'éther
10 Marghareta
11 L'apache n° 1
12 L'innocente
13 La femme dormante
14 Portrait de femme dormante
15 Alice
16 Eve
17 Nu
18 Nu
19 L'italienne
20 La femme en blouse marine
21 Amaisa
22 Portrait de femme
23 Portrait de mademoiselle H
24 Portrait du poète L
25 La femme aux mains croisées
26 Femme aux roses rouges
27 Portrait de femme
28 Pierre
29 L'apache n° 2
30 Nu
31 Nu
32 Portrait de femme

were roughly 24,530 visitors, with an average of 613 visitors per day, much higher than for other Mansard Gallery exhibitions that year (fig. 38). Clearly, this was a major event. Eighteen works were sold from the exhibition, though titles and artist names are not listed in the account books.

(fig. 32) List of works in the 1917 Galerie B. Weill exhibition

While the public reaction seemed mixed, the critical reaction was very favorable,[123] with photographs of Modigliani's paintings "appearing now nearly every day in the press."[124] English theorist, critic, and painter Roger Fry wrote a long, thoughtful, and enthusiastic two-part review in The Athenaeum saying that "Nothing like such a representative show of modern French art has been seen in London for many years."[125] He proceeded to give his insights on modernism and the struggle between naturalism and cubism. While he mentioned Modigliani briefly at the end of the first part of the article—"and such a show of de Vlaminck and Modigliani as has never before been seen in England."—he reserved the bulk of his comments on the artist for the second part of the article:

Two younger artists are seen here adequately represented. One, Modigliani, has never been shown in England before, though his drawings have been for some years coveted by English collectors. It is still pre-eminently as a draughtsman that he shows himself in his paintings. His attitude to relief is still that of a sculptor and a draughtsman. This does not mean that his colour is not good; on the contrary, precisely because he regards it merely as a medium for amplifying his plastic linear design the problem is simplified. His method is the opposite of Cézanne's and of most of those who derive from him. For Cézanne all form was revealed by the oppositions and assimilations of coloured planes; for Modigliani the form exists apart, and is merely clothed with colour. Thus he tends to model each object in a tone of local colour. His flesh is all flesh colour, lighter or darker according to the planes, but never changed into some other colour. What prevents his colour from being drab and monotonous is precisely what prevents his tone from being too mechanically exact, namely, a strong feeling—again a sculptor's feeling—for surface quality. He hates any dead uniformity of surface. His almost exaggerated sensibility plays around every particle of the surface with infinite, almost imperceptible, variations of handling and minute gradations of colour. His work varies very much; some of the portrait heads seem too thin in quality and almost schematic in design. On the other hand, in one of the nudes his attitude is almost too literal, as though a literal vision had been reduced by a purely intellectual process to a preconceived linear rhythm. But the large nude where he has taken over the theme of Giorgione's "Venus" is sensitive throughout and of great beauty. Modigliani is still, I think, a finer draughtsman than he is painter, but there is no denying his aptitude for developing a kind of pictorial-sculptural idea of form—a method, by the bye, which was common enough among the painters of the Renaissance.[126]

Interestingly, it is the graphic element of Modigliani's art that appeals to him most.

Clive Bell was generally positive about Modigliani and had almost identical views about the artist being above all a draughtsman:

Behind the chiefs [Matisse, Picasso, Derain, Bonnard] come a group of first-rate painters, several of whom are well represented in this exhibition. The collection of Modiglianis is the best that I have ever seen. Modigliani will never be a great painter, but he is a very good one. To begin with, he is not a painter at all; he is a draughtsman who colours his drawings. Indeed, it is in his pencil drawings that he is seen to the greatest advantage. Evidently Modigliani is admirably aware of his own limitations. Never does he set himself a task beyond his powers. Unfortunately, that means that he never sets himself the sort of problem from which comes the greatest art. He exploits his slightly literary sensibility with infinite tact, and, as his sensibility is great, there is not much risk of becoming a bore. But, when one notices how much he has been influenced by Picasso and Derain one notices, too,

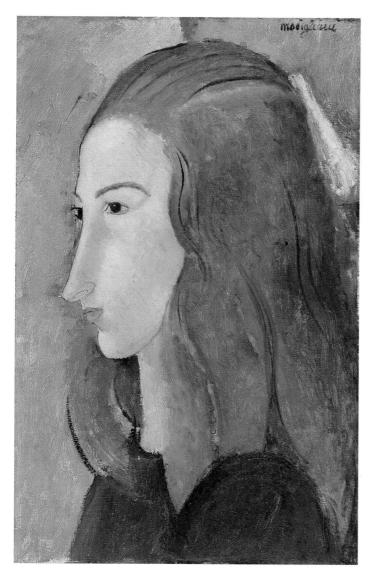

duces the painting *The Little Peasant*, which was in the exhibition and is now in the Tate collection (cat. no. 34). During Modigliani's lifetime, significantly more was written in England about his art than anywhere else.

The exhibition was organized by Osbert and Sacheverell Sitwell, two brothers who were English writers and aristocrats (fig. 39). It had been planned by them starting the previous winter, as Osbert chronicled in his autobiography.[129] Sacheverell had been in Paris the winter before and recounted to Osbert his great excitement about seeing all the modern pictures there. "He had been especially impressed by the work of Picasso and of Modigliani and had made arrangements for an exhibition in London the following summer by the various modern masters of Paris. He had also purchased a fine drawing by Modigliani, and brought this with him."[130] It is possible that he saw the *Peintres d'Aujourd'hui* exhibition at the Galerie Paul Guillaume in late December that featured Modigliani or, at least, saw the artist's works in Guillaume's gallery. The exhibition was arranged by the Sitwell brothers through Zborowski, and the three of them super-

(fig. 34) Works in Paul Guillaume's exhibition *Peintres d'Aujourd'hui*, held at his gallery at 108, rue du Faubourg Saint-Honoré, Paris, December 15 to 23, 1918. This handlist was reproduced as an advertisement in *Les Arts à Paris*, no. 3.

(fig. 33) MODIGLIANI. *Portrait of a Young Woman.* c. 1918. Oil on canvas, 18 x 11" (45.7 x 27.9 cm.) Collection Yale University Art Gallery. Bequest of Mrs. Kate Lancaster Brewster

how impossible it is that he should ever be a match for either of them.[127]

Once again, Modigliani is seen as a Cubist, someone who was influenced by Picasso. It is also notable that Bell remarks on Modigliani's "literary sensibility" given the artist's love of literature. For this reviewer and other writers, being literary seemed to mean being imaginative and anti-naturalistic. The reviewer for *The Burlington Magazine*, "M.S.P.," expressed great excitement about Modigliani's art saying: "The two painters whose work will probably be the greatest surprises are Modigliani and Maurice de Vlaminck. Modigliani's uncommon feeling for character finds expression through an extreme simplification of colour and con-

EXPOSITION

PEINTRES D'AUJOURD'HUI

du 15 au 23 Décembre 1918
à la Galerie Paul Guillaume, 108, faubourg Saint-Honoré, Paris.

Présenter quelques œuvres choisies des plus marquants parmi les peintres d'aujourd'hui, c'est tout ce que prétend cette exposition. C'est une affirmation pondérée qui répond dignement aux attaques auxquelles les détracteurs de l'art moderne français s'évertuent en ce moment.

LISTE DES ŒUVRES

HENRI MATISSE.
1. — Les Anémones.
2. — Les Coloquintes.
3. — Femme au Manteau beige.
4. — Le Pot de fleurs.
PICASSO.
5. — Pierrot blanc.
6. — Tête.
7. — Figure.
ANDRÉ DERAIN.
8. — La Cène.
9. — Le Cheval rouge.
10. — Fleurs dans un vase.
11. — Bas-relief sculpté.
G. DE CHIRICO.
12. — La Nostalgie de l'Infini.
13. — Le Retour du Poète.
14. — Le Rêve transformé.
15. — La Méditation automnale.

MAURICE DE VLAMINCK.
16. — Le Bourg dans la vallée.
17. — Les Maisons à Chatou.
18. — Nature-morte.
19. — Paysage d'hiver.
ROGER DE LA FRESNAYE.
20. — Bonheur conjugal.
21. — Nature-morte mappemonde.
22. — Nature-morte orange.
23. — Dessin fusain-aquarelle.
MODIGLIANI.
24. — Femme au voile.
25. — La jolie Ménagère.
26. — Madame Pompadour.
27. — Béatrice.
UTRILLO.
28. — Château en Corse.
29. — Vieille rue de Montmartre.
30. — La Caserne.

CATALOGUE
OF
EXHIBITION
OF
FRENCH ART
1914—1919

Marked.

Collected & organised by Osbert & Sacheverell Sitwell.

With Preface by
ARNOLD BENNETT

MANSARD GALLERY
TOTTENHAM COURT RD.
W.

August 1919

the artist had always wanted to be a sculptor, and only the cost of the materials prevented it."[133] The Sitwells were able to acquire a Modigliani painting at this time: "I was not in a position to buy so many of these canvases as I should have wished, but at least my brother and I were able to acquire a magnificent example—for the Parisian dealers who owned the majority of Modigliani's work in the exhibition suggested, knowing of our great admiration of this artist, that, as a reward for our services, we might like to select a single picture and pay them what it had cost them. Accordingly, we chose his superb 'Peasant Girl'; for which we paid four pounds, the average gallery price for a painting by him being then between thirty and a hundred pounds."[134]

There was not a painting on the exhibition checklist called *Peasant Girl*, so it must have been known under a different title (or perhaps was not in the show). Sitwell later described her as ". . . monumental, posed forever in a misty blue world . . . a wry-necked peasant girl of northern France, with her fair hair, sharp, slanting nose, and narrow eyes . . . hands clasped."[135] He added that she was related by blood to Breughel's peasant girls. There is really only one Modigliani painting that fits this detailed description—fair-haired peasant, hands clasped, misty blue world—and it is *La Belle Epicère* (Ceroni 256). The "Parisian dealers" of Modigliani's work to which he refers were, of course, Zborowski and Guillaume.

The Sitwells were not the only Englishmen to acquire a Modigliani at this time, as Osbert noted: "We were fortunate enough to sell a good many pictures on the opening day. Arnold Bennett bought

(fig. 35) Cover of the Mansard Gallery's Exhibition of French Art catalogue, August 1919

(fig. 36) Heal's Mansard Gallery, 1919

vised the hanging of the exhibition in the Mansard Gallery.[131] Evidently, Fry was there as well to observe.[132]

Osbert Sitwell noted in his memoirs that Modigliani made an especially favorable impact on English critics, as the reviews above indicate. Interestingly, Sitwell refers to Modigliani in his memoirs as "a newcomer," in spite of his previous appearance in London and successes in Paris: "Rather than the great established names, and familiar masters, it was the newcomers, such artists as Modigliani and Utrillo, who made the sensation in this show. And my brother and I can claim the honor of having been the first to introduce Modigliani's pictures to the English public. It had been possible before to understand the beauty of his drawings: but the paintings offered a new, and a greater revolution. The nudes, especially the reclining figure derived from Giorgione and Titian, manifested an astonishing feeling for the quality of oil paint: a technical mastery and exploitation strange in itself, because

on my advice a splendid nude by Modigliani, and to someone else who consulted me, I recommended another fine picture by the same master, and a Utrillo. For these two, he paid a sum of about seventy pounds . . ."[136] It appears that Bennett also acquired a portrait of Lunia Czechowska, probably the *Portrait of Madame C* listed in the catalogue. In her memoirs, Czechowska reported that: "Zb[orowski] sent the following telegram: 'Lunia sold for 1,000 francs; bought by Arnold Bennett.' Zbo told us upon his return that Bennet[t] already knew Modigliani's work and admired it enormously. He particularly liked the portraits, he said, because the sitter reminds him of the heroine in his novels."[137] She added that this painting obtained the highest price and that Modigliani had the most success of all of Zborowski's artists in the London exhibition. Thus, it appears that no fewer than four Modigliani paintings entered English collections during the artist's lifetime.

The Sitwells liked Modigliani's art so much that they were in negotiation to buy 100 or more of his paintings in the fall of 1919, but that plan did not reach fruition because the Sitwells could not arrange financing.[138]

In the fall of 1919, interest in Modigliani's work continued in England as two British arts journals reproduced his drawings. The autumn 1919 issue of *Art and Letters*, a journal edited by Osbert Sitwell, featured Modigliani's *Woman's Head*.[139] That issue also contained drawings by Gaudier-Brzeska, Lewis, John Nash, and Paul Nash, and poetry by Osbert Sitwell and their sister Edith Sitwell, as well as criticism by T.S. Eliot. Other issues of this journal contained drawings by Hamnett, Matisse, Picasso, and Severini, and articles by Aldous Huxley, Douglas Goldring (future Modigliani biographer who later wrote under the name Charles Douglas), and Pound. The December 1919 issue of the journal *Coterie* featured a Modigliani drawing of Paul Delay. That issue also featured drawings by Turnbull, John Flanagan, and Edward Wadsworth, and an article by Goldring. It is highly likely that *Woman's Head* and *Paul Delay* were two of the fifty Modigliani drawings exhibited at the Mansard Gallery.

An event occurred during the exhibition that shocked the Sitwell brothers for what it said about Zborowski's character. During the exhibition, Modigliani suffered a serious relapse in health, and it looked as if he were going to die. As Osbert described the situation: ". . . a telegram came for Zborowski from his Parisian colleagues to inform him [of Modigliani's worsening health]; the message ended with a suggestion that he should hold up all sales until the outcome of the painter's illness was known. My brother, who was inexpressibly shocked at this example of businessmen's callousness, showed me the cable, and Zborowski asked us personally to refuse to sell, if a possible purchaser should appear."[140] Zborowski was waiting to see if Modigliani died, in which case he would have immediately raised Modigliani's prices. (One wonders if Guillaume was the one who sent him the telegram.) "As it happened, Modigliani did not immediately comply with the program drawn up for him. He appeared to have regained strength, and did not die before the following year," Sitwell noted. Sitwell remarked that within a short time of Modigliani's death, however, Zborowski was wearing a fur coat and living the good life.[141]

Modigliani's art was known in England prior to the Mansard Gallery exhibition, having already been seen in 1914 at the Whitechapel Art Gallery. Moreover, his work was discussed and reproduced in a February 1919 article by Fry on drawing in the pages of *The Burlington Magazine*. The section on Modigliani is worth quoting in its entirety because it expresses eloquently Britain's early and enthusiastic appreciation of the artist:

> In Modigliani's drawings [PLATES I and II] we see the tendencies of the new movement in Paris, and here once more there is no doubt that the structural is the predominant element. Modigliani has been mainly a sculptor, as one might guess from the mode, in which every form has been reduced, as it were, to a common denominator. His notion of plasticity appears here as uniform and unvaried. All relief has for him the same geometrical section, and his effect is got by the arrangement of a number of essentially similar units. But two qualities save Modigliani from the dryness and deadness which might result from so deliberately mathematical a conception of the nature of form. One is the delicate sensibility which he shows in the statements of this simplified form, so that in spite of its apparent uniformity it has none of the deadness of an abstract intellectual concept. The beautiful variety and play of his surfaces is one of the remarkable things about Modigliani's art, and shows that his sculptor's sense of formal unity is crossed with a painter's feelings for surfaces. The other saving grace that Modigliani has is the sense of movement and life which comes from the arrangement of his plastic units. In the portrait drawing [PLATE II] one sees him accepting far more from the actual vision, allowing much more variety in the forms with which he composes, but striving none the less to get out of the actual forms as clear and simple a common element as possible.

(fig. 37) The poster for the Exhibition of French Art at Heal & Son, Ltd, 1919

Such a drawing is clearly more spontaneous and less profoundly elaborated than Picasso's portrait of Massine [PLATE (Dec. 1918)], but it belongs to the same category. It too shows the results of the modern effort to get to fundamental principles, to purge art of all that is accessory and adventitious.

Appearing five months before Carco's elegy, Fry's statement was the first lengthy discussion of Modigliani's art in print and assumes, therefore, major importance. Accompanying the article are reproductions of two Modigliani works: a watercolor and pastel color drawing of a caryatid and a pencil drawing of *Mlle. G.*

Modigliani's final lifetime exhibition was, fittingly, at the same place as his first: the Salon d'Automne in Paris. He exhibited four paintings there in 1919: a nude, two paintings of girls, and a portrait of a man. Modigliani's participation caught the attention of the Dada journal *Littérature*, which alerted readers to his presence in the show. It made note of the many avant-garde artists who did not exhibit and added: "Did exhibit: MM. Picabia, Vlaminck, Matisse, Modigliani, Gleizes and Zadkine."[142] In the Dada journal *391*, Georges Ribemont-Des-

(fig. 38) The advertisement for the Mansard Gallery's exhibition appeared throughout London, 1919

(fig. 39) Osbert Sitwell, 1919

saignes poked fun at Matisse and Modigliani's contributions to the Salon saying that Matisse makes "old funny faces" and that the work of Modigliani and others "is never anything but boiled beef."[143] After Modigliani died, *American Art News* reported in his obituary that Modigliani exhibited works in the recent Salon d'Automne that were "very free, solid and not outré [excessive or exaggerated]."[144]

Modigliani exhibited internationally in Paris, Zurich, London, and New York alongside Cubists, Dadaists, Futurists, and Vorticists, and all the leading artists of his day. He received significant dealer and collector attention both at home and abroad. During his lifetime, he was also mentioned in leading art and scholarly journals including *291, 391, Blast, Littérature, L'Éventail, L'Élan, SIC, Les Arts à Paris, Cabaret Voltaire, Coterie, Art and Letters, The Burlington Magazine,* and *American Art News,* not to mention international newspapers including *The New York Times.* His art was written about or commented on by the leading critics of his day including Apollinaire, Bell, Carco, Fry, Gaudier-Brzeska, Jacob, and Vauxcelles. These critics, and others, allow us to see his art as it appeared to them: fresh, Cubist, anti-naturalistic, imaginative, literary, and graphic. Modigliani did not die unknown and unappreciated.

AN EXHIBITION OF
FRENCH ART
1914-1919
Works by

ARCHIPENKO	OTHON-FRIESZ
DERAIN	PICASSO
FAVORY	MORGAN-RUSSELL
L'HOTE	UTRILLO
KROG	VALADON
KISLING	VLAMINCK
MATISSE	WASSILIEVNA
MODIGLIANI	ZADKINE

AUG. 9 to SEPT. 6, in the
MANSARD GALLERY
AT HEAL & SON LTD
195 TOTTENHAM COURT RD., W.

10 A.M. TO 6 P.M., INCLUDING SATURDAYS
ADMISSION 1/3

This is the first Exhibition of modern French painting
to be held in England since the outbreak of War

WORKS IN THE EXHIBITION

"Ceroni" refers to the numbers assigned to paintings and sculptures by Modigliani in Ambrogio Ceroni, *I dipinti di Modigliani*. Introduction by Leone Piccioni. Milan: Rizzoli, 1970; French edition, *Tout l'Oeuvre Peint de Modigliani*. Introduction by Françoise Cachin. Translated by Simone Darses. Paris: Flammarion, 1972.

"Guillaume" refers to works that are not documented in Ceroni yet do appear in the gallery photo albums of Paul Guillaume, Modigliani's dealer. While the photo albums are in a private collection, a duplicate set of the images is located at the Musée de l'Orangerie in Paris, which houses the Paul Guillaume Collection.

Because of the absence of a definitive reference source on Modigliani drawings, they do not appear here with reference numbers.

Measurements are given in inches, height preceding width and depth, followed by dimensions given in centimeters within parentheses.

WORKS BY AMEDEO MODIGLIANI

PAINTINGS

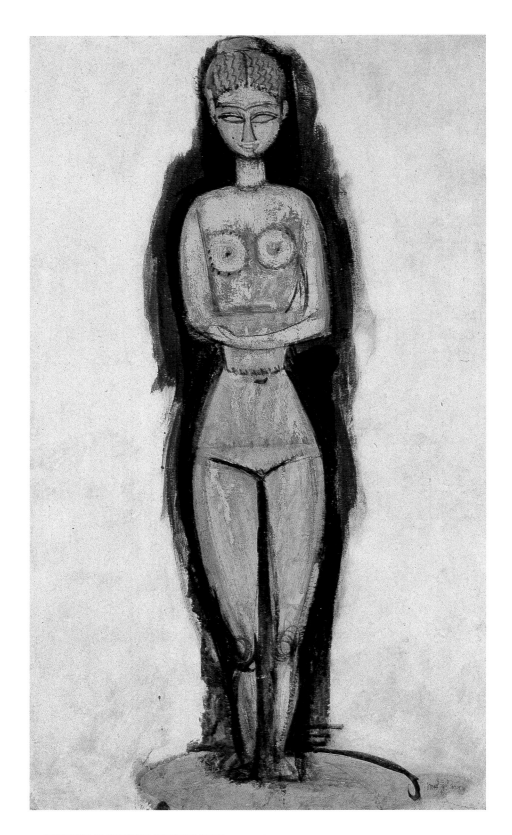

1. STANDING NUDE WITH CROSSED ARMS, 1911–12
oil on cardboard
32 ⅝ x 18 ⅞ (82.8 x 47.9)
Collection Nagoya City Art Museum, Japan
© Nagoya City Art Museum
Ceroni 34

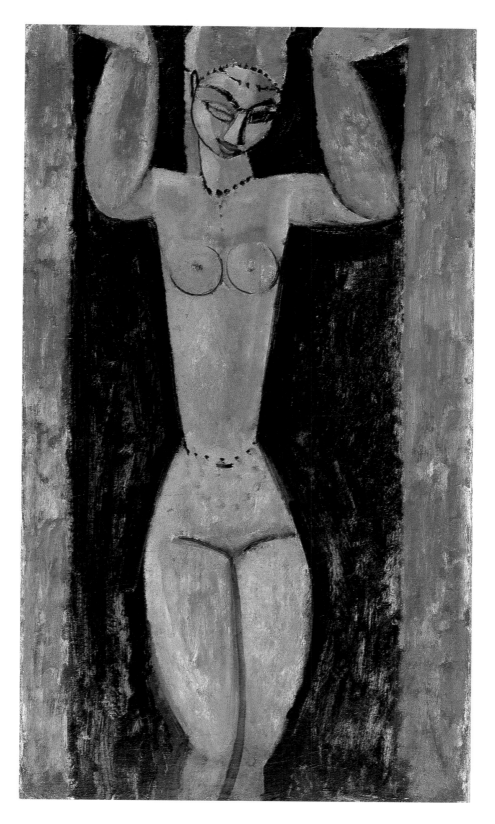

2. CARYATID, 1911–13
oil on canvas
32 ¼ x 18 ⅛ (82 x 46)
Collection Aichi Prefectural Museum of Art, Nagoya, Japan
Ceroni 36

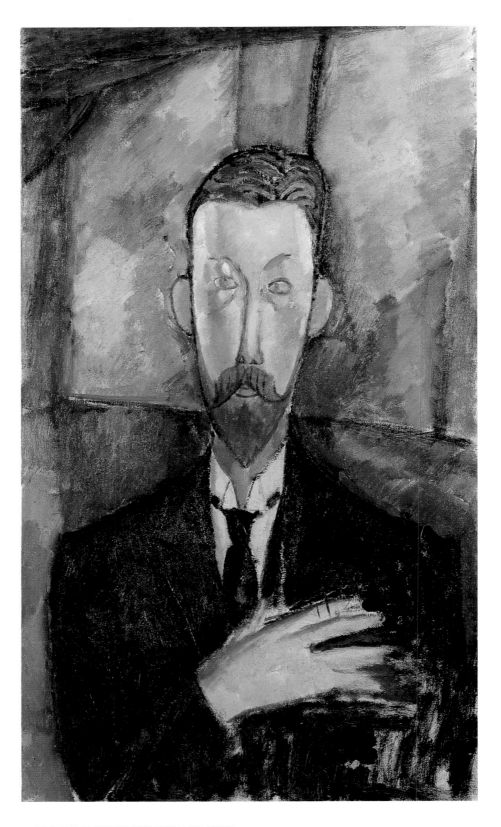

3. PAUL ALEXANDRE IN FRONT OF A WINDOW, 1913
oil on canvas
31 7/8 x 18 (81 x 45.6)
Collection Musée des Beaux-Arts, Rouen, France
Gift of Blaise and Phillipe Alexandre, 1988
Ceroni 40

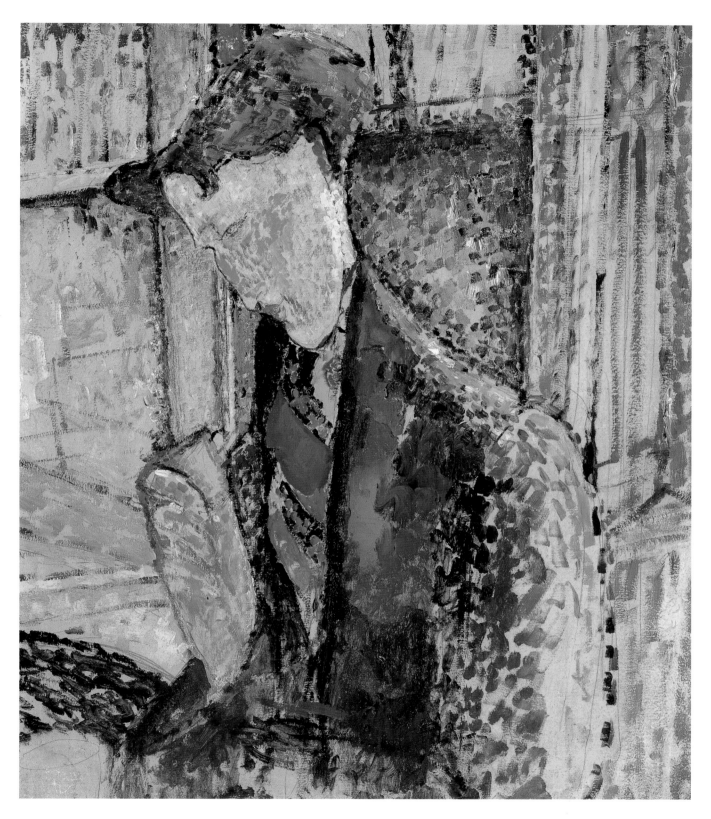

4. REVERIE (STUDY FOR THE PORTRAIT OF FRANK HAVILAND), 1914
oil on cardboard
24 ½ x 19 ½ (62.2 x 49.5)
Collection Los Angeles County Museum of Art, California
Mr. and Mrs. William Preston Harrison Collection
Ceroni 43

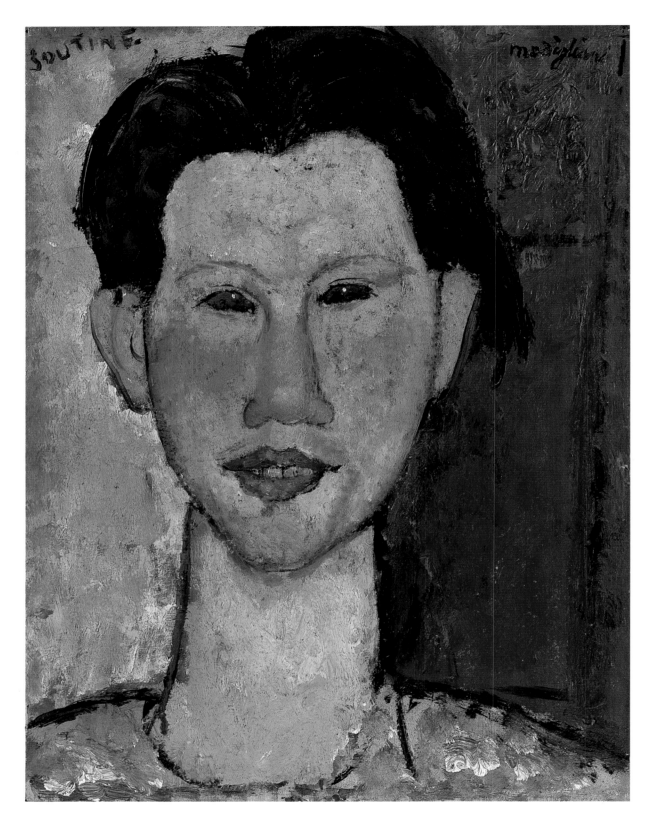

82

5. PORTRAIT OF CHAÏM SOUTINE, 1915
oil on wood
14 1/8 x 10 13/16 (36 x 27.5)
Collection Staatsgalerie Stuttgart, Germany
Ceroni 97

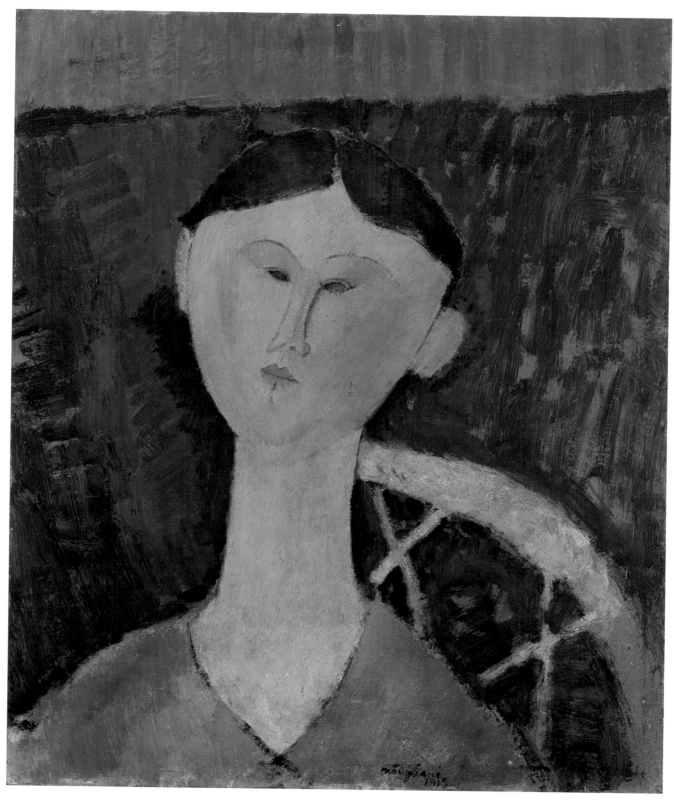

6. PORTRAIT OF MRS. HASTINGS, 1915
oil on cardboard
21 ⅞ x 17 ⅞ (55.5 x 45.4)
Collection Art Gallery of Ontario, Toronto
Gift of Sam and Ayala Zacks, 1970
Ceroni 79
Buffalo only

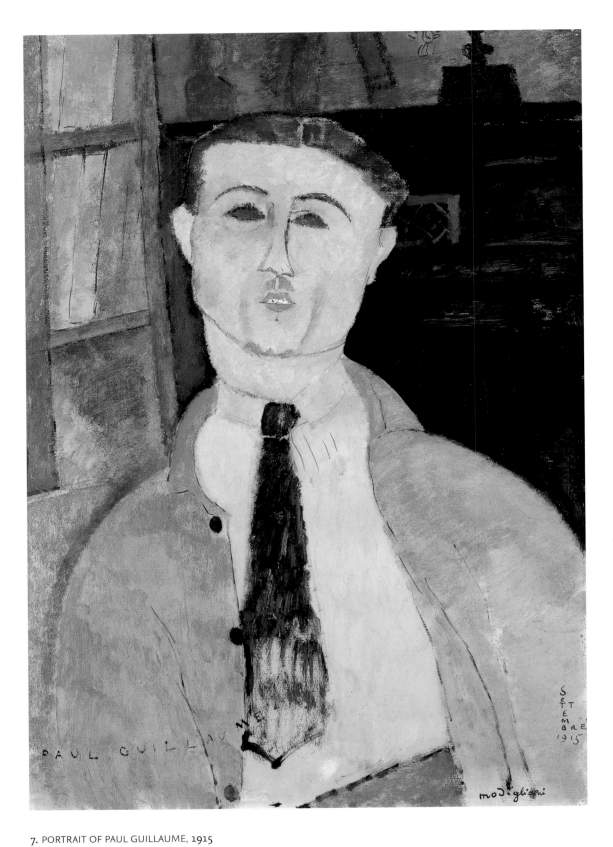

84

7. PORTRAIT OF PAUL GUILLAUME, 1915
oil on board
29 ½ x 20 ½ (74.9 x 52.1)
Collection Toledo Museum of Art, Ohio
Gift of Mrs. C. Lockhart McKelvy
Ceroni 101

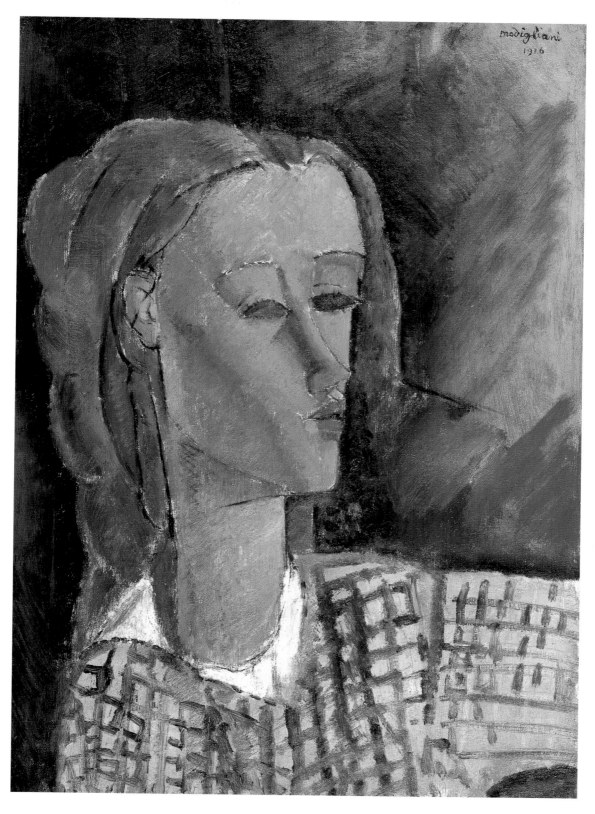

8. BEATRICE HASTINGS IN CHECKERED SHIRT, 1916
oil on canvas
25 9/16 x 18 1/8 (64.8 x 46)
The Whitehead Collection
Courtesy Achim Moeller Fine Art, New York
Ceroni 109

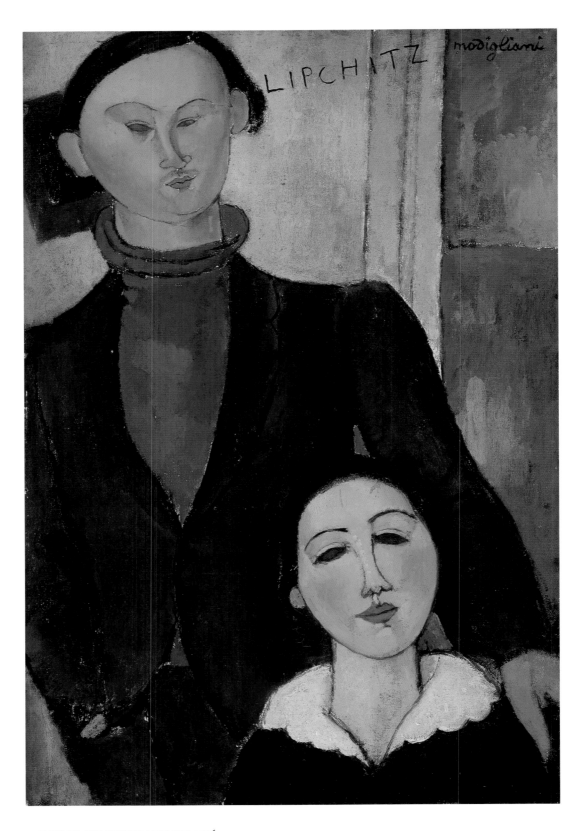

9. JACQUES AND BERTHE LIPCHITZ, 1916
oil on canvas
31 ¾ x 24 ¼ (80.7 x 54)
Collection The Art Institute of Chicago, Illinois
Helen Birch Bartlett Memorial Collection
Ceroni 161

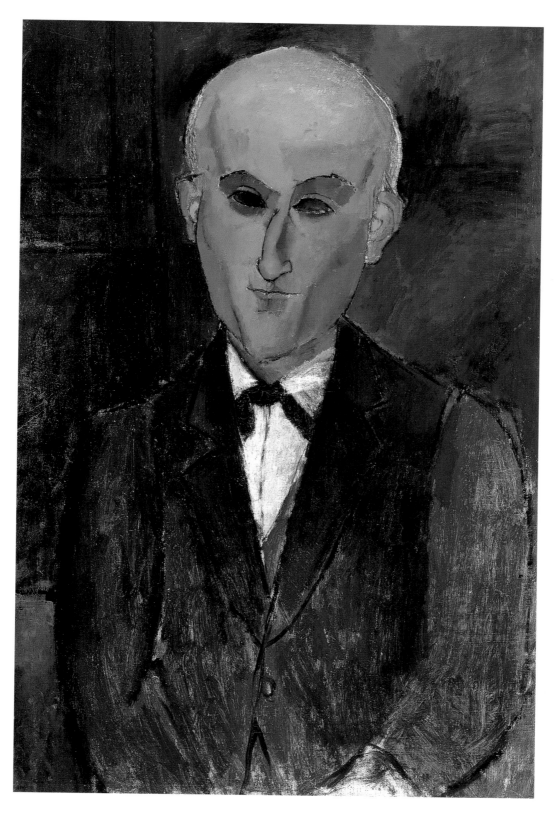

10. PORTRAIT OF MAX JACOB, 1916
oil on canvas
36 ½ x 23 ¾ (92.7 x 60.3)
Collection Cincinnati Art Museum, Ohio
Gift of Mary E. Johnston
Ceroni 105

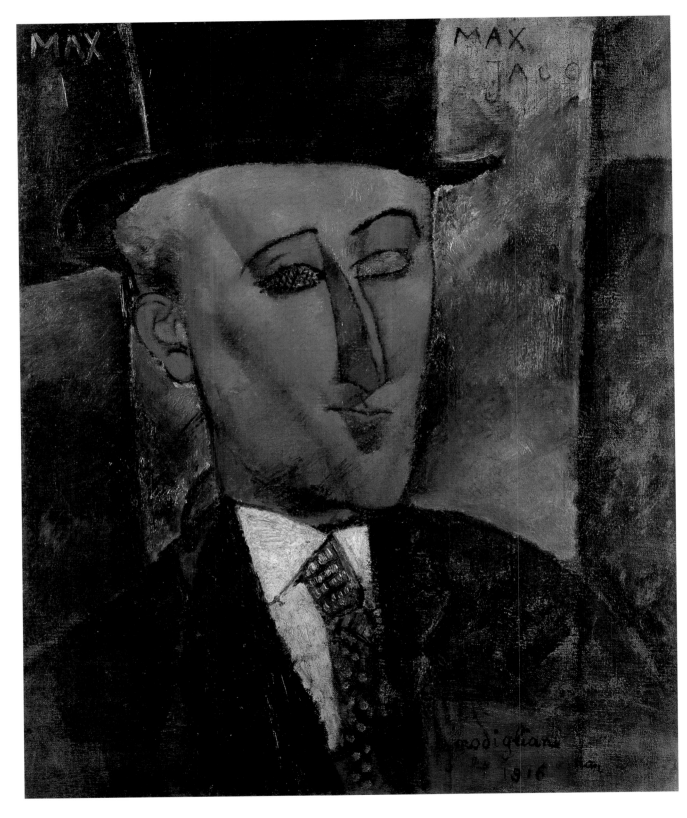

11. PORTRAIT OF MAX JACOB, 1916
oil on canvas
28 ¾ x 23 ⅝ (73 x 60)
Collection Kunstsammlung Nordrhein-Westfalen, Dusseldorf, Germany
Inv. No. 1036
Ceroni 104

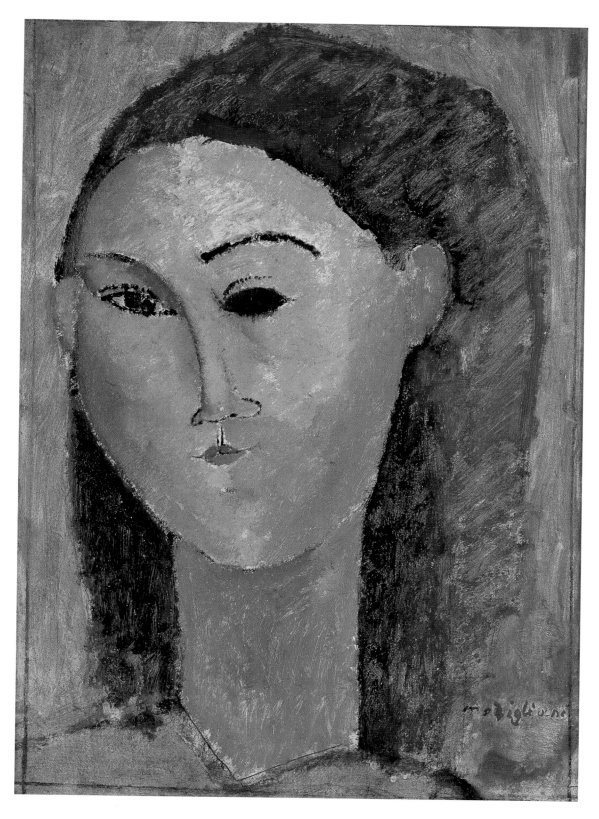

12. PORTRAIT OF A YOUNG GIRL, 1916
oil on canvas
18 ¾ x 13 (47.6 x 33)
Collection Neuberger Museum of Art, Purchase College, State University of New York
Gift from the Dina and Alexander E. Racolin Collection
Guillaume

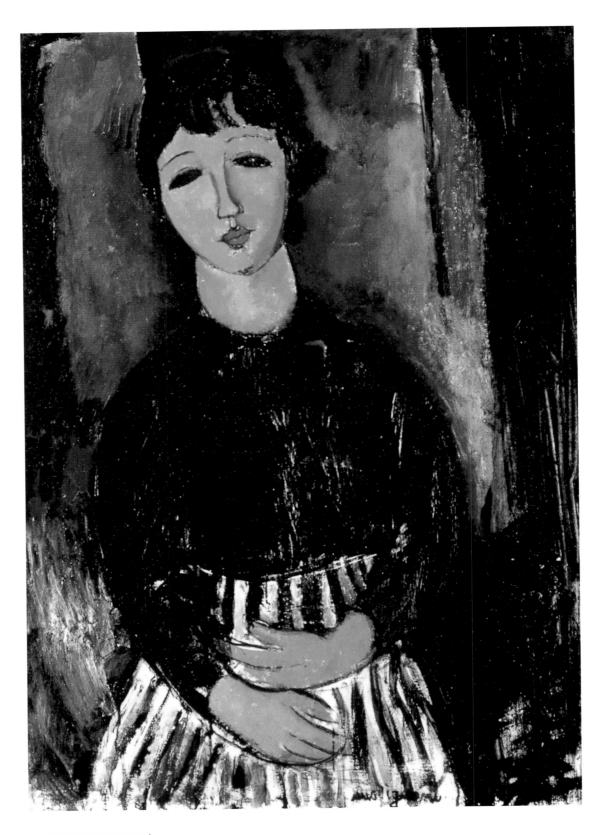

13. SEATED SERVANT, 1916
oil on canvas
36 ¼ x 25 ½ (92 x 65)
Private Collection
Ceroni 123

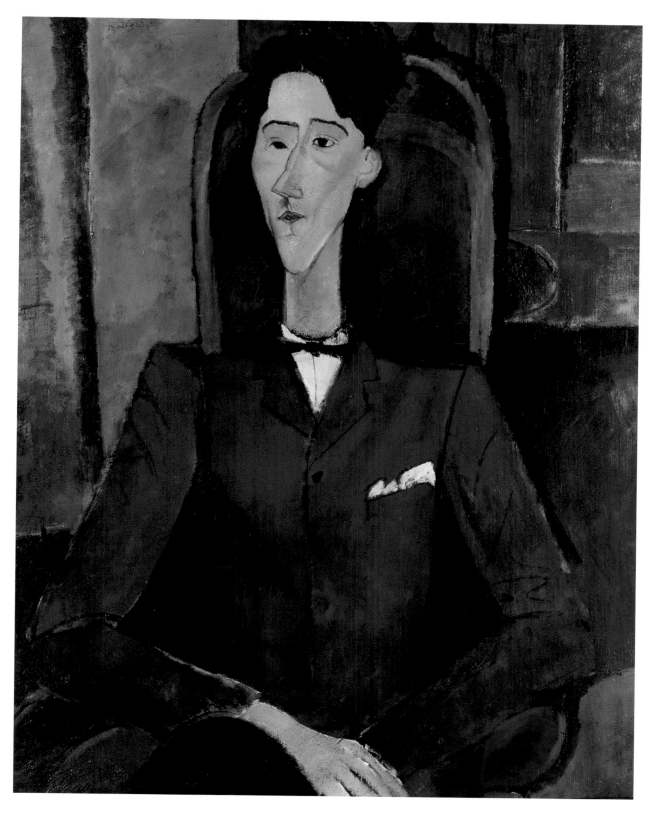

14. JEAN COCTEAU, 1916–17
oil on canvas
39 ½ x 32 (100.3 x 81.3)
Collection The Henry and Rose Pearlman Foundation, Inc.
Ceroni 106

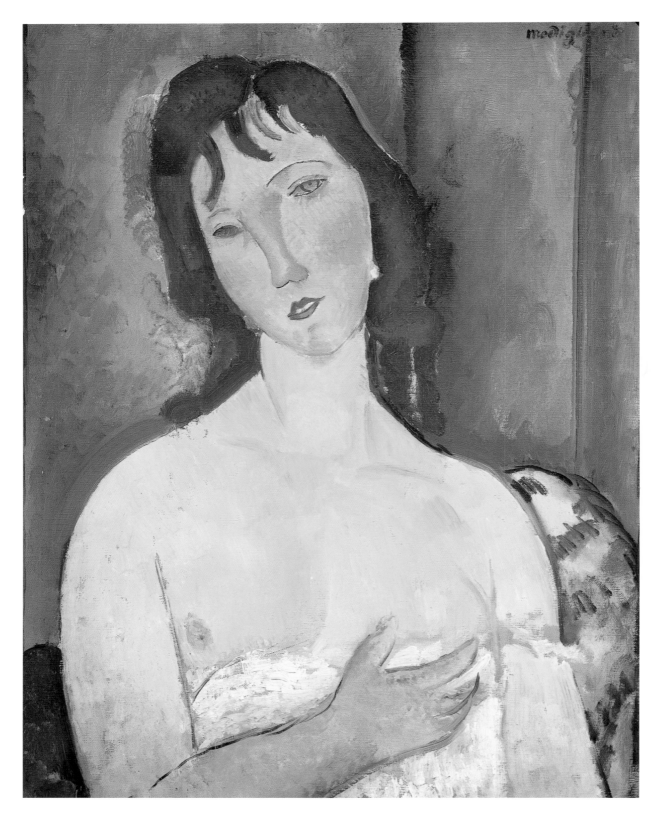

15. PORTRAIT OF A YOUNG WOMAN, 1916—19
oil on canvas
25 ½ x 19 ¾ (64.8 x 50.2)
Collection Dallas Museum of Art, Texas
Gift of the Meadows Foundation Incorporated
Guillaume

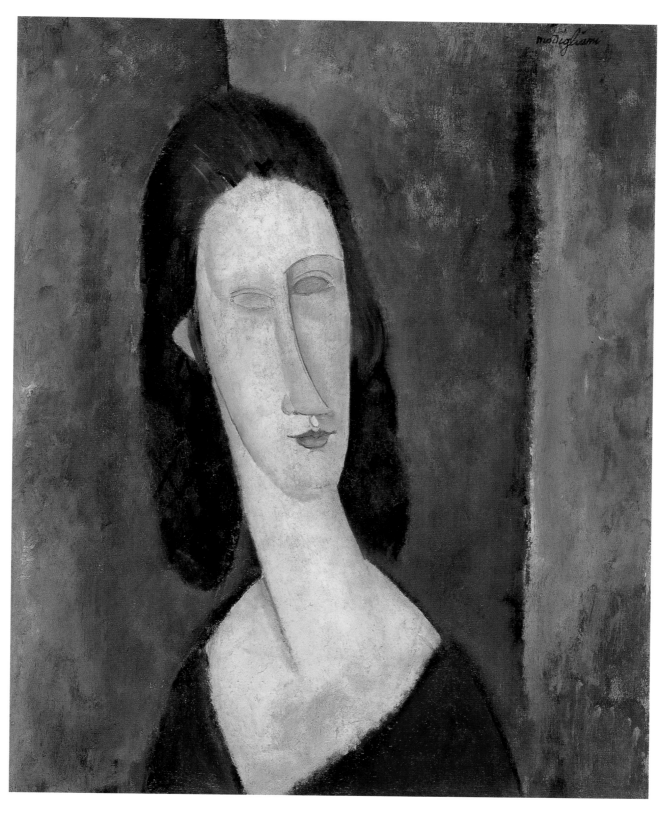

16. BLUE EYES (PORTRAIT OF MADAME JEANNE HÉBUTERNE), 1917
oil on canvas
21 ½ x 16 ⅞ (54.6 x 42.9)
Collection Philadelphia Museum of Art, Pennsylvania
The Samuel S. White 3rd and Vera White Collection
1967-30-59
Ceroni 181

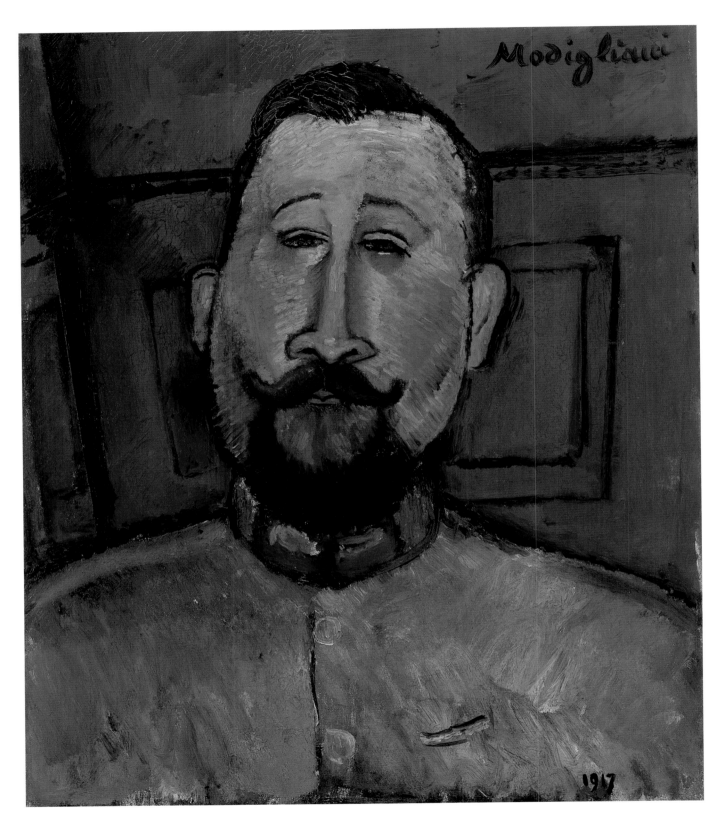

94

17. DOCTOR DEVARAIGNE, 1917
oil on canvas
22 x 18 ½ (55.9 x 47)
Alice Warder Garrett Collection, The Evergreen House Foundation and
The Johns Hopkins University, Baltimore, Maryland
Ceroni 182

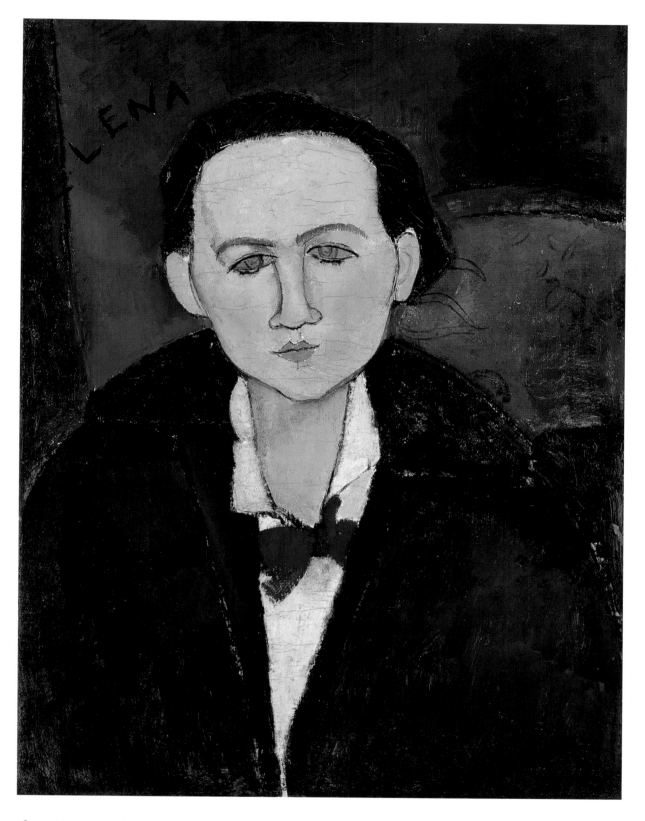

18. ELENA POVOLOZKY, 1917
oil on canvas
25 ½ x 19 ⅛ (64.8 x 48.6)
The Phillips Collection, Washington, D.C.
Ceroni 168
Buffalo and Fort Worth only

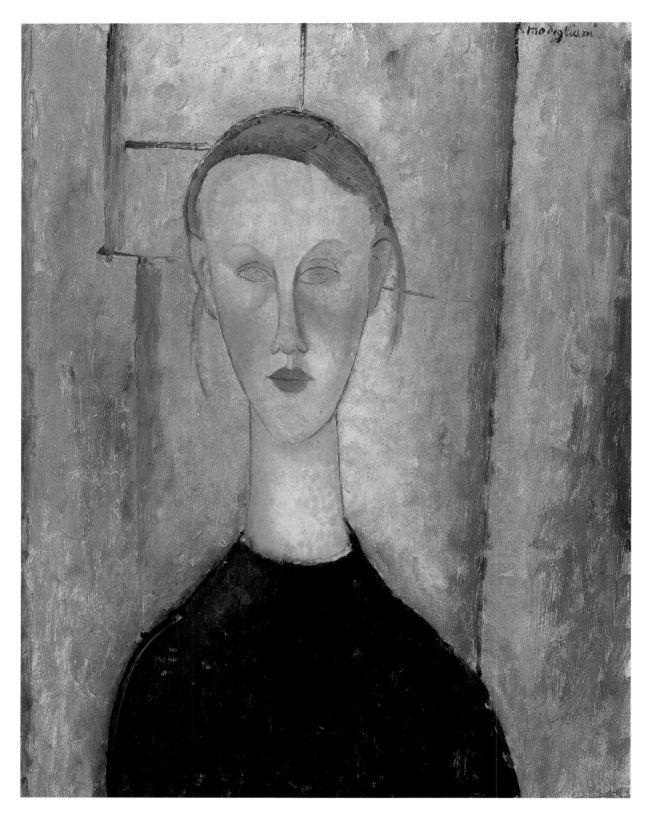

19. GIRL WITH BLUE EYES, 1917
oil on canvas
24 x 18 ¼ (61 x 46.4)
Collection McNay Art Museum, San Antonio, Texas
Bequest of Marion Koogler McNay
Guillaume

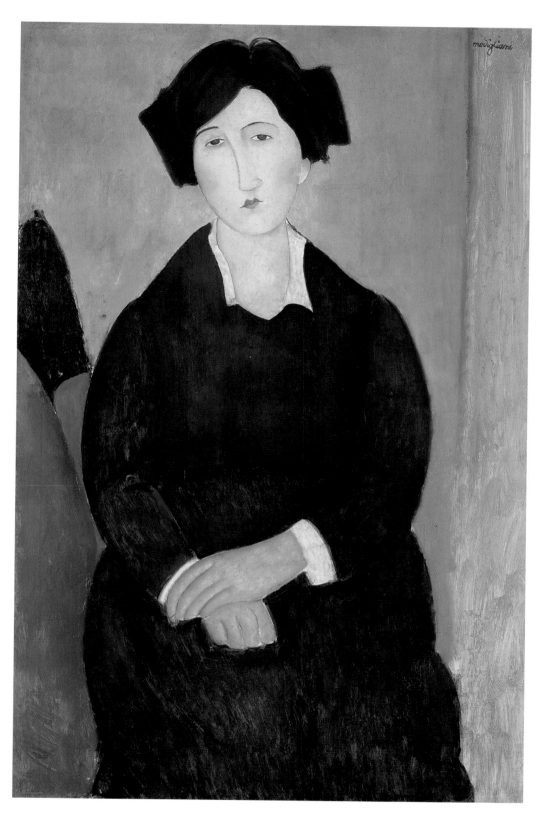

20. THE ITALIAN WOMAN, 1917
oil on canvas
40 ⅜ x 26 ⅜ (102.6 x 67)
Collection The Metropolitan Museum of Art, New York
Gift of The Chester Dale Collection, 1956
Ceroni 268

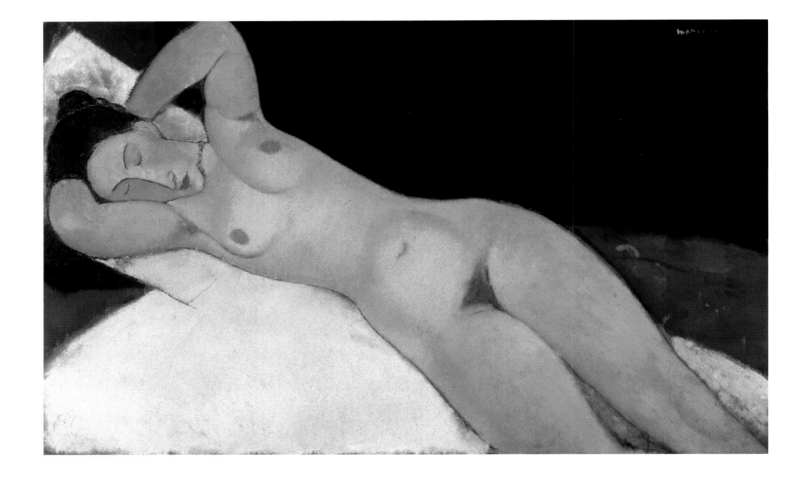

21. NUDE, 1917
oil on canvas
28 ¾ x 45 ⅞ (73 x 116.7)
Collection Solomon R. Guggenheim Museum, New York
Gift, Solomon R. Guggenheim, 1941 (41.535)
Ceroni 186

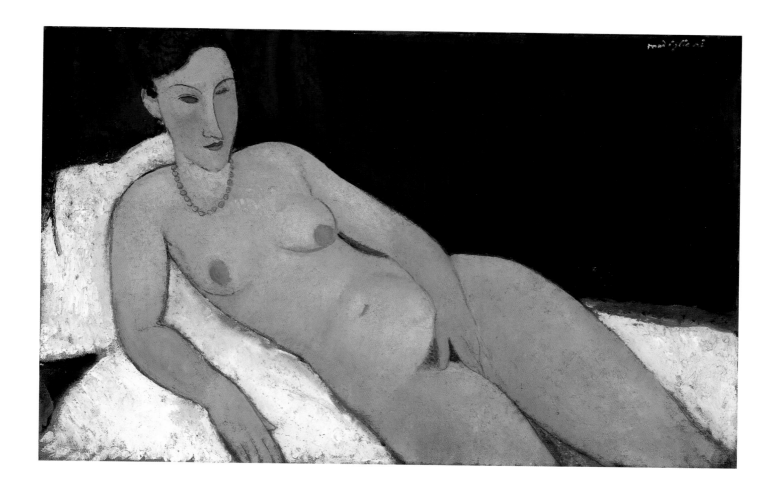

22. NUDE WITH CORAL NECKLACE, **1917**
oil on canvas
25 ³/₈ x 39 ¹/₈ (65.4 x 99.4)
Collection Allen Memorial Art Museum, Oberlin College, Ohio
Gift of Joseph and Enid Bissett, 1955
Ceroni 185
Los Angeles only

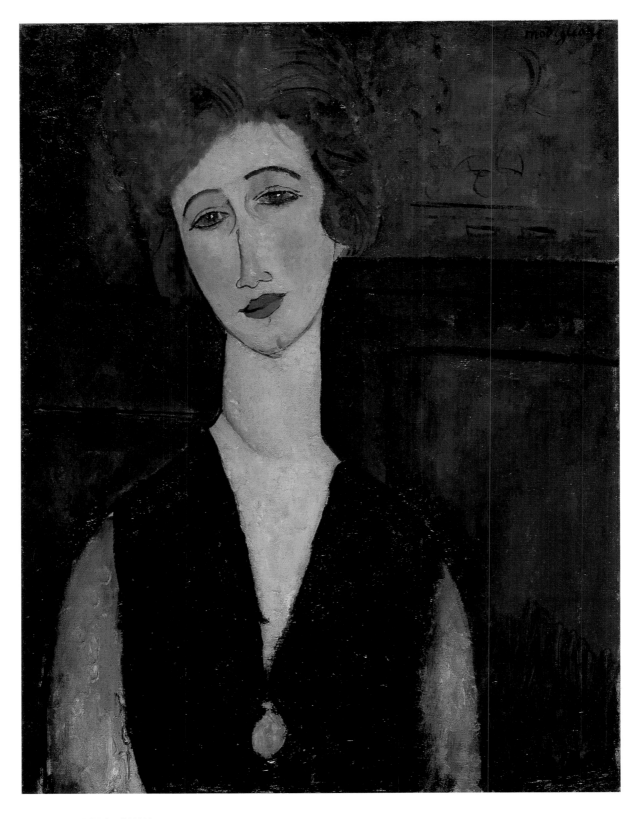

23. PORTRAIT OF A WOMAN, C. 1917
oil on canvas
25 9/16 x 19 (65.1 x 48.3)
Collection The Cleveland Museum of Art, Ohio
Gift of the Hanna Fund 1951.358
Guillaume

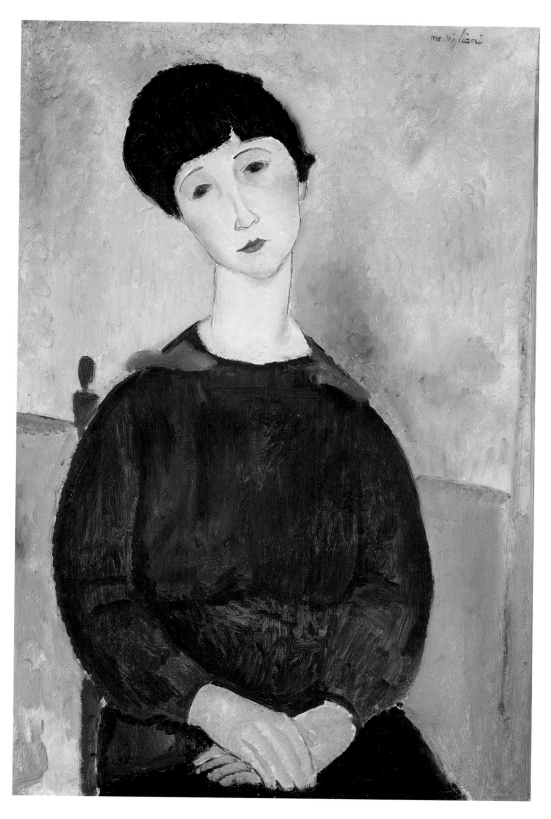

24. BLACK HAIR (YOUNG SEATED GIRL WITH BROWN HAIR), 1918
oil on canvas
36 ¼ x 23 ⅜ (92 x 59.5)
Collection Musée Picasso, Paris
Donation Picasso, RF 1973–11
Ceroni 234

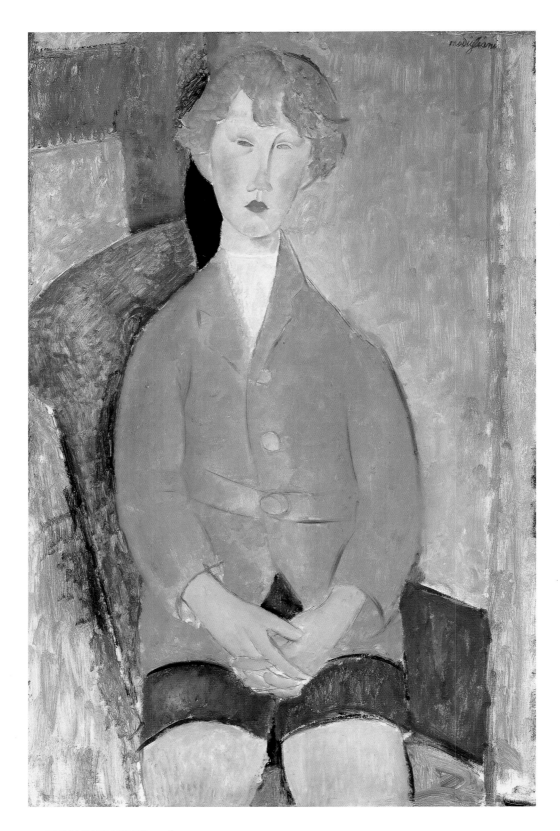

25. BOY IN SHORT PANTS, 1918
oil on canvas
39 ½ x 25 ½ (100.3 x 64.8)
Collection Dallas Museum of Art, Texas
Gift of the Leland Fikes Foundation, Inc.
Ceroni 255
Buffalo and Fort Worth only

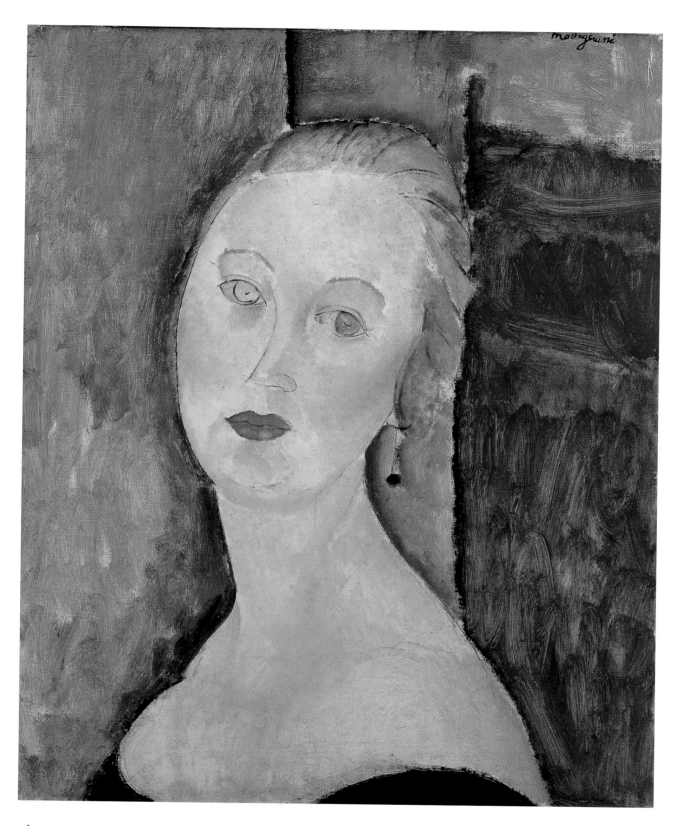

26. GERMAINE SURVAGE WITH EARRINGS, 1918
oil on canvas
21 ¼ x 16 ⅞ (54 x 43)
Collection Musée des Beaux-Arts de Nancy, France
Ceroni 277
Buffalo and Fort Worth only

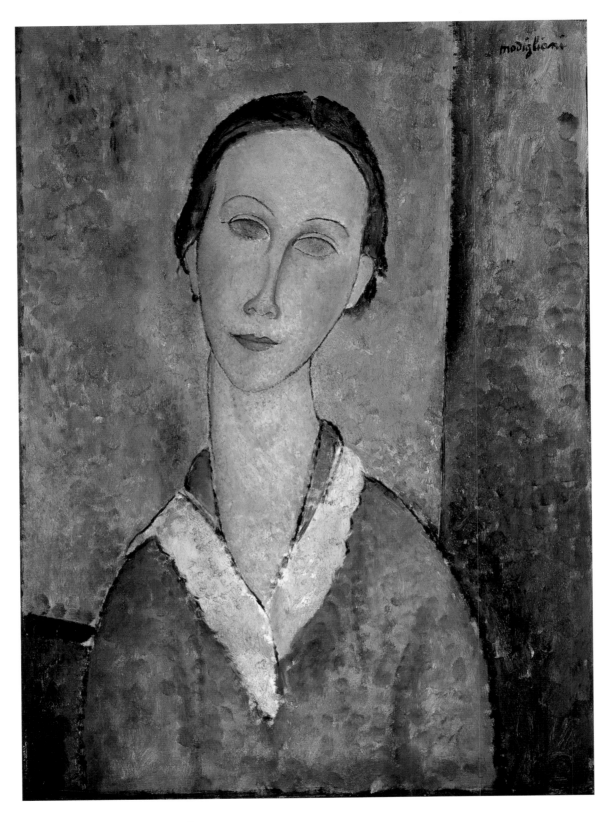

27. GIRL IN A SAILOR'S BLOUSE, 1918
oil on canvas
23 ¾ x 18 ¼ (60.3 x 46.4)
Collection The Metropolitan Museum of Art, New York
Gift of Charles F. Iklé, 1960
Ceroni 249

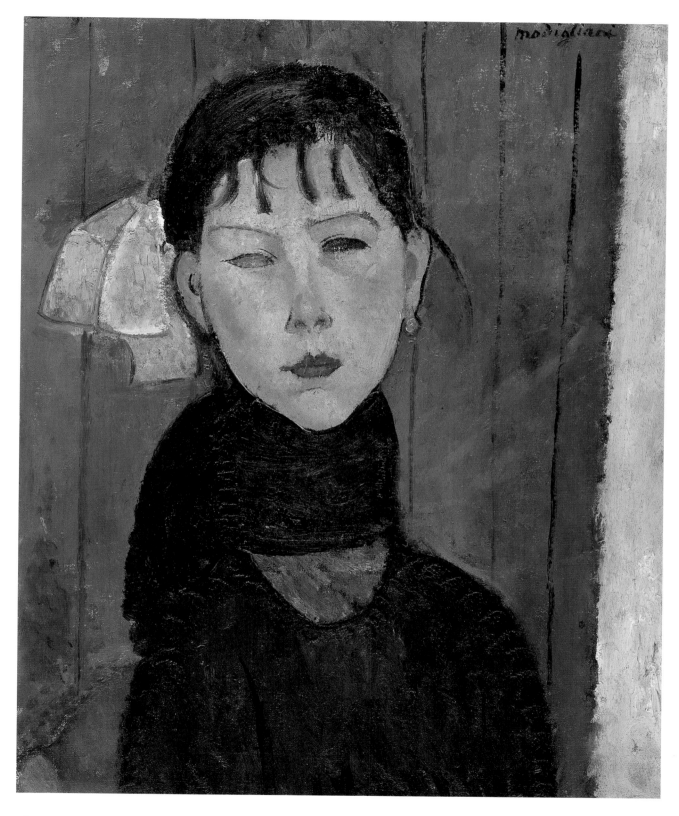

28. MARIE DAUGHTER OF THE PEOPLE, 1918
oil on canvas
24 ⅜ x 19 ⅝ (62 x 50)
Collection Öffentliche Kunstsammlung Basel, Kunstmuseum, Switzerland
Bequest of Dr. Walther Hanhart, Riehen 1975
Ceroni 253

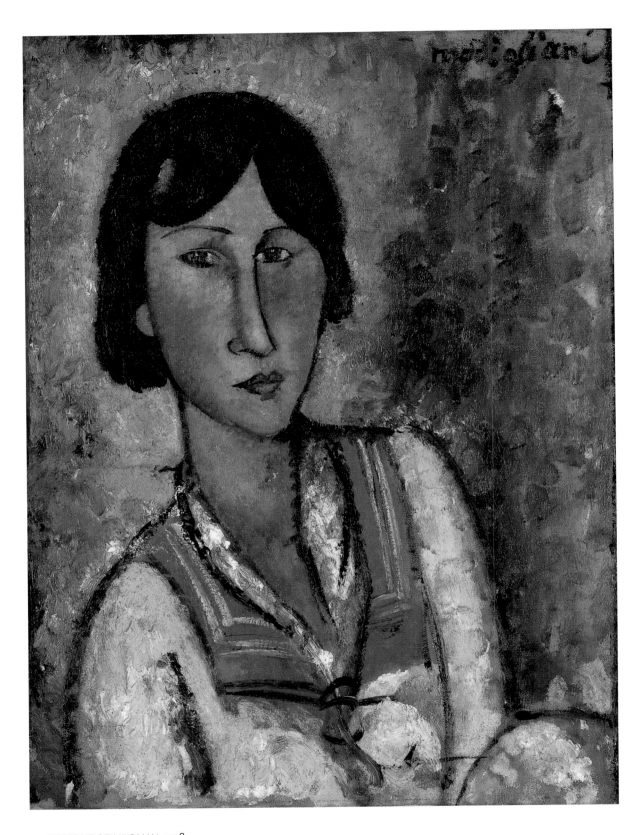

29. PORTRAIT OF A WOMAN, 1918
oil on canvas
24 x 18 ⅛ (61 x 46)
Collection Denver Art Museum, Colorado
Charles Francis Hendrie Memorial Collection, 1966.180
Ceroni 246

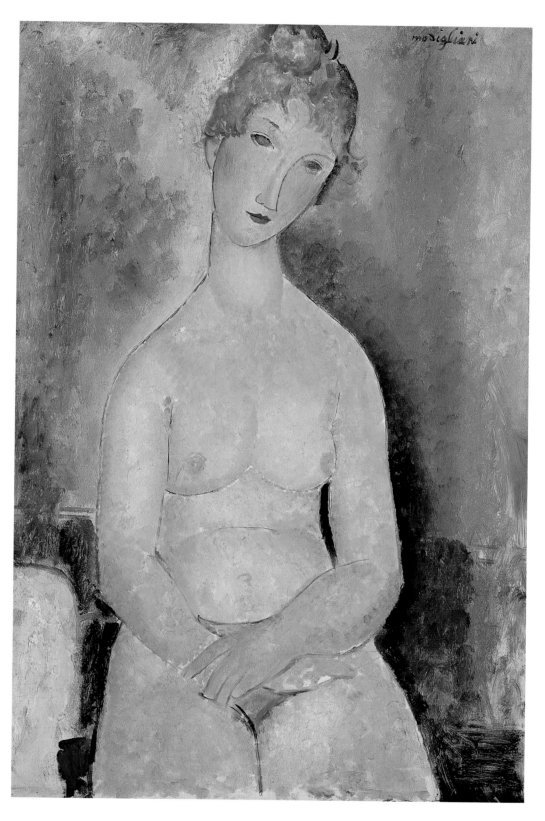

30. SEATED NUDE WITH FOLDED HANDS, 1918
oil on canvas
39 ½ x 25 ½ (100.3 x 64.8)
Collection Honolulu Academy of Arts, Hawaii
Gift of Mrs. Carter Galt, 1974 (2895.1)
Ceroni 267

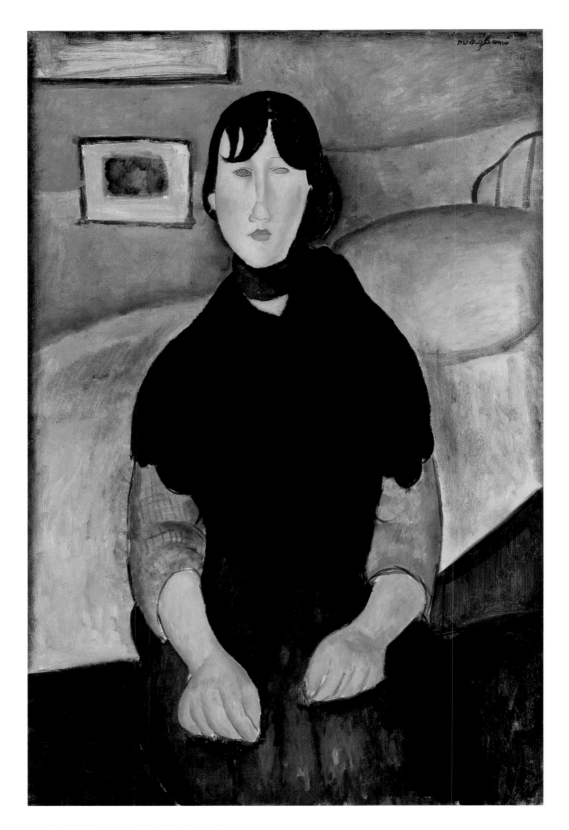

31. YOUNG WOMAN OF THE PEOPLE, 1918
oil on canvas
39 $\frac{5}{16}$ x 25 $\frac{5}{16}$ (100 x 64.5)
Collection Los Angeles County Museum of Art, California
Frances and Armand Hammer Fund
Ceroni 316

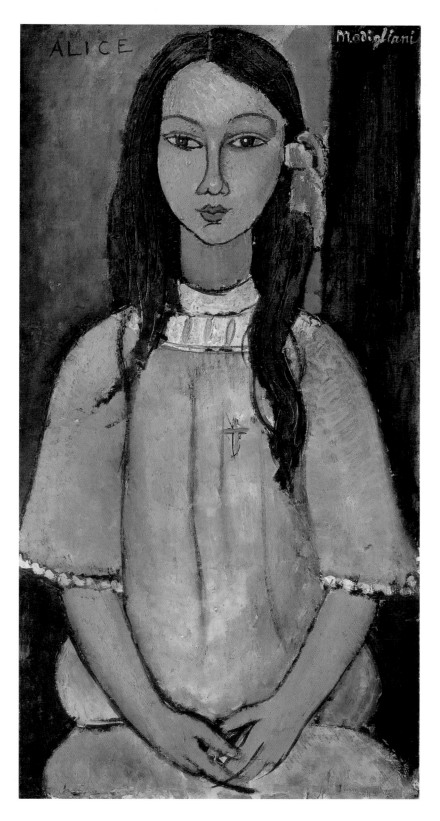

32. ALICE, C. 1918
oil on canvas
30 ⅞ x 15 ⅜ (78.5 x 39)
Collection J. Rump, Statens Museum for Kunst, Copenhagen, Denmark
Inventory No. KMSr145
Ceroni 69
Fort Worth and Los Angeles only

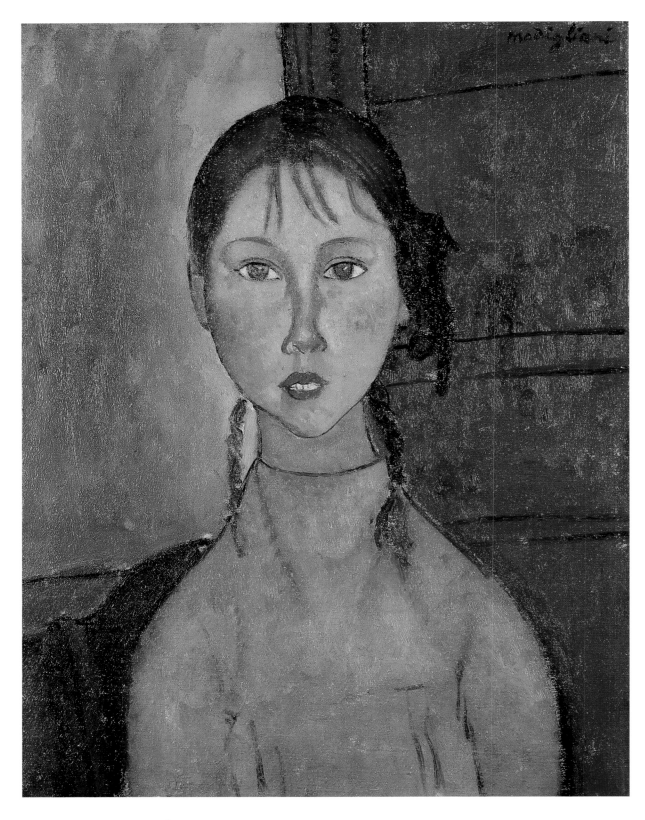

33. GIRL WITH PIGTAILS, c. 1918
oil on canvas
23 5/8 x 17 7/8 (60.1 x 45.4)
Collection Nagoya City Art Museum, Japan
© Nagoya City Art Museum
Ceroni 243
Los Angeles only

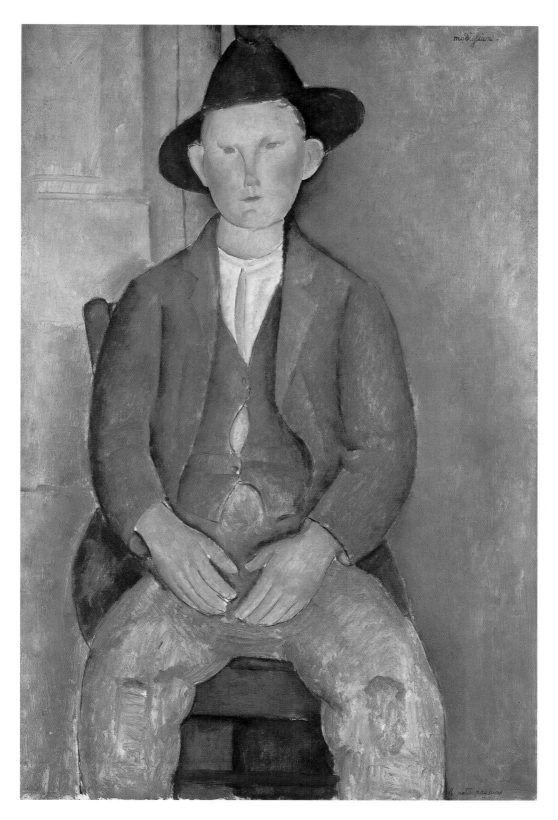

34. THE LITTLE PEASANT, c. 1918
oil on canvas
39 ⅜ x 25 ⅜ (100 x 64.5)
Collection Tate, London
Presented by Miss Jenny Blaker in memory of Hugh Blaker, 1941
Ceroni 257

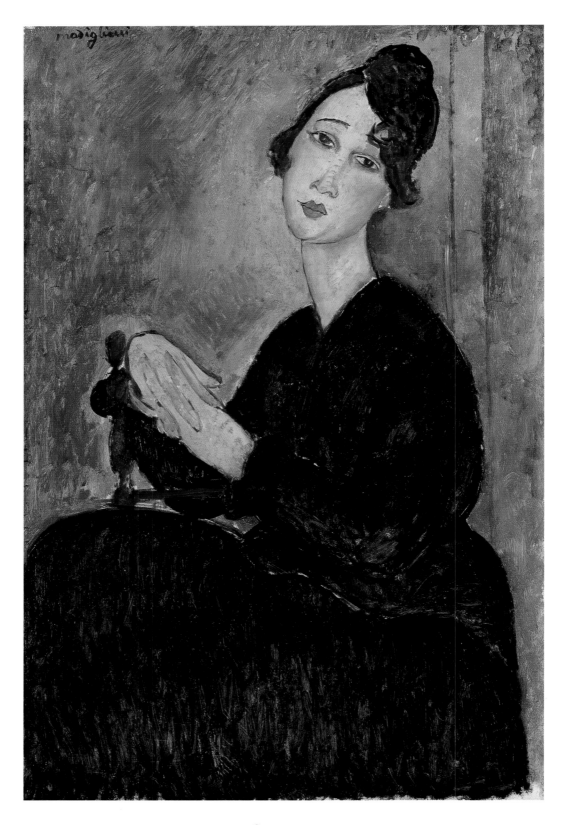

35. PORTRAIT OF DEDIE (ODETTE HAYDEN), c. 1918
oil on canvas
36 ¼ x 23 ⅝ (92 x 60)
Collection Musée National d'Art Moderne, Centre Georges Pompidou, Paris
Donation of Mr. and Mrs. André Lefèvre (Paris) in 1952
Ceroni 236

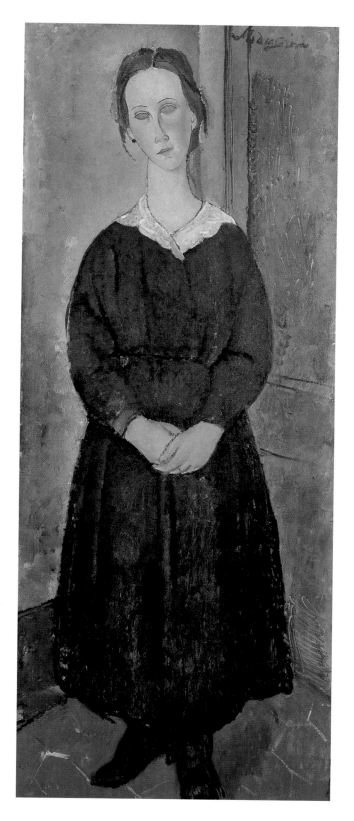

36. SERVANT GIRL, C. 1918
oil on canvas
60 x 24 (152.5 x 61)
Collection Albright-Knox Art Gallery, Buffalo, New York
Room of Contemporary Art Fund, 1939
Ceroni 248

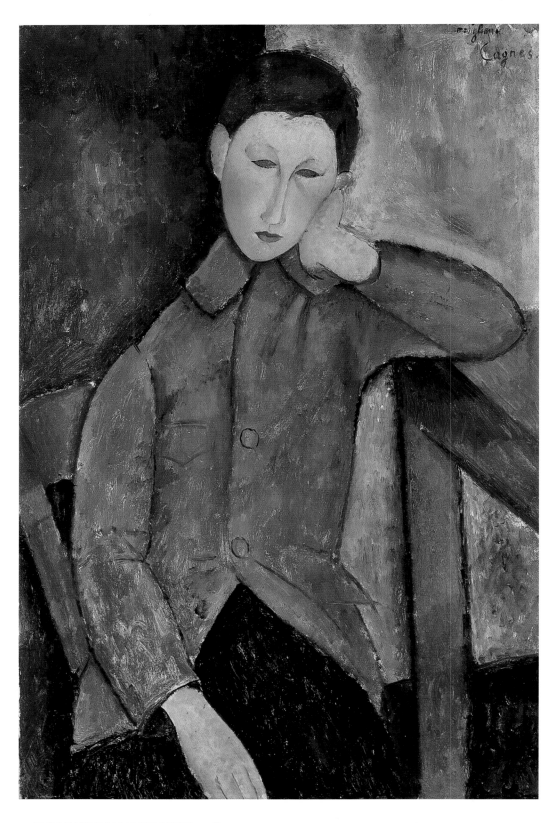

37. THE BOY (YOUTH IN BLUE JACKET), 1918–19
oil on canvas
36 ¼ x 23 ¾ (92.1 x 60.3)
Collection Indianapolis Museum of Art, Indiana
Gift of Mrs. Julian Bobbs in memory of William Ray Adams
Ceroni 297
Buffalo and Fort Worth only

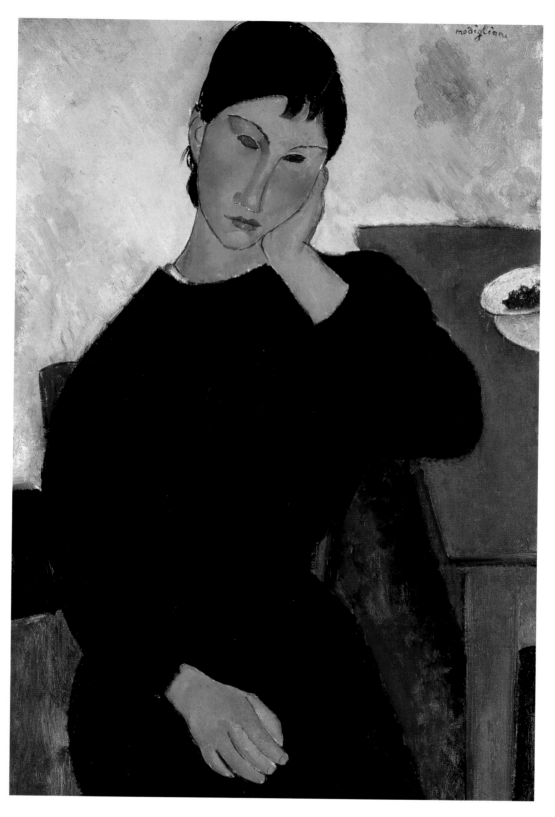

38. ELVIRA RESTING AT TABLE, 1919
oil on canvas
36 ⅜ x 23 ⅞ (92.4 x 60.6)
Collection The Saint Louis Art Museum, Missouri
Gift of Joseph Pulitzer, Jr. in memory of his wife, Louise Vauclain Pulitzer
Ceroni 270

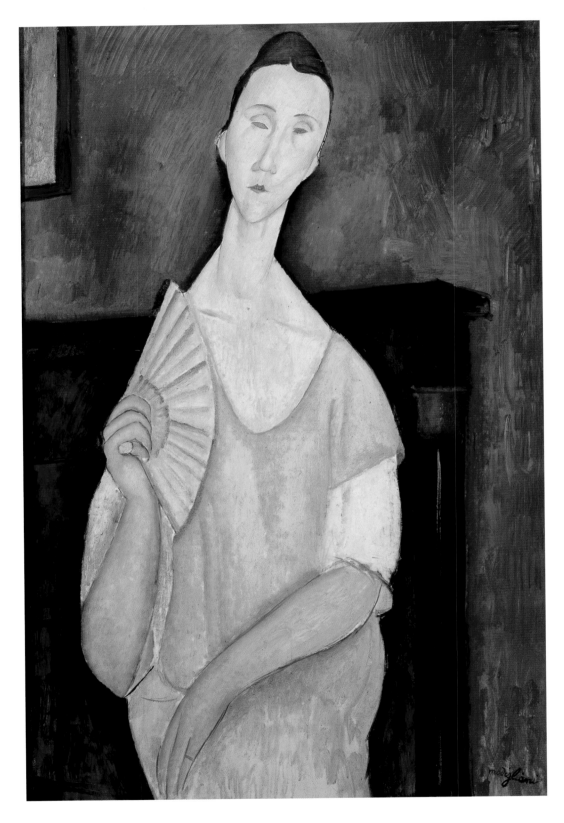

39. PORTRAIT OF LUNIA CZECHOWSKA, 1919
oil on canvas
39 ⅜ x 25 ⅝ (100 x 65)
Collection Musée d'Art Moderne de la Ville de Paris
Ceroni 321

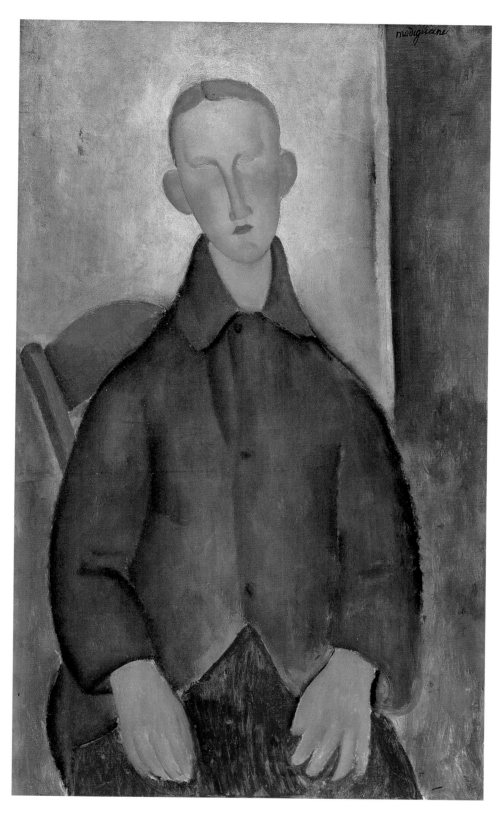

40. RED-HAIRED BOY, 1919
oil on canvas
36 ¼ x 21 ⅝ (92 x 55)
Collection Musée National d'Art Moderne, Centre Georges Pompidou, Paris
Donation of Geneviève and Jean Masurel, 1979
On loan to Musée d'Art Moderne Lille Métropole, Villeneuve d'Ascq, France
Ceroni 300
Buffalo and Fort Worth only

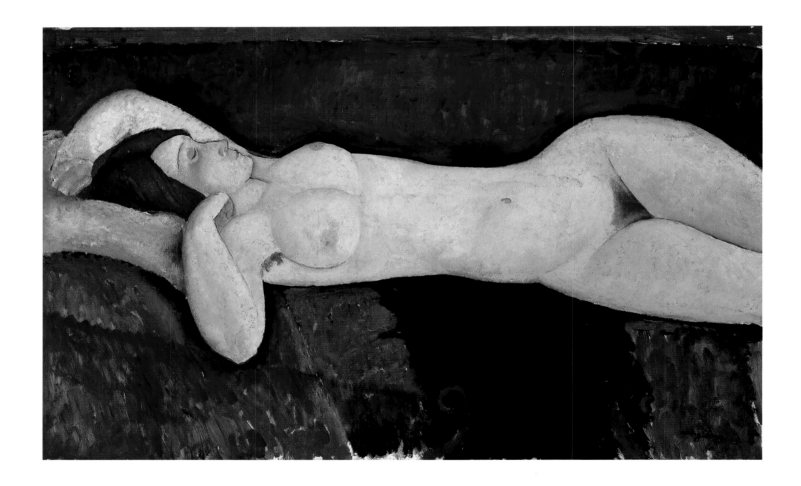

41. RECLINING NUDE, C. 1919
oil on canvas
28 ½ x 45 ⅞ (72.4 x 116.5)
Collection The Museum of Modern Art, New York
Mrs. Simon Guggenheim Fund, 1950
Ceroni 200
Buffalo and Forth Worth only

WORKS BY AMEDEO MODIGLIANI

SCULPTURE

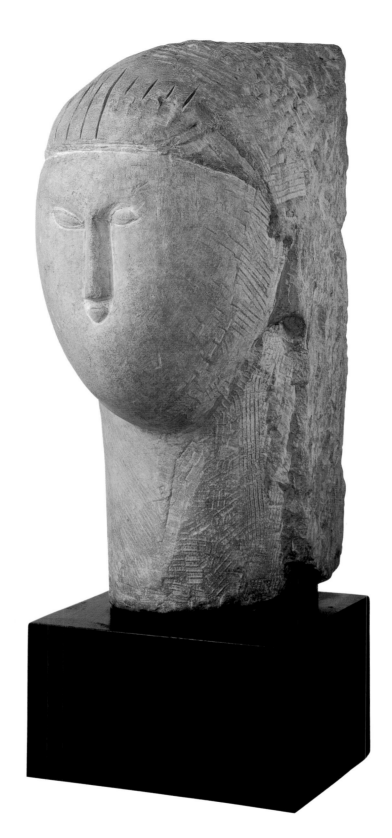

42. HEAD, 1910—11
limestone
20 x 10 x 14 (50.8 x 25.4 x 35.6)
Collection Gwendolyn Weiner
Ceroni I
Los Angeles only

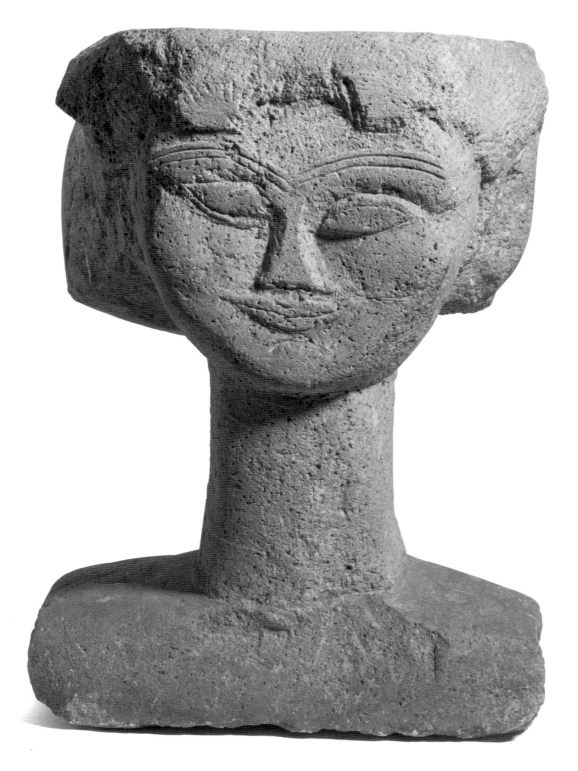

43. HEAD, c. 1911
stone
15 ½ x 12 ¼ x 7 ⅜ (39.4 x 31.1 x 18.7)
Collection Fogg Art Museum, Harvard University Art Museums, Cambridge, Massachusetts
Gift of Lois Orswell
© President and Fellows of Harvard College
Ceroni VIII
Los Angeles only

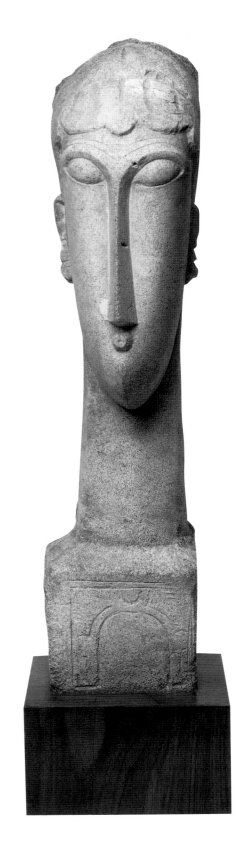

44. HEAD, 1911–12
limestone
27 ¾ x 9 ¼ x 6 ½ (70.5 x 23.5 x 16.5)
Collection Philadelphia Museum of Art, Pennsylvania
Gift of Mrs. Maurice J. Speiser, 1950
Ceroni XX

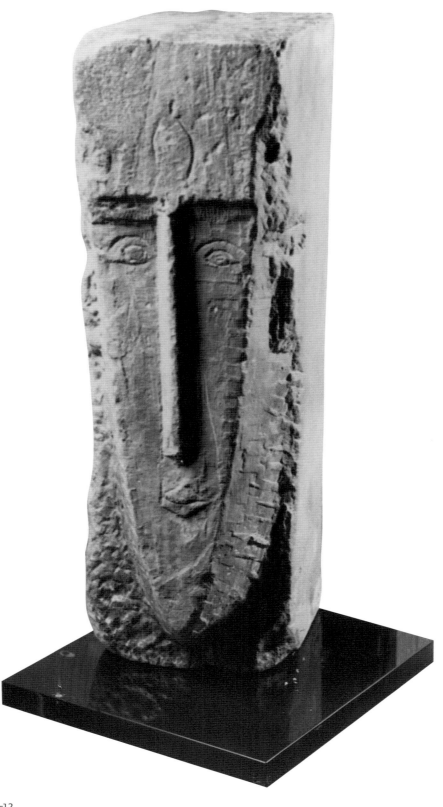

45. HEAD, 1911–12
stone
29 x 12 x 9 (73.7 x 30.5 x 22.9)
Latner Family Art Collection, Toronto, Canada
Ceroni IV

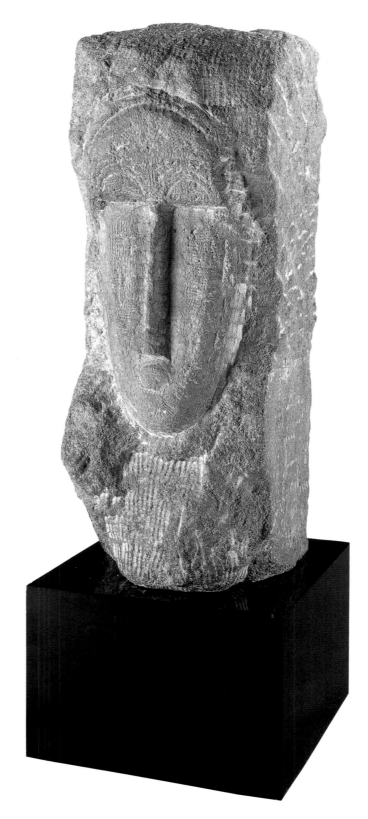

46. HEAD, C. 1911–12
stone
19 ⅝ x 7 ¼ x 9 (49.9 x 18.4 x 22.9)
Collection Hirshhorn Museum and Sculpture Garden, Smithsonian Institution, Washington, D.C.
Gift of Joseph H. Hirshhorn, 1966
Ceroni VII

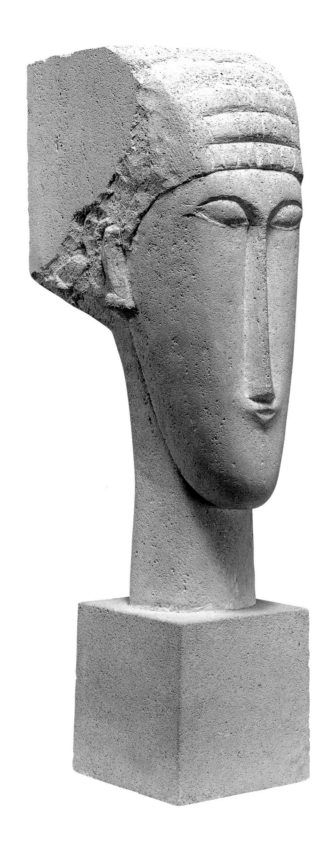

47. HEAD, 1911–13
limestone
25 x 6 x 8 ½ (63.5 x 15.2 x 21)
Collection Solomon R. Guggenheim Museum, New York
55.1421
Ceroni XXI
Buffalo and Forth Worth only

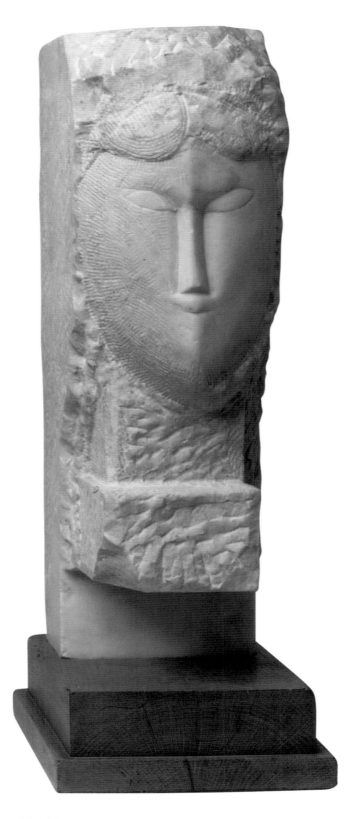

48. HEAD OF A WOMAN, C. 1913–14
white marble
19 ⅞ x 6 ⅛ x 9 ¼ (50.5 x 15.6 x 23.5)
Collection Musée National d'Art Moderne, Centre Georges Pompidou, Paris
Gift of Geneviève and Jean Masurel
On loan to Musée d'Art Moderne Lille Métropole, Villeneuve d'Ascq, France
Ceroni VI
Buffalo and Forth Worth only

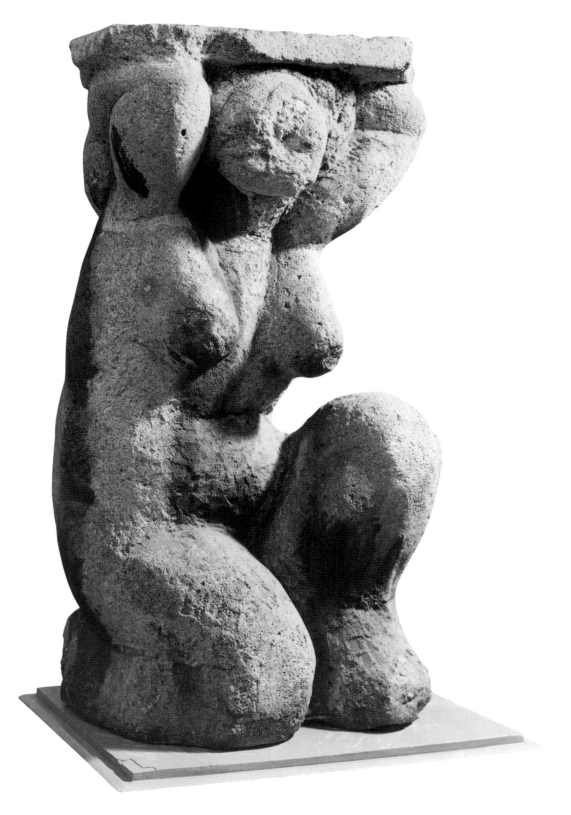

49. CARYATID, C. 1914
limestone
36 ¼ x 16 ⅜ x 16 ⅞ (92.1 x 41.6 x 42.9)
Collection The Museum of Modern Art, New York
Mrs. Simon Guggenheim Fund, 1951
Ceroni XXV
Buffalo only

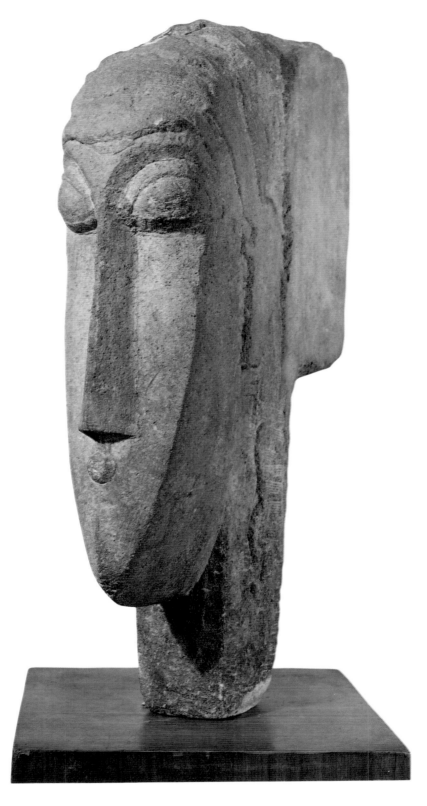

130

50. HEAD, C. 1915
limestone
22 ¼ x 5 x 14 ¾ (56.5 x 12.7 x 37.4)
Collection The Museum of Modern Art, New York
Gift of Abby Aldrich Rockefeller in memory of Mrs. Cornelius J. Sullivan, 1939
Ceroni XXIII
Buffalo only

WORKS BY AMEDEO MODIGLIANI

WORKS ON PAPER

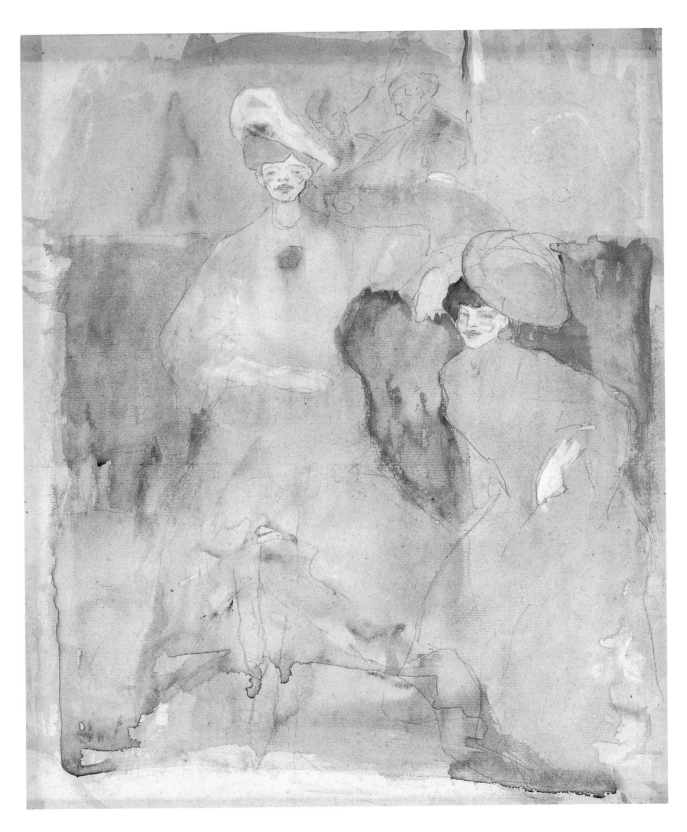

134

51. TWO WOMEN, 1908
watercolor and pencil on blue laid paper
15 x 12 (38 x 31)
Collection Albright-Knox Art Gallery, Buffalo, New York
Gift of A. Conger Goodyear, 1943

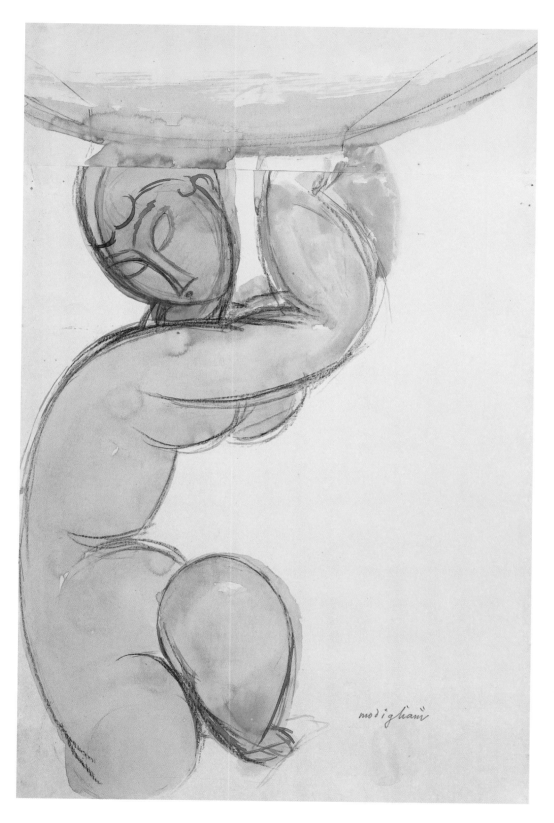

52. CARYATID, C. 1912
red pastel and blue crayon on paper
25 x 18 (63.5 x 45.7)
Private Collection, Boston, Massachusetts

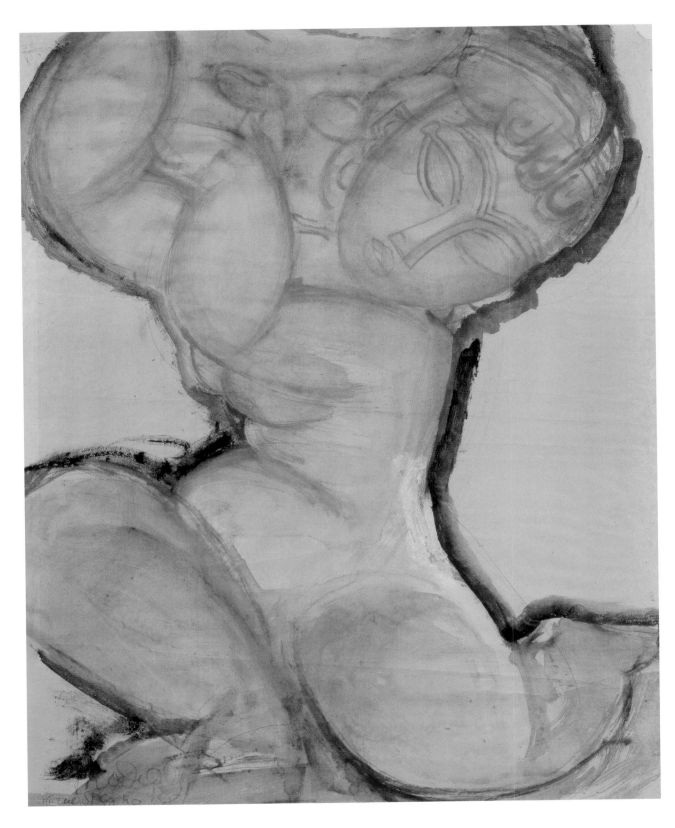

53. ROSE CARYATID WITH BLUE BORDER, C. 1913
watercolor on paper
21 ⅞ x 17 ¾ (55.6 x 45.1)
Private Collection

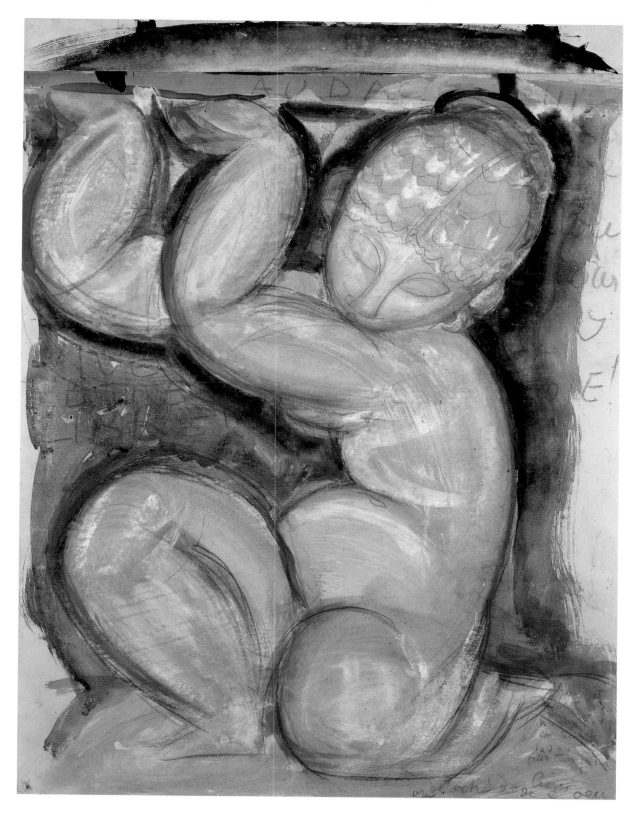

54. ROSE CARYATID, 1914
gouache and crayon on paper
23 ¾ x 17 ⅞ (60.3 x 45.4)
Collection Norton Museum of Art, West Palm Beach, Florida
Bequest of R. H. Norton, 53.132

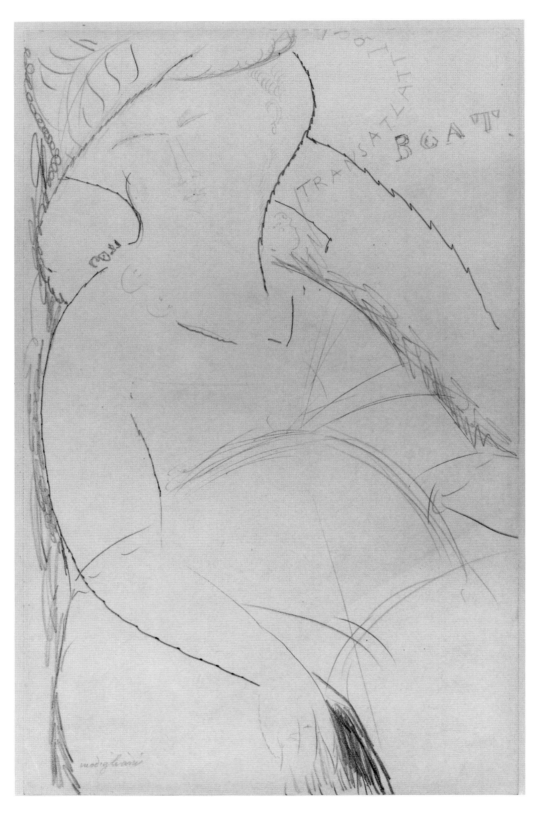

55. SEATED WOMAN—TRANSATLANTIC BOAT, c. 1915–16
pencil on paper
16 ⅝ x 10 ¼ (42 x 26)
Private Collection
Courtesy Steve Banks Fine Arts, San Francisco, California

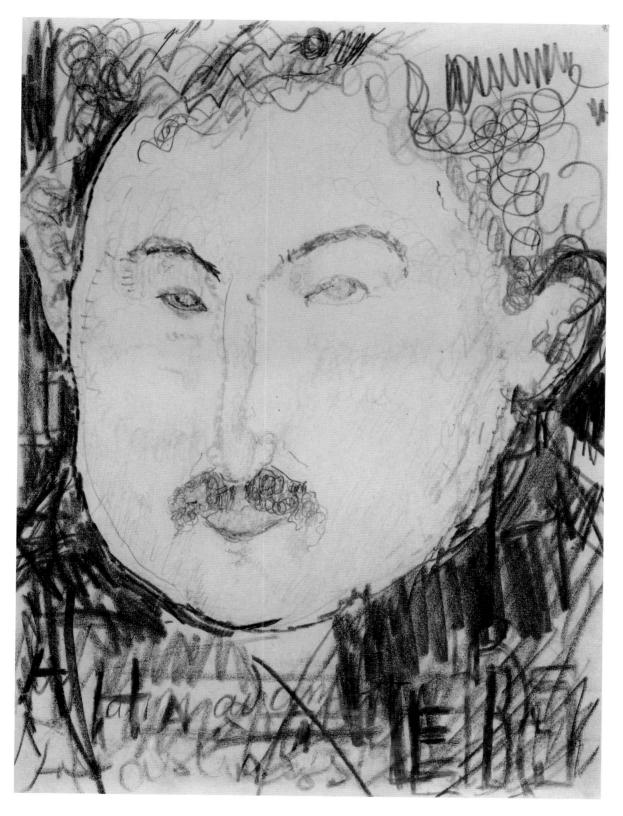

56. PORTRAIT OF ADOLPHE BASLER, C. 1916
conté crayon on paper
11 ⅝ x 8 ¹¹⁄₁₆ (29.5 x 22.1)
Collection The Brooklyn Museum of Art, New York
37.160

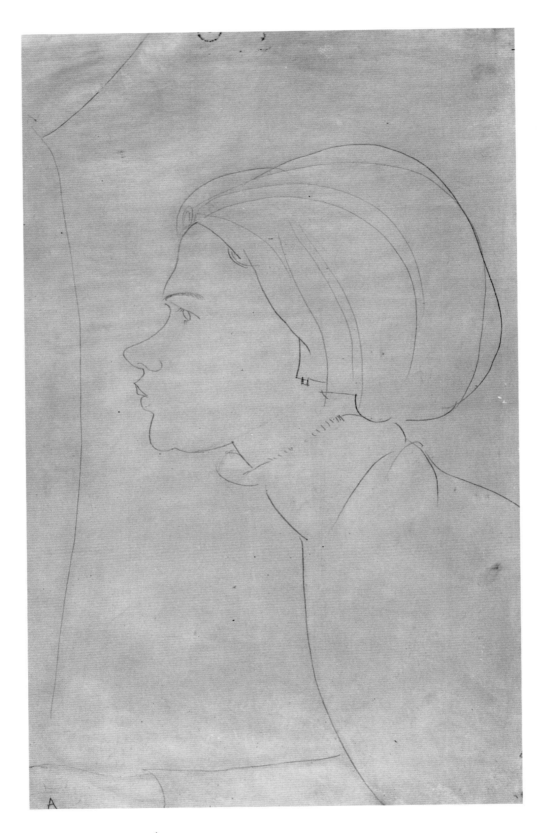

57. PROFILE OF A GIRL, 1916–17
pencil on paper
15 ½ x 9 ½ (39.4 x 24.1)
Collection Albright-Knox Art Gallery, Buffalo, New York
Gift of A. Conger Goodyear, 1954

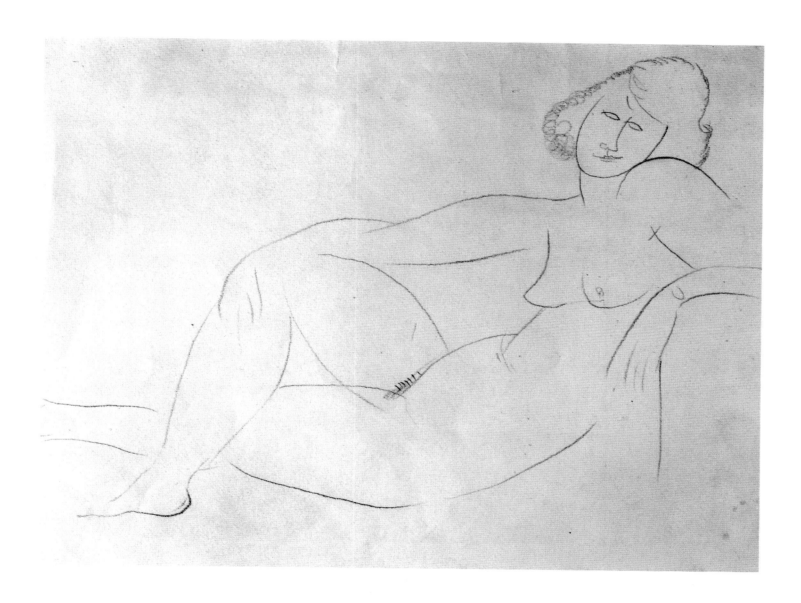

58. RECLINING NUDE, C. 1919
pencil on paper
9 ¾ x 12 ⅜ (24.8 x 31.4)
Collection Albright-Knox Art Gallery, Buffalo, New York
Gift of A. Conger Goodyear to the Room of Contemporary Art, 1940

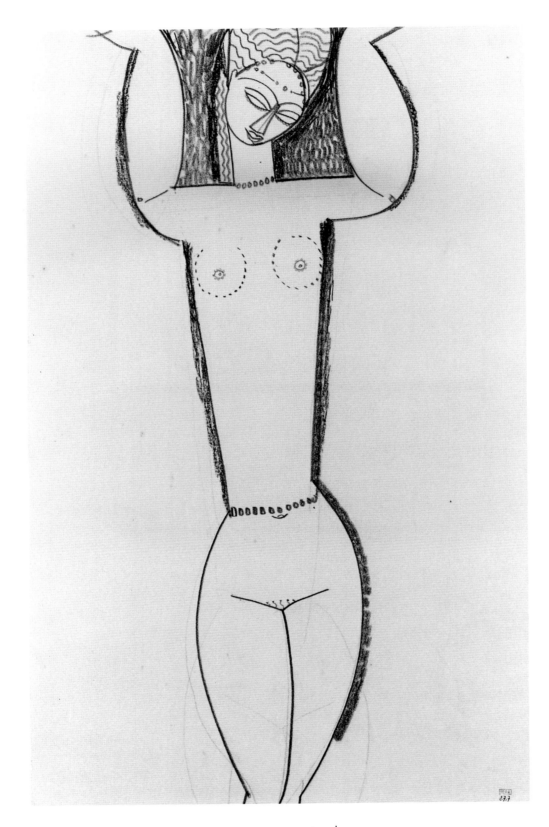

59. CARYATID, FRONTAL VIEW, NECKLACE AND BELT OF PEARLS, n.d.
crayon on paper
16 ⅞ x 10 ⁷⁄₁₆ (42.9 x 26.5)
Collection Musée des Beaux-Arts, Rouen, France
Gift of Blaise Alexandre, 2000
Inv. 2001.2.6
Buffalo and Forth Worth only

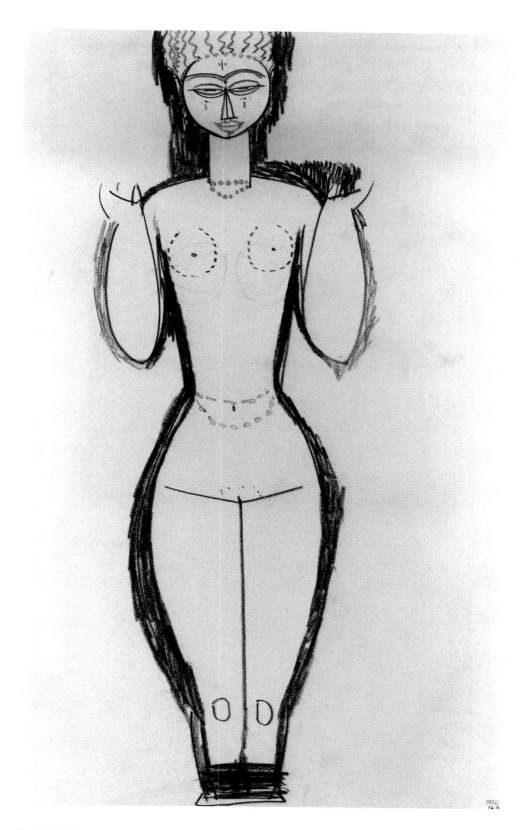

60. FEMALE NUDE, FRONTAL VIEW, FOREARMS RAISED, TATTOOS ON FACE, NECKLACE AND BELT OF PEARLS, **n.d.**
crayon on paper
16 ⅞ x 10 ½ (42.9 x 26.7)
Collection Musée des Beaux-Arts, Rouen, France
Gift of Blaise Alexandre, 2000
Inv. 2001.2.11
Fort Worth and Los Angeles only

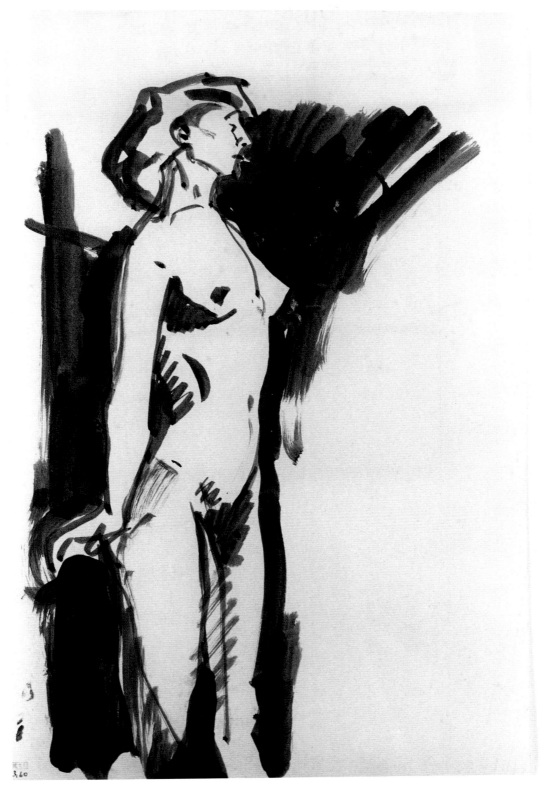

61. FEMALE NUDE, HEAD IN RIGHT PROFILE, THREE-QUARTER LENGTH, RIGHT ARM BESIDE HER BODY, **n.d.**
Chinese ink on paper
12 5/16 x 7 7/8 (31.2 x 20)
Collection Musée des Beaux-Arts, Rouen, France
Gift of Blaise Alexandre, 2000
Inv. 2001.2.26
Fort Worth and Los Angeles only

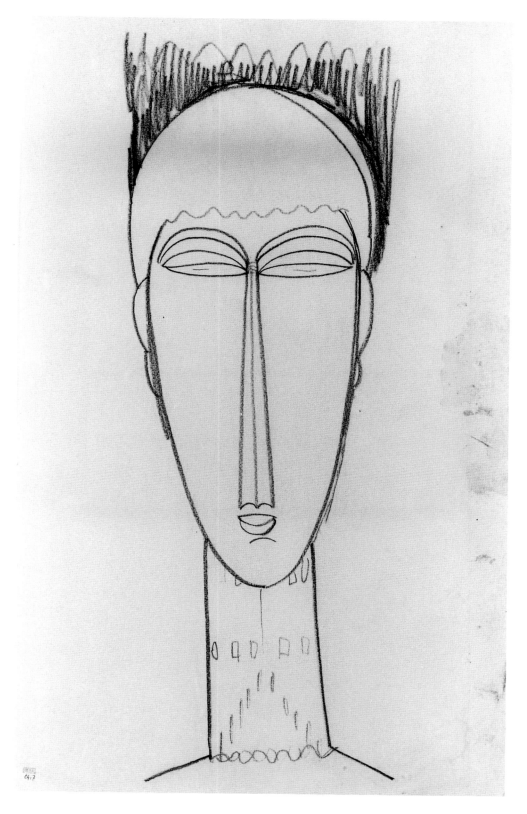

62. HEAD, FULL-FACE, WITH FRINGE, DECORATED NECK AND NECKLACE, n.d.
crayon on paper
16 ¾ x 10 ⁵⁄₁₆ (42.7 x 26.3)
Collection Musée des Beaux-Arts, Rouen, France
Gift of Blaise Alexandre, 2000
Inv. 2001.2.18
Fort Worth and Los Angeles only

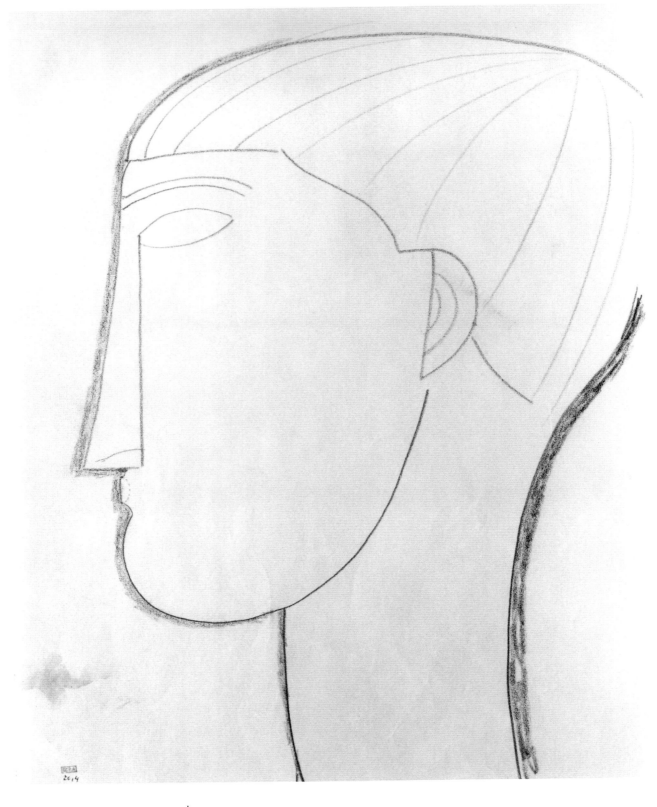

63. MALE HEAD IN LEFT PROFILE, n.d.
crayon on paper
13 ¼ x 10 ⁷⁄₁₆ (33.8 x 26.5)
Collection Musée des Beaux-Arts, Rouen, France
Gift of Blaise Alexandre, 2000
Inv. 2001.2.12
Buffalo and Fort Worth only

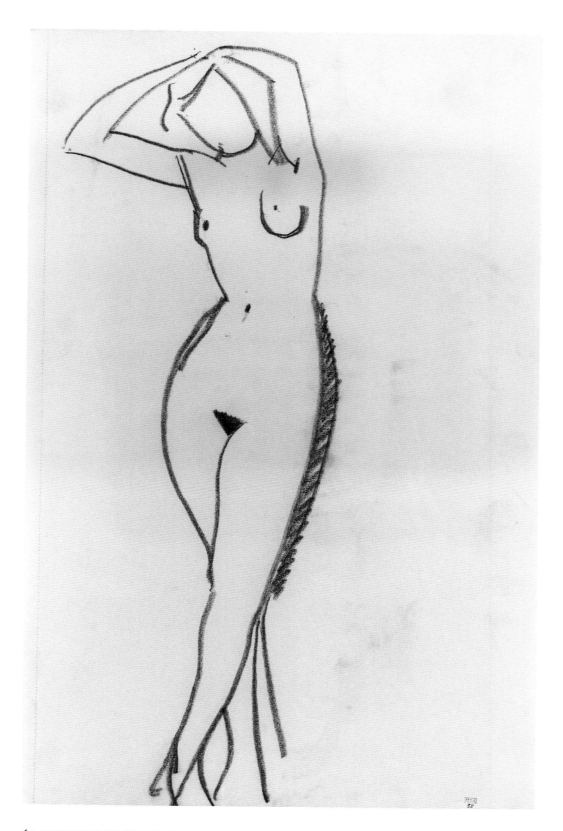

64. STANDING NUDE WOMAN, FRONTAL VIEW, SLIGHTLY TURNED TO HER RIGHT, HANDS ON HEAD,
LEFT LEG CROSSED OVER RIGHT LEG, **n.d.**
crayon on paper
16 ⅞ x 10 ¹³⁄₁₆ (43 x 27.5)
Collection Musée des Beaux-Arts, Rouen, France
Gift of Blaise Alexandre, 2000
Inv. 2001.2.22
Buffalo and Forth Worth only

WORKS BY ARTISTS OF MONTPARNASSE

ALEXANDER ARCHIPENKO. American, born Ukraine, 1887–1964
65. WALKING SOLDIER, 1917; enlarged cast executed c. 1954
painted plaster and wood
46 x 24 x 11 (116.8 x 61 x 27.9)
Collection Albright-Knox Art Gallery, Buffalo, New York
Gift of Frances Archipenko Gray, 1973
© Estate of Alexander Archipenko/Artists Rights Society (ARS), New York
Buffalo only

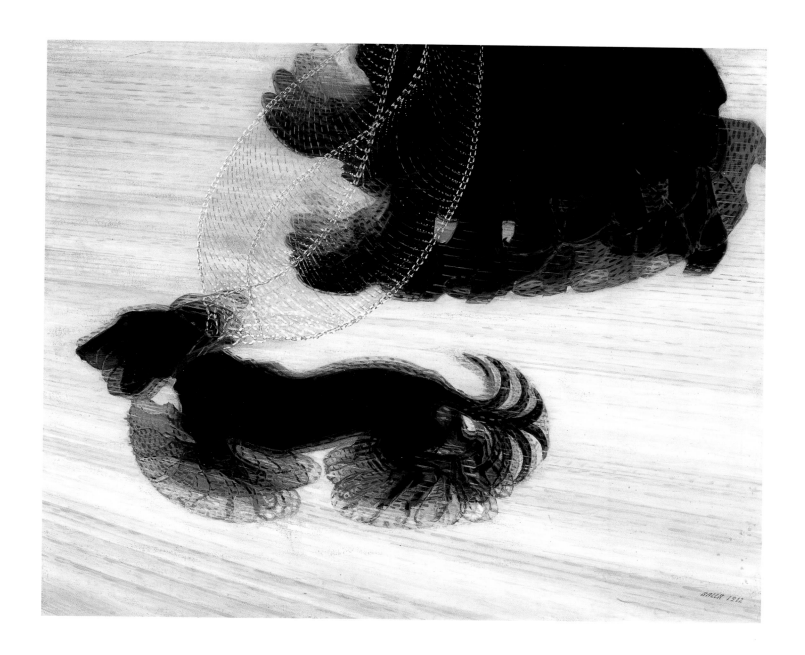

GIACOMO BALLA. Italian, 1871–1958

66. DYNAMISM OF A DOG ON A LEASH, 1912

oil on canvas

35 ⅜ x 43 ¼ (89.9 x 109.9)

Collection Albright-Knox Art Gallery, Buffalo, New York

Bequest of A. Conger Goodyear and Gift of George F. Goodyear, 1964

© 2002 Artists Rights Society (ARS), New York/SIEA, Rome

Buffalo only

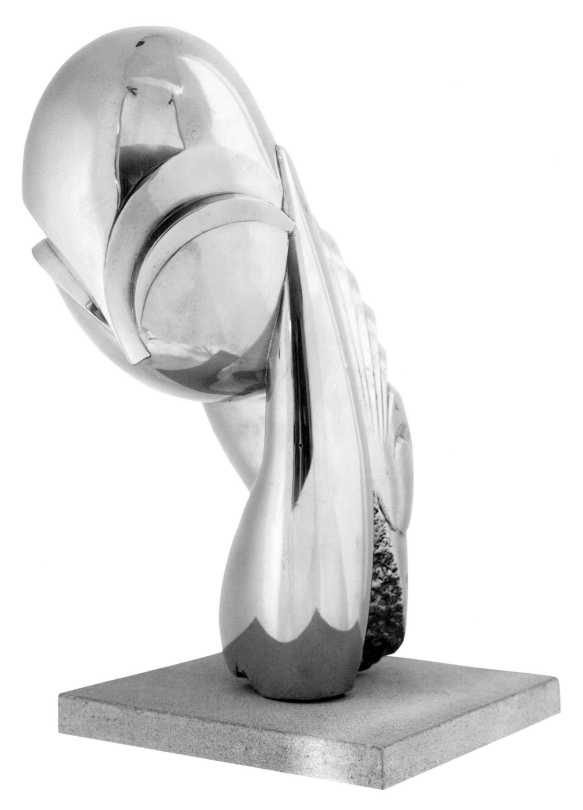

CONSTANTIN BRANCUSI. French, born Romania, 1876–1957
67. MLLE. POGANY II, 1920
polished bronze
17 ¼ x 7 x 10 (43.7 x 17.5 x 25.5)
Collection Albright-Knox Art Gallery, Buffalo, New York
Charlotte A. Watson Fund, 1927
© 2002 Artists Rights Society (ARS), New York/ADAGP, Paris

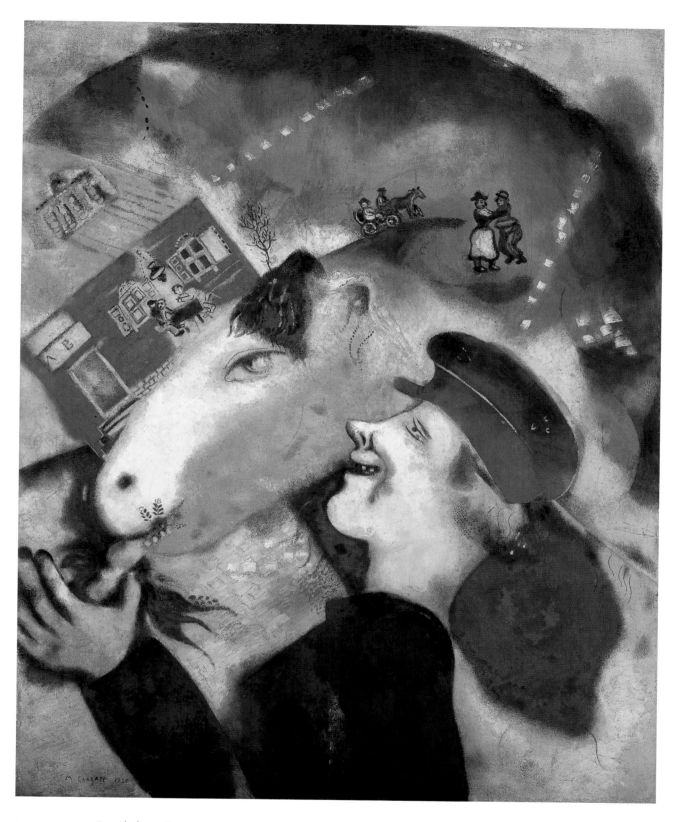

MARC CHAGALL. French, born Russia, 1887–1985

68. PEASANT LIFE, 1925

oil on canvas

39 ⅜ x 31 ½ (100 x 80)

Collection Albright-Knox Art Gallery, Buffalo, New York

Room of Contemporary Art Fund, 1941

© 2002 Artists Rights Society (ARS), New York/ADAGP, Paris

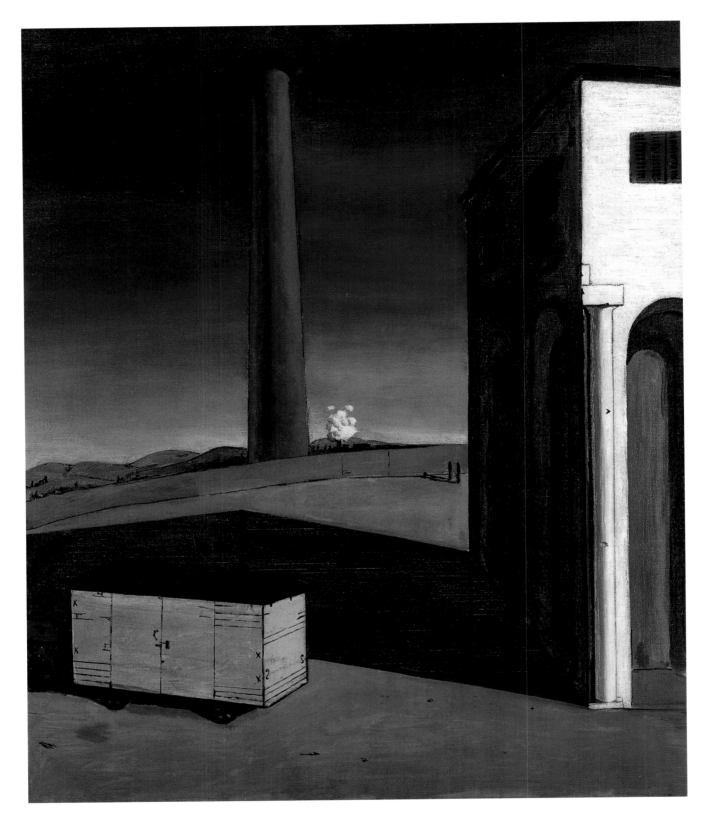

GIORGIO DE CHIRICO. Italian, 1888–1978
69. THE ANGUISH OF DEPARTURE, **1914**
oil on canvas
33 ½ x 27 ¼ (85.1 x 69.2)
Collection Albright-Knox Art Gallery, Buffalo, New York
Room of Contemporary Art Fund, 1939
© 2002 Artists Rights Society (ARS), New York/SIEA, Rome

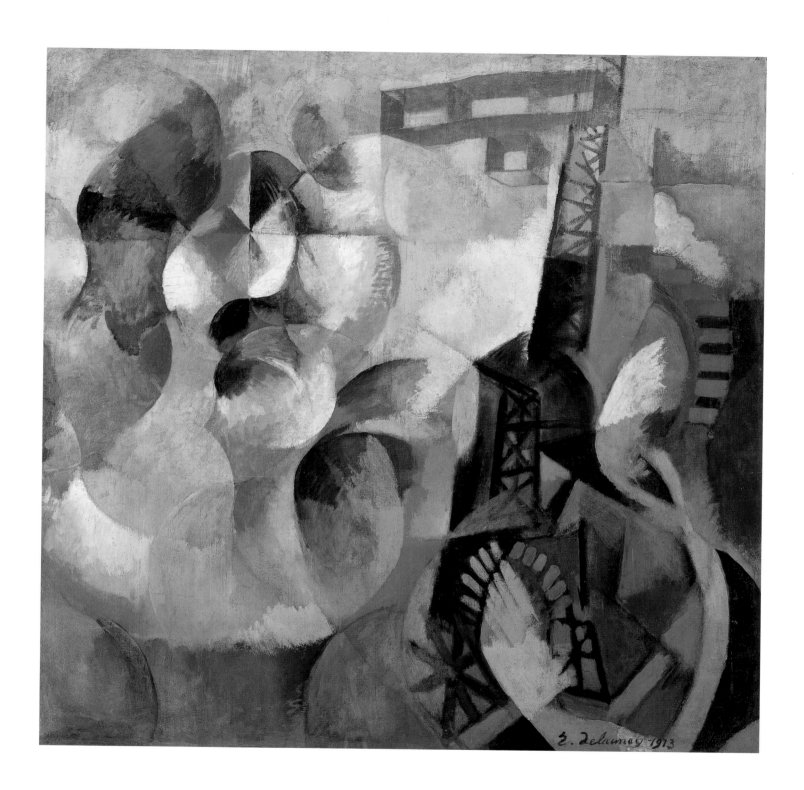

ROBERT DELAUNAY. French, 1885–1941

70. SUN, TOWER, AIRPLANE, 1913

oil on canvas

52 x 51 ⅝ (132 x 131)

Collection Albright-Knox Art Gallery, Buffalo, New York

A. Conger Goodyear Fund, 1964

SONIA DELAUNAY. French, born Ukraine, 1885–1979
71. DANCER, SECOND VERSION, 1916
tempera, chalk, and charcoal on heavy paper
22 7/16 x 18 7/8 (57.2 x 47.9)
Collection Albright-Knox Art Gallery, Buffalo, New York
George B. and Jenny R. Mathews and Evelyn Rumsey Cary Funds, 1980

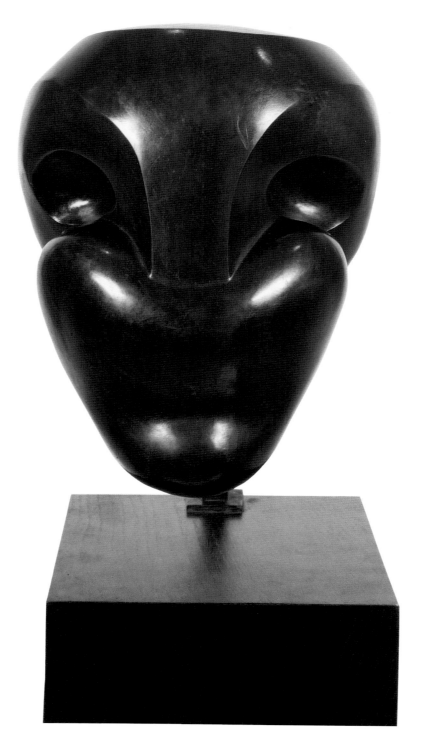

RAYMOND DUCHAMP-VILLON. French, 1876–1918
72. PORTRAIT OF PROFESSOR GOSSETT, 1918; enlarged cast executed 1957
bronze
11 ¾ x 9 ⅛ x 8 ½ (29.9 x 23.2 x 21.6)
Collection Albright-Knox Art Gallery, Buffalo, New York
A. Conger Goodyear Fund, 1965

158

JACOB EPSTEIN. English, born United States, 1880–1959
73. PORTRAIT OF MRS. EPSTEIN, 1916
bronze
9 ½ x 7 ¾ x 7 (24.1 x 19.7 x 17.8)
Collection Albright-Knox Art Gallery, Buffalo, New York
Gift of A. Conger Goodyear, 1953

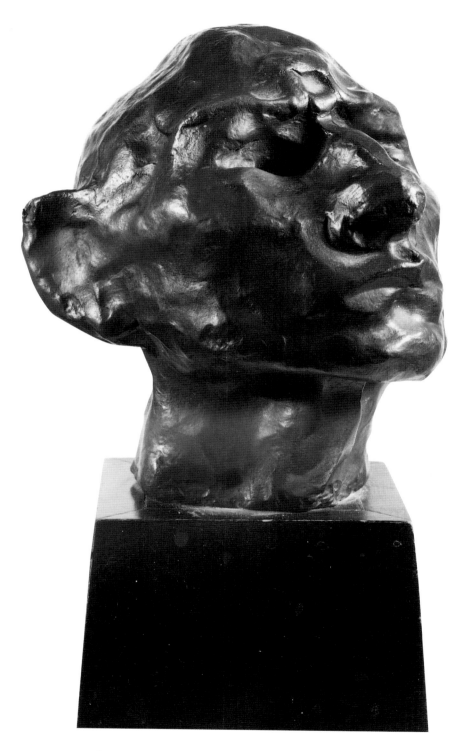

HENRI GAUDIER-BRZESKA. French, 1891–1915
74. THE IDIOT, **1912** [?]; cast executed c. 1930
bronze
6 ¾ x 5 ¾ x 6 ⅝ (17.2 x 14.6 x 16.8)
Collection Albright-Knox Art Gallery, Buffalo, New York
Bequest of A. Conger Goodyear, 1966

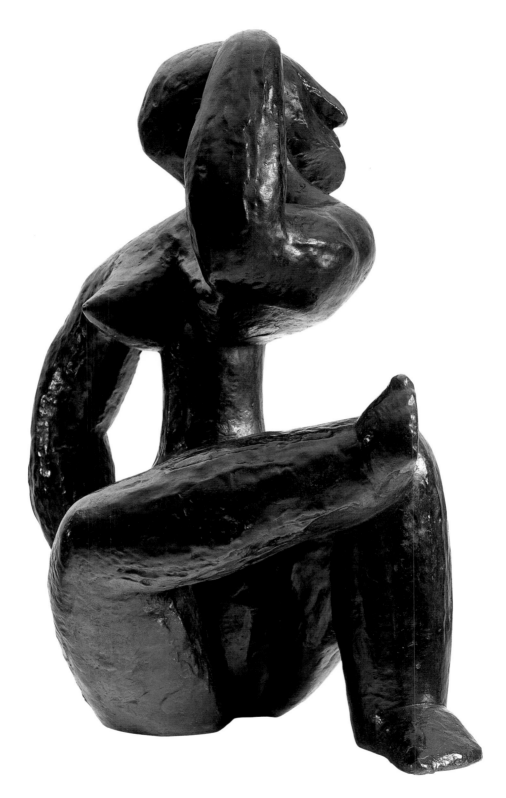

160

HENRI LAURENS. French, 1885–1954
75. LARGE SEATED WOMAN, 1932
bronze
27 ½ x 19 ½ x 13 (69.9 x 49.5 x 33)
Collection Albright-Knox Art Gallery, Buffalo, New York
Gift of The Seymour H. Knox Foundation, Inc., 1966
© 2002 Artists Rights Society (ARS), New York/ADAGP, Paris

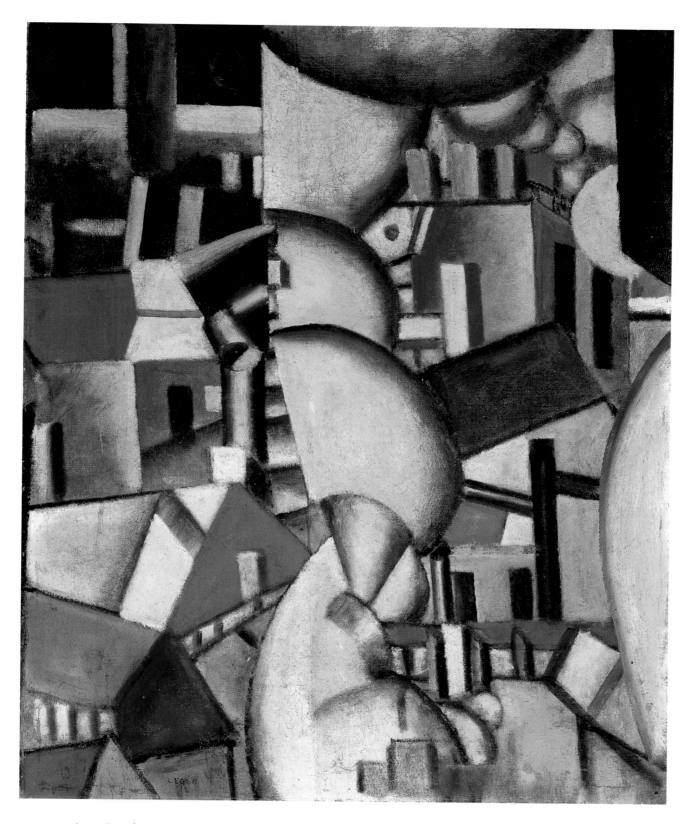

FERNAND LÉGER. French, 1881–1955
76. SMOKE, 1912
oil on canvas
36 ¼ x 28 ¾ (92 x 73)
Collection Albright-Knox Art Gallery, Buffalo, New York
Room of Contemporary Art Fund, 1940
© 2002 Artists Rights Society (ARS), New York/ADAGP, Paris

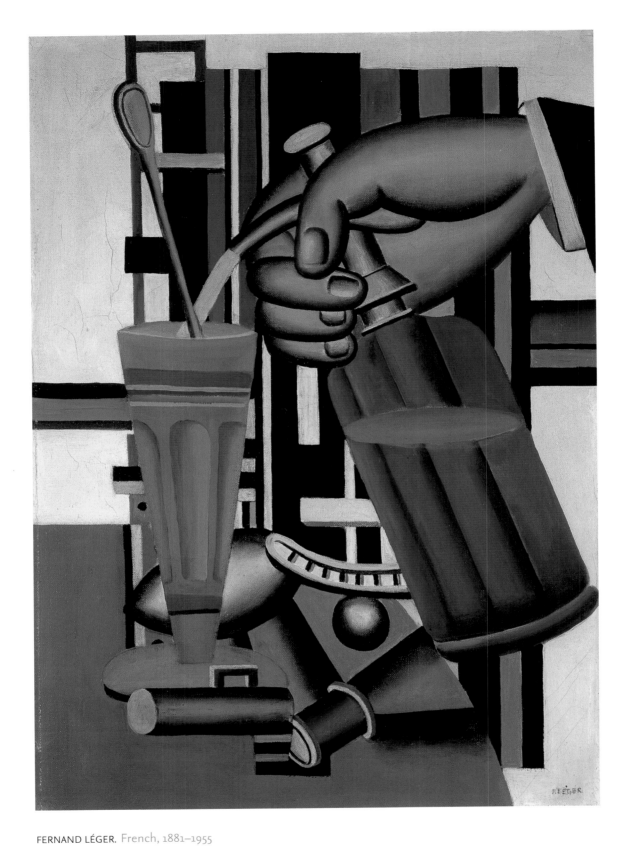

162

FERNAND LÉGER. French, 1881–1955

77. THE SIPHON, 1924
oil on canvas
25 ⅝ x 18 ⅛ (65.1 x 46)
Collection Albright-Knox Art Gallery, Buffalo, New York
Gift of Mr. and Mrs. Gordon Bunshaft, 1977
© 2002 Artists Rights Society (ARS), New York/ADAGP, Paris
Buffalo only

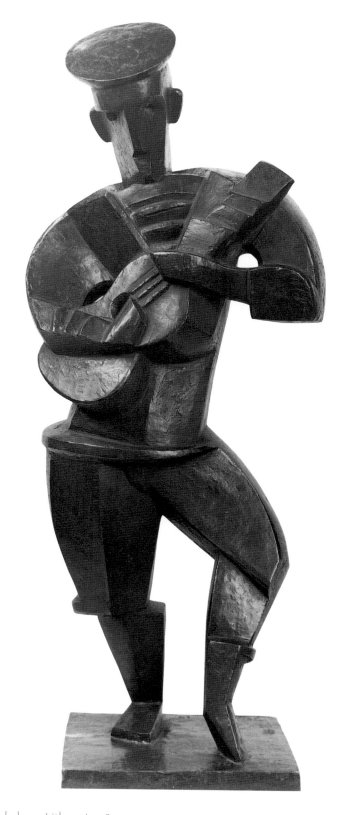

JACQUES LIPCHITZ. French, born Lithuania, 1891–1973
78. SAILOR WITH GUITAR, 1914
bronze
30 x 12 x 9 (76.2 x 30.5 x 22.9)
Collection Albright-Knox Art Gallery, Buffalo, New York
Room of Contemporary Art Fund, 1944
© Estate of Jacques Lipchitz, Courtesy Marlborough Gallery, New York

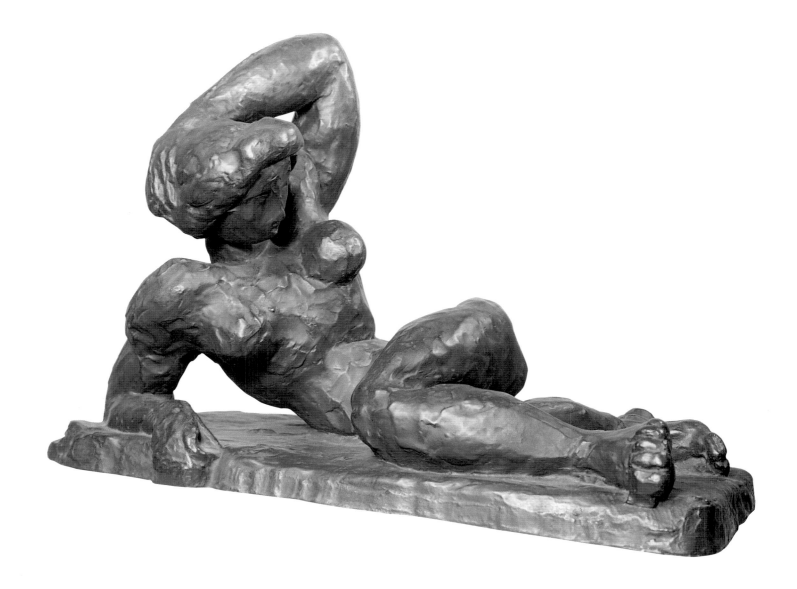

HENRI MATISSE. French, 1869–1954
79. RECLINING NUDE I, **1907**
bronze
13 ¹¹/₁₆ x 19 ¾ x 11 (34.7 x 50.2 x 27.9)
Collection Albright-Knox Art Gallery, Buffalo, New York
Room of Contemporary Art Fund, 1945
© 2002 Succession H. Matisse/Artists Rights Society (ARS), New York

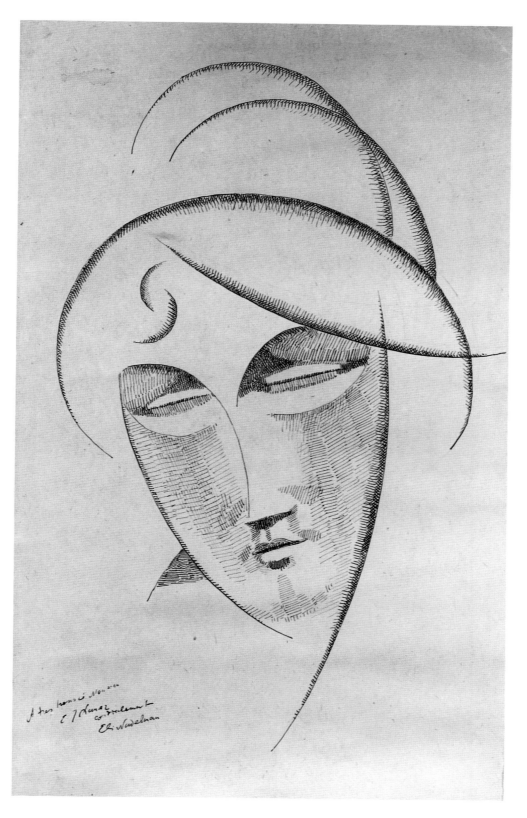

ELIE NADELMAN. American, born Poland, 1882–1946

80. HEAD OF A WOMAN, c. 1907
pen and ink and pencil on brown paper
21 x 12 ⅝ (53.3 x 32.1)
Collection Albright-Knox Art Gallery, Buffalo, New York
Charles W. Goodyear Fund, 1953

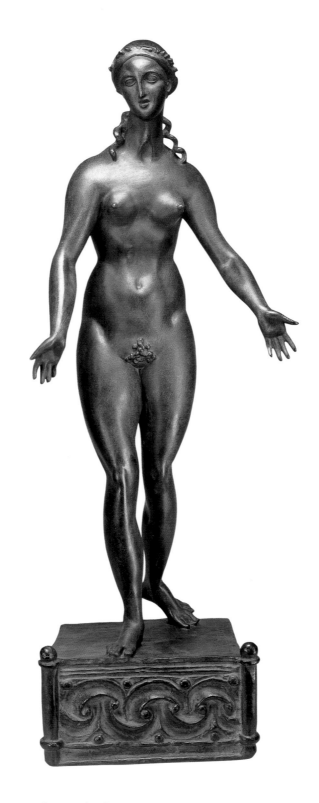

ELIE NADELMAN. American, born Poland, 1882–1946
81. STANDING FEMALE NUDE, c. 1907–10
bronze
25 ¼ x 9 x 6 ¾ (64.1 x 22.9 x 17.2)
Estate of Elie Nadelman
Courtesy Salander-O'Reilly Galleries, New York

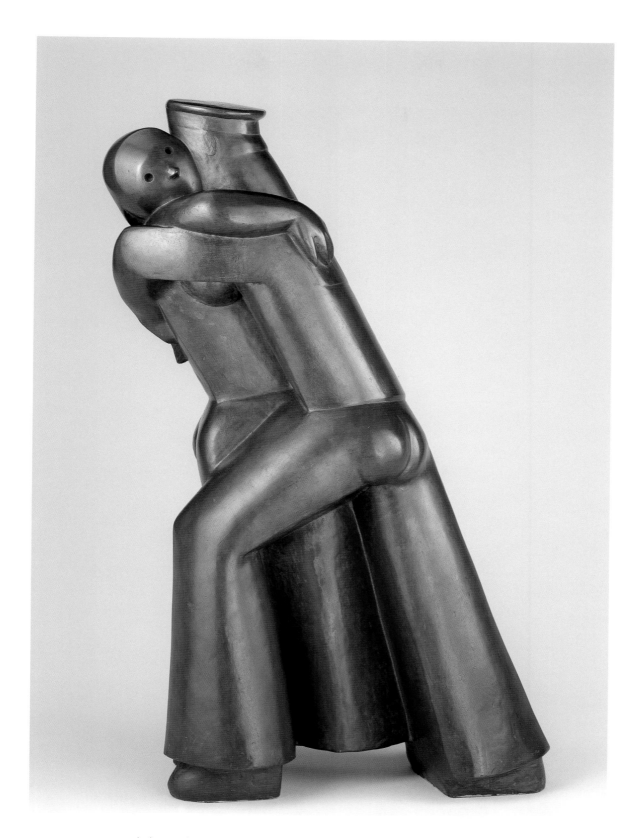

CHANA ORLOFF. French, born Ukraine, 1888–1968
82. SAILOR AND SWEETHEART, 1929
bronze
38 ½ x 25 x 17 (97.8 x 63.5 x 43.2)
Collection Philadelphia Museum of Art, Pennsylvania
Purchased with the Bloomfield Moore Fund, 1937
© 2002 Artists Rights Society (ARS), New York/ADAGP, Paris

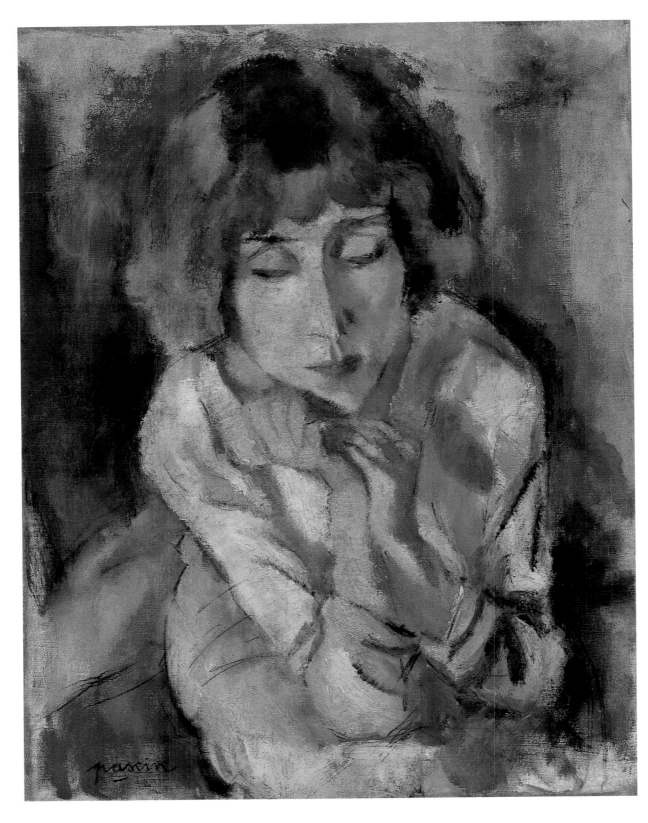

168

JULES PASCIN. American, born Bulgaria, 1885–1930
83. PORTRAIT OF HERMINE DAVID, C. 1914–19
oil on canvas
20 x 15 ¼ (50.8 x 38.7)
Collection Albright-Knox Art Gallery, Buffalo, New York
Bequest of A. Conger Goodyear, 1966

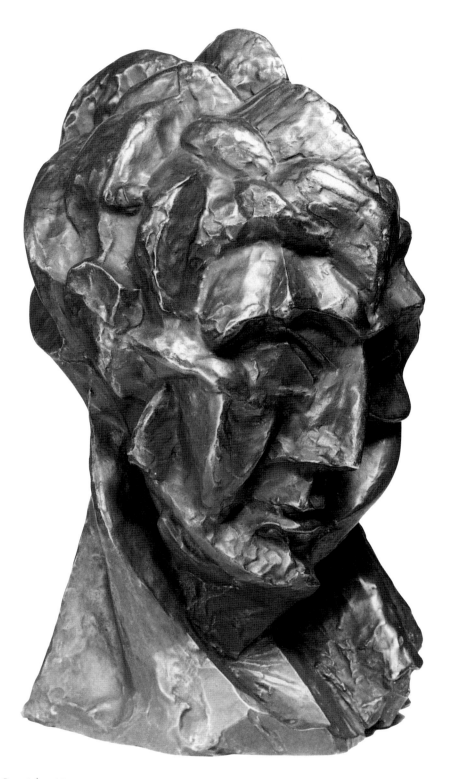

PABLO PICASSO. Spanish, 1881–1973
84. WOMAN'S HEAD, 1909
bronze
16 ¼ x 10 ⅜ x 10 ¾ (41.3 x 26.4 x 27.3)
Collection Albright-Knox Art Gallery, Buffalo, New York
Edmund Hayes Fund, 1948

DIEGO RIVERA. Mexican, 1886–1957
85. PORTRAIT OF ILYA EHRENBURG, 1915
oil on canvas
43 ⅜ x 35 ¼ (110.2 x 89.5)
Algur H. Meadows Collection, Meadows Museum, Southern Methodist University, Dallas, Texas
© 2002 Banco de México Diego Rivera & Frida Kahlo Museums Trust, Av. Cinco de Mayo No. 2, Col.
Centro, Del. Cuauhtemoc, 06059, México, D.F.
Fort Worth only

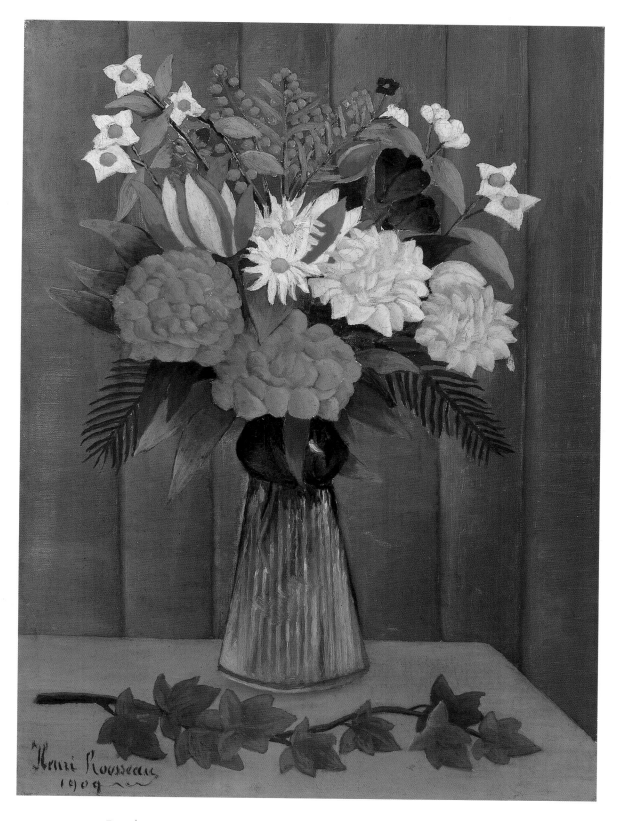

HENRI ROUSSEAU. French, 1844–1910
86. FLOWERS IN A VASE, 1909
oil on canvas
17 ⅞ x 12 ⅞ (45.4 x 32.7)
Collection Albright-Knox Art Gallery, Buffalo, New York
Room of Contemporary Art Fund, 1939

172

CHAÏM SOUTINE. French, born Lithuania, 1893–1943
87. PAGE BOY AT MAXIMS, c. 1927
oil on canvas
51 x 26 (129.5 x 66)
Collection Albright-Knox Art Gallery, Buffalo, New York
Edmund Hayes Fund, 1953
© 2002 Artists Rights Society (ARS), New York/ADAGP, Paris

MODIGLIANI IN PARIS

This chronology serves as an overview of Amedeo Modigliani's time in Paris and relies heavily on biographical information provided in Jeanne Modigliani's *Modigliani: Man and Myth*. Translated by Esther Rowland Clifford (New York: Orion Press, 1958) and Noël Alexandre's *The Unknown Modigliani: Drawings from the Collection of Paul Alexandre* (New York: Harry N. Abrams, 1993). For a comprehensive listing of Modigliani's exhibitions and reviews during this time period, please refer to the exhibition history in this book.

1884 JULY 12
Amedeo Clemente Modigliani is born in the large, cosmopolitan port town of Livorno, Italy, near Pisa.

1906 EARLY 1906
Modigliani arrives in Paris, staying initially at a hotel near the Madeleine.

Rents a studio on rue Caulaincourt in Montmartre.

Other early addresses in Paris include the Hôtel du Poirier, the Hôtel du Tertre, and the Bâteau Lavoir—the famous artists' residence, where such tenants as Kees van Dongen, Juan Gris, Fernande Olivier and Pablo Picasso lived.

Also rents a shed built of tile and wood at 7, place J.-B. Clément, a few yards away from the Bâteau Lavoir.

FALL
Meets the German Expressionist painter Ludwig Meidner.

OCTOBER–NOVEMBER
Sees Paul Gauguin retrospective at the Salon d'Automne with Meidner.

DECEMBER
Meets artist Gino Severini.

1907 Meets critic and dealer Adolphe Basler.

Meets writer Blaise Cendrars.

Picasso paints *Les Demoiselles d'Avignon* at the Bâteau Lavoir. Modigliani probably sees it in Picasso's studio.

Picasso and poet Guillaume Apollinaire are close friends; Modigliani most likely meets Apollinaire during this time.

OCTOBER 1–22
Exhibits in the Salon d'Automne where there is a Paul Cézanne retrospective. Modigliani's address is listed in the catalogue as 7, place J.-B. Clément.

NOVEMBER–DECEMBER
Meets collector Paul Alexandre, who will be his doctor and patron (cat. no. 3). (Remains in close contact with Alexandre until the beginning of World War I.)

DECEMBER
Enrolls as a Sociétaire of the Société des Artistes Indépendants. Address given as 7, place Jean-Baptiste Clément.

1908 Spends time working at 7, rue du Delta, a run-down house in the ninth arrondissement owned by Alexandre and his brother, Jean, who rent living quarters and studio spaces to artists. (Modigliani appears to have only worked there.)

Sculptor Constantin Brancusi moves to Montparnasse from the first arrondissement.

Alexandre introduces Brancusi to Modigliani.

MARCH 20–MAY 2
Exhibits six works at the Salon des Indépendants: the catalogue lists his address as 7, place J.-B. Clément, Paris 18e. Apollinaire gives poetry readings as part of the Society's "L'Après-Midi des Poètes."

Modigliani is mentioned by Louis Vauxcelles in *Gil Blas*.

NOVEMBER 21
Banquet in Picasso's studio at the Bâteau Lavoir in honor of painter Henri Rousseau. Modigliani may have attended since he knew both Picasso and Rousseau.

1909 MARCH 25
Visits preview of the Salon des Indépendants.

APRIL
Receipt for rent shows him to be living at 14, Cité Falguière, a group of artists' studios in Montparnasse.

APRIL 26–MAY 8
Elie Nadelman has a solo exhibition at the Galerie E. Druet. Modigliani most likely sees this exhibition.[1]

JUNE–SEPTEMBER
Travels to Livorno. While in Livorno, he and his aunt Laura write philosophical articles together.[2]

AUGUST
Paints the *Beggar*, also known as the *Beggar of Livorno* (Ceroni 24), dating it with the month and year. (It was shown the subsequent year in the Salon des Indépendants.)

SEPTEMBER 5
Writes to Alexandre from Livorno and requests registration forms for the Salon d'Automne, but ultimately, does not participate.

LATE 1909–LATE 1910
Henri Gaudier (who would later change his name to Henri Gaudier-Brzeska in 1911) lives in Paris on the outskirts of Montparnasse, at 14, rue Bernard-Palissy. Gaudier probably meets Modigliani during this time.

1909–1914 Sees African and Cambodian art in Montparnasse at the gallery of Joseph Brummer and at the Musée Ethnographique du Trocadéro, which he visits with Alexandre. Inspired by his discovery of African art, sculpture becomes primary, though not sole, activity.

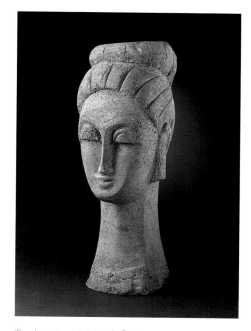

(fig. 1) MODIGLIANI. *Head of a Woman.* 1911–12
Sandstone, 22 ½ x 8 x 10 ½" (57.2 x 20.3 x 26.7 cm.)
Private Collection

1910 JANUARY 10–22
Major Cézanne exhibition at the Galerie Bernheim-Jeune in Paris, which Modigliani visits.

MARCH 18–MAY 1
Exhibits six works at the Salon des Indépendants. His address is listed in the catalogue as 14, Cité Falguière, Paris 15e.

Apollinaire mentions Modigliani in his review of the exhibition.

1910–1911 In contact with the Russian poet Anna Akhmotova.

1911 Edward Roworth, a South African painter living in London, purchases a sculpture from Modigliani, for which he reportedly pays five pounds sterling.

MARCH
Brancusi sends Modigliani's calling card, which lists address as 14, Cité Falguière, to Alexandre, inviting him to an exhibition opening at Amadeo de Souza Cardoso's studio.

MARCH 5
Exhibition opens in the studio of Modigliani's

good friend Souza Cardoso at 3, rue Colonel-Combes.

APRIL 21–JUNE 13
Exhibits six works at the Salon des Indépendants. His address is listed as 14, Cité Falguière, Paris 15e. The first major manifestation of the Cubists—works by Robert Delaunay, Albert Gleizes, Fernand Léger, Henri Le Fauconnier, and Jean Metzinger—were grouped together in Salle 41 of the exhibition.

SEPTEMBER
Meets his aunt Laura in Yport, staying at the Villa André and visits Fécamp.

1912 Meets the Russian journalist and poet Ilya Ehrenburg.

Meets Futurist artist Carlo Carra.

Piet Mondrian moves to Montparnasse.

SPRING–SUMMER
Meets Jacques Lipchitz through Max Jacob.

JUNE–OCTOBER
Jacob Epstein is in Paris to install his *Tomb of Oscar Wilde* in the Père Lachaise cemetery, and sees Modigliani daily.

OCTOBER 1–NOVEMBER 8
Exhibits a group of seven sculptures in the Cubist Room at the Salon d'Automne. Each is listed as "Tête, ensemble décoratif (sculpture)." His address is listed as 14, Cité Falguière, Paris 15e.

1913 Chaïm Soutine arrives in Paris.

JANUARY–AUGUST
Epstein returns to Paris. English painter Augustus John visits Paris and spends time with Epstein and Modigliani. John purchases two Modigliani sculptures, paying "several hundred francs" for them.[3] This purchase allows Modigliani to return to Italy.[4]

APRIL 15–JUNE 12
Returns to Livorno to sculpt. Writes to John from Livorno to say he is doing well.[5]

JUNE 13
Visits Lucca, Italy. Writes a letter to Alexandre, mentions that he is sending two marbles and returning to Paris imminently.

OCTOBER 1913–MAY 1915
Giorgio de Chirico lives at 9, rue Campagne-Première, a few doors away from Chez Rosalie, having moved from 115, Notre-Dame-des-Champs, also in Montparnasse. De Chirico is most likely in regular contact with Modigliani during this time.

1914 Meets the precocious twenty-three year-old art dealer Paul Guillaume, through Jacob.

Guillaume begins to purchase Modigliani's work and encourages him to turn to painting.

FEBRUARY–AUGUST
Spends this period sculpting and drawing instead of painting.

Attends Marie Vassilieff's annual party with Apollinaire.

Visits the Café de la Rotonde every day, and Chez Rosalie every evening.[6]

Meets English painter, Nina Hamnett, at Chez Rosalie upon her arrival in February.

Hamnett is in close contact with Modigliani, who was living on the boulevard Raspail, and purchases his drawings—for five francs or less—whenever she can.

Hamnett introduces Modigliani to poet Beatrice Hastings.[7]

Hastings and Modigliani become romantically involved.

Wyndham Lewis visits from London to arrange for the publication of his Vorticist magazine *Blast* (Paris).

Hamnett returns to England upon the outbreak of war.[8]

MAY 8–JUNE 20
Exhibits two works at the Whitechapel Art Gallery in an exhibition called *Twentieth-Century Art:*

A *Review of Modern Movements*. Modigliani's works are seen in the "Jewish Section" along with art by David Bomberg, Horace Brodsky, Mark Gertler, Nadelman, and Jules Pascin. The exhibition also includes work by Vanessa Bell, Epstein, Roger Fry, Gaudier-Brzeska, Duncan Grant, Lewis, Paul Nash, R.W. Nevinson, Lucien Pissarro, Walter Sickert, and Stanley Spencer.

JUNE
Art dealer Léopold Zborowski moves to Paris from Krakow.

JUNE 20
Gaudier-Brzeska mentions Modigliani in the Vorticist journal *Blast*.

AUGUST OR OCTOBER
André Level begins collecting Modigliani's work: pays between fifteen and sixty francs per piece. Georges Menier, an M. Parent, Paul Poiret, and various Scandinavians also begin to collect Modigliani's work.

1915 Resides with Hastings at 13, rue Norvins, in a little house in Montmartre.

FEBRUARY
Vassilieff's canteen opens at 21, avenue du Maine, where Modigliani becomes a regular.

MARCH 25
Arvid Fougstedt creates a drawing of Vassilieff's canteen, which includes a depiction of Modigliani.

SEPTEMBER
Creates a series of drawings and paintings of Guillaume (cat. no. 7).

NOVEMBER 1
Using Lucien Lefebvre-Foinet, Guillaume sends various works to Marius de Zayas at the Modern Gallery, 500 Fifth Avenue, New York. The shipment includes African sculptures and twenty-four works by Modigliani: twenty drawings (fifteen francs each); a pastel (twenty-five francs); a painting (fifty francs); and two "original stone sculp-

tures" (200 francs each). The African pieces range in price from seventy-five to 450 francs.[9]

NOVEMBER 9
Resides at 13, place E.-Goudeau (the Bâteau Lavoir); rented for him by Guillaume.

Writes to his mother that his paintings are selling.

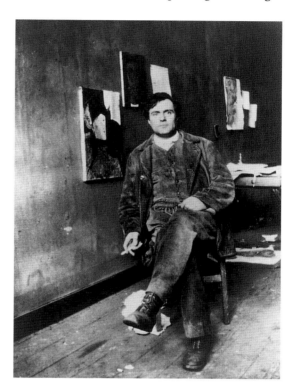

(fig. 2) Modigliani in his studio on the rue Ravignan, 1915–16

(fig. 3) Around 1915, Modigliani (second from right) sat for this photograph with Adolphe Basler (second from left) and others, probably at the Café de la Rotonde, on the boulevard du Montparnasse.

178

DECEMBER
Article by Jacob, "La Vie Artistique" is published in French in the New York avant-garde periodical 291 and mentions Modigliani.

1916 Ezra Pound's *Gaudier-Brzeska: A Memoir* is published in New York and London, and reprints Gaudier's article "The Vortex", which mentions Modigliani.

Moïse Kisling introduces Modigliani to Zborowski, who becomes Modigliani's dealer.

Modigliani introduces Soutine to Zborowski.[10]

Modigliani paints a double portrait of Lipchitz and his new bride.

JANUARY 15–FEBRUARY 1
Visits Severini's solo exhibition, *1st Futurist Exhibit of the Plastic Arts of the War and Other Previous Works*, at the Galerie Boutet de Monvel, 18, rue Tronchet. Serge Ferat, André Lhôte, Lipchitz, Metzinger, Baroness d'Oettingen, Picasso, and Léopold Survage also visit the exhibition.

FEBRUARY
Article by Jacob, "La Vie Artistique," is published in French in the New York Dada periodical 291. The article devotes a paragraph to Modigliani.

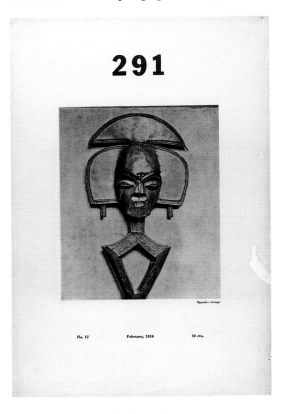

MARCH
Noir et Blanc, the second exhibition organized by Germaine Bongard, Poiret's sister, opens at her dressmaking shop on the rue de Penthièvre. Drawings by Modigliani are included.

MARCH 8–22
Exhibition of Sculpture at de Zayas's Modern Gallery in New York includes works by Brancusi, Modigliani, Adelheid Lange Roosevelt, Adolf Wolff, and Alice Morgan Wright.

APRIL
Modigliani draws Picasso at the Café de la Rotonde. While at the Rotonde with Modigliani, Hastings, Picasso, and Salmon, Walther Halvorsen proposes an exhibition of French art in Oslo, Norway, which will open at the Kunsterforbunderet in Oslo on November 22, 1916. Halvorsen asks Modigliani to make the drawing

of Picasso on the spot, which he does. For payment, Halvorsen buys drinks for Modigliani and Hastings, and gives him ten francs in addition.[11]

MAY 15
A Dada publication appears in Zurich, *Cabaret Voltaire: Recueil Litteraire et artistique*, edited by Hugo Ball. It features a pencil portrait of Jean (Hans) Arp by Modigliani.

JUNE
Exhibition at Cabaret Voltaire, Zurich, includes works by Arp, Marcel Janco, Auguste Macke, Modigliani, Nadelman, and Picasso.

JULY 16–31
Salon d'Antin exhibition, sponsored by Poiret, features works by de Chirico, André Derain, van Dongen, Raoul Dufy, Roger de la Fresnaye, Othon Friesz, Valentine Gross, Halvorsen, Frank Burty Haviland, Henri Hayden, Kisling, Léger, Matisse, Modigliani, Chana Orloff, Mánuel Ortiz de Zarate, Picasso, Georges Rouault, Severini, and Vassilieff among others. The exhibition receives attention in the Paris press.

JULY 21
A poetry reading is presented in conjunction with the Salon d'Antin. Jacob's "Christ in Montparnasse" is read, as is an excerpt of Hastings's unpublished novella "Minnie Pinnikin," a love story based upon her relationship with Modigliani.

AUGUST 12
Modigliani spends the day in Montparnasse with Jean Cocteau, Jacob, Picasso, Ortiz de Zarate, Henri-Pierre Roche, and Salmon. Cocteau photographs them.[12]

OCTOBER
Roche has an appointment to make a visit to Modigliani's studio, but leaves the night before for the United States, where he stays until February 1919. Before leaving, he gives money to his friend Angel Zarraga to buy a painting from Modigliani on his behalf. Upon his return, he finds he is the owner of a portrait of Jacob (Collection Cincinnati Art Museum).[13]

NOVEMBER 16
Modigliani writes to his mother to say that his financial situation is better than before.

NOVEMBER 19–DECEMBER 5
The first Lyre et Palette exhibition features more than fourteen paintings by Modigliani. Jacob, Kisling, Modigliani, Ortiz de Zarate, Picasso, and Erik Satie attend the opening.

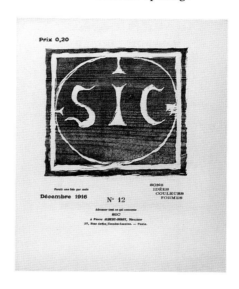

(fig. 6) Cover of the periodical SIC, December 1916. This issue mentioned Modigliani's participation in the Lyre et Palette exhibition and gave a review of the show.

1916–1917 Paints a series of nudes.

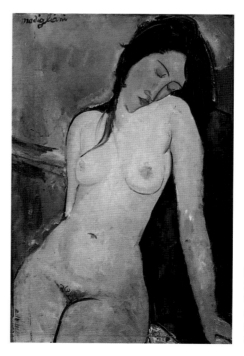

(fig. 7) MODIGLIANI.
Seated Female Nude. 1916
Oil on canvas
36 ¼ x 23 ⅝" (92.1 x 60 cm.)
Collection The Courtauld Institute
Gallery, Somerset House, London

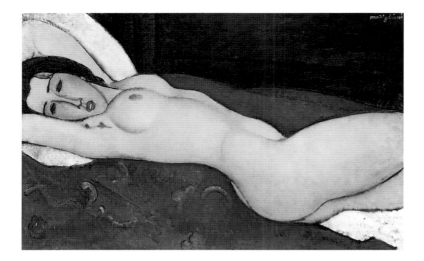

(fig. 8) MODIGLIANI. *Reclining Nude.* 1917
Oil on canvas, 23 ⅞ x 36 ½" (60.6 x 92.7 cm.)
Collection The Metropolitan Museum of Art, New York
The Mr. and Mrs. Klaus Perls Collection, 1997 (1997.149.9)
Photo © 2002 The Metropolitan Museum of Art, New York

1917 WINTER
Zborowski gives Modigliani a room in his apartment at 3, rue Joseph-Bara as a studio where Modigliani paints many of his nudes.[14]

JANUARY 14
Vassilieff and Jacob organize a banquet for Georges Braque to celebrate his discharge from the army after a long convalescence.[15] Cendrars, Gris, Hastings, Léger, Matisse, Modigliani, and Picasso attend.

APRIL 17
Modigliani paints a portrait of art dealer Georges Chéron.

MAY 1–20
A group exhibition at Galerie Chéron includes work by Modigliani.

MAY 2–29
Exhibits works at the Galerie Dada, Zurich.

MAY 15
Nord-Sud features an advertisement for works by Cézanne, de Chirico, Derain, Modigliani, Matisse, Picasso at the Galerie Paul Guillaume, 16, avenue de Villiers.

JUNE
Meets Jeanne Hébuterne and moves with her into 8, rue de la Grande-Chaumière.

JUNE 11
In a letter to Picasso, Jacob writes, "Yesterday, Satie, Modigliani and I discussed the differences and similarities between the good lord and you, seriously.[16]

(fig. 9) Advertisement for the exhibition *Sculptures Nègres* at Galerie Paul Guillaume, Paris, in *Nord-Sud*, August-September 1917, p. 32

AUGUST–SEPTEMBER
Nord-Sud repeats the advertisement for the Galerie Paul Guillaume, 16, avenue de Villiers.

DECEMBER 3–30
Modigliani's only solo exhibition during his lifetime opens at the Galerie Berthe Weill.

1918 APRIL
Hébuterne, now pregnant, and Modigliani leave for the French Riviera to sit out the war in safety.[17] In contact with other artists in the south of France: Alexander Archipenko, Pierre Bertin, Cendrars, Tsugouharu Foujita, Kisling, Gaston and Renée Modot, Pierre-Auguste Renoir, Morgan Russell, Soutine, and Germaine Survage.

While on the Riviera, Modigliani paints many children, peasants, servants, and shop girls (cat. nos. 35–37).

Modigliani lives at the Hôtel Tarelli, 5, rue de France; 13, rue de France; and the villa of Anders and Rachel Osterlind, "La Riante" in Cagnes, near Renoir's villa "Les Collettes."

NOVEMBER 11
Armistice Day

NOVEMBER 29
Modigliani's daughter Jeanne is born in the Saint-Roch hospital, Nice.

DECEMBER 15–23
Exposition Peintres d'Aujourd'hui at the Galerie Paul Guillaume, 108, rue Faubourg Saint-Honoré, Paris, includes four paintings by Modigliani. The other artists featured in the exhibition are: de Chirico, Derain, de la Fresnaye, Matisse, Picasso, Maurice Utrillo, and Maurice de Vlaminck. Among those at the opening are Roger Allard, Bernheim, Jacques-Emile Blanche, Bongard, Bontet de Monvel, Jacques Doucet, Louise Faure Favier, Gustave Fuss-Amoré, André Gide, Natalie Gontcharova, the Count de Gouy, Joseph Hessel, Alphonse Kahn, Albert Marquet, Menier, Picasso, Poiret, the Princess of Polignac, Salmon, Gertrude Stein, and Vauxcelles.

DECEMBER 31
Spends New Year's Eve with Léopold Survage at the Coq d'Or, Nice.

(fig. 11) MODIGLIANI. *Landscape.* 1919
Oil on canvas, 23 5/8 x 17 3/4" (60 x 45 cm.)
Private Collection
The artist painted this landscape during his stay
on the Riviera from 1918 to 1919

(fig. 10) Paul Guillaume and Modigliani stroll on the Promenade des Anglais in Nice, most likely during the winter of 1918–19.

(fig. 12) Rachel Osterlind, with portrait painted by Modigliani in the background.

1919 FEBRUARY

An article by Fry, "Line as a Means of Expression," appears in this issue of *The Burlington Magazine*, accompanied by two illustrations by Modigliani.

FEBRUARY 27

Modigliani writes to Zborowski from the south of France saying that he will start working at 13, rue de France, Nice.

MARCH 28

Paintings, watercolors, pastels, and drawings by Derain, van Dongen, Dufy, Modigliani, Picasso, Vlaminck, and others from the collection of Eugene Descaves are sold at the Hôtel Drouôt auction house in Paris.[18]

(fig. 13) This cover of the May 1919 issue of *Les Arts à Paris* was designed by Natalia Gontcharova. The *Peintre d'Aujourd'hui* exhibition and Modigliani are discussed therein.

MAY 27

Receives a receipt for his request for an identity card, with address given as "Villa la Riante" in Cagnes.

MAY 31

Modigliani leaves the Riviera for Paris, settling at 8, rue de la Grande-Chaumière.

JUNE 24

Hébuterne, who remained in the south, wires Modigliani in care of Zborowski, 3, rue Joseph-Bara, asking for money for the trip to Paris.

JUNE 28

The Versailles Treaty is signed officially ending war with Germany.

JULY

Attends the exhibition of Mikhail Larionov and Gontcharova at the Galerie Barbazanges.

JULY 7

Modigliani writes a document promising to marry Hébuterne.

JULY 15

An article on Modigliani appears in *L'Éventail: Revue de Littérature et d'Art*, published in Geneva, Switzerland.

AUGUST

Modigliani is featured in *Exhibition of French Art 1914-1919*, organized by Osbert and Sacheverell Sitwell, at the Mansard Gallery, Tottenham Court Road, London. Nine paintings and fifty drawings are exhibited including the *Little Peasant* (now at the Tate, London). Other artists featured include Derain, Marthe Tour Donas, Friesz, Alice Halicka, Hayden, Kisling, Léger, Lhôte, Louis Marcoussis, Matisse, Picasso, Russell, Soutine, Survage, Suzanne Valadon, Vassilieff, and Vlaminck.

FALL

Art and Letters reproduces a drawing by Modigliani.

(fig. 14) MODIGLIANI, *Woman's Head*, appeared in the Autumn 1919 issue of *Art and Letters*.

SEPTEMBER
An article in *The Burlington Magazine* discusses Modigliani.

OCTOBER
Thora Dardel moves to Paris.

NOVEMBER
Francis Picabia's Dada publication *391* provides an account of the Salon and notes that Modigliani is exhibiting. The list also mentions Gleizes, Matisse, Picabia, Vlaminck, and Ossip Zadkine.

NOVEMBER 1
Les Arts à Paris reproduces Modigliani's painting *La Jolie Fille Rousse*.

NOVEMBER 1–DECEMBER 10
Modigliani exhibits at the Salon d'Automne. Lists the address of his dealer Zborowski 3, rue Joseph-Bara, as his own.

(fig. 15) Cover of *Les Arts à Paris*, November 1, 1919. This issue features Modigliani's painting *La Jolie Fille Rousse*.

DECEMBER
Littérature refers to Modigliani's participation in the Salon d'Automne.

Coterie available in London and New York, features a drawing of Paul Delay by Modigliani. The editorial committee of that issue of *Coterie* consists of Richard Aldington, T.W. Earp, T.S. Eliot, Russell Green, Hamnett, Aldous Huxley, and Lewis. Other issues of *Coterie* around that time featured drawings by Archipenko, Derain, Gaudier-Brzeska, Kisling, Sickert, and Zadkine. Paints Paulette Jourdain (Ceroni 333), Zborowski's assistant and maid. This may have been the last work painted by Modigliani.

1920 JANUARY 24
Modigliani dies of tubercular meningitis.

JANUARY 26
Hébuterne, who is nine-months pregnant with their second child, commits suicide by jumping out of her fifth-floor bedroom window.

JANUARY 27
Modigliani is buried in Père Lachaise cemetery.

"Ceroni" refers to the numbers assigned to Modigliani paintings and sculptures in Ambrogio Ceroni, *I dipinti di Modigliani*, Introduction by Leone Piccioni (Milan: Rizzoli, 1970); French edition, *Tout l'Oeuvre Peint de Modigliani*. Introduction by Françoise Cachin. Translated by Simone Darses (Paris: Flammarion, 1972).

PREFACE

1 Billy Klüver and Julie Martin, *Kiki's Paris: Artists and Lovers, 1900–1930* (New York: Harry N. Abrams, 1989), p. 91.

2 Charles Douglas, *Artist Quarter: Reminiscences of Montmartre and Montparnasse in the First Two Decades of the Twentieth Century* (London: Faber and Faber, 1941), pp. 303–308. See also Simone Thirioux's letter to Modigliani, 1919, in Jeanne Modigliani, *Modigliani: Man and Myth* (New York: Orion Press, 1958), pp. 115–16.

3 Joseph Lanthemann, *Modigliani Catalogue Raisonné* (Barcelona: Gráficas Condal, 1970), p. 79.

4 Pierre Sichel, *Modigliani: A Biography* (New York: E.P. Dutton, 1967).

5 According to the official death certificate, he died at 9:45 p.m. on January 24, 1920. Copy in the Alberto G. D'Atri papers, Archives of American Art / Smithsonian Institution.

6 See for example, Norman L. Kleeblatt and Kenneth E. Silver, eds., *An Expressionist in Paris: The Paintings of Chaim Soutine* (New York: Jewish Museum in association with Prestel, 1998).

7 Both Jean Cocteau and Ilya Ehrenburg made this comment.

8 Noël Alexandre, *The Unknown Modigliani: Drawings from the Collection of Dr. Paul Alexandre* (New York: Harry N. Abrams, 1993).

9 Paul Guillaume, "Lettre ouverte à Francis Carco," *Les Arts à Paris* (Paris), June 1927, p. 24.

10 There are three publications of special importance that address Montparnasse. The first to seriously tackle the subject was the excellent 1985 exhibition catalogue *Circle of Montparnasse: Jewish Artists in Paris, 1900 to 1945* by Kenneth E. Silver and Romy Golan (New York: The Jewish Museum). It was soon followed by the landmark book *Kiki's Paris: Artists and Lovers, 1900–1930*. Most recent is the exhibition catalogue *École de Paris, 1904–1929, la Part de l'autre* (Paris: Musée d'Art Moderne de la Ville de Paris, 2000).

11 Douglas, *Artist Quarter*, pp. 300–301.

12 Jacques Lipchitz, *Amedeo Modigliani (1884–1920)* (New York: Harry N. Abrams, 1954), n.p.

13 Jean Cocteau in "Ce Numéro est consacré à Amadeo Modigliani," *Paris-Montparnasse* (Paris), February 1930, p. 17. Translation from French into English by the author.

14 Editorial, *Paris-Montparnasse* (Paris), February 1930, p. 27. Translation from French into English by the author.

MODIGLIANI AND MONTPARNASSE

1 See Noël Alexandre, *The Unknown Modigliani: Drawings from the Collection of Dr. Paul Alexandre*, trans. Christine Baker and Michael Raeburn (New York: Harry N. Abrams, 1993), p. 59 for Modigliani's rent receipt for 14, Cité Falguière in Montparnasse, dated April 1909. Other parts of the book suggest that he may have moved there in 1908. On Modigliani's thirteen-month absence from Montparnasse from April 1918 to May 1919, see "Montparnasse Heads South: Archipenko, Modigliani, Matisse and WWI Nice," in Kenneth Wayne, ed., *Impressions of the Riviera: Monet, Renoir, Matisse and their Contemporaries* (Portland, Maine: Portland Museum of Art, 1998), pp. 27–37. He also went home to Livorno in 1909 and 1913 for visits lasting a few months. See Chronology in this book for details.

2 Anonymous, "La Chasse aux Modèles," *Gil Blas* (Paris), November 12, 1913, p. 4.

3 Max Goth, "Deux Artistes polonais," *Gil Blas* (Paris), August 3, 1913, p. 4.

4 André Warnod, *Les Berceaux de la Jeune Peinture* (Paris: Albin Michel, 1925), p. 214.

5 Marcel Duchamp quoted in Jimmie "The Barman"

Charters, *This Must Be the Place: Memoirs of Montparnasse* (1934; reprint New York: Collier Books/MacMillan Publishing Company, 1989), pp. 100–101.

6 For his early drawings, see especially Alexandre, *The Unknown Modigliani*. For early paintings, refer to Ambrogio Ceroni, *I dipinti di Modigliani*, intro. by Leone Piccioni (Milan: Rizzoli, 1970); French edition, *Tout l'Oeuvre Peint de Modigliani*, intro. by Françoise Cachin; trans. Simone Darses (Paris: Flammarion, 1972). Pagination is the same in both editions. Hereafter, all notes refer to the original Italian edition.

7 Alexandre, *The Unknown Modigliani*, p. 67.

8 Ibid., p. 92.

9 Ibid.

10 In the catalogue of the Salon de la Société Nationale des Beaux-Arts of 1907, his address is listed as 16, place Dauphine in the first arrondissement. In the 1908 salon catalogue of the same Société, his address is listed as 54, rue du Montparnasse.

11 See especially "Mondrian in Montparnasse: The Rise and Fall of an Artist's Quarter" in the fascinating book *26, rue du Départ: Mondrian's studio in Paris, 1921–1936*, ed. Cees Boekraad (Berlin: Ernst & Sohn, 1995), pp. 19–29.

12 See "Biographical Notes [on Amedeo Modigliani] by his mother" in Alexandre, *The Unknown Modigliani*, pp. 28–32.

13 "Editorial: La Surveillance des étrangers," *Gil Blas* (Paris), May 16, 1910, p. 1.

14 Joseph Csáky's memoirs—Csáky, Joszef, *Emlekek a Modern Müzeszet nagy Evitzedeböl 1904–1914* (Budapest: Corvina, 1972)—are now available in translation in Edith Balas, *Joseph Csáky: A Pioneer in Modern Sculpture* (Philadelphia: American Philosophical Society, 1998) as Appendix B: "Memoirs from the Great Decade of Modern Art, 1904–1914," pp. 162 – 217; for this extract, see p. 212.

15 For a discussion of their soirées, see Gertrude Stein's *The Autobiography of Alice B. Toklas* (New York: Vintage Books, 1933).

16 For more on Gertrude Stein and the American aspect of Montparnasse, see the excellent study by Gail Stavitsky, *Gertrude Stein: The American Connection* (New York: Sid Deutsch Gallery, 1990).

17 For more on American artists in Paris, see Jocelyne Rotily, *Artistes américains à Paris, 1914–1939* (Paris: Éditions L'Harmattan, 1998).

18 Duchamp-Villon lived at 9, rue Campagne-Première early in his career. See George Heard Hamilton and William C. Agee, *Raymond Duchamp-Villon* (New York: Walker and Company, 1967), p. 126.

19 See the section on l'Institut Rodin in Alain Beausire, *Quand Rodin Exposait* (Paris: Éditions du Musée Rodin, 1988), pp. 164–69. See also André Warnod, *Les Berceaux de la Jeune Peinture* (Paris: Albin Michel, 1925), p. 215.

20 Letter to Dr. Uhlemayer, October 1909, in H.S. Ede, *Savage Messiah: A Biography of the Sculptor Henri Gaudier-Brzeska* (1931; reprint London: Gordon Fraser, 1971), p. 20.

21 See "Closerie des Lilas" in Billy Klüver and Julie Martin, *Kiki's Paris: Artists and Lovers, 1900–1930* (New York: Harry N. Abrams, 1989), pp. 24–25.

22 Ibid.

23 Ibid.

24 Fernande Olivier, *Loving Picasso: The Private Journal of Fernande Olivier* (New York: Harry N. Abrams, 2001), pp. 170–71.

25 Gino Severini, *Life of a Painter* (Princeton, New Jersey: Princeton University Press, 1995), p. 66.

26 Paul Fort, *Mes Mémoires: Toute la vie d'un poète, 1872–1943* (Paris: Flammarion, 1944), p. 85.

27 See a photo of the message board of the Café du Dôme in Sylvie Bonin, *Je me souviens du 14e arrondissement* (Paris: Parigramme, 1993), p. 56.

28 See Epstein letter to Rodin, September 12, 1912, in the Musée Rodin Archives, Paris.

29 Klüver and Martin, *Kiki's Paris*, p. 31.

30 Annette Gauthrie-Kampka, *Les Allemands du Dôme: la colonie allemande de Montparnasse dans les années 1903–1914* (Bern, Berlin, et al: Peter Lang SA,

Éditions scientifiques européennes, 1995). See also *Pariser Begegnungen, 1904–1914* (Duisburg, Germany: Wilhelm Lehmbruck Museum), and Friedrich Ahlers-Hestermann, "Der Deutsche Kunstlerkreis des Café du Dôme in Paris," *Kunst und Kunstler* (Berlin), no. 16, 1918, pp. 369–401.

31 See *Pariser Begegnungen, 1904–1914*.

32 Billy Klüver and Julie Martin, "Carrefour Vavin" in *The Circle of Montparnasse: Jewish Artists in Paris, 1905–1945* (New York: The Jewish Museum, 1985), pp. 70–71.

33 Anonymous, "La Rotonde," *Cri de Paris* (Paris), June 3, 1917, p. 10.

34 Klüver and Martin, *Kiki's Paris*, p. 63.

35 Ibid.

36 Charles Douglas, *Artist Quarter: reminiscences of Montmartre and Montparnasse in the first two decades of the twentieth century* (London: Faber and Faber, 1941), p. 143. See also Ilya Ehrenburg, *People and Life, 1891–1921* (New York: Alfred A. Knopf, 1962).

37 *L'École de Paris, 1904–1929, la part de l'autre* (Paris: Musée d'Art Moderne de la Ville de Paris, 2000), p. 374. Chez Rosalie reopened under new management in the 1930s.

38 Paolo Baldacci, *De Chirico: The Metaphysical Period 1888–1919* (Boston: Little, Brown and Company, 1997), pp. 164, 197, and 294–95.

39 "Souvenirs de Lunia Czechowska" in Ambrogio Ceroni, *Amedeo Modigliani, Peintre* (Milan: Edizioni del Milione, 1958), p. 28.

40 "Vassilieff's Canteen" in Klüver and Martin, *Kiki's Paris*, pp. 70–71.

41 Ibid.

42 Ibid.

43 Jean-Claude Delorme and Anne Marie Dubois, *Ateliers d'Artistes à Paris* (Paris: Éditions Parigramme, 1998), p. 86.

44 See note 1 in this essay for details.

45 Jeanine Warnod, *La Ruche & Montparnasse* (Geneva: Weber, 1978), p. 8.

46 See ibid. and Delorme and Dubois, *Ateliers d'Artistes à Paris*, pp. 87–93.

47 Jeanne Modigliani suggests in her book that her father lived there; see Jeanne Modigliani, *Modigliani: Man and Myth* (New York: Orion Press, 1958), p. 49. See also Warnod, *La Ruche & Montparnasse*, p. 184.

48 Balas, *Joseph Csáky*, p. 172.

49 Ibid.

50 Warnod, *La Ruche & Montparnasse*, passim.

51 Klüver and Martin, "Carrefour Vavin" in *The Circle of Montparnasse*, pp. 76–77.

52 Ibid.

53 Ibid.

54 For example, the four principal professors of sculpture at the Académie Julian over the years all taught at the École des Beaux-Arts as well. They were Henri-Michel-Antoine Chapu, Paul-Maximilien Landowski, Marius-Jean Antonin Mercié, and Raoul Verlet.

55 "Registre d'inscription des élèves dans les ateliers de peinture, sculpture, architecture, ateliers exterieurs, 1874–1945," École des Beaux-Arts Archives, Archives Nationales, Paris (AJ52/248).

56 See Catherine Fehrer, *The Julian Academy, Paris 1868–1939* (New York: Sheperd Gallery, 1989).

57 L. Verax, "De l'envahissement de l'École des Beaux-Arts par les étrangers. Réclamations des élèves français" (Paris: Imprimeries réunies, n.d.), p. 22. From internal evidence, the article can be dated to circa 1887.

58 Règlement de l'École nationale et spéciale des Beaux-Arts à Paris, 1902, article 108.

59 Règlement de l'École nationale et spéciale des Beaux-Arts à Paris, 1902, article 14.

60 Jacob Epstein, *An Autobiography* (1955; reprint New York: E.P. Dutton, 1963), p. 13.

61 Ibid., p. 16.

62 Alexandre, in *The Unknown Modigliani*, p. 11, says that Modigliani studied at the Ranson in 1908, when it was still located in Montmartre.

63 Interview by the author, Paris, May 28, 1992.

64 Klüver and Martin, *Kiki's Paris*, Map 2. See also Klüver and Martin, "Carrefour Vavin" in *The Circle of Montparnasse*, pp. 69–79.

65 Warnod, *Les Berceaux de la Jeune Peinture*, p. 217, and Jean-Emile Bayard, *Montparnasse: Hier et Aujourd'hui, ses Artistes et Écrivains étrangers et français le plus célèbres* (Paris: Jouve et Cie, 1927), p. 399.

66 See the list of students in Marit Werenskiold,

De Norske Matisse-Elevene, Laretid Og Gjennombrudd, 1908–1914 (Oslo: Gyldendal Norsk Forlag, 1972), pp. 192–208.

67 "Kassovyj octčet Russkoj Hudožestvennoj Akademii" Parižskij Vestnik, May 10, 1913, p. 4, in Jean-Claude Marcadé, "L'Avant-Garde Russe," Cahiers du Musée National d'Art Moderne, (Paris), October/December 1979, pp. 174–83.

68 Marevna, Life with the Painters of La Ruche, trans. Natalie Heseltine (New York: MacMillan, 1974), p. 27. Nina Hamnett also refers to the attendance of Modigliani and Zadkine at the Académie Russe. Nina Hamnett, Laughing Torso (New York: Ray Long and Richard R. Smith, 1932), pp. 57–58.

69 "Kassovyj octčet Russkoj Hudožestvennoj Akademii" Parižskij Vestnik, May 10, 1913, p. 4, in Jean-Claude Marcadé, "L'Avant-Garde Russe," Cahiers du Musée National d'Art Moderne, October/ December 1979, pp. 174–83.

70 Hamnett, Laughing Torso, p. 50.

71 Modigliani, Modigliani: Man and Myth, p. 38. She notes only that he studied there briefly in 1906 when he arrived in Paris and was living in Montmartre. It is highly likely that he would have returned when he moved to the rue de la Grande-Chaumière.

72 Marevna, Life with the Painters of La Ruche, p. 28.

73 Klüver and Martin, "Carrefour Vavin" in The Circle of Montparnasse, p. 77.

74 Pierre Muller, "Une visite chez Colarossi," Gil Blas (Paris), January 7, 1912, p. 4.

75 Ibid.

76 Marevna, Life with the Painters of La Ruche, p. 28.

77 A plaque on the front of the Academy indicates that it was opened in 1904.

78 Bayard, Montparnasse: Hier et Aujourd'hui, p. 307.

79 Jean-Pierre Vanderspelden, Jean-Antoine Injalbert, Satuaire, 1845–1933 (Béziers, France: Musée des Beaux-Arts, 1991), p. 17. A photo on page 15 shows Injalbert's modeling class at the Académie de la Grande Chaumière from circa 1907. It is unclear how many years Injalbert continued to teach there since there are no archives from the Academy. An official at the school told me that all records were destroyed when the current owner bought the

Academy in the 1950s.

80 Daniel Marquis-Sébie, Une leçon d'Antoine Bourdelle à la Grande Chaumière (Paris: L'Artisan du Livre, 1930), p. 12.

81 See the actual journals of L'Académie Julian.

82 Warnod, Les Berceaux de la Jeune Peinture, p. 217.

83 Student registers, Académie Julian Archives, Archives Nationales, Paris (Series 63 AS).

84 The students came from Norway, Iceland, Sweden, England, Germany, Austria, Switzerland, Russia, Hungary, the United States, and France. See the list of students in Werenskiold, De Norske Matisse-Eleven, pp. 197–208.

85 On March 17, 1913, the newspaper Commoedia announced that Archipenko would be opening an academy in his studio. The April 10, 1913, issue of Gil Blas announced that Archipenko opened an academy on that day. According to the catalogue of the Salon des Indépendants of March–April 1913, Archipenko's address at the time was 169 bis, boulevard du Montparnasse. In the early 1960s, he said in an interview that his Academy was located on the avenue du Maine, which means that it was near the Académie Russe. See Archipenko interview, Pierre Sichel Papers, Mugar Memorial Library, Boston University, Massachusetts.

86 Katherine Michaelsen quotes from the memoirs of a Hungarian student, Beni Ferenczy, in her brief description of Archipenko's Academy. See Katherine Michaelsen, Alexander Archipenko: The Early Works, 1907–1921 (New York and London: Garland Publishing, 1977), pp. 14–15.

87 Hamnett, Laughing Torso, pp. 67–68.

88 See discussion on "L'Institut Rodin" in Alain Beausire, Quand Rodin Exposait (Paris: Éditions Musée Rodin, 1988), pp. 164–69.

89 Alfred Ebelot's letter is dated March 24, 1900, and was printed in La Nacion (Buenos Aires), April 16, 1900, in Beausire, Quand Rodin Exposait, p. 167.

90 Académie des Beaux-Arts, Statuts et Règlement (Paris: Typographie de Firmin-Didot et Cie, Imprimeurs de l'Institut de France, 1908), Premier article, p. 62.

91 For more on this topic see Patrick Elliott, "Sculpture in France, 1918–1939" (Ph.D. diss., Courtauld

Institute of Art, University of London, 1991), passim.

92 January 31, 1920, in Douglas Cooper, ed., *Letters of Juan Gris, 1913–1927* (London: Privately printed, 1956), p. 75.

93 The subscription ledger or "cahier d'abonnement" for *Les Soirées de Paris*, currently in a private collection, was listed in *Les Soirées de Paris* (Paris: Galerie Knoedler, 1958), and was cited in Noémi Blumenkranz-Onimus, "Les Soirées de Paris ou le mythe du moderne" in *L'Année 1913* (Paris), vol.2, p. 1098.

94 An Italian army officer of noble Swiss lineage named Francesco Flugi d'Aspermont is the most likely candidate. See Francis Steegmuller, *Apollinaire: Poet Among The Painters* (1963; reprint New York: Penguin Books, 1986), pp. 16–19.

95 Guillaume Apollinaire, *Apollinaire on Art: Essays and Reviews, 1902–1908*, ed. LeRoy C. Breunig (1972; reprint New York: Da Capo Press, 1988).

96 William Rubin, "Picasso" in *"Primitivism" in 20th-Century Art* (New York: The Museum of Modern Art, 1984), p. 295.

97 Brummer's address comes from Joseph Csáky's memoirs in Balas, *Joseph Csáky*, p. 169. Csáky mentioned that he went directly to the Cité Falguière to see Brummer, who was also from Szeged, upon his arrival in Paris. Zoltan Szelesi's introduction to the memoirs mentioning Csáky's arrival in Paris in August 1908 is available only in Hungarian in Joseph Csáky, *Csáky, Joszef, Emlekek a Modern Müzeszet nagy Evitzedeböl 1904–1914*, p. 11.

98 From a six-page handwritten statement in Hungarian in the Brummer Archives, The Cloisters Collection/The Metropolitan Museum of Art, New York. The document is not a letter but might be the text of a speech or a toast at a dinner. Perhaps it was read at Brummer's wedding. The story ends with World War I. Hereafter referred to as the Sterne document.

99 Adolphe Basler, *Modigliani* (Paris: Les Éditions G. Crès, 1931), p. 9. From the English translation in Schmalenbach, *Modigliani*, pp. 185–86. The poetess was Beatrice Hastings (1879–1943).

100 The Brummer Archives, The Cloisters Collection/The Metropolitan Museum of Art, New York.

101 Ledger books, The Brummer Archives, The Cloisters Collection/The Metropolitan Museum of Art, New York.

102 Ibid.

103 "Brummer, József, szobrászi," *Délmagyroszág* (Budapest), December 25, 1910, p. 44.

104 Ibid.

105 There is a letter, dated 1904, indicating that he studied decorative sculpture. The Brummer Archives, The Cloisters Collection/The Metropolitan Museum of Art, New York.

106 "Brummer, József, szobrászi," *Délmagyroszág*, p. 44.

107 Ibid.

108 It appears, however, that Brummer returned to Hungary on a regular basis.

109 William H. Forsyth, "The Brummer brothers: an instinct for the beautiful," *Art News* (New York) October 1974, pp. 106–107, suggests 1917.

110 Brummer Archives, The Cloisters Collection/The Metropolitan Museum of Art, New York.

111 Alfred H. Barr, *Matisse: His Art and His Public* (New York: The Museum of Modern Art, 1951), pp. 116–17.

112 Ibid., p. 117.

113 Located in the Brummer Archives, The Cloisters Collection/The Metropolitan Museum of Art, New York.

114 Sterne document, Brummer Archives, The Cloisters Collection/The Metropolitan Museum of Art, New York. See note 98 of this essay.

115 Brummer Archives, The Cloisters Collection/The Metropolitan Museum of Art, New York, and Musée Rodin Archives, Paris.

116 "Brummer, József, szobrászi," *Délmagyroszág*, p. 44.

117 See the chapter "Modern Sculptors Collect Antiquities" in Kenneth Wayne, "The Role of Antiquity in the Development of Modern Sculpture in France 1900–1914" (Ph.D. diss., Stanford University, 1994).

118 Jean-Louis Paudrat, "From Africa" in William Rubin, *"Primitivism" in 20th-Century Art*, p. 144.

119 Sterne document, Brummer Archives, The Cloisters Collection/The Metropolitan Museum of Art,

New York.

120 Until around April 1910, the business was called Delhomme et Brummer. I have been unable to identify Delhomme. Starting in January 1912, it was called Brummer Frères when presumably his brother Ernest joined him.

121 This is documented in Brummer's ledger books, Brummer Archives, The Cloisters Collection/The Metropolitan Museum of Art.

122 See the Csáky memoirs in Balas, *Joseph Csáky*, p. 175.

123 This address is listed on the "Extrait du Registre d'Immatriculation" from the Service des Étrangers, Préfecture, Brummer Archives, The Cloisters Collection/The Metropolitan Museum of Art, New York. Two dated additions to the form note that Brummer moved twice after that: March 11, 1911, to 44, rue Jacob, and October 2, 1912, to 53, rue Notre-Dame des Champs.

124 Csáky memoirs in Balas, *Joseph Csáky*, p. 180.

125 Ibid.

126 Undated letter from Henri Rousseau to Joseph Brummer: "N'oublie pas que demain je te prendrai à une heure pour aller chez Picasso." Rousseau died in 1910. Letter reprinted in *Les Soirées de Paris* (Paris), January 15, 1914, p. 50.

127 See Klüver and Martin, *Kiki's Paris*, Map 2, p. 248. There is no indication from the ledger books that Picasso bought African works or anything else from Brummer. It is possible that he received African works as gifts or as exchanges with Brummer. Or perhaps he bought his African pieces directly from Paul Guillaume.

128 Csáky memoirs in Balas, *Joseph Csáky*, p. 171.

129 An unmarked newspaper clipping in the Kahnweiler auction catalogue kept at the Bibliothèque des Commissaires-Priseurs, Paris, lists the buyers of works at the sale.

130 Jacob Epstein, *An Autobiography*, p. 189.

131 Jacques Lipchitz with H.H. Arnason, *My Life in Sculpture* (New York: Viking Press, 1972), p. 32.

132 Irene Patai, *Encounters: The Life of Jacques Lipchitz* (New York: Funk and Wagnalls Company, 1961), p. 319.

133 Ibid.

134 Lipchitz with Arnason, *My Life in Sculpture*, pp. 9–10.

135 On December 7, 1921, Lipchitz bought "un bois nègre" from Brummer for 300 francs.

136 Before becoming a dealer of modern art in 1916, Léonce Rosenberg was a dealer in antiquities. It is possible that Lipchitz bought antiquities from him as well during the years 1909–1911.

137 Quoted in Lincoln Kirstein, *The Sculpture of Elie Nadelman* (New York: The Museum of Modern Art, 1948), p. 26.

138 Ibid.

139 "Défense de parler de Nadelman ici." Quoted ibid., p. 18.

MODIGLIANI AND THE AVANT-GARDE

1 Ernest Brummer, "Modigliani Chez Renoir" in *Paris-Montparnasse* (Paris), Special Issue, no. 13, February 1930, pp. 15–16. Partially reproduced in English in Werner Schmalenbach, *Modigliani: Paintings, Sculptures, Drawings* (Munich: Prestel), 1990, p. 198 in the section on Anders Osterlind.

2 Ibid.

3 Jeanne Modigliani situates the visit in 1919 and says that Renoir agreed to meet him because "I have heard that he is a great painter." See Jeanne Modigliani, *Modigliani: Man and Myth* (New York: Orion Press, 1958), p. 79. See also Pierre Sichel, *Modigliani: A Biography of Amedeo Modigliani* (New York: E.P. Dutton, 1967), pp. 409–412.

4 Jean Cocteau, *Modigliani* (Paris: Hazan and London: Zwemmer, 1950), n.p.

5 Ludwig Meidner, "The Young Modigliani: Some Memories," *The Burlington Magazine* (London), April 1943, p. 87ff.

6 Ibid.

7 Noël Alexandre, *The Unknown Modigliani: Drawings from the Collection of Dr. Paul Alexandre* (New York: Harry N. Abrams, 1993), p. 62.

8 Ibid.

9 Ibid.

10 Ibid.

11 Guillaume Apollinaire, "En fransk Utstilling," *Dagbladet* (Oslo), November 5, 1916. The current whereabouts of these drawings is unknown. In an e-mail dated April 6, 2001, curator Elsebeth Heyer-

dahl-Larsen of the Kunstnerforbundet informed me that *Dagbladet* no longer owns the drawings and that the Halvorsen family does not have them either.

12 Research reveals that the two artists exhibited together on at least ten occasions: Salon d'Automne of 1907; Salon des Indépendants of 1910 and 1911; an exhibition of black-and-white drawings at the salon of Madame Bongard, Paris, March 1916; in the exhibition *L'Art Moderne en France* at the Salon d'Antin, Paris, July 1916; in the first Lyre et Palette exhibition, Paris, November–December 1916; in the *Peintres d'Aujourd'hui* exhibition at the Galerie Paul Guillaume in December 1918; in the *Exhibition of French Art, 1914–1919* in Heal's Mansard Gallery in London, August–September 1919; and in the Salon d'Automne of 1919.

13 For more on Matisse in Nice, see Jack Cowart and Dominique Fourcade, *Henri Matisse: The Early Years in Nice, 1916–1930* (Washington, D.C.: National Gallery of Art in association with Harry N. Abrams, 1986).

14 Modigliani's portrait of her is reproduced in the brochure to the National Gallery of Art's Modigliani exhibition in 1984. For more on Vassilieff and her Cubist paintings, see *Marie Vassilieff (1884–1957), Eine Russische Künstlerin in Paris* (Berlin: Das Verborgene Museum, 1995).

15 See Jérôme Doucet, Preface in *XX Dessins* [of Amadeo de Souza Cardoso] (Paris, 1912).

16 Sichel, *Modigliani*, p. 416.

17 Marevna, *Life with the Painters of La Ruche*, trans. Natalie Heseltine (New York: MacMillan Publishing, 1974).

18 Georges Braque in Giovanni Scheiwiller, ed., *Amedeo Modigliani: Selbstzeugnisse, Photos, Zeichnungen, Bibliographie* (Zurich: Verlag der Arche, 1958), p. 79.

19 See Vassilieff's account in Frederick Wright, "Recollections of Modigliani by those who knew him," *Italian Quarterly* 2 (Boston), Spring 1958, pp. 41–43.

20 Juan Gris to Maurice Raynal, January 18, 1917, in Douglas Cooper, ed., *Letters of Juan Gris* [1913–1927; collected by Daniel-Henry Kahnweiler] (London: Privately published, 1956), letter no. LVI.

21 Billy Klüver and Julie Martin, *Kiki's Paris: Artists and Lovers, 1900–1930*, (New York: Harry N. Abrams, 1989), p.71.

22 Jeanne Modigliani, *Modigliani: Man and Myth*, p. 67. Unfortunately, little is known about Modigliani's relations with Gertrude Stein. It is likely that he regularly attended her Saturday night soirées.

23 Apparently, Juan Gris lived there from 1906 until 1922. See Jeanine Warnod, *Le Bâteau-Lavoir* (Paris: Les Presses de la Connaissance, 1975), p. 157. Warnod says that Modigliani was there in 1908. Jeanne Modigliani suggests that Modigliani was at the Bâteau Lavoir even earlier, soon after arriving in Paris; see Jeanne Modigliani, *Modigliani: Man and Myth*, pp. 39 and 49.

24 Léopold Survage in Enzo Maiolino, ed., *Modigliani Vivo: Testimonianze inedite e rare* (Turin: Fogoloa Editore, 1981), pp. 63–68. For an English translation of part of this text, see Schmalenbach, *Amedeo Modigliani*, pp. 202–203.

25 Jacques Lipchitz, *Amedeo Modigliani (1884–1920)* (New York: Harry N. Abrams, 1954), n.p.

26 Jacob Epstein, *Let There Be Sculpture* (New York: G.P. Putnam's Sons, 1940), p. 38.

27 Ibid.

28 Ibid., pp. 38–39.

29 Charles Douglas, *Artist Quarter* (London: Faber and Faber, 1941), pp. 75–76.

30 Ibid., p. 76.

31 See footnote 23 regarding Modigliani at the Bâteau Lavoir. Jeanine Warnod indicates that Picasso lived there from 1904 to 1909, and had a studio there until 1912, in her *Le Bâteau-Lavoir*, p. 157.

32 Reported in Douglas, *Artist Quarter*, p. 112.

33 Noël Alexandre, *The Unknown Modigliani*, p. 62. Vollard visited Picasso's studio in April 1906 and acquired virtually all of his recent work. See Marilyn McCully, ed., *Picasso, The Early Years, 1892–1906* (Washington, D.C.: National Gallery of Art, 1997), p. 49. Kahnweiler opened his rue Vignon gallery in the summer of 1907, and he did not offer Picasso a contract until 1912, so it is hard to pinpoint the date of this visit.

34 Louis Latourettes cited in Douglas, *Artist Quarter*, p. 85.

35 Klüver and Martin, *Kiki's Paris*, p. 76.

36 The two artists exhibited together in an exhibition of black-and-white drawings at the salon of Madame Bongard, March 1916; at the Cabaret Voltaire in Zurich, June 1916; at the exhibition *L'Art Moderne en France*, July 1916 at the Salon d'Antin in Paris; at the first Lyre et Palette exhibition in Paris, November–December 1916; at the exhibition *Peintres d'Aujourd'hui*, December 1918; and in the *Exhibition of French Art, 1914–1919* at Heal's Mansard Gallery, London.

37 Hélène Seckel-Klein with Emmanuelle Chevrière, *Picasso Collectionneur* (Paris: Réunion des Musées Nationaux, 1998), pp. 186–89.

38 André Level, *Souvenirs d'Un Collectionneur* (Paris: Alain C. Mazo, 1959), p. 41.

39 Douglas, *Artist Quarter*, p. 301.

40 Ibid.

41 Ibid.

42 Reported in William Fifield, *Modigliani: The Biography* (New York: William Morrow and Company, 1976), p. 285.

43 See his account in Maiolino, ed., *Modigliani Vivo*, pp. 109–15.

44 Alexandre, *The Unknown Modigliani*, p. 62.

45 Adolphe Basler, *Modigliani* (Paris: Les Éditions G. Crès, 1931), p. 6. From the English translation in Schmalenbach, *Amedeo Modigliani*, pp. 185–86.

46 Gino Severini, *The Life of a Painter* (Princeton, New Jersey: Princeton University Press, 1995), p. 81.

47 Alexandre in *The Unknown Modigliani*, p. 92 and Paul Guillaume in Maiolino, *Modigliani Vivo*, p. 169. For an English translation of part of Guillaume's text, see Schmalenbach, *Amedeo Modigliani*, pp. 193–94.

48 Mentioned by Anna Akhmotova, in Schmalenbach, *Amedeo Modigliani*, p. 184.

49 On Modigliani's portraits of Cendrars see Pierre-Olivier Walzer, "Cendrars vu par Modigliani," *Continent Cendrars*, no.5 (Bern: Centre d'Études Blaise Cendrars, 1990), pp. 52–59.

50 In his memoirs, Ehrenburg mentions that Modigliani drew him several times. Ilya Ehrenburg, *Men, Years, Life* (London: MacGibbon & Kee, 1962), pp. 149 –54. Reprinted in Schmalenbach, *Amedeo Modigliani*, p. 191.

51 He also made many drawings of Reverdy. See *À la Rencontre de Pierre Reverdy et ses Amis* (Paris: Musée National d'Art Moderne, 1970), pp. 44–45.

52 Roch Grey, "Modigliani," *L'Action* (Paris), December 1920, pp. 49–53.

53 Quoted in Schmalenbach, *Amedeo Modigliani*, p. 184.

54 Cocteau, *Modigliani*, n.p.

55 For more on these three photographs and others in the series see Billy Klüver, *A Day with Picasso* (Cambridge, Massachusetts, and London: MIT Press, 1997).

56 See Walzer, "Cendrars vu par Modigliani," *Continent Cendrars*, pp. 52–59.

57 Three of his poems are reproduced in *Les Arts à Paris* (Paris), October 1925, for example.

58 Noted in *The Unknown Modigliani*, p. 91.

59 Ibid., pp. 62–63.

60 Ehrenburg, *People and Life; Memoirs of 1891–1921* vol.1, pp. 149–54. Reprinted in Schmalenbach, *Amedeo Modigliani*, p. 191.

61 Ibid.

62 Basler, *Modigliani*, p. 8. For an English translation, see Schmalenbach, *Amedeo Modigliani*, pp. 185–86.

63 See the essay on Modigliani and his Lifetime Exhibitions for more on this important exhibition.

64 "Ce Portrait de Modigliani, je l'ai perdu le soir même" in Georges Auric, *Quand J'étais là* (Paris: Bernard Grasset, 1979), pp. 71–73.

65 Ibid.

66 See her account of the portrait sessions in Maiolino, ed., *Modigliani Vivo*, p. 60.

67 See Alexandre, *The Unknown Modigliani*, passim.

68 André Level, *Souvenirs d'Un Collectionneur* (Paris: Alain C. Mazo, 1959), pp. 41–42.

69 Many works from his collection can now be found at the Musée d'Art Moderne Lille Métropole, Villeneuve d'Ascq, where they were given by his nephew, Jean Masurel. See the special issue of *Galerie des Arts* (Paris), December 1983, devoted to "La Collection Dutilleul," and especially the article by Francis Berthier, "La merveilleuse et grande aventure de Roger Dutilleul," pp. 46–71.

70 Basler, *Modigliani*, pp. 10–11. English translation in Schmalenbach, *Amedeo Modigliani*, p. 186.

71 Guillaume in Maiolino, ed., *Modigliani Vivo*, pp. 169–73.

1 See the documentation in this book for Modigliani's lifetime exhibitions and for bibliographic references.

2 See Malcolm Gee, *Dealers, Critics, and Collectors of Modern Painting: Aspects of the Parisian Art Market between 1910 and 1930* (New York: Garland, 1981). Appendix J: Exhibitions of modern art in Paris, 1910–1930.

3 For more on the effect of the war on art in France, see the seminal book by Kenneth E. Silver, *Esprit de Corps: The Art of the Parisian Avant-Garde and the First World War, 1914–1925* (Princeton, New Jersey: Princeton University Press, 1989).

4 "Salon des Indépendants" in *L'École de Paris, 1904–1929, la part de l'autre* (Paris: Musée d'Art Moderne de la Ville de Paris, 2000), pp. 393–94.

5 "Salon d'Automne" in ibid., p. 394. The rest of the information in this paragraph derives from this source.

6 Louis Vauxcelles, *Gil Blas* (Paris), March 20, 1908, and Guillaume Apollinaire, "Watch Out for the Paint! The Salon des Indépendants, 6000 Paintings are Exhibited," *L'Intransigeant* (Paris), March 18, 1910, in *Apollinaire on Art: Essays and Reviews, 1902–1918*, ed. Leroy C. Breunig (1972; reprint New York: Da Capo Press, 1988), p. 68.

7 Apollinaire, ibid., p. 64.

8 Ibid., p. 65.

9 Ibid., p. 66.

10 Guillaume Apollinaire, "The Vernissage," *L'Intransigeant* (Paris), March 19, 1910, in *Apollinaire on Art*, p. 70.

11 See note from Brancusi to Paul Alexandre mailed on March 4, 1911, inviting him to "Modigliani's exhibition" the next day on March 5, 1911, in Noël Alexandre, *The Unknown Modigliani: Drawings from the Collection of Paul Alexandre* (New York: Harry N. Abrams, 1993), p. 100.

12 Ibid. Curiously, Souza Cardoso literature gives October as the date for that exhibition. See Joana Cunha Leal, "Amadeo de Souza Cardoso: A Biography," in *At the Edge: A Portuguese Futurist, Amadeo de Souza Cardoso*, ed. Laura Coyle (Washington, D.C.: Corcoran Gallery of Art, 1999), p. 18.

13 Kenneth Silver, "Amadeo in the Tower of Babel" in *At the Edge: A Portuguese Futurist*, ed. Laura Coyle, p. 53.

14 Jeanne Modigliani, *Modigliani: Man and Myth* (New York: Orion Press, 1958), p. 57. This English translation uses the word "sketches" while the original French referred to "gouaches."

15 See Salon d'Automne of 1912 and the Modern Gallery exhibition of March 1916. It appears to be the sculpture sold at the Hôtel Drouôt on Wednesday, June 15, 1927, lot. 6, illustrated. Its dimensions are given as "64 cent. ½; Larg., 19 cent."

16 Jeanne Modigliani, *Modigliani: Man and Myth*, p. 58.

17 Neither Alexandre, *The Unknown Modigliani* nor Jeanne Modigliani, *Modigliani: Man and Myth*, refers to it as a joint show. See *At the Edge: A Portuguese Futurist*, ed. Laura Coyle, p. 18, for the Souza Cardoso point of view.

18 John Golding, *Cubism: A History and Analysis, 1907–1914* (1959; reprint London: Faber and Faber Ltd., 1968), p. 24.

19 Jacques Lipchitz, *Amedeo Modigliani (1884–1920)* (New York: Harry N. Abrams, 1954), n.p.

20 Guillaume Apollinaire, "The Opening of the Salon d'Automne Will Take Place Tomorrow," *L'Intransigeant* (Paris), September 30, 1912, in *Apollinaire on Art*, p. 247.

21 Guillaume Apollinaire, "The Opening," *L'Intransigeant* (Paris), October 1, 1912, in *Apollinaire on Art*, p. 249.

22 See Juliet Steyn, "The Complexities of Assimilation in the 1906 Whitechapel Art Gallery Exhibition 'Jewish Art and Antiquities'," *The Oxford Art Journal* (England), vol.13, no.2, 1990, pp. 44–50.

23 Anonymous, "Post-Impressionists for Whitechapel," *Manchester Guardian* (England), April 9, 1914. A clipping of this article is in the Whitechapel Art Gallery Archives.

24 See this book's exhibition history.

25 P. Mitford-Barberton, "Edward Roworth" in *Dictionary of South African Biography* (Pretoria: Human Resources Council, 1981), pp. 523–24. Roworth was born in Lancashire, England, and settled in South Africa in 1902, becoming one of its most famous artists.

26 The Records Office of the Slade School of Art kindly provided this information.

27 Ivanonia Keet, in a letter to the author, April 22,

1992. A copy of this letter has been given to the Tate Gallery, London, for inclusion in their object file. Keet explained further that her father left the sculpture with one of his wife's sisters in London, planning to send for it. Before he was able to make shipping arrangements, his sister-in-law had given it to the Tate through someone connected to the Gallery.

28 Mitford-Barberton, "Edward Roworth" in *Dictionary of South African Biography*, pp. 523–24.

29 Henri Gaudier-Brzeska, "Vortex," *Blast* (London), June 20, 1914, reprinted in Evelyn Siber, *Gaudier-Brzeska* (London: Thames and Hudson, 1996), pp. 279–82.

30 Ezra Pound, *Gaudier-Brzeska: A Memoir* (London and New York: John Lane Co., 1916).

31 Eugenia Modigliani, "Biographical notes [on Amedeo Modigliani]," December 10, 1924, in Alexandre, *The Unknown Modigliani*, p. 31.

32 Ibid.

33 See Gee, *Dealers, Critics, and Collectors of Modern Paintings*, Appendix J.

34 *L'Élan* (Paris), published by Amedée Ozenfant, refers to this exhibition in the February 1916 issue and notes that it will be on view until the first of April.

35 The list of contributors comes from the February 1916 issue of *L'Élan* and André Salmon, "La Vie Artistique: Noir et Blanc," *L'Intransigeant* (Paris), March 19, 1916. Salmon's list is slightly shorter than the one listed in *L'Élan* and includes different names: Fauconnet, Léger, and Marevna.

36 Gino Severini, *The Life of a Painter* (Princeton, New Jersey: Princeton University Press, 1995), p. 161. Susan Ball says that Ozenfant organized the three known Bongard exhibitions, including this one. Susan Ball, "Ozenfant and Purism: The Evolution of a Style, 1915–1930" (Ann Arbor, Michigan: UMI Research Press, 1981), pp. 18–19. According to Gee, the third exhibition, in June 1916, was devoted to contemporary painters. It is possible that Modigliani was featured in that one as well, but there is not enough definitive information.

37 Severini, *The Life of a Painter*, pp. 161–62.

38 Ibid.

39 Ibid.

40 Claudine Grammont, ed., *Correspondance entre Charles Camoin et Henri Matisse* (Paris: La Bibliothèque des Arts, 1997), p. 91.

41 Ibid.

42 For more information on all of them, see *Paul Poiret et Nicole Groult: Maîtres de la Mode Art Déco* (Paris: Musée de la Mode et du Costume Palais Galliera, 1986), passim.

43 See discussion on the exhibition *L'Art Moderne en France* in this essay.

44 See the fascinating and important book by Marius de Zayas, *How, When and Why Modern Art Came to New York*, ed. Francis Naumann (Cambridge, Massachusetts, and London: MIT Press, 1996), pp. vii–xiv.

45 Marius de Zayas, "Picasso Speaks," *The Arts* (New York), May 1923, pp. 315–16, in *Picasso on Art: A Selection of Views*, ed. Dore Ashton (New York: Da Capo Press, 1972), pp. 3–6.

46 de Zayas, *How, When and Why Modern Art Came to New York*, p. x.

47 For a complete history of Stieglitz and his gallery, see *Modern Art and America: Alfred Stieglitz and His New York Galleries*, ed. Sarah Greenough (Washington, D.C.: National Gallery of Art in association with Bulfinch Press, 2000).

48 de Zayas, in a letter to Paul Haviland, August 25, 1915, Special Collections, Getty Research Institute, Los Angeles.

49 See footnote 45 for a complete reference.

50 de Zayas, *How, When and Why Modern Art Came to New York*, p. 90.

51 Ibid., p. 90.

52 Ibid., p. 99.

53 Ibid., p. 95.

54 For more on this interesting artist, see Douglas Hyland, "Adelheid Lange Roosevelt: American Cubist Sculptor," *Archives of American Art Journal* (New York), vol. 21, no. 4, 1981, pp. 10–17. Her husband was Theodore Roosevelt's first cousin, once removed.

55 Charlotte Streifer Rubinstein, *American Women Sculptors: A History of Women Working in Three Dimensions* (Boston: G.K. Hall & Co., 1990), pp. 220–23.

56 For more on Wolff, see F.M. Naumann and P. Avrich, "Adolf Wolff: 'Poet, Sculptor and Revolutionist, but mostly Revolutionist'," *The Art Bulletin* (New York), September 1985, pp. 486–500.

57 Alfred Stieglitz quoted in Dorothy Norman, "Introducing 291" in the reprint of *291* (New York: Arno Press, 1972). The first issue of *291* was published in March 1915 and a total of twelve issues were produced.

58 C. Max Jacob, "La Vie Artistique," *291* (New York), December 1915–January 1916, n.p. Unless otherwise noted, all translations from French into English are by the author.

59 C. Max Jacob, "La Vie Artistique," *291* (New York), February 1916, n.p. The "C" before Max Jacob's name stands for Cypriet. He assumed this name after converting from Judaism to Catholicism.

60 Jacob, "La Vie Artistique," February 1916, n.p.

61 de Zayas, *How When and Why Modern Art Came to New York*, p. 126.

62 It closed in the past few years and is now a children's toy store. I visited Lefebvre-Foinet in 1992 to see about consulting their extensive archives but was denied access. The current whereabouts of those papers is unknown.

63 de Zayas Archives, Seville, Spain.

64 See Hyland, "Adelheid Lange Roosevelt: American Cubist Sculptor," *Archives of American Art Journal*, note 23. He concludes, erroneously, that there must have been three Roosevelt sculptures in the exhibition, even though reviews only refer to two.

65 In the early 1970s, Marius de Zayas's son Rodrigo de Zayas placed photocopies of the de Zayas material in the Butler Library at Columbia University, New York, which is where I saw photocopies of these photographs. He also placed materials in the Beinecke Library at Yale University, New Haven, Connecticut. When I inquired about the actual photographs, Rodrigo de Zayas was not able to locate them in his vast archive in Seville.

66 See Friedrich Teja Bach, Margit Rowell, and Ann Temkin *Constantin Brancusi, 1876–1957* (Philadelphia: Philadelphia Museum of Art, 1995), pp. 130–31.

67 *The New York Times*, March 13, 1916, p. 8.

68 Ibid.

69 *The Christian Science Monitor* (Boston), March 25, 1916, p. 11.

70 This description helps to confirm the presence of the Karlsruhe and Philadelphia sculptures. Like mastheads, the Philadelphia piece is flat in the back; the Karlsruhe piece is flatter than most of Modigliani's sculptures.

71 *The World* (New York), March 12, 1916, p. 6.

72 *American Art News* (New York), March 11, 1916, p. 9.

73 *The Brooklyn Daily Eagle* (New York), March 13, 1916, p. 11.

74 de Zayas, *How, When and Why Modern Art Came to New York*, p. 94.

75 Ibid.

76 Paul Guillaume, in a letter to Marius de Zayas, March 16, 1916, Marius de Zayas Archives, Seville, Spain.

77 de Zayas Archives, Butler Library, Columbia University, New York.

78 According to the file on this work in the Philadelphia Museum of Art, their head was in Guillaume's collection in 1925 when it was sold to the Speisers of Philadelphia. The Karlsruhe sculpture came from the heirs of Max Pellequer via the Galerie Beyeler, Basel. Max Pellequer was a banker and art collector who was quite active in art in Paris in the 1920s. Pellequer most likely bought the work directly from Guillaume in the 1920s.

79 See discussion of the Cabaret Voltaire in *Dada: Monograph of a Movement*, ed. Willy Verkauf (New York: George Wittenborn, 1957), pp. 144–46.

80 Hugo Ball, *Flight Out of Time* (New York: Viking Press, 1974), p.65.

81 Ball, *Cabaret Voltaire: a collection of artistic and literary contributions* (Zurich), May 15, 1916, n.p.

82 For extensive discussions on this Salon, see William Rubin, Hélène Seckel, and Judith Cousins, *Les Demoiselles d'Avignon* (New York: The Museum of Modern Art in association with Harry N. Abrams, 1994), pp. 164–70, and Klüver, *A Day with Picasso*, pp. 61–67.

83 Klüver, *A Day with Picasso*, p. 62.

84 Severini, *Life of a Painter*, p. 164.

85 Mentioned in *SIC* (Paris), July 1916, no. 7. Their

announcement stressed the interdisciplinary aspect, "Peinture, poésie, musique." All *SIC* subscribers were promised an entry card assuring them of two places at the literary and musical events, reproduced in Rubin, Seckel, and Cousins, *Les Demoiselles d'Avignon*, p. 166. The card notes the exact dates of the show and names André Salmon as the organizer.

86 The program of the July 18 concert featured Satie's *Gymnopédies* and *Sarabande* and works by Henri Cliquet, Roger de Fontenay, Darius Milhaud, and Georges Auric. The program ended with Stravinsky's *Trois Morceaux pour Quatour à Cordes*, performed by Yvonne Astruc, Darius Milhaud, Arthur Honegger, and Félix Delgrange. See Arthur Gold and Robert Fizdale, *Misia: The Life of Misia Sert* (New York: Morrow Quill, 1981), p. 174. Nothing is known regarding the program of the July 25th concert.

87 The catalogue lists the specific readings that took place.

88 *Cri de Paris* (Paris), July 23, 1916, p. 10. Reproduced in Rubin, Seckel, and Cousins, *Les Demoiselles d'Avignon*, p. 169.

89 In French, "… des blagues de Modigliani" in M[arcel] S[erano], "Une Exposition: L'Art Moderne en France," *Le Bonnet Rouge* (Paris), July 19, 1916, p. 2.

90 Michel Georges-Michel, "L'Art 'Montparnasse' ou une peinture trop 'moderne'," *L'Excelsior* (Paris), July 23, 1916, p. 5. His novel about Montparnasse was called *Les Montparnos* in French and in English *Left Bank* (1924; reprint New York: Horace Liverlight, 1931).

91 Roger Bissière, "La Logique et les expositions," *L'Opinion* (Paris), July 22, 1916, pp. 95–96.

92 Picasso was represented by paintings titled, appropriately enough for such an event, *Violin* and *Guitar*.

93 See Étienne-Alain Hubert, "Pierre Reverdy et le cubisme en mars 1917," *Revue de l'Art* (Paris), no. 43, 1979, pp. 59–66, for references to reviews of this exhibition.

94 Arvid Fougstedt, "De Allara modernaste Parisutstallningarna: Hos 'Lyre et Palette,' hos madame Bangard och Andre Derain," *Svenska Dagbladet* (Stockholm), February 11, 1917, p. 4.

95 Emile Lejeune, "Montparnasse à l'Epoque Héroique: Un peintre genevois réunit dans son atelier les chefs de file de la nouvelle peinture," *Tribune de Genève* (Geneva, Switzerland), January 25, 1964, article no. 1. Fourteen more articles followed, with the last one appearing on March 19, 1964.

96 Ibid.

97 Emile Lejeune, "Montparnasse à l'Epoque Héroique: Un peintre genevois réunit dans son atelier les chefs de file de la nouvelle peinture," *Tribune de Genève* (Geneva, Switzerland), February 8, 1964, article no. 7.

98 "Vernissage Cubiste," *Le Cri de Paris* (Paris), November 26, 1916, pp. 9–10.

99 *SIC* (Paris), no. 12, December 1916.

100 Louis Vauxcelles, "La Vie Artistique: quelques cubistes," *L'Évenement* (Paris), November 21, 1916, p. 2.

101 Paul Morand, *Journal d'un Attache d'Ambassade, 1916–1917* (Paris: Table ronde, 1949), p. 84, in Frederick Brown, *An Impersonation of Angels: A Biography of Jean Cocteau* (New York: Viking Press, 1968), p. 158.

102 Gee, *Dealers, Critics, and Collectors of Modern Painting*, Appendix J. In an e-mail dated April 9, 2001, Gee wrote that he got this information from *Le Petit Messager des Arts* (Paris), no. 43.

103 The other portrait, dated April 17, 1917, is reproduced in Osvaldo Patani, *Amedeo Modigliani: Catalogo Generale Dipinti*, p. 184.

104 *L'École de Paris, 1904–1929, la part de l'autre* (Paris: Musée d'Art Moderne de la Ville de Paris, 2000), p. 384.

105 Berthe Weill, *Pan! dans l'Oeil!* (Paris: Librairie Lipschutz, 1933), pp. 226–30.

106 The catalogue lists thirty-two paintings and Francis Carco adds that there were thirty drawings.

107 Pierre Sichel, *A Biography of Amedeo Modigliani* (New York: E.P. Dutton, 1967), pp. 395–97.

108 Francis Carco, "Modigliani," *L'Éventail* (Geneva, Switzerland), July 15, 1919, pp. 201–209.

109 Ibid. The issue that followed on August 15, 1919, includes Modigliani drawings with an explanation in the back that they were intended for publication in the July 15 issue but did not make the deadline.

110 Frederick S. Wright, "Recollections of Modigliani

by those who knew him," *Italian Quarterly 2* (Boston), Spring 1958, p. 48.

111 Le Reporter, "La Presse: A Propos de l'Exposition 'Peintres d'Aujourd'hui' à la Galerie Paul Guillaume," *Les Arts à Paris* (Paris), May 15, 1919, n.p.

112 Quoted in Ibid.

113 Quoted in Ibid.

114 Quoted in Ibid.

115 Quoted in Ibid.

116 André Salmon, "La Semaine Artistique," *L'Europe Nouvelle* (Paris), December 21, 1918, p. 2404.

117 Osbert Sitwell, *Laughter in the Next Room* (London: Macmillan & Company, Ltd., 1948), p. 172.

118 Arnold Bennett, Preface, *Exhibition of French Art, 1914–1919* (London: Mansard Gallery, 1919), n.p.

119 Susanna Goodden, *A History of Heal's: At the sign of the fourposter* (London: Lund Humphries, 1984).

120 Ibid., p. 59.

121 General evidence suggests that it opened on August 1 and continued into early September.

122 Heal's Archives, National Art Library, Archive of Art and Design, Victoria & Albert Museum, London. I am extremely grateful to Sophie Bowness for doing research for me in this archive.

123 Sitwell, *Laughter in the Next Room*, p. 172.

124 Ibid., p. 176.

125 Roger Fry, "Modern French Art at the Mansard Gallery," *The Athenaeum* (London), August 8, 1919, pp. 723–24.

126 Roger Fry, "Modern French Painting at the Mansard Gallery II," *The Athenaeum* (London), August 15, 1919, p. 755.

127 Clive Bell, "The French Pictures at Heal's," *The Nation* (London), August 16, 1919, reprinted with several letters to the editor in response to this article in the subsequent edition of Osbert Sitwell's autobiography: *Laughter in the Next Room, Being the Fourth Volume of Left Hand, Right Hand! An Autobiography by Osbert Sitwell* (London: Macmillan & Company, Ltd., 1949), Appendix A.

128 M.S.P., "Monthly Chronicle and Notes: Modern French Art," *The Burlington Magazine* (London), September 1919, pp. 120–25.

129 Sitwell, *Laughter in the Next Room* (1948), pp. 58–59.

130 Ibid.

131 Ibid., p. 165.

132 Ibid.

133 Ibid., pp. 166–67.

134 Ibid., p. 167.

135 Ibid., pp. 182–86.

136 Ibid., p. 171.

137 "Souvenirs de Lunia Czechowska" in Ambrogio Ceroni, *Amedeo Modigliani, Peintre* (Milan: Edizioni del Milione, 1958), pp. 29–30.

138 Sitwell, *Laughter in the Next Room* (1948), p. 178ff.

139 See *Arts & Letters* (London), Autumn 1919, p. 149.

140 Sitwell, *Laughter in the Next Room* (1948), p.177.

141 Ibid., pp. 177–78.

142 "Salon d'Automne 1919," *Littérature* (Paris), December 1919, p. 32.

143 Georges Ribemont-Dessaignes, "Salon d'Automne," *391* (Paris), no.9, 1919, p. 2.

144 *American Art News* (New York), February 28, 1920, p. 4.

CHRONOLOGY

1 It is probable that Modigliani saw this exhibition and not Nadelman's second solo exhibition at the Galerie E. Druet, since he was in the south of France during the second, which took place from May 26 to June 7, 1913. (Basler mentions that Nadelman had a significant impact on Modigliani. See Adolphe Basler, *Modigliani* [Paris: Les Éditions G. Crès, 1931], p. 6).

2 On July 3, 1909, Modigliani's mother wrote a postcard to her daughter-in-law Vera noting that Modigliani was with her in Livorno.

3 Circumstantial evidence suggests that it was on Epstein's second trip to Paris, not on his first, that Augustus John visited him and bought the Modigliani sculptures. Augustus John, *Chiaroscuro: Fragments of an Autobiography* (London: Jonathan Cape, 1952), pp. 130–31. See also Nina Hamnett, *Laughing Torso* (London: Ray Long and Richard R. Smith, 1932), p. 59.

4 Hamnett, *Laughing Torso*, p. 59.

5 Ibid. The year and months of this second trip home have always been open to question, but can now be asserted firmly thanks to the publication of

Modigliani's postcards to Paul Alexandre, in Noël Alexandre, *The Unknown Modigliani: Drawings from the Collection of Dr. Paul Alexandre* (New York: Harry N. Abrams, 1993), pp. 102–11.

6 Ibid.

7 Hamnett, *Laughing Torso*, p. 69. There are other stories about how Hastings met Modigliani, ones which seem less plausible to this author. See Pierre Sichel, *Modigliani: A Biography* (New York: E.P. Dutton, 1967) pp. 264–67.

8 Hamnett in Charles Douglas, *Artist Quarter: Reminiscences of Montmartre and Montparnasse in the First Two Decades of the Twentieth Century* (London: Faber and Faber, 1941), p. 216. See also Hamnett, *Laughing Torso*, p. 105; she also received an occasional postcard from Modigliani during the war.

9 See the corrected invoice on Paul Guillaume stationery, 38 bis, rue Jouffroy in the de Zayas Archives, Seville, Spain.

10 Emile Lejeune, "Montparnasse à l'Epoque Héroique: 'Sur les rails du tram, Soutine me vend pour 50 francs l'une des toiles qui contribua le plus à sa renommée'." *Tribune de Genève* (Geneva, Switzerland), February 13, 1964, n.p.

11 Billy Klüver and Julie Martin, *Kiki's Paris: Artists and Lovers, 1900–1930* (New York: Harry N. Abrams, 1989), pp. 76–77 and 221–22.

12 See Billy Klüver, *A Day with Picasso* (Cambridge, Massachusetts, and London: MIT Press, 1997).

13 Scarlett and Philippe Reliquet, *Henri-Pierre Roché, L'Enchanteur Collectionneur, Biographie* (Paris: Éditions Ramsay, 1999), pp. 71–72. Roché owned other Modiglianis as well, including a portrait of Rivera, a Portrait of Picasso (in pencil), and a caryatid. He owned the last two until the end of his life.

14 Hanka Zborowski in Francis Carco, *L'Ami des Peintres: Souvenirs* (Geneva: Éditions du Milieu du Monde, 1944), p. 41. Ceroni dates many of Modigliani's nudes to 1916. Therefore, the dating here is not exact. See also Lunia Czechowska, "Souvenirs" in Ambrogio Ceroni, *Amedeo Modigliani, Peintre* (Milan: Edizioni del Milione, 1958), p. 19.

15 See *Letters of Juan Gris 1913–1927*, trans. and ed. Douglas Cooper (London: Privately printed, 1956), for a description of the event. An invitation is in the archives of the Picasso Museum in Paris.

16 Max Jacob to Picasso, June 11, 1917, in Hélène Seckel, *Max Jacob et Picasso* (Paris: Réunion des Musées Nationaux, 1994), p. 146.

17 Guillaume Apollinaire, "Echoes," *L'Europe Nouvelle* (Paris), April 6, 1918, in *Apollinaire on Art: Essays and Reviews, 1902–1918*, ed. Leroy C. Breunig (1972; reprint New York: Da Capo Press, 1988), p. 459, and Jeanne Modigliani, *Modigliani: Man and Myth*, pp. 88–89.

18 A catalogue of the sale exists, Documentation du l'Hôtel Drouôt, Paris.

SELECTED BIBLIOGRAPHY

For a more extensive bibliography, see Werner Schmalenbach's *Amedeo Modigliani: Paintings, Sculptures, Drawings*. Munich: Prestel-Verlag, 1990.

ON THE ARTIST

BOOKS

1926 Salmon, André. *Modigliani: Sa Vie et Son Oeuvre.* Paris: Éditions des Quatre Chemins, 1926.

1928 Scheiwiller, Giovanni. *Modigliani.* Paris: Éditions des Chroniques du Jour, 1928.

1930 Scheiwiller, Giovanni, ed. *Omaggio a Modigliani.* Milan: 1930.

1931 Basler, Adolphe. *Modigliani.* Paris: Les Éditions G. Crès, 1931.

1933 Schaub-Koch, Émile. *Modigliani.* Lille and Paris: Mercure Universel, 1933.

1950 Cocteau, Jean. *Modigliani.* London: A. Zwemmer and Paris: Fernand Hazan. Reprinted in *Bibliothèque Aldine Des Arts*, vol. 16. Paris: L. Delaporte, 1950.

1954 Lipchitz, Jacques. *Amedeo Modigliani (1884–1920).* New York: Harry N. Abrams in association with Pocket Books, 1954.

1958 Ceroni, Ambrogio. *Amedeo Modigliani, Peintre.* Milan: Edizione del Milione, 1958.

Modigliani, Jeanne. *Modigliani: Man and Myth.* Translated by Esther Rowland Clifford. New York: The Orion Press, 1958.

1962 Werner, Alfred. *Modigliani the Sculptor.* New York: Arts, 1962.

1966 Werner, Alfred. *Amedeo Modigliani.* New York: Harry N. Abrams, 1966.

1967 Sichel, Pierre. *Modigliani: A Biography of Amedeo Modigliani.* New York: E. P. Dutton, 1967.

1970 Ceroni, Ambrogio. *I dipinti di Modigliani.* Introduction by Leone Piccioni. Milan: Rizzoli, 1970. French edition, *Tout l'Oeuvre Peint de Modigliani.* Introduction by Françoise Cachin. Translated by Simone Darses. Paris: Flammarion, 1972.

Lanthemann, J. *Modigliani 1884–1920: Catalogue Raisonné; Sa Vie, Son Oeuvre Complet, Son Art.* Barcelona: Gráficas Condal, 1970.

1976 Fifield, William. *Modigliani: The Biography.* New York: William Morrow and Company, 1976.

1980 Mann, Carol. *Modigliani.* London: Thames and Hudson, 1980.

1981 Maiolino, Enzo, ed. *Modigliani Vivo: Testimonianze inedite e rare.* Turin: Fògola, 1981.

Contensou, Bernadette and Daniel Marchesseau. *Amedeo Modigliani: 1884–1920.* Paris: Musée d'Art Moderne de la Ville de Paris, 1981.

1984 Modigliani, Jeanne. *Jeanne Modigliani Racconta Modigliani.* Edited by Giorgio e Guido Guastalla. Livorno: Edizione Graphis Arte, 1984.

Nannipieri, Ali et al. *Modigliani: gli anni della scultura.* Livorno: Progressivo d'Arte Contemporanea, 1984.

1986 Schuster, Bernard and Arthur S. Pfannstiel. *Modigliani: A Study of His Sculpture.* Jacksonville, Florida: Namega, 1986.

1990 Schulmann, Didier et al. *Modigliani.* Martigny, Switzerland: Fondation Pierre Gianadda, 1990.

Schmalenbach, Werner. *Amedeo Modigliani: Paintings, Sculptures, Drawings.* Translated from the German by David Britt (essay) and Peter Underwood (documents); from the French by Caroline Beamish; from the Italian by Brian Binding. Munich: Prestel-Verlag, 1990.

1991 Patani, Osvaldo. *Amedeo Modigliani: Catalogo Generale Dipinti.* Milan: Leonardo, 1991.

1993 Alexandre, Noël. *The Unknown Modigliani: Drawings from the Collection of Paul Alexandre.* Translated by Christine Baker and Michael Raeburn. New York: Harry N. Abrams, 1993.

1998 Modigliani, Jeanne. *Amedeo Modigliani: Une Biographie.* Paris: Éditions Olbia, 1998.

1999 Chiappini, Rudy, ed. *Amedeo Modigliani.* Milan: Skira, 1999.

ARTICLES

1919 Carco, Francis. "Modigliani." *L'Éventail* (Geneva), July 15, 1919, pp. 201–09. Reprinted in *L'Éventail: Revue de Littérature et d'art.* Geneva, Switzerland: Slatkine Reprints, 1971.

1920 Salmon, André. "La Semaine Artistique: 31e Salon des Indépendants.—Mort de Modigliani." *L'Europe Nouvelle* (Paris), Jan. 31, 1920, pp. 185–86.

"Nécrologie." *La Chronique des Arts et de la Curiosité, Supplément à la Gazette des Beaux-Arts* (Paris), Feb. 15, 1920, pp. 22–23.

"Obituary: Medigliani [sic]." *American Art News* (New

York), Feb. 28, 1920, p. 4.

1925 de Vlaminck, Maurice. "Souvenir de Modigliani." *L' Art Vivant* (Paris), Nov. 1, 1925, pp. 1–2.

1939 Salmon, André. "Le Vagabond de Montparnasse: Vie et Mort du Peintre Amedeo Modigliani." *Les Oeuvres Libres* (Paris), Feb. 1939.

1943 Meidner, Ludwig. "The Young Modigliani: Some Memories." *The Burlington Magazine* (London), April 1943, pp. 87–91.

1958 Wright, Frederick. "Recollections of Modigliani by Those Who Knew Him." *Italian Quarterly* (Boston), Spring 1958.

GENERAL BOOKS

1916 Pound, Ezra. *Gaudier-Brzeska: A Memoir*. London: John Lane, 1916.

1920 Salmon, André. *L' Art Vivant*. Paris: Les Éditions G. Crès et Cie, 1920.

Coquiot, Gustave. *Les indépendants: 1884–1920*. Paris: Ollendorff [1920].

Cocteau, Jean. *Carte Blanche: Articles Parus dans Paris— Midi du 31 Mars au 11 Aout 1919*. Paris: Éditions de la Sirène, 1920.

1924 Coquiot, Gustave. *Des Peintres Maudits*. Paris: André Delpeuch, 1924.

Carco, Francis. *Le Nu dans la Peinture Moderne (1863– 1920)*. Paris: Les Éditions G. Crès et Cie, 1924.

1927 Bayard, Jean-Emile. *Montparnasse: Hier et Aujourd'hui, ses Artistes et Écrivains étrangers et français le plus célèbres*. Paris: Jouve et Cie, 1927.

1928 Raynal, Maurice. *Modern French Painters*. Translated by Ralph Roeder. New York: Brentano's, 1928.

1932 Hamnett, Nina. *Laughing Torso: Reminiscences of Nina Hamnett*. New York: Ray Long and Richard R. Smith, 1932.

1941 Douglas, Charles. *Artist Quarter: Reminiscences of Montmartre and Montparnasse in the First Two Decades of the Twentieth Century*. London: Faber and Faber [1941].

1945 Salmon, André. *L' Air de la Butte*. Paris: Les Éditions de la Nouvelle France, 1945.

1962 Ehrenburg, Ilya. *People and Life: 1891–1921*. Translated by Anna Bostock and Yvonne Kapp. New York: Knopf, 1962.

1963 Severini, Gino. *Témoignages: 50 ans de Réflexion*. Rome: Éditions Art Moderne, 1963.

1968 Brown, Frederick. *An Impersonation of Angels: A Biography of Jean Cocteau*. New York: Viking Press, 1968.

1974 Marevna, *Life with the Painters of La Ruche*. Translated by Natalie Heseltine. New York: MacMillan, 1974.

1978 Warnod, Jeanine. *La Ruche & Montparnasse*. Geneva: Weber, 1978.

1981 Gee, Malcolm. *Dealers, Critics, and Collectors of Modern Painting: Aspects of the Parisian Art Market between 1910 and 1930*. New York: Garland, 1981.

1985 Silver, Kenneth E. and Romy Golan. *The Circle of Montparnasse: Jewish Artists in Paris 1905–1945*. New York: Universe Books, 1985.

1986 Steegmuller, Francis. *Apollinaire: Poet Among The Painters*. New York: Penguin Books, 1986.

1987 Adéma, Pierre-Marcel, et al. *André Salmon*. Rome: Bulzoni, 1987.

Severini, Gino. *Écrits sur l'art, Gino Severini*. Paris: Cercle d'art, 1987.

1988 Apollinaire, Guillaume. *Apollinaire on Art: Essays and Reviews, 1902-1908*. Edited by LeRoy C. Breunig. New York: Da Capo Press, 1988.

1989 Klüver, Billy and Julie Martin. *Kiki's Paris: Artists and Lovers 1900–1930*. New York: Harry N. Abrams, 1989.

Silver, Kenneth E. *Esprit de Corps: The Art of the Parisian Avant-garde and the First World War, 1914–1925*. Princeton, New Jersey: Princeton University Press, 1989.

1991 Gersh-Nešic, Beth S. *The Early Criticism of André Salmon: A Study of His Thoughts on Cubism*. New York and London: Garland, 1991.

1996 de Zayas, Marius. *How, When and Why Modern Art Came to New York*. Edited by Francis Naumann. Cambridge, Mass. and London: MIT Press, 1996.

1998 Wayne, Kenneth ed. *Impressions of the Riviera: Monet, Renoir and their Contemporaries*. Portland, Maine: Portland Museum of Art, 1998.

2000 *L'École de Paris, 1904–1929, La part de l'Autre*. Paris: Musée d'Art Moderne de la Ville de Paris, 2000.

Greenough, Sarah, ed. *Modern Art and America: Alfred Stieglitz and His New York Galleries*. Washington, D.C.: National Gallery of Art in association with Bulfinch Press, 2000.

Each exhibition is followed by a list of Modigliani works exhibited (with corresponding exhibition catalogue numbers) and relevant reviews and mentions in the press at the time of the exhibition. For a comprehensive list of Modigliani exhibitions after 1919, see Werner Schmalenbach's *Amedeo Modigliani: Paintings, Sculptures, Drawings*. Munich: Prestel, 1990. Every effort has been made to provide the most complete listing of the artist's lifetime exhibitions. However, as new material emerges additional exhibitions may be uncovered.

SOLO EXHIBITION

1917 Galerie Berthe Weill, Paris, France. *Exposition des Peintures et des Dessins de Modigliani*, Dec. 3–30, 1917. Cat.

1. La dame au grands yeux
2. Portrait du poète L.
3. La femme qui crie
4. La petite Lucienne
5. Portrait de Madame L.
6. Le garçon rouge
7. Indiana
8. Portrait du comte W.
9. L'éther
10. Marghareta
11. L'apache no. 1
12. L'innocente
13. La femme dormante
14. Portrait de femme dormante
15. Alice
16. Eve
17. Nu
18. Nu
19. L'Italienne
20. La femme en òlouse marine
21. Amaisá
22. Portrait de femme
23. Portrait de mademoiselle H.
24. Portrait du poète L.
25. La femme aux mains croisées
26. Femme aux roses rouges
27. Portrait de femme
28. Pierre
29. L'apache no. 2
30. Nu
31. Nu
32. Portrait de femme

Carco, Francis. "Modigliani." *L'Éventail* (Geneva), July 15, 1919, pp. 201–209. Corresponding reproductions appear in *L'Éventail* (Geneva), Aug. 15, 1919, pp. 225, 233, 243, 245.

GROUP EXHIBITIONS

1907 Grand Palais des Champs-Élysées, Paris, France. Salon d'Automne [5e Exposition], Oct. 1–22, 1907. Presented by Société du Salon d'Automne. Cat., *Catalogue des Ouvrages de Peinture, Sculpture, Dessin, Gravure, Architecture et Art décoratif*.

1285. Portrait de L.M., p.
1286. Etude de tête
1287. Tête, d. aqu.
1288. Tête de profil, d. aqu.
1289. Etude, d. aqu.
1290. Etude, d. aqu.
1291. Portrait (étude), d. aqu.

1908 Serres du Cours-la-Reine, Paris, France. 24e Exposition, Mar. 20 – May 2, 1908. Presented by Société des Artistes Indépendants. Cat.

4325. +Portrait
4326. +Femme Nue
4327. +Etude
4328. +Femme Nue
4329. +L'Idole
4330. +Dessin (app. à M. Gaston Lévi)
+ = à vendre

Vauxcelles, Louis. "Le Salon des Indépendants." *Gil Blas* (Paris), Mar. 20, 1908.

1910 Cours-la-Reine, Paris, France. 26e Exposition, Mar. 18–May 1, 1910. Presented by Société des Artistes Indépendants. Cat.

3686. +Le jouer de violoncelle
3687. +Lunaire
3688. +Etude

3689. +Etude
3690. +Le mendiant (app. à M. J. A....)
3691. +La mendiante (app. à M. J. A....)
+ = à vendre

Apollinaire, Guillaume. "Watch out for the Paint!
The Salon des Indépendants 6,000 Paintings Are
Exhibited." *Apollinaire on Art: Essays and Reviews
1902–1918*. Edited by Leroy C. Breunig. Translated by
Susan Suleiman. New York: Viking, 1972, pp. 64–69.

**1911 Studio of Amadeo de Souza Cardoso, 3, rue
Colonel-Combes, Paris, France. Mar. 5– [closing
date unknown], 1911.**

**Quai d'Orsay (Pont de l'Alma), Paris, France. 27e
Exposition, Apr. 21–June 13, 1911. Presented by
Société des Artistes Indépendants. Cat.**

6655. Cariatide
6656. Tête
6657. Dessin
6658. Dessin
6659. Dessin
6660. Dessin

**1912 Grand Palais des Champs-Élysées, Paris, France.
Salon d'Automne [10th Exposition], Oct. 1–Nov.
8, 1912. Presented by Société du Salon d'Au-
tomne. Cat., *Catalogue des Ouvrages de Peinture,
Sculpture, Dessin, Gravure, Architecture et Art Décoratif.***

1211. Tête, ensemble décoratif, sc.
1212. Tête, ensemble décoratif, sc.
1213. Tête, ensemble décoratif, sc.
1214. Tête, ensemble décoratif, sc.
1215. Tête, ensemble décoratif, sc.
1216. Tête, ensemble décoratif, sc.
1217. Tête, ensemble décoratif, sc.

"Le Salon d'Automne." *La Vie Parisienne* (Paris),
Oct. 5, 1912, p. 713.

"La Salle des Cubistes au Salon d'Automne."
L'Illustration (Paris), Oct. 12, 1912, p. 268.

Roger, Claude. "Au Salon d'Automne Maîtres Cubes."
Commoédia Illustré (Paris), Oct. 20, 1912, pp. 62–65.

**1914 Whitechapel Art Gallery, London, England.
Twentieth Century Art: A Review of Modern Movements.
May 8 –June 20, 1914. Cat.**

287. Head (stone). Edward Roworth, Esq.
288. Drawing for sculpture

* "Post-Impressionists for Whitechapel."
The Manchester Guardian (England), Apr. 9, 1914.

* "Art and Reality: Challenge of Whitechapel to
Piccadilly. An Exhibition in the East." *The Times*
(London), May 8, 1914.

* "20th Century Art: Whitechapel Exhibition."
The Daily Telegraph (London), May 8, 1914.

* P.G.K. "Side-splitting Art: Humor, conscious
and unconscious. 'Isms' in East End." *Daily
Express* (London), May 8, 1914.

* "East End Critics: Futurist Art in Whitechapel."
The Observer (London), May 10, 1914.

* "Art Exhibitions: Whitechapel Gallery." *The
Morning Post* (London), May 11, 1914.

* "Perhaps." *Daily Express* (London), May 11, 1914.

* Phillips, Claude. "Art in Whitechapel: Twentieth
Century Exhibition." *The Daily Telegraph* (London),
May 12, 1914.

* "Art and Artists: Twentieth-Century Art at
Whitechapel." *The Observer* (London), May 14, 1914.

* "Art Exhibitions: Cubists in East-End. Pictures-
Puzzles to be seen in Whitechapel." *The Standard*
(London), May 14, 1914.

* C.M., "Twentieth Century Art." *Evening Standard
and St. James's Gazette* (London), May 19, 1914.

* "Art and Artists: The Whitechapel Art Gallery."
The Star (London), May 20, 1914.

* J.M.M. "Twentieth-Century Art." *The Westminster
Gazette* (London), May 21, 1914.

Davies, Randall. "Art and Drama: The New English and Whitechapel." *The New Statesman* (London), June 13, 1914, pp. 307–308.

⋆ *These articles and reviews are located in the Whitechapel Art Gallery archives. No page numbers were cited on the newspaper clippings.*

1916 Modern Gallery, New York. *Exhibition of Sculpture,* **Mar. 8–22, 1916. Checklist.**

 12. Figurehead
 13. Figurehead

"Other Exhibitions." *The Evening Mail* (New York), Mar. 11, 1916, p. 7.

"Some 'Modernist' Sculpture." *American Art News* (New York), Mar. 11, 1916, p. 9.

"News of the Art World." *The World* (New York), Mar. 12, 1916, p. 6.

"Art Notes: Sculpture in Modern Gallery." *The New York Times*, Mar. 13, 1916, p. 8.

"The World of Art." *The Brooklyn Daily Eagle*, Mar. 13, 1916, p. 11.

"New York Art Exhibitions and Gallery News: 'Polyhedral', Other Sculptures." *The Christian Science Monitor* (Boston), Mar. 25, 1916, p. 11.

Chez Madame Bongard, 5, rue de Penthièvre, Paris, France. *Exposition de Dessins en Blanc et Noir* **[Mar.–Apr.], 1916.**

"Expositions." *L'Élan* (Paris), no. 9, 1916.

"Etc. . ." *SIC* (Paris), Mar. 1916, p. 32. Reprint. Paris: Éditions Jean Michel Place, 1980.

L'Intransigeant (Paris), Mar. 14, 1916.

Salmon, André, "La Vie Artistique: Noir et Blanc." *L'Intransigeant* (Paris), Mar. 19, 1916.

Bissière, "La Réveil des Cubistes." *L'Opinion* (Paris), Apr. 15, 1916, p. 382.

Cabaret Voltaire, Zurich, Switzerland. *L'Exposition Cabaret Voltaire,* **June 1916. Checklist from** *Cabaret Voltaire.* **Lichtenstein: Kraus Reprint, 1977.**

 Portrait Hans Arp I (dessin)
 Portrait Hans Arp II (dessin)

Salon d'Antin, Paris, France. *L'Art Moderne en France,* **July 16–31, 1916. Cat.**

 111. Portrait
 112. Portrait (App. a M.A.)
 113. Portrait

SIC (Paris), July 1916, p. 54. Reprint. Paris: Éditions Jean Michel Place, 1980.

L'Intransigeant (Paris), July 16, 1916. (Reproduced in *A Day With Picasso* by Billy Klüver, pp. 65–67.)

S[erano], M[arcel]. "Une Exposition: L'Art Moderne en France." *Le Bonnet Rouge* (Paris), July 19, 1916, p. 2.

Bissière. "Beaux-Arts and Curiosité: La Logique et les expositions." *L'Opinion* (Paris), July 22, 1916, pp. 95–96.

"Lettres et Art: Cubistes." *Le Cri de Paris* (Paris), July 23, 1916, p. 10.

Georges-Michel, Michel. "L'Art 'Montparnasse' ou une peinture trop 'moderne'." *L'Excelsior* (Paris), July 23, 1916, p. 5.

L'Intransigeant (Paris), July 27, 1916.

Vauxcelles, Louis. "La Vie Artistique: Quelques jeunes." *L'Évènement* (Paris), July 28, 1916, p. 2.

"Le Carnet des Ateliers: Chez Barbazanges." *Le Carnet de la Semaine* (Paris), Aug. 6, 1916.

Lyre et Palette, Paris, France. 1re Exposition, Nov. 19–Dec. 5, 1916. Cat.

 11. La Jolie Ménagère
 12. Portrait de P.G.
 13. Madame Pompadour
 14. Les Époux Heureux
 15. Portrait du Peintre K.

16. Portrait du Peintre K.

17. La Petite Louise

18. Antonia

19. Portrait de la Poétesse H.

20. René Jean

21. Figure

22. [no title given]

23. [no title given]

24. [no title given]

25. Dessins

Vauxcelles, Louis. "La Vie Artistique: Quelques cubistes." *L'Évènement* (Paris), Nov. 21, 1916

"Peinture." *SIC* (Paris), Dec. 1916, p. 96. Reprint. Paris: Editions Jean Michel Place, 1980.

Fougstedt, Arvid. "De allra modernaste Paris— utstallningarna." *Svenska Dagbladet* (Stockholm), Feb. 11, 1917, p. 4.

1917 Galerie Chéron, Paris, France. May 1–20, 1917.

"Dans La Rubrique: Expositions Diverses." *Petit Messager des Arts, des Artistes et des Industries* (Paris), no. 43, p. 8.

Galerie Dada, Zurich, Switzerland. *Ausstellung von Graphik, Broderie, Relief*, May 2–29, 1917. Brochure.

1918 Galerie Paul Guillaume, Paris, France. *Exposition Peintres D'Aujourd'hui*, Dec. 15–23, 1918. Checklist printed in *Les Arts à Paris* (Paris), Dec. 15, 1918, no. 3, n.p.

24. Femme au voile

25. La jolie Ménagère

26. Madame Pompadour

27. Béatrice

Salmon, André. "La Semaine Artistique: Prolongation de l'Armistice." *L'Europe Nouvelle* (Paris), Dec. 21, 1918, p. 2404.

"La Presse: A propos de l'Exposition 'Peintres d'Aujour- d'hui'." *Les Arts à Paris* (Paris), May 15, 1919, pp. 12–13.

1919 Mansard Gallery, London, England. *Exhibition of French Art: 1914–1919*, Aug. 1919. Cat., preface by Arnold Bennett.

41. Little peasant

42. The Lady in white

43. Nude

44. Portrait of the painter Survage

45. Portrait of Madame C.

46. Portrait of Madame L.

47. Nude. Young Woman

48. The spider

49. Apache

"Fine Arts: Modern French Art at the Mansard Gallery." *The Athenaeum* (London), Aug. 8, 1919, pp. 723–24.

"Fine Arts: Modern French Painting at the Mansard Gallery." *The Athenaeum* (London), Aug. 15, 1919, pp. 754–55.

A series of letters appears in *The Nation* following a favorable review by Clive Bell. All letters repro- duced in *Laughter in the Next Room* by Osbert Sitwell.

M.S.P. "Monthly Chronicle and Notes: Modern French Art." *The Burlington Magazine* (London), Sept. 1919, pp. 120–25.

"Naked and Unashamed: French Pictures at the Mansard Gallery." *The Times* (London), Sept. 4, 1919, p. 13.

Grand Palais des Champs-Élysées, Paris, France. Salon d'Automne [12th Exposition], Nov. 1–Dec. 10, 1919. Presented by Société du Salon d'Au- tomne. Cat., *Catalogue des Ouvrages de Peinture, Sculpture, Dessin, Gravure, Architecture et Art Décoratif*.

1368. La Fille du Peuple, p.

1369. Portrait d'homme, p.

1370. Nue, p.

1371. Portrait d'une jeune fille, p.

"Palet: Salon d'Automne 1919." *Littérature* (Paris), Dec. 1919, p. 32.

Ribemont-Dessaignes, Georges. "Salon d' Automne." *391*, Nov. 1919, p. 2. Reprint. *391: Revue publiée de 1917 à 1924 par Francis Picabia*. Edited by Michel Sanouillet. Paris: Le Terrain Vague, 1960, v.1, pp. 66–67.

(fig. 1) MAN RAY, Photograph of Beatrice Hastings, 1922

INTRODUCTION KENNETH WAYNE

"Minnie Pinnikin" is Beatrice Hastings's long-lost novella about her relationship with Amedeo Modigliani during the years 1914 to 1916, presumably written during these same years. Hastings (1879–1943) read an excerpt of the novella at a literary event on July 21, 1916, which was held in conjunction with the exhibition *L'Art Moderne en France* at which Modigliani exhibited.[1]

"Minnie Pinnikin" concerns the escapades of two characters named Minnie Pinnikin and Pâtredor (a.k.a. Pinarius), who represent Hastings and Modigliani. In a letter dated September 17, 1936, Hastings described the novella to Modigliani biographer Douglas Goldring: "I tell the story [of my relationship with Modigliani] in 'Minnie Pinnikin,' an unpublished book that I can't be bothered about with Musso[lini] and Hitler preparing to shake hands and bust up Europe."[2] In that same letter, Hastings wrote: "I was Minnie Pinnikin and thought everyone lived in a fairyland as I did."[3] It is clear that the Pâtredor or Pinarius character represents Modigliani, for he is both an artist and a poet who, like Modigliani, makes portraits of Minnie Pinnikin with "swan-like" necks. Modigliani is known to have made a reference to this novella: a very faint Modigliani drawing survives entitled *Sketch of Minnie Pinniken* [sic] *in the Pastry Shop* (Collection The Museum of Fine Arts, Houston). A third character, Bompas, also figures prominently in the story, but his true-life counterpart is not known.

"Minnie Pinnikin" is arranged in twelve chapters (though number eleven is missing entirely) and only five have been given titles: "On the Boulevard Edgar Quinet"; "On the Boulevard Montparnasse"; "At Malakoff"; "The Dream of Minnie Pinnikin"; "At the home of Minnie Pinnikin." The text also refers to the Montparnasse cafés that Modigliani was known to have frequented including La Rotonde and the Closerie des Lilas.

"Minnie Pinnikin" is a surrealist text with a narrative that drifts in and out of dream-like passages. Like automatic writing or stream-of-consciousness writing, the narrative is not linear and the intended significance is often unclear. Moreover, the manuscript is in French, having been written by a non-native speaker whose French syntax is

very awkward. There are several hand notations on the typewritten manuscript that serve to obfuscate rather than clarify the plot. For example, the name Pinarius is often crossed out in favor of Pâtredor, and vice versa. It is not entirely clear if they are the same character.

"Minnie Pinnikin" most resembles the surrealistic *Les Chants de Maldoror* by the Comte de Lautréamont (Isidore Ducasse). A favorite book of Modigliani's, it soon afterwards also became that of the Surrealists. Like the art movements Dada and Surrealism, "Minnie Pinnikin" can be read as a reaction to the devastation of World War I. In her letter to Goldring, Hastings indirectly confirms that the "fairyland" quality of "Minnie Pinnikin" is an escapist reaction to the horrors around her: "I am in a fairyland now playing (that is doing only what I like) all day long with now and again a sudden ghastly glimpse of a world going mad."[4]

In addition to underscoring the spirit of Montparnasse during World War I, "Minnie Pinnikin" provides a sense of the literary trends that Modigliani might have been exposed to during 1914 to 1916, the period when his art matured and his signature style developed. When considered in the context of Modigliani's critical response at the time—which repeatedly stressed the anti-naturalism of his canvases—"Minnie Pinnikin" helps to suggest that Modigliani was developing a proto-Surrealist art form. While recording specific individuals, his art can be read as an attempt to move away from realistic or naturalistic depictions.

The "Minnie Pinnikin" manuscript, excerpts of which are published herein for the first time, is located in the archives of The Museum of Modern Art, New York, where an incomplete photostatic copy (53-pages long, and missing pages 36 or 37, 47 to 51; it ends abruptly) has been housed for approximately fifty years. The manuscript came to reside in the archives through former MoMA Curator William S. Lieberman, currently the Jacques and Natasha Gelman Chair of the Department of Modern Art at the Metropolitan Museum of Art, New York. Lieberman was conducting research for MoMA's 1951 exhibition *Modigliani: Paintings, Drawings, Sculpture*, when he was put into contact with Goldring and Charles Beadle[5] by the art historian Douglas Cooper.[6] Through them, he obtained a copy of "Minnie Pinnikin." According to a note found with the manuscript in the MoMA archives, the copy had been obtained from Hastings's nurse (no name mentioned); Doris Lilian Green, executor of Hastings's estate, was a nurse and is presumably the one who gave the manuscript to Goldring and Beadle.[7] It would have been following Hastings's suicide on October 30 or 31, 1943, in Worthing, England, in Sussex, that they received the manuscript from Green.[8] The note with "Minnie Pinnikin" indicates that the corrections on the manuscript were made by the French poet and artist Max Jacob.

Lieberman made reference to the manuscript only once, in a Perls Galleries exhibition catalogue, *The Nudes of Modigliani*, 1966: "Beatrice Hastings wrote a novel about their life together which remains unpublished. The typescript is curious, written in French and corrected by hand by Max Jacob." A year later, Modigliani biographer Pierre Sichel referred to the manuscript in this way: "But 'Minnie Pinnikin,' the book in which Beatrice reveals the story of Modigliani and herself, remains unpublished and is presumed lost."[9]

It is unclear whether the novel was originally written in English or in French. The MoMA manuscript—the only known one—is in French and was translated into English for publication here. Presumably, if Green had had an English version of the manuscript, she would have given that to her fellow Englishmen instead of the French. This suggests that the original English version most probably was lost. An indication that it might have been written originally in English is the brief mention of "Minnie Pinnikin" in the advertisement for the literary event on July 21, 1916, where it is noted that the excerpt was "traduit de l'anglais par l'auteur" or "translated from the English by the author."

"Minnie Pinnikin" stands as a key resource about Modigliani during the years that his painting style matured and his career was becoming fully established. As such, it is an invaluable document. Furthermore, "Minnie Pinnikin" provides an account from the perspective of the artist's lover and model,[10] making it an excellent complement to the portraits reproduced in this catalogue.

MINNIE PINNIKIN.

— — — — — — — —

Sur le boul. Edgar Quinet.

A entendre la musique de la cornemuse, Minnie Pinnikin se hâta vers
le boulevard. Le monde était plein de lignes d'or qui partaient de
partout. L'une d'elles allongeait le toit en bois du marché. L'éco-
ssais, entouré de gens, jouait debout sur le haut du pavé. On riait,
on esquissait des mouvements de danse. Il y avait grande foule.

 Arrivée tout prés, Minnie Pinnikin vit *Pinarius Pâtredor* sur le toit du
marché. Il pêchait des hommes de la rue, les balançait avec ses long-
ues mains. "Qu'il est beau ce matin!" s'exclama *-t-elle*. C'é-
ait vrai, il était bien beau. Le soleil dansait dans sa chevelure se
pencha pour regarder dans ses yeux.

 Lorsqu'il eut attrapé assez de monde, il se mit à danser. Les
gens firent des cabrioles. Puis, il disparut. La musique s'éloigna.
Et les gens sautèrent du toit et reprirent, l'air honteux, leur traf-
fique de marchands de choux, de journaux, de friperie, de poisson.

 Minnie Pinnikin chercha *Pinarius Pâtredor*. Il revint avec l'écossais. Tou
deux portaient des *litres* de vin qu'ils distribuèrent aux gens, ce
qui les guérissait de *la* honte d'avoir dansé en plein samedi matin.

 Tout à coup *Pinarius Pâtredor* s'aperçeva de Minnie Pinnikin et il lâcha tou
pour courir après elle. Ils allaient se marier un jour, cela se voyait
mais ni l'un ni l'autre n'en avait encore parlé parceque tout simplemen
ils n'en étaient pas là. Ils n'étaient qu'aux premières exercices amou
euses: sauter de cime en cime des montagnes, faire le tour du monde sa
s'arrêter nulle part, boire d'un trait des fleuves d'espoir grands comm
la Seine. Ils se tutoyaient, c'est tout.

 "Où vas-tu?" demanda *Minnie Pinarius Pâtredor*.
 "Où tu voudras."

206

(fig. 2) The first page of "Minnie Pinnikin" by Beatrice Hastings

Collection The Museum of Modern Art Archives, New York: William S. Lieberman Papers, V.23.16.b.iii

"Minnie Pinnikin" BEATRICE HASTINGS

Three chapters of the existing eleven are reproduced here in full. They have been selected as best representative of the overall work. Brief synopses of the remaining chapters are provided as an overview of the plot. Translations have been provided by Isabelle Martinez.

1. ON BOULEVARD EDGAR QUINET

At the sound of the bagpipe, Minnie Pinnikin hurried to the boulevard. The world was full of golden beams coming from all over the place. One of them stretched across the wooden roof of the marketplace. The Scottish man, surrounded by onlookers, stood on the cobblestone playing music. People were laughing, half making dancing movements. A large crowd gathered.

When Minnie Pinnikin came closer, she could see Pâtredor on the roof of the marketplace. He was fishing men from the street, swinging them with his long hands. "How beautiful he looks this morning!" she exclaimed. It was true he was really beautiful. The sun that danced in his hair leaned forward to look into his eyes.

Once he had caught enough people, he started to dance. People were cavorting about. Then he disappeared. The music grew fainter and everybody jumped off the roof and timidly went back to his or her business of selling cauliflower, newspapers, clothes and fish.

Minnie Pinnikin looked for Pâtredor. He came back with the Scottish man. They both gave away liters of wine that they were carrying, so that they felt better after their shameful Saturday morning dancing.

Suddenly, Pâtredor became aware of Minnie Pinnikin and he dropped everything to run after her. One could tell that they would be married one day, but no one ever mentioned it simply because it was not yet time. They were still playing the first love games: jumping from hill to hill, traveling the world without stopping anywhere, drinking rivers of hope as big as the Seine in one gulp. They said, "Tu"[11] to each other but that was all.

"Where are you going?" Pâtredor asked.

"Wherever you would like."

It was the year 1914, and before . . . So, Pâtredor said, " to La Rotonde?"

"Yes."

"Or would you rather go to the Ile Saint Louis? I know a small café there where they like me very much."

But at the same time, Bompas arrived. He wore a red and orange scarf on his brown suit. He brushed his gray beard on the side to show it.

"Very nice like that," said Pâtredor.

"And facing?"

"Ugly."

Instead of blowing up at the remark, Bompas stood on his dignity. "One cannot look good from all sides."

"Yes, you look very nice. Are you coming to La Rotonde?"

"Oh no! You always want to get me there and then you leave me. Is that what I deserve for my devotion? I wish I had a few coins worth of paint in my studio so that I could work."

He took the essentials and left shouting out loud to the passers-by—"You know, when I am working, no one should come knocking at my door. No one. I won't open to anyone, not even to my dealer, especially not my dealer. He bothers me. Ten hours a day. That is what I call working. I can spend six months without doing anything. But once I have started—pfou!—leave me alone—everybody—no visitors! Bompas-Artist-Painter!"

He disappeared leaving behind a group of people staring at each other in bewilderment.

Pâtredor took Minnie Pinnikin to the Ile Saint Louis. They did not talk much for being poets, they did not need to share their thoughts. They stopped so many times to watch street shows, and they lingered so long on the bridges to observe passers-by that the sun threatened to disappear if they did not hurry to the café. "I love to watch people having dinner outside in April but . . . this season, I have a long way to go in a short period of time and cowboys in the far-west shout out to the eagles if they can improve upon the spring light." Pinarius had to translate it all to Minnie Pinnikin because the sun spoke French with a southern accent. Then they started to run.

"I knew you would come tonight," said the owner of "La Larme du Crocodile" to Pinarius. "I have a large dish of mussels with a white wine sauce ready for you."

"I told you they like me here, Minnie Pinnikin. When people like you, you are never too late."

2. ON BOULEVARD MONTPARNASSE

Minnie and Pâtredor encounter a billposter[12]. The billposter, having torn a corner of his advertisement, asks Pâtredor to paint over the damage. Pâtredor paints Minnie with a swan-like neck and hat. The two walk on to a café and intervene in an argument of children's rights between the owner and her daughter.

3. IN MALAKOFF

Pinarius suggests that Minnie and he go to Malakoff. Bompas protests because he is only half done with his great painting. "Everything was green in Malakoff, except the streets where Bompas took them to buy postcards." Bompas, Minnie, and Pinarius stop at a café to write postcards and have a drink. Pinarius sketches Minnie on the marble table. Minnie and Pinarius go in search of cherries. They return to meet a drunk Bompas at the café. He is eager to return to Paris for dinner.

4.

This chapter begins with a strange passage about Pinarius who is killing women who smile at him by pushing them into the river. When the police come in search of Pinarius, Minnie diverts the officer's attention. Pinarius continues to act strangely, by chasing cats, children, and servants. The chapter ends with Pinarius urging Minnie to see a portrait of her that he has painted. "Indeed, for once Pinarius had painted from life." Minnie and Pinarius argue about the painting. Pinarius threatens to throw it out. Minnie wants to keep it as a souvenir. Later, Bompas comes home drunk and sells it for two francs.

5. MINNIE PINNIKIN'S DREAM

On the road that cuts across, there were two little paths: one led to Minnie Pinnikin's house, the other one to a thicket where fairies used to dance and now gypsies throw out metal tins and pieces of fabric, leading people to dislike them.

Minnie Pinnikin halted to tie her shoes. While kneeling and looking down, she thought she heard music coming from the thicket, a marvelous sound from strange instruments and wild voices. She stood up quickly and walked into the branches and flowers, fast, fast and still faster. Between two bushes of golden thorns, she gave a furtive glance in the thicket. There was nothing but shadows and sparkles and big white flowers in the trees and small flowers in the grass. She walked into the thicket, stood there and then she felt sleepy while slipping on the ground...

Pinarius (but in the dream he was not named Pinarius, he had no name because Minnie Pinnikin dreamt all this before she left England when she decided to follow the idea that was leading her around the world.) Pinarius exclaimed, "Minnie Pinnikin, come this way!" He wore an outfit of white flannel like Minnie Pinnikin did with a green scarf tied on the side and he was busy drawing a portrait of a lady. An old bearded man in brown velvet stood grumbling near the easel. Pinarius was drawing Minnie Pinnikin's portrait and the old man said he was wasting a good canvas.

The wild music was still sounding and fantastic dancers appeared surrounding Minnie Pinnikin.

Pinarius stretched his arm forward and she snuggled up. Everybody stopped. Pinarius's eyes sparkled like the sweet flowery hills of heaven and Minnie Pinnikin gazed upon the far hills.

"Let's dance for the wedding!" Pinarius exclaimed.

When the dance was over, Minnie Pinnikin sat under a green canopy near a pile of oranges. There were red cushions, little straw stools, a wine flask and a bunch of red grapes.

Pinarius lay his head down on a red cushion and dreamt he was in front of a thin cloud standing on earth and, in its center, there was a hole that looked like a door through which one could enter and exit. He woke up, told his dream, thought it was real and said—"We shall not marry here, Minnie Pinnikin. Let's go and see what there is on the other side of the hole." Then, everybody stood up and left.

The provident ladies, who were but plaster heads with pink, blue, and purple colors, bit into the side of the cloud and held it with their nice teeth, the interior being held by the hole.

The old ladies with blue legs and green heads walked forward carrying the red cushions. The male and female penitents in black took the straw stools. The crowd of angels, animals, knights, and children rolled oranges. Minnie Pinnikin carried the grapes and Pinarius had the wine flask.

Thus they walked through the hole whereas the old man was holding back, grumbling and saying he did not want to come but he eventually did. There was nothing on the other side of the hole but a burning desert and a red and white temple on the far horizon. The colored heads said, "Hey you, you should not risk getting a sunburn! As far as we are concerned, warmth will do us good." Saying so, they flipped the edge of the cloud over through the hole like one would turn a sleeve over and they started to fly forward. Then the band passed through the hole and moved forward from beneath to the end of the cloud and the hole willingly rushed forward so that they could go through. All this kept on repeating until they arrived at the court of the temple like a kingdom under a canopy. Then, the colored heads loosened the cloud and it took off through the hole.

After all, it was only the front of a temple. There was no back. So when they had walked through the main door, they simply reached the other side. The penitents wanted to beat off the priests who were in the temple saying it was deceptive, but Pinarius started to laugh and said it was always like that—that there was never a back

to anything anywhere. Minnie Pinnikin said, "Things go wrong, so we should not hurry. Let's sit down and eat some oranges."

The high priest had a stone on his head and only one arm that he constantly kept straight up. Minnie Pinnikin peeled an orange for him and she dropped the pieces into his mouth. For this reason, he told her and Pinarius that they could consider themselves married. Then Pinarius gave Minnie Pinnikin the wedding gifts. There was a star, a blue flower, a wave from the sea, and a golden flying snake. " I am not as wealthy as I used to be," he said. "I would have offered you a wheel, an elephant, a jewel, and a son. Today, I have only small things left but I will work hard to regain the fortune I lost in the cataclysm."

She gave him a scale, a bottle of lotion and a hat.

The high priest said he wished he had not vowed to devote his life to carry the stone or else he would have showed them a path through the desert that was a dead end but half way it led somewhere. "We will find it," answered Pinarius, but at the same time he murmured to the old ladies with blue legs and green heads that they should stay with the priests. At that point, the high priest rushed to say that he would rather show them the path than stay with the old ladies because he knew he could never convince the ladies of this article of faith: there is no back to anything. The ladies would do their best to make up some sort of back and then the desert would become crowded with academies and discussion.

"What beautiful music for my wedding," exclaimed Minnie Pinnikin while she was already on her way and everybody danced, the sand played the violin, the wind sang and the space played the drums and eventually they found an oasis with a city on the background.

"I cannot go further," the high priest said. "If you do, that won't take you anywhere, just as I have told you."

"Let's go!" Pinarius commanded.

"That city is in the clouds. It is a real mirage of a city," said Minnie Pinnikin.

They moved along in the air with ease, first the angels carrying Minnie Pinnikin and Pinarius who carried the children who carried the knights who carried the animals who carried the penitents who carried the old ladies who carried the old man. The colored heads took off last, all by themselves.

The city sparkled with colors and was surrounded with sweet grass on which some bony horses, as light as hope, were galloping. There were water wells in which pebbles would fling themselves to watch the circles they made. There were holes to make you fall down and other holes to make you rise up and tents of space and corridors of all lengths and hundreds of entryways without doors. At the main

door, there was an odd keeper, confused by a door that did not exist and that he kept open. He constantly shouted—"Enter! Enter!"

And then—as it always happens in dreams—Minnie Pinnikin woke up.

But because of the dream, when she came to Paris, she happened to be in a dairy shop one day and Pinarius heard her asking the lady who gave her the bill what a "couvert"[13] was, then he turned back, they both blushed and said hello.

6.

Bompas and an art critic meet at La Closerie des Lilas. Bompas encourages the critic to go to his exhibition, which had opened that morning and had already sold sixty-four paintings. Bompas leads the critic and a group of others to the gallery.

7.

This chapter reveals that Minnie has been conveying her dreams to Pinarius. Pinarius suggests that they go to the fair, where they might find wedding gifts. They meet up with Bompas and continue on to the fair. Once at the fair, they encounter a talking monkey. The three awake at the lamppost where they entered the fair, and realize that they have been hallucinating.

8.

Minnie and Pinarius return to the fair to buy wedding gifts. Bompas encounters an art critic named Pierre Pelouse. Minnie engages in an abstract conversation with Time. Exclaiming that everything has changed since the fair opened, Bompas sees a small booth at the fair labeled, "Phone Office for Lost Cats," and then witnesses several cats conversing. Confused, Bompas knocks on the door of the booth, to find a man with glasses. Increasingly frightened and confused, Bompas runs to the Rotonde. [One page is lost.]

9.

Pinarius and Minnie engage in a conversation about borders. Like the earlier conversation between Minnie and Time, Hastings takes poetic license with this conversation by connecting a trail of word associations, word plays, and puns about borders.

10.

On the way to the fair, Bompas was dragging behind saying he wouldn't come but still came. "You are killing me. That is what you want. You wish I could disappear so that there would be room for idiots."

"Minnie Pinnikin," said Pinarius, "who is behind me when I make something which is OK and I hear him say that it is great."

"Oh yes!, I have one like that too. This guy messes up everything!"

"You know, it may sound childish, but I think he is a real guy, a real guy who is not me, because if he were me, I would listen to myself but instead, I do not listen, I cannot stand him."

"And he comes, and he comes, and he comes. A hundred times he is kicked out, and a hundred times he comes back. Oh, I know him, come on!" I think that these people have nothing to do except bother us. I will do my part. Anytime he murmurs something is great, I will destroy it."

"This might not prevent him from still doing it … Anyway, it will take time and you may destroy good work because he is not infallible even in his bad taste."

"But everything takes time, especially when art is concerned."

"Bompas interrupted. "Note that this remark does not come from you originally."

"It has nothing to do with being original, Bompas. We have just found out, Minnie Pinnikin and I, that the best opinion we may have of ourselves does not belong to us."

"What kind of logic is this? My best opinion of *myself* does belong to *me*!"

"Well, when you have done something which is OK, who comes to tell you it is great?"

"Nobody. They are jealous and envious. They think that only what they do is great. But I, Bompas, rely only on my opinion."

"And do you think this opinion is yours?"

"Of course. I know it. Ouf! That Fair again! Isn't there anything else better to do than go to that Fair every night and get bored? What is that booth? I did not see it last night."

On the door of a very narrow booth, they saw a sign—"Booth of the Electrical Lady. See the Future."

"I want to see this!" cried Minnie Pinnikin.

"Me too!" Pinarius said.

"What a joke!" Bompas grumbled.

Minnie Pinnikin knocked at the door that opened on a tall blond lady, large and beautiful. She sat in front of a black curtain. She looked at Minnie Pinnikin. "There is room for one person only," she said. "You, lady, you are first."

Minnie Pinnikin walked inside and the door closed after her.

There was no longer a curtain. Instead, at the back of the booth was an opening to a void. The Electrical Lady passed through Min-nie Pinnikin's body and stood behind her. "In general," the Lady said, "I do not ask my customers what they want. I simply push them through the opening. But I will give you the choice. Do you wish to leave or jump into the void?"

"I would not mind jumping if there is no other means of knowing the future."

"There is no other means. Jump then."

Minnie Pinnikin took a three-second free-fall. Then she felt as if she were being held. "I have wings!" she said to herself. " I have turned into a bird!" Then she flew back trying some gymnastic maneuvers and eventually feeling confident, she flew over the void. Soon, the void disappeared and she saw a country of beautiful dreams. "My god! What a country! That is all I have ever desired! Oh! I wish Pinarius were with me, we would stay here forever!"

The Electrical Lady appeared at the opening. "Since you do not think it is perfect, you may not wish to stay then?"

"I would like to get Pinarius."

"Ah! Will you tell him all about it?"

"Maybe. Should I not then?"

"Well, it does not matter. Nobody will believe you."

"Not even Pinarius?"

"Not even Pinarius. One must see to believe."

"He should come then!"

"He will come but he won't see the exact same thing. Come inside. I will go and get him."

"Can I tell everything?"

"Everything."

"As much as you want, but not more than Bompas?"

Indeed, Pinarius did not want to believe Minnie Pinnikin had flown like a bird over a void that became a beautiful country. He kissed her and said, "You are joking! They got you and you want us to go too. Well. I will go."

"I won't!" Bompas cried. I do not like to be fooled."

Pinarius knocked at the door. When he saw the opening at the back of the booth, the Electrical Lady having passed through his body like a bolt of lightning, he stepped back. A minute later, he felt he was falling down for half an hour and then he landed on a huge hot air balloon on which he jumped and jumped while a crowd of small silly ghosts laughed at him. He almost got mad, but he thought of Minnie Pinnikin who saw everything in a positive way. "I will do so." And he started to laugh. Then he was back to the booth.

"So, are you set on the Future now?" asked the Lady.

"Is that what it is, the future, a hot air balloon? I expected that."

"Do not lie!" the lady interrupted him. "You did not expect to be anything but fooled. You got it. Now you will lie to fool everybody. You will learn with time. Everybody goes through the same path."

"So, Minnie Pinnikin lied to us?"

"No. You did not believe her nonetheless."

Pinarius stood outside where Minnie Pinnikin and Bompas were waiting for him.

"It is great!" exclaimed Pinarius. "You fly like a bird! You see marvelous things. I wish I could do this all the time. Come on! Let's go to Montparnasse, I want to tell all."

"You are a liar," Bompas answered. "They got you and you want everybody to go. I am going to see for myself what this is all about. I do not like being fooled. I will go and see." He banged at the door. "Hey, Electrical Lady! Show me the Future!"

The Lady smiled at him. "You will see yours, sir. Come on in."

Then Bompas tried to run away, but his right foot on which he had stepped inside the booth was stuck on the floor and the left foot moved forward by itself. The door closed behind him. When he felt the Lady passing through his body, he screamed. "Help! Someone is poking me! Someone is killing me. Help!"

He kept on screaming as the Lady lunged at him with a giant stick pushing him into the void. He fell for an eternity. He saw his past scrolling down in front of his closed eyes. He saw himself and his many bad sides. At each image, he moaned. "Horror! This is not me! This is not me! I recognize myself though. Yes, it is me, it is indeed me! Help! Help me from myself. I am tormented."

Pan! He reached the bottom of the void. It was no better down there than it was in the air, because the bottom was a bed of toes. Suddenly, Bompas remembered this young man he pushed to take drugs in order to forget his own grief. "I wish I had not done that," Bompas said. "He told me later that his conscience poked at him like toes. That made me laugh. Then he committed suicide to escape from moral sufferings. Pouah! I am being sentimental now." The toes started to move. "No! No!" he cried. But they did not stop poking him less because he was crying and they shouted—"Well, go ahead and laugh at this! Moral sufferings are nothing, they do not poke like toes do. Laugh, laugh!"

"It is not funny," he admitted. "I cannot handle it anymore. I will commit suicide. I will end my pain." He stood up and hung himself on a post. For all the good it did! The toes grew up like trees and poked him more than ever and on top of that, his neck was hurting badly. "I want to get down," he said: "I might as well suffer on earth, rather than hang on a post. Hanging myself did not help.

Help! Cut that rope, please anyone with a heart!"

A young man who was walking by came to the post. Bompas, scared, closed his eyes, because the walking man was but the poor boy who had committed suicide weakened by the drugs. "He will torture me!" said Bompas, almost passing out, "he will torture me and I won't be able to fight."

But, without a word, the man cut the rope and left with a sad look on his face.

Bompas blushed or almost did. "He does not blame me at all— that is worse than anything else." He ran after the young man to beg for his forgiveness. He was still in sight ahead of him

[The end of this chapter is lost.]

11.

[This chapter is lost.]

12. AT MINNIE PINNIKIN'S

This chapter begins in another dream world in which Pâtredor colors Minnie's dress with pastels while eating fairy cake. Pâtredor begins to read a book upside-down. Minnie discusses what she owes in rent. [The final pages of this chapter are lost.]

NOTES

1 The catalogue for this exhibition advertises the literary event as a "Matinée Littéraire." It refers to the title of this work incorrectly as "Minnie Pinnikins." The works of Roger Allard, Jean le Roy, Max Jacob, Ilya Ehrenburg, Pierre Reverdy, and Fernand Fleuret were also featured. The only known copy of this catalogue is in the archives of The Museum of Modern Art, New York.

2 Beatrice Hastings to Douglas Goldring, September 17, 1936, in Pierre Sichel, *A Biography of Amedeo Modigliani* (New York: E. P. Dutton, 1967), p. 265.

3 Ibid.

4 Ibid., pp. 265–66.

5 They wrote under the pseudonym Charles Douglas, *Artist Quarter: Reminiscences of Montmartre and Montparnasse in the First Two Decades of the Twentieth Century* (London: Faber and Faber, 1941).

6 William Lieberman to Kenneth Wayne, by telephone, October 2, 2001.

7 A copy of Hastings's will at the Probate House in London indicates that Doris Lilian Green of 8, Cambridge Road, Worthing, England, was executor of her estate.

8 Hastings's suicide is reported in "Worthing Authoress's Suicide, Found Dead in Gas-filled room," *Worthing Gazette* (England) November 10, 1943. The article mentions Miss Doris Lilian Green and the fact that she was a nurse.

9 Sichel, *A Biography of Amedeo Modigliani*, p. 266.

10 For more on Beatrice Hastings see Stephen Gray, "A Wild Colonial Girl: Reconstructing Beatrice Hastings," *Current Writing* (Durban, South Africa), vol. 6, no. 2, 1994, pp.113–26; and John Richardson, *A Life of Picasso: The Painter of Modern Life*, Vol. II: 1907–1917 (New York: Random House, 1996), pp. 368, 427.

11 The French familiar form of "you."

12 A person who posts advertisements on kiosks and buildings.

13 A "couvert" is a set of dining utensils.

Page numbers in *italics* refer to illustrations.
All works are by Modigliani unless otherwise indicated.

PHOTOGRAPH CREDITS

All photographs of works in the collection of the Albright-Knox Art Gallery have been produced by Biff Henrich and are © The Buffalo Fine Arts Academy.

Page 1 Fonds Marc Vaux, Documentation du Musée National d'Art Moderne, Centre Georges Pompidou, Paris

ESSAY 1

Fig. 1 Photograph courtesy Klüver/Martin Archive

Fig. 2 Photograph courtesy Klüver/Martin Archive

Fig. 3 Harlingue-Viollet / Photograph courtesy Klüver/Martin Archive

Fig. 4 Reproduced from Billy Klüver and Julie Martin. *Kiki's Paris.* New York: Harry N. Abrams, 1989, p. 70.

Fig. 5 Photograph by Kenneth Wayne

Fig. 6 Photograph courtesy Klüver/Martin Archive

Fig. 7 Photograph courtesy Klüver/Martin Archive

Fig. 8 Photograph © Thérèse Bonney/Bibliothèque Historique de la Ville de Paris

Fig. 9 Photograph courtesy the Brummer Archives, The Cloisters Collection/The Metropolitan Museum of Art, New York

Fig. 10 Photograph courtesy the Brummer Archives, The Cloisters Collection/The Metropolitan Museum of Art, New York

Fig. 11 Photograph © Christie's Images New York

ESSAY 2

Fig. 1 Photograph by Kenneth Wayne

Fig. 2 Photograph by Bob Grove

Fig. 3 Photograph courtesy Klüver/Martin Archive

Fig. 4 Photograph courtesy Réunion des Musées Nationaux/Art Resource, New York

Figs. 5 & 6 Photographs by Tom Loonan

Fig. 8 Photograph courtesy Rosengart Collection, Lucerne

Fig. 9 Photograph courtesy Galerie Schmit, Paris

Fig. 10 Photograph by Scott Bowron Photography, New York; courtesy Acquavella Galleries, New York

Fig. 11 Photograph courtesy Central Art Archives/Hannu Aaltonen

Fig. 12 Photograph © Tel Aviv Museum of Art

Fig. 13 Photograph by Biff Henrich

Fig. 14 Photograph courtesy Claude Bernès, Paris

Fig. 15 Photograph courtesy Klüver/Martin Archive, reproduced from Irene Patai, *Encounters; The Life of Jacques Lipchitz.* New York: Funk & Wagnalls Co., 1960, following p. 118

Fig. 16 Photograph courtesy The Cleveland Museum of Art. © The Cleveland Museum of Art, 2002

Fig. 17 Photograph courtesy Department of English, University of Reading, U.K.

Fig. 18 Photograph courtesy The Garman Ryan Collection, The New Art Gallery, Walsall, England

Fig. 19 Photograph courtesy Nathan and Marion Richard Smooke Collection, sale, Phillips, New York, November 2001

Fig. 20 Photograph by Philip Bernard, courtesy Musée d'art moderne Lille Metropole, Villeneuve d'Ascq

Fig. 21 Photograph courtesy Christie's Images New York

Fig. 22 Reproduced from Cabaret Voltaire exhibition catalogue. Reprinted, Lichtenstein: Krause Reprint, 1977. Photograph by Tom Loonan

Fig. 23 Photograph courtesy Klüver/Martin Archive, reproduced from Colette Giraudon, *Paul Guillaume et Les Peintres du XXe Siècle: de l'Art Nègre à l'Avant–Garde.* Paris: La Bibliothèque des Arts, 1993, p. 36

Fig. 24 Reproduced from Blaise Cendrars, *Dix–Neuf Poèmes Élastiques.* Paris: Au Sans Pareil, 1919, p. 1. Photograph by Tom Loonan

Figs. 26, 27, & 28 Photograph courtesy Klüver/Martin Archive and Association des Amis de Jean Cocteau, Paris. © 2002 Artists Rights Society (ARS), New York/ADAGP, Paris

Fig. 29 Reproduced from Blaise Cendrars, *Dix–Neuf Poèmes Élastiques.* Paris: Au Sans Pareil, 1919. Photograph by Tom Loonan.

Fig. 30 Photograph courtesy Galerie Daniel Malingue, Paris

Fig. 31 Photograph courtesy Klüver/Martin Archive

ESSAY 3

Fig. 1 Photograph courtesy Fundacao Calouste Gulbenkian, Lisbon

Fig. 2 Photograph courtesy Fundacao Calouste Gulbenkian, Lisbon

Cat. no. 23 © The Cleveland Museum of Art

Cat. no. 24 Photograph courtesy Réunion des Musées Nationaux / Art Resource, New York

Cat. no. 25 © Dallas Museum of Art, 1992

Cat. no. 26 Photograph by G. Mangin © Musée des Beaux-Arts de Nancy

Cat. no. 27 Photograph © 2000 The Metropolitan Museum of Art

Cat. no. 28 Photograph by Martin Bühler, Oeffentliche Kunstsammlung, Basel

Cat. no. 29 © Denver Art Museum 2002

Cat. no. 31 © 1990 Museum Associates, Los Angeles County Museum of Art

Cat. no. 32 Photograph by Hans Petersen

Cat. no. 34 © Tate, London 2001

Cat. no. 35 Photograph courtesy CNAC/MNAM/Dist. Réunion des Musées Nationaux / Art Resource, New York

Cat. no. 39 Photograph by P.H. Joffre. © Photothèque des Musées de la Ville de Paris

Cat. no. 40 Photograph by Muriel Anssens

Cat. no. 41 Photograph © 2001 The Museum of Modern Art, New York

WORKS BY AMEDEO MODIGLIANI: SCULPTURE

Cat. no. 42 Photograph by Mark L. Stephenson / Sky Valley Pictures

Cat. no. 43 Photograph by Michael Nedzweski

Cat. no. 44 Photograph by Graydon Wood, 1993

Cat. no. 46 Photograph by Lee Stalsworth

Cat. no. 47 Photograph by David Heald. © The Solomon R. Guggenheim Foundation, New York

Cat. no. 48 Photograph courtesy CNAC/MNAM/Dist. Réunion des Musées Nationaux / Art Resource, New York

Cat. no. 49 Photograph © 2001 The Museum of Modern Art, New York

Cat. no. 50 Photograph © 2001 The Museum of Modern Art, New York

WORKS BY AMEDEO MODIGLIANI: WORKS ON PAPER

Cat. no. 52 Photograph by Biff Henrich

Cat. no. 54 Photograph © Lucien Capehart Photography

WORKS BY THE ARTISTS OF MONTPARNASSE

Cat. no. 82 Photograph by Graydon Wood, 1992

CHRONOLOGY

Fig. 1 Photograph courtesy Nathan and Marion Richard Smooke Collection, sale, Phillips, New York, November 2001

Fig. 2 Photograph courtesy Klüver/Martin Archive, Fonds Joseph Altounian, Paris

Fig. 3 Photograph Fonds Marc Vaux, Documentation du Musée National d'Art Moderne, Centre Georges Pompidou, Paris

Fig. 4 Photograph courtesy Library, Getty Research Institute, Los Angeles

Fig. 5 Photograph courtesy Library, Getty Research Institute, Los Angeles

Fig. 6 Photograph courtesy Library, Getty Research Institute, Los Angeles

Fig. 7 Photograph courtesy SCT Enterprises, Ltd., Courtauld Institute, London

Fig. 9 Reproduced from *Nord–Sud: Revue Littéraire, Collection Complète*. Paris: Editions Jean–Michel Place, 1980. Photograph by Tom Loonan

Fig. 10 Reproduced from Colette Giraudon, *Paul Guillaume et Les Peintres du XXe Siècle: de l'Art Nègre a l'Avant-Garde*. Paris: La Bibliothèque des Arts, 1993, p. 32. Photograph by Tom Loonan

Fig. 11 Photograph courtesy Sotheby's, New York

Fig. 12 Photograph from Galerie Charpentier, Paris, reproduced in Jeanne Modigliani, *Modigliani: Man and Myth*. Esther Rowland Clifford, trans. New York: The Orion Press, 1958, Fig. 31. Photograph by Tom Loonan

Fig. 13 Reproduced from Colette Giraudon, *Paul Guillaume et Les Peintres du Xxe Siècle: de l'Art Nègre a l'Avant-Garde*. Paris: La Bibliothèque des Arts, 1993, p. 42. Photograph by Tom Loonan

Fig. 14 Photograph courtesy Library, Getty Research Institute, Los Angeles

Fig. 15 Reproduced from *Les Arts à Paris chez Paul Guillaume 1918–1935*, Paris: Musée de l'Orangerie, 1993, p. 74. Photograph by Tom Loonan

APPENDIX

Fig. 1 Photograph courtesy Klüver/Martin Archive. © 2002 Man Ray Trust/Artists Rights Society (ARS), NY/ADAGP, Paris